W9-AGY-422

MADE IN THE U.S.A.

MADE IN THE U.S.A.

AMERICAN ART FROM **THE PHILLIPS COLLECTION** 1850–1970

EDITED BY Susan Behrends Frank

WITH AN ESSAY BY Eliza E. Rathbone

Yale University Press, New Haven and London

IN ASSOCIATION WITH
The Phillips Collection, Washington, D.C.

This publication is proudly supported by the Henry Luce Foundation.

Additional support provided by Furthermore: a program of the J. M. Kaplan Fund.

Published on the occasion of the exhibition
Made in the USA: American Masters from The Phillips Collection, 1850–1970
organized by The Phillips Collection.

The exhibition is presented by Altria Group Inc. **Altria**

The Phillips Collection, Washington, D.C.
February 22–August 31, 2014

www.yalebooks.com/art

Designed and set in Simoncini Garamond and Avenir by Laura Lindgren
Printed in China through Asia Pacific Offset

Library of Congress Cataloging-in-Publication Data
Phillips Collection.
 Made in the U.S.A. : American Art from the Phillips Collection, 1850–1970 / Edited by Susan Behrends Frank ; With an essay by Eliza E. Rathbone.
 pages cm
 Includes bibliographical references.
 ISBN 978-0-300-19615-3 (pbk. with flaps : alk. paper)
1. Art, American—Catalogs. 2. Art—Washington (D.C.)—Catalogs. 3. Phillips Collection—Catalogs.
I. Frank, Susan Behrends, editor. II. Title.
 N6510.P49 2013
 709.73—dc23 2013011040

A catalogue record for this book is available from the British Library.

The paper in this book meets the requirements of ANSI/NISO Z39.48-1992 (Permanence of Paper).

10 9 8 7 6 5 4 3 2 1

Cover illustrations: *(front)* Arthur G. Dove, *Red Sun* (detail), 1935 (p. 87); *(back)* Charles Sheeler, *Skyscrapers*, 1922 (p. 129)
Frontispiece: Bradley Walker Tomlin, *No. 9* (detail), 1952 (p. 214)

CONTENTS

vi Director's Foreword
DOROTHY KOSINSKI

1 From Ryder to Rothko, the Quest for the Best of American Art:
Duncan Phillips, Visionary Champion of American Art
SUSAN BEHRENDS FRANK

25 The Rothko Room at The Phillips Collection
ELIZA E. RATHBONE

FEATURED WORKS FROM THE COLLECTION
THEMATIC TEXTS BY SUSAN BEHRENDS FRANK

32 Realism and Romanticism

46 Impressionism

60 Forces in Nature

74 Nature and Abstraction

96 Exotic Places

106 Modern Life

122 The City

140 Memory and Identity

162 Still Life Variations

176 Legacy of Cubism

192 Degrees of Abstraction

204 Abstract Expressionism

234 Biographies of the Artists
COMPILED BY SUSAN BEHRENDS FRANK

252 Selected Chronology: American Art at The Phillips Collection to 1970
COMPILED BY SUSAN BEHRENDS FRANK

261 Checklist of Featured Works from the Collection

265 Photographic Credits and Copyrights

DIRECTOR'S FOREWORD

The Phillips Collection has been a champion of American art since it opened to the public in Washington, D.C., in 1921, so it is unsurprising to learn that more than three-fourths of this revered collection is American in origin. *Made in the U.S.A.: American Art from The Phillips Collection, 1850–1970* is the first publication to give an in-depth presentation of the museum's American treasures.

In 2010–13 the Phillips organized an international exhibition of one hundred of its American masterworks entitled *To See As Artists See: American Art from The Phillips Collection, 1850–1960,* which traveled first to Rovereto, Italy, then to Madrid and Tokyo, before touring Nashville, Fort Worth, and Tampa in the United States. More than 300,000 people saw the exhibition on its worldwide tour and scholars in Italy and Spain contributed important essays to the Italian- and Spanish-language catalogues detailing the participation of The Phillips Collection in the Venice Biennales of 1924, 1950, and 1952, as well as the influence of Spanish art on American art and artists. That tour allowed us to see the complexity and strength of our American collection in a manner far beyond the usual capacity of our limited galleries. In celebration of the return of our American masterworks, the Phillips is presenting a special exhibition in 2014 of its American treasures that not only complements this beautiful publication, but is the largest and most in-depth installation of the American collection ever undertaken by the museum.

While aspects of The Phillips Collection's American holdings have been singled out in the past in both exhibitions and publications (i.e., impressionism, the Stieglitz circle, and Jacob Lawrence), this is the first time the museum has set out to tell a broader, more comprehensive story about the art of the United States, one that establishes connections between the past and the present, while also highlighting the diversity of voices between the World Wars when modernism often clashed with the public's understanding of what kind of art constituted America's cultural identity. This book, although still just a small sample of the entire collection, features one hundred sixty works by more than one hundred artists. Like the exhibition it accompanies, it is organized into twelve thematic sections that take the reader on a journey that unfolds chronologically from the paintings of America's great realist artists at the end of the nineteenth century, such as Winslow Homer and Thomas Eakins, to the heroic works of the abstract expressionists after World War II, including Mark Rothko, Adolph Gottlieb, and Clyfford Still. Critical essays about the history of Duncan Phillips's engagement with American art and the establishment of the Rothko Room at the museum written by Dr. Susan Behrends Frank, associate curator for research, and Eliza E. Rathbone, chief curator, respectively, give the reader

fresh insight into the assemblage of this admired collection. In addition there are biographies of all the artists featured in the book, as well as an extensive chronology. We hope that this major publication will give a new audience, as well as a familiar one, a broad look at the depth and reach of the museum's collection of American art.

Duncan Phillips (1886–1966), the museum's founder, intended from the outset that this gallery in the nation's capital, which bears his family name, had a mission "to reveal the richness of the art created in our United States."[1] A firm believer in the power of the individual to make a significant contribution to the community, Phillips dedicated his life to finding, fostering, and celebrating the very best of American art, particularly the work of America's living artists and especially those guided by their independence and individualism rather than popular trends. He never championed one point of view over another, but neither did he pretend to be all-inclusive in his choices. Phillips had little sympathy for fads or for art that was emotionally cool or cerebral. His romantic nature searched instead for the exceptional and the independent, often choosing to collect in depth the work of certain artists rather than an example of every trend. As a result, the collection of American art he assembled not only reflects his personal taste, but can be seen as revelatory of the changing character of American art in the twentieth century. There was no handbook of modernism when Phillips began collecting, so he relied on his eye for good work, talent, and great promise, understanding that time would be the ultimate arbiter of the collection. Within that framework, the art and the artists featured here, with few exceptions, are those that Phillips singled out as important standard bearers for the modern spirit in American art from the late nineteenth through the mid-twentieth century.

Phillips's 1926 publication, *A Collection in the Making*, chronicles his early engagement with post–World War I American art when he was carving out virgin territory as the first museum to purchase the paintings of Arthur Dove, Georgia O'Keeffe, Charles Sheeler, and John Sloan, to name but a few. No other American museum at the time was making this deep commitment to postwar American painting, not even in New York, which had no museum dedicated to contemporary art until the end of the 1920s. It is a regrettable fact that after World War I the United States experienced a massive institutional and critical retreat from modernism and American art in general. Phillips was that rare voice between the wars determined to lift the art of the United States out of obscurity, advocating for our national art to be considered part of the mainstream, not as something separate and of lesser consequence. There were others in the 1910s and 1920s who were also building important collections of modernism, including Albert Barnes, Katherine Dreier, A. E. Gallatin, Ferdinand Howald, and Gertrude Whitney, but, as my respected colleague William Agee has pointed out, Duncan Phillips's involvement with American art, especially between the wars, was deeper than that of his contemporaries and had greater consequences.[2] Unlike most of these other collectors, Phillips was a writer and established critic who used the power of his pen to aggressively argue for American art in art magazines, newspapers, and exhibition publications. Also unlike his contemporaries, Phillips

believed his collection needed to reflect the continuity of art across time and so he reached back into the nineteenth century to collect America's first modern masters, particularly Eakins, Homer, and Albert Pinkham Ryder, in order to demonstrate the connections between past and present in American modernism.

Phillips was particularly sensitive to assistance he could provide early in an artist's career or during uncertain economic times. The material support he gave so many American artists between the wars was indispensable and much more extensive than other patrons were willing to do at the time. For some it included financial stipends that allowed them to travel, while others used it as a lifeline to give up commercial work and concentrate exclusively on their painting. For Phillips, it allowed him to play a personal role in an artist's career, while also building and shaping the collection in the most profound way. Acquisitions, stipends, and exhibitions were key to Phillips's patronage as he assembled an ever-growing collection of contemporary American art. Passionate about the art of his time, Phillips remained actively engaged until the end of his life, establishing the Rothko Room in 1960 when he was 74 years old, the first such dedicated space for the artist's work and now a signature of the museum.

The Phillips Collection, under the leadership of Duncan Phillips, held American art to the highest standard and principles of inclusion that reflected the country's demographic and ethnic diversity. Thus, the collection includes examples by women, the self-taught, artists of color, and those who immigrated here from around the world. It was this "fusion of various sensitivities" and "unification of differences," as Phillips described it, that was something to celebrate as the defining character of our national art.[3] Today one can trace a standardized history of American modernism in the collection, but it is, in reality, so much more compelling because of the unexpected and sometimes lesser known artists whose works surprise and delight us. The Phillips's American collection is more than just a compilation of great names; its strength is the rich diversity and multiplicity of voices assembled by Phillips over a lifetime.

We are grateful to the Henry Luce Foundation and its program director for American art, Ellen Holtzman, for supporting this publication with a generous grant. We want to thank Furthermore: a program of the J. M. Kaplan Fund for its support of photography expenses related to this publication. We are also very appreciative of the enthusiasm shown by Yale University Press and extend our special thanks to Patricia Fidler and Katherine Boller for their work on this project, as well as to Kate Zanzucchi, managing editor, Sarah Henry, assistant production manager for art books, and freelancers Elma Sanders, copyeditor, Laurie Burton, proofreader, and Laura Lindgren, designer. Substantive content editorial work was done by Johanna Halford-MacLeod and Esther Ferington.

We applaud Dr. Susan Behrends Frank, associate curator for research, for having shaped this exceedingly thoughtful project. Bearing deep knowledge of the collection and its history, Dr. Frank has crafted a compelling story of Duncan Phillips's advocacy of American art and, in particular, his unique commitment to the artists of his time. Her scholarship and insights are amply reflected in this handsome book.

We also thank Joseph Holbach, chief registrar and director of special initiatives, who nurtured the American art exhibition and arranged its complex international tour. Joe worked closely with Susan Frank to frame the concept of the project and to insure its success at each of the venues in Europe, Asia, and across the States. These exhibition presentations were critical to the success of this rich scholarly publication as they allowed us to see and appreciate the magnitude of our American art holdings in a way not previously possible.

Chief curator Eliza E. Rathbone has fully supported this project and has contributed significantly to this publication with her important essay on the Rothko Room.

Elizabeth Steele, chief conservator, Patricia Favero, associate conservator, and Sylvia Albro, paper conservator, ensured that all of the works were in the best condition possible for the traveling exhibition and its presentation at the Phillips in 2014. Ritha Spitz, conservation volunteer, attended to the overall appearance of the original frames on these works.

I also want to recognize the invaluable contributions of other Phillips staff members who have worked hard to make this project a success: Gretchen Martin, assistant registrar for visual resources and collection; Ann Greer, director of communications and marketing; Cecilia Wichmann, publicity and marketing manager; Vivian Djen, marketing communications editor; Suzanne Wright, director of education; Brooke Rosenblatt, manager of public programs and in-gallery interpretation; Dale Mott, director of development; Christine Hollins, director of institutional giving; Bridget Zangueneh, grants writer; Sue Nichols, chief operating officer; Cheryl Nichols, director of budgeting and reporting; Lydia O'Connor, finance assistant; Darci Vanderhoff, chief information officer; Caroline Mousset, director of music programs; Karen Schneider, librarian; Sarah Osborne-Bender, cataloguing and technical services librarian; Bill Koberg, head of installations; Shelly Wischhusen, chief preparator; Alec MacKaye, preparator; Angela Gillespie, director of human resources; Dan Datlow, director of facilities and security; Peter Kinsella, security manager; Liza Strelka, curatorial coordinator; and Brooke Horne, executive assistant to the director and the board of trustees. Special thanks go to Seri Pak, intern for Dr. Frank, and Daniel Yett, volunteer, who both made it possible to gather information, images, and materials that facilitated this publication.

Dorothy Kosinski, Ph.D.
Director, The Phillips Collection

1. Duncan Phillips, "The Plan and Purpose of The Phillips Memorial Art Gallery," *Extracts from the Minutes of First Annual Meeting of Trustees of Phillips Memorial Art Gallery*, brochure (Washington, D.C.: The Phillips Memorial Art Gallery, 1921), 11.

2. William Agee, "Duncan Phillips and American Modernism: The Continuing Legacy of the Experiment Station," in *The Eye of Duncan Phillips: A Collection in the Making*, ed. Erika D. Passantino (Washington, D.C., and New Haven, Conn.: The Phillips Collection and Yale University Press, 1999), 375.

3. Duncan Phillips, "Foreword," in *The American Paintings of The Phillips Collection*, exh. cat. (Washington, D.C.: Phillips Memorial Art Gallery, 1944), third page of unpaginated brochure.

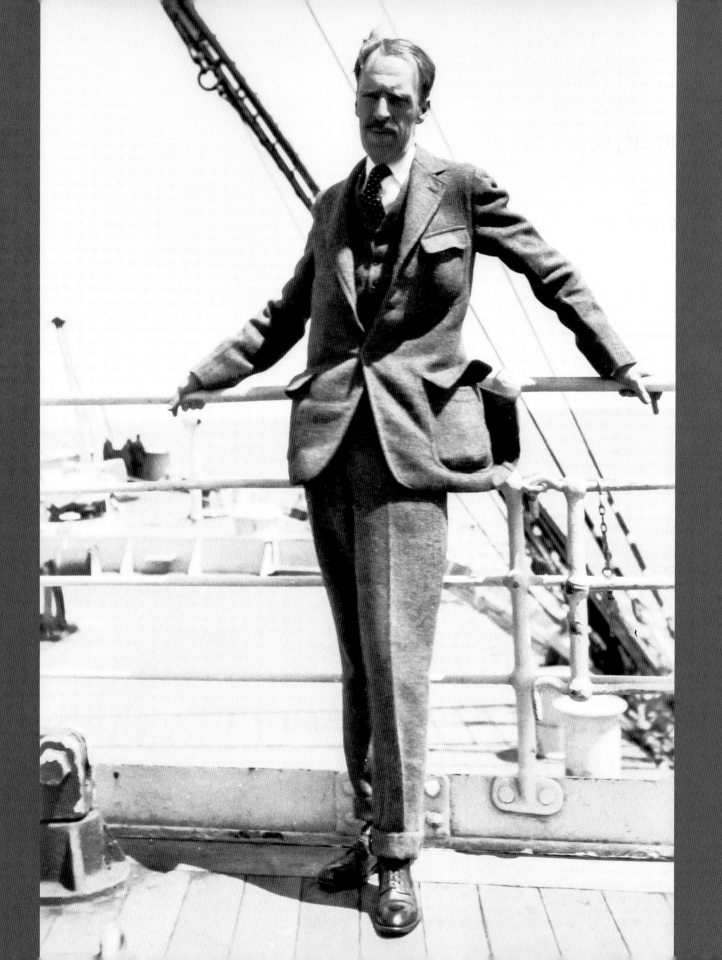

From Ryder to Rothko, the Quest for the Best of American Art

Duncan Phillips, Visionary Champion of American Art

SUSAN BEHRENDS FRANK

> Our most enthusiastic purpose will be to reveal the richness of the art created in our United States, to stimulate our native artists and afford them inspiration . . . to show how our American artists maintain their equality with, if not indeed their superiority to, their better-known foreign contemporaries.
>
> Duncan Phillips, 1921

Decades before the United States was recognized as the world's center for contemporary art, Duncan Phillips (1886–1966) sought out and celebrated the work of America's living artists. For over forty years, Phillips was a major force in promoting American modernism, through acquisitions, exhibitions, and the presentation of American art in his museum, as well as through his writing.

Unconstrained by conventions of museum display, works of art from different countries and epochs hang side by side at The Phillips Collection. In part, this practice reflects the early concerns of the collection's founder to show that the art of the United States could hold its own with that of Europe. The earliest photographs of installations at The Phillips Collection date from 1923. They show how Phillips hung the work of contemporary Americans, such as Ernest Lawson, Julian Alden Weir, Robert Spencer, and John Henry Twachtman, alongside the work of European artists Gustave Courbet, Alessandro Magnasco, and El Greco, for example. In this approach, Phillips affirmed his belief that American artists were the equals of European masters of any period, simultaneously expressing the idea of temperamental affinities connecting artists of different times and nations. American artists were enthusiastic from the outset about having their work incorporated into a collection that included paintings by European masters. Georgia O'Keeffe, for example, conveyed her excitement to Alfred Stieglitz shortly after her visit to the Phillips in March 1926, where she saw her work and that of Arthur Dove included with pictures

Duncan Phillips on a transatlantic journey, 1930s

1

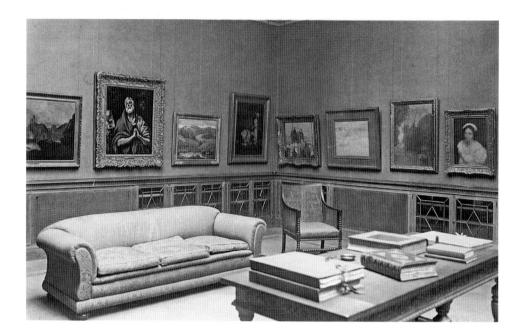

The Main Gallery with paintings by El Greco, Ernest Lawson, Julian Alden Weir, Robert Spencer, and John Henry Twachtman, 1923

by proto-modern masters such as Courbet, Honoré Daumier, Pierre-Auguste Renoir, and El Greco.[1]

Born into a wealthy Pittsburgh family, Phillips was the second son and namesake of a glass manufacturer and his wife, Liza Irwin Laughlin, who was an heir to the Jones and Laughlin Steel Company in Pittsburgh. They moved to Washington, D.C., in 1896, building themselves a mansion near Dupont Circle. The young Phillips attended private schools and moved easily among the city's political and social elite as an adult. After graduating from Yale, he set out to make his way as an art critic in New York, where he and his older brother, James, began visiting galleries, buying paintings for their own pleasure, and advising their parents on acquisitions for the family's small collection of American art.[2]

Duncan Phillips was a humanist. A product of the Progressive Era and the intellectual climate of pre–World War I New York, he believed he could contribute to society through the arts and art education. In early 1918, he wrote to a new friend, the elderly painter Julian Alden Weir, that he envisioned himself establishing a small museum in the nation's capital devoted to American art, the "art of our best men . . . open at all times to the people of Washington and the strangers within our gates, eventually making a gift of the [family] Collection to the city or the nation."[3]

Returning to Washington late that year, at the insistence of his widowed mother after the sudden death of his older brother, Phillips wished to create a memorial to his father and brother.[4] With his mother's cooperation and part of his inheritance at his disposal, Phillips transformed the family's small collection of American paintings into the seedbed for a museum dedicated to modern art, the sources of the modern spirit, and the work of living artists. A man of his time, Phillips shared a widespread American belief in the power of individuals to reshape and mold American life. The

museum that bore his family name was his own best effort to be a "beneficent force in the community where I live" because "art is part of the social purpose of the world."[5]

Phillips was neither the first collector to establish a Washington museum, nor the first in Washington to focus on American art. Washington-born William Wilson Corcoran opened his gallery in 1869 "for the purpose of encouraging American genius,"[6] and in 1905 the Detroit industrialist Charles Lang Freer made a gift to the nation of his personal collection of Asian and American painting. Freer stipulated that his collection could not be altered, and his late-nineteenth-century vision is encapsulated in the Freer Gallery of Art, which finally opened on the National Mall in 1923. Although inspired by Freer's example, Phillips decided that his own private museum would be molded publicly, like most civic or publicly funded institutions, though without the inconvenience of potentially obstructive acquisitions committees.

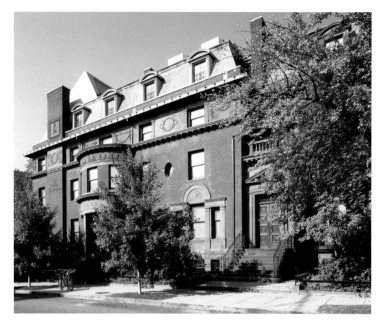

The Phillips Collection at 1600 Twenty-First Street, N.W., Washington, D.C. Photograph by Robert Lautman, 2006

The territory that Phillips staked out as his life's work was uncharted. In 1918, when he decided to establish a museum dedicated to modernism and the work of America's best artists, there were neither histories nor museums of modern art. In New York, the Museum of Modern Art was not established until 1929, and the Whitney Museum of American Art did not open until 1931, after Gertrude Whitney's proposed gift of 500 contemporary American paintings, along with an endowment, was refused by the Metropolitan Museum of Art. Phillips was thirty-five years old when the Phillips Memorial Art Gallery opened to the public in 1921 in the skylit gallery that he had added to the family home.[7] In the three years since the gallery's inception as an idea, he had assembled a collection of 237 works, three-fourths (188) of which were paintings by sixty-two different American artists. At his death in 1966, the museum's permanent collection numbered nearly 2,000 works, of which 1,400 were by American artists.

In his first published art criticism, early in the second decade of the twentieth century, Phillips promoted American art, expressing pride and confidence in American artists, as he would for the rest of his career. In 1914 he wrote, "Not only does America inherit the arts of all nations and of all ages, but rich should be the harvesting and exquisite the flowering of the strong, sound and aspiring American spirit from the seeds of aesthetic purpose, now so wisely and so bountifully being sown in her own native soil."[8] He was enthusiastic about American art of the recent past and the present and opposed to what he viewed as fads, as well as to the stultifying effects of academic conservatism.

The Phillips Collection's holdings of American art are not encyclopedic; rather, they gather the work of independently minded artists, most of whom were alive

and actively exhibiting when their work entered the collection. In many instances, the works were the first by their makers to enter a museum collection. The long and illustrious list of artists from whom Phillips was the first museum director to purchase work includes John Sloan (1919), Arthur Dove (1926), Georgia O'Keeffe (1926), Charles Sheeler (1926), Milton Avery (1929), and Kenneth Noland (1951).[9] In addition, Phillips was an early backer of such artists as Charles Burchfield, Stuart Davis, Edward Hopper, and Jacob Lawrence, adding their work to the collection when they were struggling to gain the attention of collectors and museums.[10]

A poll of museum directors, art critics, and artists published in *Look* magazine in 1948 entitled "Are These Men the Best Painters in America Today?" confirms Phillips's knack for spotting talent.[11] John Marin, then seventy-eight years old, came in first. Max Weber was next, followed by Yasuo Kuniyoshi, Davis, Ben Shahn, Hopper, and Burchfield. The top ten and many of the others had been represented in The Phillips Collection for years, and in many cases Phillips was the first museum director to buy their work. So closely, in fact, was Marin identified with the museum that Duncan Phillips was asked to write the tribute to him on the occasion of the 1950 Venice Biennale, where he was the featured American artist. Moreover, most of the artists identified in the *Look* poll (there were more than thirty of them) had been working for decades and were only now, at midcentury, being recognized as exceptional by the mainstream art establishment. In the 1920s, when they struggled to get their work exhibited and into museum collections, one of the few places where an American artist could find a museum open to exhibiting and acquiring examples of new directions in American painting was at The Phillips Collection.

Adopting a practice associated with commercial galleries and unprecedented in a museum setting, Phillips gave living artists solo exhibitions. He believed that these were an important source of encouragement for artists, especially at the beginning of their careers. In 1925, he created a second gallery space in his museum where he could experiment with these more focused exhibitions.[12] In the 1930s, some progressive museum directors—including Alfred Barr, the first director of the Museum of Modern Art, and A. Everett "Chick" Austin, the transformative director of the Wadsworth Atheneum in Hartford, Connecticut—followed suit. The Whitney resisted until 1948, when it finally set aside its policy prohibiting solo shows for living artists. The list of artists to whom The Phillips Collection gave first solo museum exhibitions includes Maurice Sterne (1926), John D. Graham (1929), Karl Knaths (1929), Marin (1929), Harold Weston (1930), Preston Dickinson (1931), Jacob Lawrence (1942), Avery (1943), Joseph Solman (1949), Theodoros Stamos (1950), Bradley Walker Tomlin (1955), and Sam Gilliam (1967). In addition, the Phillips notably mounted first museum retrospectives for Dove in 1937 and Marsden Hartley in 1943, a year before the Museum of Modern Art accorded Hartley the same distinction. While Phillips's high-profile European acquisitions in the 1920s of work by Daumier, El Greco, and Renoir brought his newly launched museum national

and international attention, his exhibition program supported his goal of showing American painting "as part of the main channel of all artistic progress."[13]

The Beginnings of a Collection of American Masters

Early on, Phillips liked landscapes, narratives, and romantic subjects. His sensibilities were particularly attuned to the American impressionists and the artists in the orbit of painter and teacher Robert Henri, whose independence was seen as an expression of the American character. Phillips wrote extensively in the second decade of the century about artists he admired and believed had advanced the cause of American art: William Merritt Chase, Arthur B. Davies, Lawson, Albert Pinkham Ryder, Twachtman, and Weir. He also bought their work. Davies and Weir, senior members of the art community, became his friends and mentors.

In Phillips's view, the modern spirit in American painting arose with the urban realists who flocked to Henri after the turn of the century: George Bellows, Guy Pène du Bois, William Glackens, Lawson, Rockwell Kent, George Luks, and Sloan. Shunning the conservatism of the National Academy of Design, they rejected artistic cliques, exhibition restrictions, and mainstream styles such as impressionism that presented only pastoral interpretations of the American countryside and pretty views of the city. They focused instead on the grittiness of the industrialized city and its immigrant neighborhoods, in a style derived from the flamboyant brushwork and dark palettes of seventeenth-century masters Frans Hals and Diego Velázquez. Phillips found the work of these contemporary realists, called the "ashcan" artists, highly appealing. In 1912, he characterized the Henri circle's "true" depictions of the city as "moments vividly experienced."[14] By the time he opened his museum, Phillips had assembled a significant number of works by these urban realists, as well as by the American impressionists.

Although Phillips was primarily engaged in acquiring the work of living American artists, he also bought earlier works that he considered links between past and present. Believing, for example, that the modern spirit could be found in the work of America's "old masters," he sought paintings by George Inness, whose expressive, mystical landscapes transcend description, Winslow Homer, an epic painter of humanity's eternal confrontation with nature, Thomas Eakins, the hero of visual fact and psychological realism, and Ryder, the visionary painter of nature as rhythmic abstract form. Other artists whose works Phillips acquired included James Abbott McNeill Whistler, viewed by Phillips as a self-conscious stylist whose portraits had "Venetian chivalry and romantic charm,"[15] and Chase, a painter's painter and an important teacher, who "made possible the present and future of American painting."[16]

Davies, an organizer of the Armory Show in 1913, was admired by Phillips for his originality. Phillips purchased his first Davies in 1916 and an additional twelve by 1930. Maurice Prendergast, whom Phillips characterized as "one of the most original artists of our time," and Twachtman, whose art he defined as "luminism carried to the heights of spiritual expression," were two of the collector's favorites when the museum opened.[17]

Phillips acquired his first Prendergast in 1917 and by 1922 had eleven works by him. Four distinct examples of Twachtman's landscapes, with their Asian sensibility and design, were bought between 1919 and 1921. Twachtman, who was deeply respected by modernists Hartley and Marin, was singled out by the French painter Pierre Bonnard when he visited the Phillips in 1926 and admired *The Emerald Pool* (c. 1895), confirming Phillips's estimation of Twachtman as one of America's "modern masters."[18]

Building the "Experiment Station"

From the outset, Phillips emphasized an institutional commitment "to stimulate contemporary artists by establishing personal contact and friendly relations, to win their confidence."[19] He purchased in quantity work by artists he particularly admired, even if they were not yet generally recognized. He focused on contemporary American art that was often abstract and increasingly expressionist in style and concept. In the years after World War I, when conservative critics were promoting representational American art in traditional aesthetic styles, this placed Phillips outside the mainstream. Under his leadership, The Phillips Collection in the 1920s was unusual in its willingness to embrace many varieties of abstraction.

Phillips's understanding of abstraction grew out of his admiration for the work of American impressionists Childe Hassam, Prendergast, and Twachtman. Their emphasis on design, pattern, color relationships, and flatness prepared him to understand the work of the next generation of American modernists. In 1922, Augustus Vincent Tack, Twachtman's student in the 1890s and a friend and mentor to Phillips, began painting abstract, decorative works inspired by nature and the New Testament, "compositions of form and color based on essential rhythm."[20] Phillips was the first collector to appreciate and acquire these works, writing enthusiastically about Tack's *The Voice of Many Waters* (c. 1923–24) as "a landscape for the mind . . . and the upper regions of the spirit" like that of the great Chinese landscape painters.[21] A decade earlier, he could not have imagined abstraction as either spiritual or emotional. Now he became Tack's most outspoken patron. For the next forty years, Phillips championed the decorative and mystical abstractions that he believed were the first true blending of Eastern and Western art in America.

As Phillips's aesthetic sensibility became more sophisticated in the 1920s, he sought out New York galleries known for carrying the newest American painting, including the Bourgeois Gallery, the Daniel Gallery, Stieglitz's The Intimate Gallery, and the Downtown Gallery. For example, Phillips bought paintings by so-called neo-cubists Niles Spencer, Stefan Hirsch, and Karl Knaths in the mid-1920s through the Daniel and Bourgeois galleries, their first paintings to enter a museum collection, thereby giving these young artists encouragement at the outset of their careers. Phillips took tremendous pleasure in discovering these "new men," preferring to show his "sympathy with the gallant tentative modern adventures on new trails by buying the works of our American modernists who are not yet fashionable, sensational, and overrated."[22]

Charles Daniel, a dealer whom Phillips had patronized for a number of years, wrote the collector in 1924 that no complete collection of American art should omit Hartley, Sheeler, or Marin.[23] Phillips, who already had purchased from Daniel paintings by Hartley, Henri, Lawson, and Dickinson by 1923, bought Sheeler's *Skyscrapers* (1922) from the gallery in 1926, the first work by this seminal American modernist to enter a museum. Phillips valued it for the "emotional essence" in its distorted view of the office canyons of New York.[24] Marin's work also entered the collection in 1926 after Phillips saw the artist's watercolors at Stieglitz's gallery. In addition, Kent's sleek South American landscapes caught the collector's eye in the mid-1920s. Kent was a Henri student whose realist canvases Phillips had first acquired in 1918 from the Daniel Gallery; his newest landscapes simplified sky, water, and mountains into flat, abstract forms and cool color harmonies. Phillips wrote in 1928 that they captured "the dramatic, the elemental . . . and the cosmic."[25]

When Phillips began his focused explorations of aspects of American art in the museum's Little Gallery in 1925, his first installations featured artists whose work was more or less representational, including Davies, Kenneth Hayes Miller, and Charles Demuth. One-person exhibitions of some of Phillips's favorite artists at this time soon followed, such as the impressionists Lawson and Hassam, and the ashcan artists Jerome Myers and Luks; for Luks, the solo show at the Phillips Memorial Gallery in 1926 was his first museum exhibition.

American Themes by American Painters (January 1927) was conceived by Phillips as "the first of a series of intimate exhibitions . . . revealing the fact that we are developing a fresh and native national expression independent of European influence."[26] The artists Phillips chose for this exhibition comprised, he believed, "the rich ore of American painting" up to that time, which included not only Homer, but contemporary realists such as Sloan and Sheeler. Included in the exhibition was Hopper's *Sunday* (1926), which Phillips purchased in April 1926. It was only the second oil by Hopper to enter a museum and Phillips paid the record price of $600 for it. In *A Collection in the Making* (published December 1926), Phillips became the first to write about the tension between Hopper's psychological content and the underlying abstraction of his compositions, recognizing how Hopper's realism, filled with the "boredom of the solitary" figure and the psychological isolation of modern life, "defies our preconceptions of the picturesque" captured in his carefully orchestrated compositions of color and volumetric form.[27]

Phillips's conversion to formalism was gradual. He was affected by Roger Fry's book *Vision and Design*, published in 1920.[28] Using European examples, including works by Cézanne and El Greco, Fry argued that the overall emotional idea present in a work is revealed through its formal elements of color, design, line, and form, not through its subject. Filling an entire room with the work of Tack in 1924 precipitated Phillips's first public advocacy of abstraction, in a comparison of visual design and rhythms of form, color, and line in painting to music. By 1926 Phillips was a formalist, writing that "However unrepresentative, [paintings] can train our observant powers

by focusing them on aspects and effects, colors, . . . line, . . . patterns of forms in space, . . . rhythmical arrangements of various kinds."[29] That March, he resigned from the American Federation of Arts, of which he had been a member since 1915, impatient with its conservatism.[30]

Even with his increased understanding of abstraction, Phillips remained averse to a machine aesthetic and overly theoretical or cerebral art, such as analytical cubism, and he had no interest in the witty antics of dada. His romantic preference for a more expressionist art with emotional or spiritual tendencies was shared by the circle of critics and artists around Stieglitz, the avant-garde photographer and dealer who had been a primary supporter of European modernism in the United States prior to World War I. By 1917, however, Stieglitz had soured on what he saw as commercialization and lack of emotional depth in some European movements and vowed to support instead only those American artists who had a spiritual element in their work.[31] At the end of World War I, Stieglitz and his colleagues promoted a renaissance in American art based on emotional intensity and a connection to nature revelatory of the artist's soul. Such a new American art, they believed, could only spring from local experience and native surroundings; it was to be, as Stieglitz wrote, an American art "without that damned French flavor."[32] The definition of modernism espoused by the Stieglitz circle was antithetical to the position taken by avant-garde European expatriates such as Marcel Duchamp and Francis Picabia who came to New York in the second decade of the twentieth century and celebrated American advances in technology and industry. By contrast, as Wanda Corn has argued, "American," "soil," and "spirit" were the words most often used by the Stieglitz circle to express their aesthetic position.[33]

The Americans singled out by Stieglitz were Demuth, Dove, Hartley, Marin, and O'Keeffe, along with himself and the photographer Paul Strand. Although Phillips had seen Dove's work in New York in 1922, it was only when he encountered it again, along with the work of O'Keeffe, in New York in February 1926 at Stieglitz's new space, The Intimate Gallery, that Phillips was ready to act. The new and personal approach evident in the work of Dove and O'Keeffe proved irresistible. He purchased his first pictures by each, *Golden Storm* (1925) and *Waterfall* (1925) by Dove, and *My Shanty, Lake George* (1922) and another work by O'Keeffe, later exchanged for *Pattern of Leaves* (1923).

Notably, Phillips attributed his evolution as a critic and a collector to the discovery of Dove's work.[34] Where previously Phillips had responded to pictures that could easily be described in words, Dove's abstractions, as Elizabeth Hutton Turner has pointed out, challenged him to "see" without the overlay of narrative, anecdote, or metaphor.[35] In a tribute to Dove after the artist's death, Phillips wrote that he awoke to a "sensuously visual" evocation of "painterly equivalents" in Dove's work that captured the "essence of nature's reality."[36] For Dove and O'Keeffe, abstraction was a language used to convey natural forces as individual experience. Phillips took special note of Dove's color, surfaces, and edges, and thrilled to "an elemental something in your abstractions, they start from nature and personal experience and they are free from fashionable mannerisms of . . . Paris."[37] Phillips was the first museum director to

recognize the seminal role played by these two artists in creating a new paradigm for American modernism after the Great War.

A month later, Phillips returned to Stieglitz's gallery for an exhibition of Marin watercolors. Again, he was captivated by a highly inventive artist's abstract language for natural forms. Phillips became Marin's most ardent supporter, acquiring nine of his watercolors within a year, prompting Stieglitz to playfully diagnose him with incurable "Marinitis."[38]

Promoting his artists, Stieglitz wrote to Phillips in late 1926, "I feel that you will not only have to have a large group of Marins but undoubtedly groups of Doves and O'Keeffe, Hartley, not to speak of my own photographs, if you really want your gallery to reflect a growth of something which is typically American and not a reflection of France or Europe."[39] Although he wanted examples of Stieglitz's photographs for the collection, Phillips had to wait until after the photographer's death in 1946 when O'Keeffe followed through on her husband's stated intention to give Phillips a large group from the series Stieglitz called *Equivalents*. With their moon and cloud imagery, these, Phillips confirmed in a July 30, 1949, letter of thanks to O'Keeffe, were his favorite Stieglitz photographs.[40] Ultimately Phillips acquired six O'Keeffes and eight Hartleys. His commitment to Dove was lifelong. Phillips added more than forty-eight works by Dove to the museum's collection, including twelve watercolors and one assemblage. In 1937 he gave Dove his first museum retrospective, the only one during the artist's lifetime.

Demonstrating a similar loyalty to Marin, whom he also regarded as an American genius, Phillips acquired more than twenty-three works in all media from all periods of Marin's career and gave the artist nine exhibitions. Marin's first visit to The Phillips Collection for his solo exhibition there in 1929 was the start of the closest friendship that Phillips had with any artist of the Stieglitz circle.

It was not only through acquisitions that Phillips gave support and encouragement to America's artists, but also through his exhibition program. In November 1925 Phillips wrote to the dealer Stephen Bourgeois, who represented modernists such as Hirsch, that he intended to start a "series of exhibitions showing contemporary tendencies in painting."[41] *Nine American Painters*, mounted in January 1926, featured new acquisitions by Demuth, Dickinson, Hirsch, Robert Spencer, Niles Spencer, Maurice Sterne, and William Zorach, among others. In the work of these men, Phillips found a cubist style combined with a sense of underlying beauty and rhythmical wholeness. *Nine American Painters* was written up in the *Sunday Star* as Washington's opportunity "to see and to estimate the work of some of the more advanced painters of the younger school, the school of the so-called modernists."[42] For the artists, with the exception of Demuth, who had already been included in a group show in the Little Gallery, the exhibition was their first exposure in Washington.

Nine American Painters was followed by an *Exhibition of Paintings by Eleven Americans*, artists Phillips considered "expressionist" in their desire "to create a fresh and rhythmical language of form and color which will convey their emotions."[43]

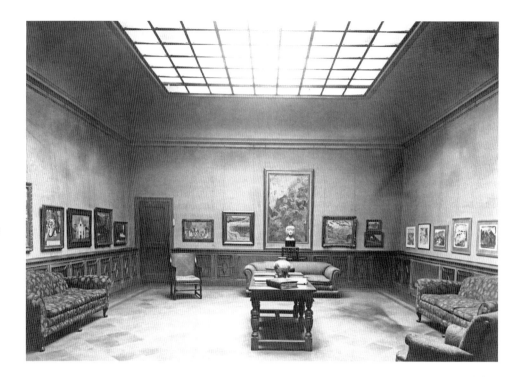

The Main Gallery in February 1927 with a special installation featuring contemporary American and French painting with works by Pierre Bonnard and Henri Matisse (left wall) opposite John Marin watercolors (right wall); works by Maurice Prendergast, John Henry Twachtman, Augustus Vincent Tack, and Paul Cézanne occupy the center wall along with an Eighteenth Dynasty Egyptian head

Phillips's newly acquired works by Dove and O'Keeffe were prominently on view alongside Kent's *Mountain Lake—Tierra del Fuego* (between 1922 and 1925), Weber's brilliantly colored midday landscape *High Noon* (1925), Hartley's 1908 Maine landscape *After Snow*, and abstract works by Tack, such as *Storm* (c. 1922–23). Both exhibitions were Phillips's way of familiarizing the "open-minded visitor" with the new and unfamiliar visual language of abstraction.[44]

No installation, however, was as boldly demonstrative of Phillips's commitment to the new American painting as the one he presented in the Main Gallery shortly after buying his first Marin watercolors. Unorthodox even by today's standards, it was unlike anything to be found at any other museum in 1927, bringing together as it did, in one space on equal terms, modern French painting and contemporary American art. Phillips, who was always interested in highlighting and linking similar artistic temperaments across national lines and through the centuries in order "to clarify . . . certain significant aspects of the creative impulse through the ages,"[45] focused in this instance on artists who showed an expressionist intensity in their work. The exhibition, which Phillips titled *Sensibility and Simplification in Ancient Sculpture and Contemporary Painting*, was organized around the formal elements of line, color, mass, space, and light, rather than subject matter, and it included a recently acquired Eighteenth Dynasty Egyptian head. Phillips gave special emphasis to the work of Bonnard and Marin, newly represented in the collection. "I have chosen them for special emphasis because they are the two most fascinating temperaments in contemporary art," he explained.[46]

A line of twelve Marin watercolors hung opposite paintings by Bonnard, Henri Matisse, and Édouard Vuillard. Phillips wrote to Barr, then teaching a course on

modern art at Wellesley College, of his intention to use Marin's watercolors to "give Washington a bracing shock."[47] A letter from Phillips to Graham encouraged him to visit the collection with his friends to see a "simply thrilling" whole "wall of Marin" along with "another wall of French Moderns, including new works by Matisse, Bonnard, Utrillo and Segonzac."[48] Anchoring the center wall, Tack's vertical abstraction *The Voice of Many Waters* was flanked on one side by Cézanne's *Mont Saint-Victoire* (1886–87, acquired 1925), along with a work thought at that time to be by Seurat, and on the other side by a Prendergast paired with Twachtman's *The Emerald Pool*, the work Bonnard had so admired at the Phillips a few months earlier.[49] Tack, Prendergast, Twachtman, Cézanne, and Seurat—two Europeans and three Americans—were the artists viewed by Phillips as the great "modern masters" of the collection in early 1927.

At about this time, Phillips began referring to his museum as an "experiment station" or "laboratory," where new artists of many different temperaments were "being tested by the great things in the Collection."[50] The collection was being "molded," as he wrote, "in full view of the public" in an "unorthodox institution" that was willing to make mistakes and "learn from them in its consecrated task of searching for talent."[51] In a letter to the *New York Herald Tribune*, Phillips proposed his approach as a model for other museums, especially the Metropolitan Museum of Art. With no New York museum committed to the work of living artists in 1927, Phillips was outspoken in his belief that an institution like the Metropolitan should follow his example and set aside a space, a curator, and a small purchase fund to "experiment with vital works of art."[52]

With the experiment station on view, Phillips continued his exhilarating search for new talent. Dedicated to "many methods of seeing and painting," Phillips affirmed that he stood "for open-mindedness and tolerance of different points of view," seeking out the best painting by individual artists.[53] Not only was he taken with the independence of Dove, Marin, and O'Keeffe, but Phillips was also sympathetic to contemporary American painting with roots in French art. This sympathy put him at odds with the conservative American art establishment, which advocated for an art free of modern European, especially French, influence. Conservatives favored representational, regionalist art that offered reassuring images of the country's heartland. In a country that was still primarily agrarian, the tension between traditionalists and modernists was thick between the wars. National identity was at the heart of the debate over what constituted the American-ness of American art. Modernism, a foreign import, was highly suspect.

Phillips, however, was not dissuaded from pursuing artists he believed in. He singled out Graham, a recent Russian immigrant teaching in nearby Baltimore. They met around 1927, Graham immediately seeing the seriousness of Phillips's endeavor to build a first-rate collection of modern American and European painting, and Phillips recognizing Graham's importance in bridging the divide between European painting and American modernism. Graham's distinctive work of the late 1920s and 1930s is infused with the mystery of Giorgio de Chirico, the cubism of Pablo Picasso, and the

primitivism of African art. Phillips collected Graham's early work in depth, acquiring twenty-eight works by the artist.

Davis came to Phillips's attention through Graham, who encouraged the collector to see Davis's new work at the Downtown Gallery in New York in 1930. Davis's depictions of the streets and buildings of Paris as compositions of line and flat color shapes appealed immediately to Phillips as lighthearted improvisations of "linear perspectives and color schemes," related not only to Picasso but also to European moderns such as Henri Rousseau, Georges Braque, and Matisse; they soon became his favorites.[54] Phillips purchased *Blue Café* (1928) from the Downtown show and bought another work within a year, ultimately acquiring five early examples for the collection.

In Knaths, Phillips saw "a modernist, a radical simplifier whose drastic abbreviations show the influence of Matisse and . . . Braque. Yet he is absolutely himself and . . . absolutely American."[55] Acquiring more than fifty pictures by Knaths over a period of thirty years, beginning in 1926 with *Geranium in Night Window* (1922), Phillips held thirteen solo shows for him between 1929 and 1957, celebrating him as a painter of expressive color who emphasized nature's mysteries and simple, American subjects. Of all the Americans who adapted European avant-garde pictorial strategies, Knaths, Phillips believed, was the one most able to humanize and Americanize abstraction and present a refreshing alternative to the machine-age aesthetic of the era.[56]

Phillips was the first museum professional to identify the promise of Milton Avery, buying one of his early paintings from a New York gallery show in 1929 and detecting in his work affinities with that of Dove and Marin. Avery became one of Phillips's favorite artists, as shown by his purchase of five Avery paintings in 1943, the year he gave the artist his first one-person museum exhibition. At the time, critics saw Avery's simplified forms and flat, interrelated color shapes as the work of an American Matisse. His later works, such as *Black Sea* (1959), became more abstract, reflecting the influence of his colleagues and close friends, the painters Adolph Gottlieb and Mark Rothko. Phillips's enthusiasm for Avery never waned. He acquired eleven works by the artist, making him a cornerstone of the collection.

The Legacy of the Experiment Station

Never concerned with creating a comprehensive collection or documenting a period or movement, Phillips sought instead to capture the expressions of individuals. His marriage in 1921 to Marjorie Acker, a painter and the niece of the prominent American artist Gifford Beal, brought a personal dimension to his interest in the world of art. Phillips emphasized the necessity of "seeing as true artists see,"[57] believing that we benefit as viewers by giving ourselves over to the direct experience of the work of art and the artist's intentions, insights that he believed his own circumstances had given him.

By 1930 the "search for the individual artist of distinction" and the "recognition of the many phases of expression" guided Phillips in his choices.[58] He preferred

artists outside the mainstream, those who painted solely according to their personal inclinations. From the outset, he was committed to purchasing "many examples of the work of artists I especially admire and delight to honor . . . instead of having one example of each of the standardized celebrities," and this differentiated his museum from all others.[59] As long as artists were true to themselves and sincere in their work, "not merely submissive to current modes and schools," Phillips supported them.[60] He was particularly attracted to work by artists of color, women, and naive or self-taught artists. Phillips was often the first to acquire work by artists as varied and individualistic as John Kane, a self-taught artist from Phillips's hometown of Pittsburgh, regarded as a naive poet-painter in the American folk tradition, and Grandma Moses, whose work Phillips doggedly pursued and enthusiastically collected, from the time of her highly successful debut in 1941 at New York's Galerie St. Etienne.[61]

Mainstream critics often overlooked minority artists who captured aspects of contemporary American life, but Phillips was among the few to collect the work of Horace Pippin, a self-taught African American artist who drew on memories of a childhood spent near Philadelphia before World War I, as well as Allan Rohan Crite, a formally trained chronicler of Boston's African American neighborhoods, and Lawrence, trained at the Harlem Art Workshop in New York and the artist most closely identified with the black experience in America. It was Phillips who in 1942 gave Lawrence his first one-person museum exhibition after acquiring half of the artist's monumental sixty-panel work, *The Migration Series* (1940–41).

An early and articulate proponent of the country's heritage as "a fusion of various sensitivities, a unification of differences,"[62] Phillips accepted a broad range of styles by a diverse group of artists, including work by immigrants who were new to the United States and brought a variety of cultural influences into the American avant-garde. Rufino Tamayo, for example, was a Mexican modernist working primarily in New York whose work first attracted Phillips in 1930. Phillips admired the work of Kuniyoshi for the way he incorporated his Japanese heritage into a unique vision of America. The work of Peppino Mangravite, born in Italy and trained by Henri in New York, particularly fascinated Phillips, who bought four of his paintings. The place of these independent artists within The Phillips Collection, alongside other equally diverse American painters between the wars, such as James Lesesne Wells, Hobson Pittman, and Doris Lee, was a clear manifestation of Phillips's belief, expressed as early as 1914, that a renaissance of American painting would grow out of diversity, for "not only does America inherit the arts of all races and of all ages, but rich should be the harvesting and exquisite the flowering."[63]

Phillips collected his favorite artists in depth, calling them "unit" artists, whose representation in the collection included examples from all aspects of their careers, and in different media when appropriate for the artist. Phillips believed that, rather than have just one example of every trend, he could better understand a particular artist if he had a number of examples of their work. A "unit" might have only five or six works, such as that of Twachtman or O'Keeffe, but the high quality of the works

would be undeniable and be representative of the artist's career. Other artists who received this special designation included Avery, Burchfield, Davies, Dove, Graham, Hartley, Kent, Knaths, Lawson, Luks, Marin, Myers, Prendergast, Ryder, Sterne, Tack, Weir, and Weston. Collecting deep holdings of his favorite American artists led Phillips to develop relationships with some of these individuals over the years. Knaths, Marin, Tack, and Weston, for example, became the collector's personal friends, while others, such as Graham, were friendly acquaintances. Phillips's patronage included not only material support through acquisitions, but also financial support in the form of stipends and commissions. The list of artists he assisted in tough economic times includes Davis, Dove, Graham, Graves, Kent, Knaths, Lawson, Marin, Tack, and Weston, with Dove, Graham, Kent, and Knaths receiving monthly stipends in exchange for the right to first choice from their yearly output.

Phillips's regular payments to Dove began in 1930 and, unlike for the others whom Phillips assisted, lasted until the artist's death in 1946, allowing him to give up commercial illustration and focus on his painting. Artist and patron never met, but weeks before he died, Dove wrote to Phillips: "You have no idea what sending on those checks means to me at this time. After fighting for an idea all your life I realize that your backing has saved it for me and I meant to thank you with all my heart and soul for what you have done. It has been marvelous."[64]

Kent wrote in 1925 that Phillips's financial support "has done more to give me freedom to work than I have ever had before in my life."[65] The following year, as a gesture of his appreciation, Kent gave Hartley's *Mountain Lake—Autumn* (c. 1910) to Phillips, a work that Hartley had given to Kent in 1912. It became one of Phillips's favorites. He wrote to Kent: "The Hartley painting is so fine a picture that I hesitate to accept it, but the reason you give is a good one, namely that in our Gallery many people will enjoy it to the artist's benefit and to our mutual satisfaction."[66]

Phillips's assistance to Graham came early in the artist's career, a critical time. A steadfast supporter, Phillips not only purchased Graham's work, he also commissioned a painting in 1927 and gave the artist a stipend in 1928 and 1930 that made it possible for Graham to go to Paris. In appreciation, Graham gave Phillips a painting in 1933, *Harlequin in Gray* (1928)—further confirmation of the high esteem American artists had for Phillips and his museum.

Phillips was Tack's most important benefactor, commissioning a series of sixteen decorative abstractions from the artist in 1928, including *Aspiration*, for the museum's Lower Gallery (today the Music Room). Although Phillips ultimately did not make a permanent installation of the series, the artist's work was regularly on view at the museum, where it was seen by a younger generation of artists, including Morris Louis and Noland in the early 1950s and Sam Gilliam in the 1960s.

With the Depression still gripping the country in 1938, Marin received monthly assistance from Phillips, and in 1939, Davis, who had spent the previous six years painting in his bedroom, turned to Phillips after learning that a studio would soon be available in his New York building. Davis wrote that the matter of financing

the studio was, from his perspective, "a matter of life and death."[67] As the husband of an artist, Phillips understood the importance of a studio and immediately purchased two paintings from Davis, including *Eggbeater No. 4* (1928), which Davis believed to be his best work of the 1920s. Offering further encouragement, Phillips assured the artist of his unique place in American painting.[68] The acquisition through the Downtown Gallery in 1946 of Davis's *Still Life with Saw* (1930), a work related to the surrealist abstractions of Joan Miró, brought to five the number of Davis oils in the collection.

Phillips's support of young artists was well known. Although he did not accept everything he was offered, he kept the promise articulated in 1926, "to open our doors to all works of art which are true and beautiful . . . by whatever method they come to us, tested or tentative, new or old."[69] Oscar Bluemner made his approach in 1928 in writing, asking for an opportunity to show his work, as "I am ambitious to have one of my 'red' (American) landscapes . . . in your collection where I believe all my friends of the Stieglitz group are."[70] Ultimately Phillips bought three of Bluemner's works. In September 1940, Ilya Bolotowsky, a founding member in 1936 of the American Abstract Artists, made his request in person when he appeared unannounced at Phillips's summer home in Ebensburg, Pennsylvania. The two Bolotowsky paintings Phillips purchased remain in the collection today.[71]

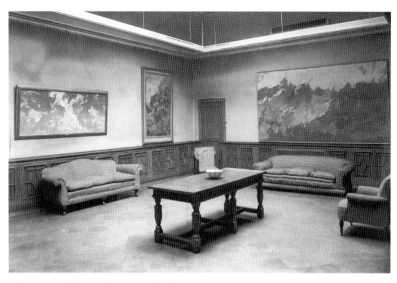

The Main Gallery with *Memorial Exhibition: Abstractions by Augustus Vincent Tack*, summer 1950, featuring *Time and Timelessness (The Spirit of Creation)* (1943–44), *The Voice of Many Waters* (c. 1923–24), and *Aspiration* (1931)

The Experiment Station after the War

At the end of World War II, when contemporary American art took the world stage and New York became the international locus of the avant-garde, Phillips could only have been thrilled to see his unwavering belief in American artists so widely confirmed. Marin, Alexander Calder, Davis, Hopper, and Kuniyoshi, for example, were celebrated at the Venice Biennales of 1950 and 1952. While New York now took the lead in new American art, the Phillips still played a seminal role in bringing contemporary art to Washington audiences well into the 1970s.

In the 1940s, '50s, and '60s, Phillips continued his search for new talent. In 1954, at age sixty-eight, he wrote that he was "attracted to qualities of contemporary art precisely because they thrill me with refreshing differences."[72] It speaks to Phillips's continuing engagement with the art of his time that major works in the collection by artists as varied as Josef Albers, Richard Diebenkorn, Sam Francis, Gilliam, Seymour Lipton, Robert Motherwell, Rothko, Clyfford Still, and Mark Tobey were acquired from exhibitions organized at the museum.

Phillips kept himself current by regularly attending exhibitions in New York and Washington, developing relationships with New York dealers, including Sidney Janis and Betty Parsons, while also maintaining contact with artists in the capital. In 1942, for example, Phillips acquired the work of the Seattle-based Morris Graves from the artist's first New York exhibition. Graves, whose work appealed to Phillips because its humanist message transcended cultural barriers, rapidly became one of Phillips's unit artists with ten acquisitions in little more than a decade.

Likewise, Phillips was an early admirer of Noland, who was teaching in Washington, D.C. Phillips purchased his first Noland in 1951 and his second from an exhibition of Washington artists that he organized the following year.[73] Noland thought of the Phillips as a special sanctuary; his frequent trips to the museum in the 1950s were, he said, "like going to church."[74] He spent long hours in the museum's Paul Klee Room and remarked years later on the importance that the collection's works by Tack, Avery, and Dove, as well as "the beautiful little Ryder" *Moonlit Cove* (early to mid-1880s) had held for him in those formative years.[75] *April* (1960), from Noland's *Concentric Circles* series (1958–63), was bought from a Washington gallery the year it was painted. With its organic qualities and radiating forms, it seems to echo Dove's *Me and the Moon* (1937) and O'Keeffe's *Red Hills, Lake George* (1927).

A classic stripe painting by Louis, Noland's friend and colleague, was added to the collection in 1963 from an exhibition at the Corcoran Gallery of Art.[76] Motherwell's work entered the collection in 1965, when Phillips organized the first museum exhibition of the artist's collages in the United States.[77] From that exhibition Phillips purchased two works.[78]

As Eliza Rathbone, chief curator of The Phillips Collection, has noted, the postwar American art that most attracted Phillips in the 1950s and 1960s was connected to themes and ideas already prevalent in the collection, particularly the search for a place in nature or the cosmos—a common thread in the work of American artists after the war, as well as in work by Tack and Dove or by Europeans such as Miró and Klee.[79] Thus, the art of Gottlieb found a place in the collection as early as 1952, when *The Seer* (1950), a culminating example of his pictographs, was acquired. A second Gottlieb, *Equinox* (1963), purchased in 1963 from Sidney Janis, reflects Phillips's concern with "the aesthetic interpretations of the age we live in—even the symbols for the anarchy, the turmoil and the inner tensions."[80] Still's work also was of great interest to Phillips at this time. He offered Still a solo show in 1964 and hoped to visit him at his studio in Westminster, Maryland.[81] Notoriously difficult, Still did not accept the offer. A few years after Duncan's death, Marjorie Phillips bought an early mature work by Still, *1950-B* (1950), from an exhibition of contemporary painting organized by the museum.[82]

The biomorphic abstractions that Stamos painted in the late 1940s seemed to offer formal and spiritual connections to Dove's work. Phillips bought three paintings by Stamos in 1949, including *The Sacrifice of Kronos, No. 2* (1948), the first of eight works to enter the collection. The following year, when Phillips gave the artist his first

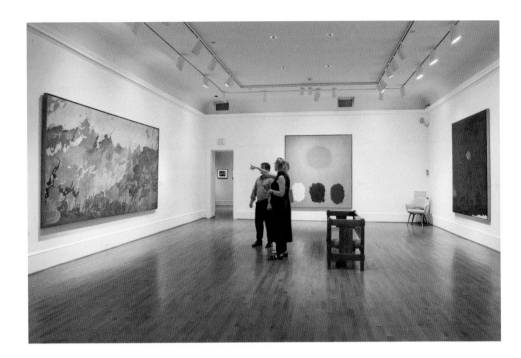

The Main Gallery in 2008 with Augustus Vincent Tack, *Aspiration* (1931), Adolph Gottlieb, *Equinox* (1963), and Clyfford Still, *1950-B* (1950)

one-person museum exhibition, Stamos visited Washington and stayed at the Phillips's family home. The friendship that developed between artist and patron led to another Stamos show at the museum in 1954. A lecture that Stamos delivered at the Phillips on that occasion, "Why Nature in Art?,"[83] made clear his admiration for the American painters most often identified with The Phillips Collection—Ryder, Hartley, and Dove.

Phillips did not respond to the most forceful and aggressive examples of abstract expressionism; he never bought a Franz Kline or a classic gestural painting by Jackson Pollock. The Pollock he did purchase was a collage from around 1951, a rare and atypical work for the artist, chosen perhaps because of its Asian flavor. Likewise, Phillips made clear the appeal of Willem de Kooning's *Asheville* (1948, acquired 1952), when he wrote to dealer Sidney Janis in December 1951, while organizing *Painters of Expressionistic Abstractions* (March 10–April 29, 1952), of his preference for the artist's "pure abstractions in which no figures or parts of figures are to be found."[84]

The addition of a new wing to the museum in 1960 reflected Phillips's desire to continue collecting contemporary art. Consistent with his romantic aesthetic, Phillips favored the poetic and lyrical side of postwar painting that seemed alive with light and movement. This included the colorful gestural abstractions of Philip Guston, Tomlin, Joan Mitchell, and Francis, which Phillips could relate to the museum's great modern colorists, including Bonnard and Matisse. Around 1954, through the dealer Betty Parsons, Phillips became aware of Kenzo Okada, a Japanese American artist working in an abstract expressionist manner, and responded immediately to his veils of color and light-filled forms. Within three years Phillips added three Okadas to the collection, often exhibiting them with work by Tomlin and Rothko, artists in whom Phillips detected a similar poetic impulse.

Installation outside the Rothko Room, summer 1986, with Henri Matisse, *Studio, Quai St. Michel* (1916), and Richard Diebenkorn, *Interior with View of the Ocean* (1957)

Diebenkorn came to Phillips's notice in the mid-1950s through Gifford Phillips, Duncan's only nephew, who happened to be Diebenkorn's foremost patron at the time. Duncan Phillips purchased two major works by Diebenkorn, the first in 1958, and the second, *Girl with Plant* (1960), from a solo show that Phillips organized in 1961. In Diebenkorn, he found a postwar artist with direct connections to the legacies of Cézanne, Matisse, and Bonnard. Diebenkorn, who visited The Phillips Collection regularly while stationed near Washington during World War II, spoke reverently of its impact on him, "It wasn't, of course, like a museum at all. . . . It was a refuge, a sanctuary for me to absorb everything on those walls."[85] Along with the Doves and the Marins, Matisse's *Studio, Quai St. Michel* (1916, acquired 1940) was his lodestar: "The painting has been stuck in my head ever since I first laid eyes on it there [at the Phillips]. I've discovered pieces of that painting coming out in my own over the years."[86]

Exhibitions and acquisitions of contemporary sculpture became possible with the addition of the new wing. Notable shows included a major traveling exhibition of David Smith's work that filled the whole first floor of the new wing and a gallery in the original house in 1962 and an exhibition of Lipton's sculpture in 1964. Phillips was unsuccessful in his effort to buy a work by Smith, faring better with Lipton, whose *Ancestor* (1958), part of the artist's *Hero* series, was acquired for the collection in 1964.[87]

Rothko's work elicited Phillips's deepest and most intuitive response to postwar American painting and the New York School. He acquired his first two Rothkos in 1957 from a group exhibition that he organized through Sidney Janis. In 1960, Phillips held a one-person show for Rothko, from which he bought two additional works. Rothko's desire to have his work exhibited in small, dedicated spaces must have recalled for Phillips an idea he had expressed in 1921 of devoting rooms to the singular "genius" of certain artists, Prendergast and Twachtman for example, where "admirers" could make "pilgrimages."[88] It is within the larger history of that idea, partly reflected in the concept of the units, that one can more fully understand how Phillips was uniquely predisposed to make a similarly permanent and immersive environment for Rothko's work in the new addition being planned for the museum in 1959. The Tack commission in 1928 and the establishment two decades later of the Klee Room, a defining feature of The Phillips Collection until 1982, can be seen as stages on the way to establishing a special environment for abstract art. The Rothko Room, installed at the Phillips in 1960, was the first permanent installation of Rothko's work as a separate group; it set the standard for displaying his work and remains a signature of the museum today.

Duncan Phillips, Visionary Champion of American Art

From the moment he established his museum at the end of World War I, Phillips was intent on lifting American art out of obscurity.[89] Believing that American art deserved an international audience, Phillips was thrilled to lend eight major paintings by contemporary artists (Gifford Beal, Davies, Kent, Lawson, Prendergast, Sloan, Robert Spencer, and Tack) to the Venice Biennale in 1924, the first year that the United States participated on a national level with a large group of exhibitors and a shared project under the auspices of the American Federation of the Arts.[90] Seventy-five works were shown in the American wing that year; The Phillips Collection was the largest single institutional lender, demonstrating the standing of its American collection just three years after opening. A generation later, the significance of the collection of modern American art assembled by Phillips between the wars is reflected in the loans made to the 1950 and 1952 Venice Biennales—eight Marins to the 1950 Biennale and Davis's *Eggbeater No. 4* (1928) and Hopper's *Approaching a City* (1946) to that of 1952.[91]

Phillips understood the importance of having works by key American modernists in major New York and Washington museums. In 1941, while Dove was still alive, Phillips, who was a lifetime trustee of the Museum of Modern Art, gave MoMA its first painting by Dove.[92] After Stieglitz's death in 1946, Phillips advised O'Keeffe about the dispersal of Stieglitz's collection, making particular note of the importance of giving "a few outstanding examples of Stieglitz, O'Keeffe, Marin, Demuth, and Dove" to the National Gallery of Art in Washington (opened 1941) in order to set the standard "for the proposed collection of contemporary American pictures" at this very young institution in the nation's capital.[93] Phillips and Marin were particularly keen that the National Gallery should get one of Marin's great pictures from the Stieglitz collection.[94] In 1964, just two years before his death, Phillips gave the Metropolitan Museum of Art one of Tack's 1930s abstractions (*Night Clouds and Stardust*), ensuring that a major example from Tack's best decade would be represented in this great New York institution.

Phillips intended that his museum should be a place where unity would be found in diversity. He advocated for "art as part of the social purpose of the world," believing that "a gallery can be a meeting place of many minds, harmonized by a genuine respect for the spirit of art."[95] He argued against an American art trapped in what he called "adolescent nationalism."[96] Believing that art is an international, universal means of expression that crosses boundaries of race and language, Phillips celebrated the fact that his collection included naturalized Americans from Russia, Hungary, Romania, Italy, and Japan, among others, for it meant that American art was truly an international art. He embraced the diversity of American art, declaring in 1944 that "all the world contributes to our spiritual and creative resources since all the world is contained in our United States."[97]

Phillips assembled a collection of American painting when there were no roadmaps for what would stand the test of time. It is a collection substantially

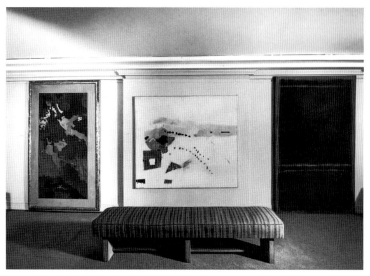

View of *Abstract Expressionists from the Collection* in the Print Rooms, March 1957, with Augustus Vincent Tack, *Night, Amargosa Desert* (1935), Kenzo Okada, *Footsteps* (1954), and Mark Rothko, *Green and Maroon* (1953)

different from that of his contemporaries because Phillips was interested in connections between works of art and willing to take risks by supporting young artists of diverse aesthetic temperaments in need of encouragement. From the outset, he emphasized that he was looking for the "rivers of artistic purpose" that linked contemporary artists to each other and to the "old masters who anticipated modern ideas."[98] He collected works that were important on their merits, not because they illustrated schools of thought, were faddish, or carried famous names. He championed American artists with individuality and embraced the work of self-taught and minority artists as part of the larger story of the nation and its heritage, believing that the work of these under-represented or overlooked artists deserved a place at the table.

At the same time, he looked for artists with connections to the great American and European traditions. The idea of the connectedness of art from century to century and from country to country was always a guiding principle—the universality of expression. Phillips was attracted to American artists who found in their work a link to nature and its rhythms, a sensibility attuned to universal rhythms in the natural world, which he once described as capturing "the cosmic *unconsciously*."[99] He made these connections for himself in his acquisitions and for the visitor through exhibitions and special installations, pairing, for example, the first installation of Stamos at the museum with Dove. When Phillips acquired his first Rothko, *Green and Maroon* (1953) in 1957, expressing a vision of American abstraction as a transcendent, spiritualized experience of pure form and color, he immediately hung it with work by Tack and Okada in *Abstract Expressionists from the Collection*. Phillips understood that this combination of Eastern and Western aesthetics offered a snapshot of the visionary sublime that could only be captured in his museum.

Throughout his life, Phillips gave American artists his patronage and encouragement. In 1929, he wrote that "the true artist needs a friend and a true patron of art has nothing better to give the world than the helping hand he extends to the lonely, lofty spirits."[100] It was the maxim that guided him in his lifelong quest to assemble a collection of the best of American art for all to see and enjoy.

Epigraph from Duncan Phillips, "The Plan and Purpose of the Phillips Memorial Art Gallery," *Extracts from the Minutes of First Annual Meeting of Trustees of Phillips Memorial Art Gallery*, brochure (Washington, D.C.: The Phillips Memorial Art Gallery, 1921), 11 (hereafter cited as Phillips, "Plan and Purpose").

1. "O'Keeffe tells me how beautiful the two Doves look in your home. She returned from Washington full of rare enthusiasm. She thoroughly enjoyed every moment with you & Mrs. Phillips & the pictures—She tells every one worth while what a splendid work you are doing.—Your Courbets & Daumiers, the Renoir, & Greco she tells me about. Is full of them." Alfred Stieglitz to Duncan Phillips, March 4, 1926. See "Selected Correspondence," in Elizabeth Hutton Turner, *In the American Grain: The Stieglitz Circle at The Phillips Collection* (Washington, D.C.: Counterpoint and The Phillips Collection, 1995), 115–16.

2. James Phillips, writing to his father, Major Duncan Clinch Phillips, January 6, 1916, asked for an annual sum of $10,000 to spend on building a family art collection; see Marjorie Phillips, *Duncan Phillips and His Collection*, rev. ed. (New York and Washington, D.C.: W. W. Norton and The Phillips Collection, 1982), 54–55.

3. Duncan Phillips to Julian Alden Weir, April 1918, copy in The Phillips Collection Archives (hereafter cited as TPC Archives).

4. Two years older than Duncan, James Laughlin Phillips had been married for only a year when he died suddenly on October 21, 1918, a victim of the Spanish influenza pandemic. This devastating family tragedy occurred just thirteen months after the death of Major Phillips, the family patriarch, on September 13, 1917.

5. See Duncan Phillips, *A Collection in the Making*, Phillips Publication No. 5 (New York and Washington, D.C.: E. Weyhe and Phillips Memorial Gallery, 1926), 4, 5.

6. Deed and Charter of the Corcoran Gallery of Art, May 10, 1869, Corcoran Gallery Archives, cited in *Corcoran Gallery of Art*, ed. Sarah Cash (Washington, D.C., and Manchester, Vt.: Corcoran Gallery of Art and Hudson Hills Press, 2011), 24.

7. The museum was called the Phillips Memorial Art Gallery for about one year, before being renamed the Phillips Memorial Gallery. It was renamed the Phillips Gallery in October 1948 and became The Phillips Collection in July 1961.

8. Duncan Phillips, "Nationality in Pictures," in *The Enchantment of Art* (New York: John Lane Company, 1914), 96.

9. The list of American artists whose works the Phillips was the first museum to purchase also includes Preston Dickinson (1923), Stefan Hirsch (1925), Bernard Karfiol (1925), Niles Spencer (1925), Max Weber (1925), James Chapin (1926), Karl Knaths (1926), John Graham (1927), Man Ray (1927), Peppino Mangravite (1928), David Burliuk (1929), John Kane (1930), Morris Kantor (1930), Rufino Tamayo (1930), James Lesesne Wells (1931), Ilya Bolotowsky (1940), Lee Gatch (1941), Jacob Kainen (1942), Grandma Moses (1942), and Alfonso Ossorio (1951).

10. Phillips acquired the first of his ten works by Burchfield in 1926, the year in which he purchased a major oil by Hopper. Two Paris streetscapes by Davis were acquired by Phillips in 1930, just months after the Pennsylvania Academy of the Fine Arts in Philadelphia added a Davis still life to its collection. Lawrence's *Migration Series*, the first work by this artist to enter a museum, was acquired in 1942 by The Phillips Collection and the Museum of Modern Art, the Phillips taking the odd-numbered panels, and MoMA taking the even-numbered panels.

11. "Are These Men the Best Painters in America Today?" in *Look*, February 3, 1948. The top list chosen by museum directors and art critics was: John Marin, Max Weber, Yasuo Kuniyoshi, Stuart Davis, Ben Shahn, Edward Hopper, Charles Burchfield, George Grosz, Franklin Watkins, and Lyonel Feininger and Jack Levine who tied for tenth place. Walt Kuhn, John Sloan, Thomas Hart Benton, Morris Graves, Karl Knaths, and Rufino Tamayo were among many other artists identified. The artists also gave Marin top honors but included Sloan and Tamayo in the top ten.

12. "We have converted a former bedroom of the residence into a little gallery which communicates with the main Gallery up a few steps and we are now ready to start a series of exhibitions which we will change much more often than we can afford to do in the larger gallery. I plan to give 'one man shows' which would run two weeks, open on the same days and same hours as the main Gallery." Duncan Phillips to Leila Mechlin, December 29, 1924, Archives of American Art (hereafter cited as AAA), Box 3 of 45, Folder M (2), 1924.

13. Duncan Phillips, "The Phillips Collection," No. IV of unpublished outline prepared for E. Newlin Price; dated to 1924; formerly MS 89, TPC Archives. Phillips purchased El Greco's *The Repentant Peter* (1600–1605 or later) in 1922, Renoir's *Luncheon of the Boating Party* (1880–81) in 1923, and Daumier's *The Uprising* (1848 or later) in 1925.

14. Duncan Phillips, "City in Painting and Etching," in *The Enchantment of Art: As Part of the Enchantment of Experience Fifteen Years Later*, Phillips Publication No. 4 (Cambridge, Mass.: Riverside Press, 1927), 82–83.

15. *Enchantment of Art* (1927), 207.

16. Duncan Phillips, "William M. Chase," *American Magazine of Art* 8 (December 1916), 45.

17. Duncan Phillips, "Maurice Prendergast," *Arts* (March 1924), 125, and "Exhibition Notes: American Old Masters," in *The Artist Sees Differently: Essays Based Upon the Philosophy of a Collection in the Making*, Phillips Publication No. 6, vol. 1 (New York and Washington, D.C.: E. Weyhe and Phillips Memorial Gallery, 1931), 103.

18. Susan Behrends Frank, *American Impressionists: Painters of Light and the Modern Landscape* (New York: Rizzoli International and The Phillips Collection, 2007), 61.

19. Phillips, *Collection in the Making*, 8.

20. Augustus Vincent Tack to his dealer, John Kraushaar, August 8, 1922, quoted in David W. Scott, "Mutual Influences: Augustus Vincent Tack and Duncan Phillips," in Leslie Furth et al., *Augustus Vincent Tack: Landscape of the Spirit*, exh. cat. (Washington, D.C.: The Phillips Collection, 1993), 79.

21. Duncan Phillips, "Sensibility and Simplification in Ancient Sculpture and Contemporary Painting," in *A Bulletin of the Phillips Collection Containing Catalogue and Notes of Interpretation Relating to a Tri-Unit*

Exhibition of Paintings and Sculpture (February and March 1927), 11.

22. Phillips, *Collection in the Making*, 9.

23. Charles Daniel to Duncan Phillips, July 20, 1924. See "Charles Sheeler," in *The Eye of Duncan Phillips: A Collection in the Making*, ed. Erika D. Passantino (Washington, D.C., and New Haven, Conn.: The Phillips Collection and Yale University Press, 1999), 415, 768n10.

24. Duncan Phillips, "Modern Wit in Two Dimensional Design," *A Bulletin of the Phillips Memorial Gallery Containing Notes of Interpretation Relating to the Various Exhibition Units* (October 1931–January 1932), 22.

25. Thus did Phillips express his admiration for Kent's *Azopardo River*, one of the artist's newest canvases. Duncan Phillips, "Contemporary American Painting," *A Bulletin of the Phillips Collection Containing Catalogue and Notes of Interpretation Relating to a Tri-Unit Exhibition of Paintings & Sculpture* (February–May 1928), 47.

26. Duncan Phillips, "American Themes by American Painters," *A Bulletin of the Phillips Collection* (February and March 1927), 59. Phillips purchased three works by Stefan Hirsh from the Bourgeois Gallery in 1925, while a first work by Niles Spencer and one by Karl Knaths were acquired in 1925 and 1926, respectively, from the Daniel Gallery.

27. Phillips, *Collection in the Making*, 69.

28. Roger Fry, *Vision and Design* (New York: Brentano's, 1920).

29. Phillips, *Collection in the Making*, 5.

30. Duncan Phillips to Leila Mechlin, March 26, 1926, copy in TPC Archives.

31. For a full discussion of the Stieglitz circle between the wars, see "Spiritual America," in Wanda M. Corn, *The Great American Thing: Modern Art and National Identity, 1915–1935* (Berkeley: University of California Press, 1999), 3–40.

32. Alfred Stieglitz to Paul Rosenfeld, September 5, 1923, in Turner, *In the American Grain*, 15n9.

33. Corn, *Great American Thing*, 31.

34. Duncan Phillips, "Arthur G. Dove, 1880–1946," *Magazine of Art* (July 1947), 194.

35. Turner, *In the American Grain*, 15.

36. Phillips, "Dove, 1880–1946," 194.

37. Duncan Phillips to Arthur Dove, May 3, 1933, TPC Papers, AAA, Reel 1944, frame 503.

38. Alfred Stieglitz to Duncan Phillips, April 16, 1926, TPC Archives. The letter is reproduced in "Selected Correspondence," in Turner, *In the American Grain*, 116.

39. Alfred Stieglitz to Duncan Phillips, December 11, 1926, TPC Archives. The letter is reproduced in "Selected Correspondence," in Turner, *In the American Grain*, 124.

40. Georgia O'Keeffe to Duncan Phillips, July 16, 1949, and Duncan Phillips to Georgia O'Keeffe, July 30, 1949, copies in TPC Archives. The letters are reproduced in "Selected Correspondence," in Turner, *In the American Grain*, 171.

41. Duncan Phillips to Stephen Bourgeois, November 30, 1925, TPC Papers, AAA, reel 1931.

42. Leila Mechlin, "Notes of Art and Artists," *Washington, D.C., Sunday Star*, January 17, 1926.

43. Duncan Phillips, *Exhibition of Paintings by Eleven Americans* (Washington, D.C.: Phillips Memorial Gallery, 1926), first page of unpaginated brochure.

44. Other artists included in this exhibition were Odilon Redon and the Americans Alfred Maurer, Eugene Speicher, Vincent Canadé, Karl Knaths, and Walt Kuhn.

45. Grayson Harris Lane, "Duncan Phillips and the Phillips Memorial Gallery: A Patron and Museum in Formation, 1918–1940," Ph.D. diss., Boston University, 2002, 121. Phillips quote taken from "Plan and Purpose," 11.

46. Duncan Phillips, "Sensibility and Simplification in Ancient Sculpture and Contemporary Painting," *A Bulletin of the Phillips Collection* (February and March 1927), 12.

47. Duncan Phillips to Alfred H. Barr, Jr., January 15, 1927, copy in TPC Archives.

48. Duncan Phillips to John Graham, February 9, 1927, copy in TPC Archives.

49. The "Seurat" painting, *Little Circle Camp*, was a new acquisition in spring 1927. It was later re-attributed to Albert Dubois-Pillet, one of Seurat's colleagues.

50. "For one reason or another these artists [Gifford Beal, John Sloan, Edward Hopper, Charles Burchfield, Niles Spencer, John Graham, John Marin, Stefan Hirsch, and others] are all in my laboratory, being tested by the great things in the Collection. They have one thing in common. There is an emotional urge in them all, a fine impulse to express, however inadequately, the storm or shine of their various reactions to life." Duncan Phillips, *An Exhibition of Expressionist Painters from the Experiment Station of the Phillips Memorial Gallery*, Baltimore Museum of Art, April 8–May 1, 1927, last page of unpaginated brochure.

51. Duncan Phillips, "Free Lance Collecting," *Space* 1 (June 1930), 7.

52. Duncan Phillips to *New York Herald Tribune*, February 10, 1927, TPC Papers, AAA, Reel 1936, frames 910–11.

53. Phillips, "A Collection Still in the Making," in *Artist Sees Differently*, 14.

54. Duncan Phillips, "Modern Art, 1930," in *Art and Understanding: A Phillips Publication* 1, no. 2 (March 1930), 143. Also, Phillips, "Modern Wit in Two Dimensional Design," 21.

55. Duncan Phillips, "Karl Knaths," *Art and Understanding* 1, no. 1 (November 1929), 113.

56. For the relationship between Phillips and Knaths, see Lane, "Duncan Phillips and the Phillips Memorial Gallery," 177–84.

57. Phillips, *Collection in the Making*, 4.

58. Phillips, "Free Lance Collecting," 7.

59. Phillips, *Collection in the Making*, 8.

60. Phillips, "Art and Understanding," in *Artist Sees Differently*, 25–26.

61. Phillips bought Grandma Moses's *The Old House at the Bend of the Road* (1940 or earlier) from Moses's first gallery show in New York (Galerie St. Etienne). He apparently kept that painting for his personal collection. In 1942, *Cambridge Valley* (1942), which he acquired from the American British Art Center in New York, became the first work by Moses to enter a museum collection. See Jane Kallir, "The American Vision," in Passatino, *Eye of Duncan Phillips*, 170.

62. Duncan Phillips, "Foreword," in *The American Paintings of The Phillips Collection*, exh. cat. (Washington, D.C.: Phillips Memorial Art Gallery, 1944), third page of unpaginated brochure.

63. Phillips, "Nationality in Pictures," in *Enchantment of Art* (1914), 96. *Enchantment of Art* (1927), 70, substitutes "races" for "nations."

64. Arthur Dove to Duncan Phillips, late October 1946, TPC Archives. This is Dove's last letter to Phillips; Dove died on November 22, 1946.

65. Rockwell Kent to Duncan Phillips, October 25, 1925, TPC Papers, AAA, Reel 1933, frames 227–28.

66. Duncan Phillips to Rockwell Kent, December 27, 1926, quoted in Passatino, *Eye of Duncan Phillips*, 390.

67. Stuart Davis to Duncan Phillips, September 16, 1939, TPC Papers, AAA, Reel 1952, frame 1361.

68. Duncan Phillips to Stuart Davis, October 3, 1939, TPC Papers, AAA, Reel 1952, frame 1367.

69. Phillips, *Collection in the Making*, 8.

70. Oscar Bluemner to Duncan Phillips, November 25, 1928, TPC Archives.

71. See Lane, "Duncan Phillips and the Phillips Memorial Gallery," 168n39, which cites an October 11, 1990, interview with Laughlin Phillips.

72. Duncan Phillips, *The Phillips Collection and Related Thoughts on Art*, brochure, 1954, unpaginated; originally presented as a radio talk entitled "The Pleasures of an Intimate Art Gallery," Washington, D.C., WCFM Radio, February 24, 1954.

73. Clement Greenberg first indicated interest in Noland in 1954. That year, he included him in his *Emerging Talent* exhibition at the Samuel M. Kootz Gallery in New York.

74. Kenneth Noland in conversation with William C. Agee, April 5, 1992, in William C. Agee, "Duncan Phillips and American Modernism: The Continuing Legacy of the Experiment Station," in Passatino, *Eye of Duncan Phillips*, 376, 760n6.

75. Paul Richard, "Full Circle for Noland, The Artist's Tribute to the Phillips," in *Washington Post*, May 4, 1982.

76. Passatino, *Eye of Duncan Phillips*, 642.

77. The printed booklet for *Collages by Robert Motherwell: A Loan Exhibition* states that the Phillips Collection is presenting the first exhibition in the United States of Motherwell's collages. Motherwell and Frankenthaler's visit to the exhibition is recorded in Marjorie Phillips, *Duncan Phillips and His Collection*, 299.

78. Motherwell's *In White and Yellow Ochre* (1961) was purchased for the museum collection in 1965. *Mail* (1959) was purchased by Marjorie Phillips for her personal collection in 1965 and transferred to the museum in 1966.

79. Eliza Rathbone, "American Art After the Second World War," in Passatino, *Eye of Duncan Phillips*, 550.

80. Duncan Phillips, "Foreword," in *Federation of Modern Painters and Sculptors, 1955–1956*, exh. cat. (New York: Federation of Modern Painters and Sculptors, 1955), unpaginated, as quoted in Passatino, *Eye of Duncan Phillips*, 569.

81. Marjorie Phillips to Clyfford Still, August 11, 1964, copy in TPC Archives.

82. A small *Loan Exhibition of Contemporary Paintings* (May 10–June 22, 1969) was organized by the Phillips Collection with the cooperation of André Emmerich Gallery, Marlborough-Gerson Gallery, and Betty Parsons Gallery. Still's *1950-B* was purchased from this show.

83. Theodoros Stamos, "Why Nature in Art?," unpublished essay, 1954, copy in TPC Archives. Lecture given by the artist December 1, 1954, at Phillips Collection at opening of exhibition *Recent Work by Theodoros Stamos* (December 1, 1954–January 3, 1955).

84. Duncan Phillips to Sidney Janis, December 31, 1951, copy in TPC Archives. See also Passatino, *Eye of Duncan Phillips*, 571 and n13.

85. Richard Diebenkorn, interview by Fritz Jellinghouse, 1982, transcript from cassette tape, TPC Archives.

86. Diebenkorn's comments from *Documentary Film on The Phillips Collection*, produced by Checkerboard Film, 1986, quoted in "Richard Clifford Diebenkorn, Jr.," in Passatino, *Eye of Duncan Phillips*, 800n14.

87. Correspondence between Phillips and Smith in the museum archives indicates that Phillips was interested in *17 H's*, but the two could not agree on a price. See Smith to Phillips, June 18, 1963, and Phillips to Smith, June 24, 1963. Passatino, *Eye of Duncan Phillips*, 570, and Marjorie Phillips, *Duncan Phillips and His Collection*, 297.

88. Phillips, "Plan and Purpose," 10.

89. Elizabeth Tebow, "The American Vision, Part I: The American Tradition and American Impressionism," in Passatino, *Eye of Duncan Phillips*, 128.

90. Of the seventy-five paintings included in the U.S. Pavilion, eight were loans from the Phillips Collection, the largest group of American paintings borrowed from a single institution. The works were: Gifford Beal, *Sword Fisherman* (c. 1921); Arthur B. Davies, *Springtime of Delight* (1906); Rockwell Kent, *The Road Roller* (1909); Ernest Lawson, *Old Willow* (undated); Maurice Prendergast, *Ponte della Paglia* (1898–99 and 1922); John Sloan, *The Wake of the Ferry II* (1907); Robert Spencer, *The Auctioneer* (undated); and Augustus Vincent Tack, *Portrait of Elihu Root* (1922).

91. The eight Marin works loaned to the 1950 Venice Biennale by The Phillips Collection included two oils, *Bryant Square* (1932) and *Pertaining to Fifth Avenue and Forty-Second Street* (1933), and six watercolors, *Maine Islands* (1922), *Grey Sea* (1924), *Near Great Barrington* (1925), *Hudson River Near Bear Mountain* (1925), *Quoddy Head, Maine Coast* (1933), and *Adirondacks at Lower Ausable Lake* (1947).

92. Phillips was elected to the board of trustees of the Museum of Modern Art, New York, on October 25, 1929. In 1941 he gave MoMA *Willows* (1940), the first of six works by Dove to enter this institution.

93. Duncan Phillips to Georgia O'Keeffe, February 4, 1948, TPC Archives. The letter is reproduced in "Selected Correspondence," in Turner, *In the American Grain*, 170.

94. Ibid., and also John Marin to Duncan and Marjorie Phillips, February 21, 1948, copy in TPC Archives. The letter is reproduced in "Selected Correspondence," in Turner, *In the American Grain*, 170.

95. Phillips, *Artist Sees Differently*, 14–15.

96. Phillips, "Foreword," in *The American Paintings of the Phillips Collection*, last page of unpaginated brochure.

97. Ibid., third page of unpaginated brochure.

98. Phillips, *Collection in the Making*, 6.

99. Phillips, "Contemporary American Painting," 37.

100. Duncan Phillips, "The Palette Knife: A Collection Still in the Making," *Creative Art* 4 (May 1929), 23.

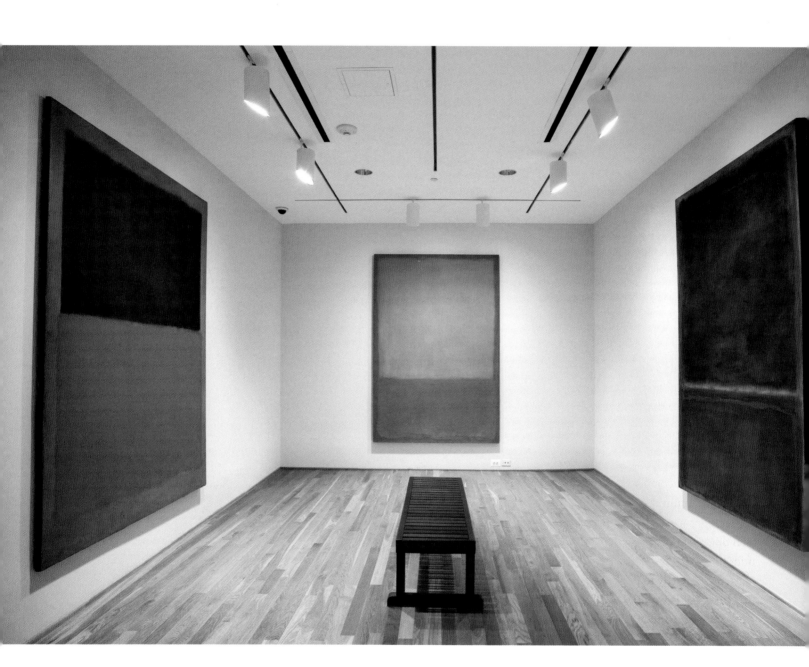

The Rothko Room at The Phillips Collection

ELIZA E. RATHBONE

Many who love Mark Rothko first encountered his work in a small room at The Phillips Collection. The room today exists in the 2005 addition to the museum, but it is nonetheless of the same dimensions and in the same orientation as it was in its first inception when it came into existence in 1960. Few could disagree that it is one of the most successful installations of the artist's work. Only the Rothko Chapel in Houston has remained as abiding a setting for the contemplation of Rothko's painting. These two statements of commitment to the artist, the one in Washington, the other in Houston, mark the beginning and end of Rothko's final decade before he died in 1970.[1] The first installation of the room at The Phillips Collection and the realization of the chapel in Houston bracket ten years during which the artist focused enormous energy on fulfilling his ideal of creating a total environment. For Rothko, who was exceptionally sensitive to the conditions in which his work was shown, it was a period of significant stylistic evolution. The Rothko Room, regarded by many as chapel-like, and the Rothko Chapel both convey the artist's objective of an exclusive dominion over space and spectator that he desired for his work—an encounter with his paintings that would engage the spectator not only visually but also physically, emotionally, and spiritually. Both installations stand to this day as testimony to the sensitivity and conviction of remarkable collectors, Duncan and Marjorie Phillips and John and Dominique de Menil.

While the significance of the chapel in Houston may be well known, and has been well documented, the importance of the Rothko Room in The Phillips Collection has undoubtedly been more sensed by visitors than remarked upon in the literature. This may be due partly to the fact that the paintings that hang there were not commissioned for the space. It would be more accurate to say that the space was commissioned for the paintings. The four paintings installed there date from the 1950s and were acquired by Phillips over a period of seven years during which time the idea of the room came about. That this was the first virtually permanent space dedicated to Rothko's work is indisputable, but how it came to be is a story that has never fully been told.

The choices made by Duncan Phillips in his first decade of collecting for his museum already foretold that his encounter with Rothko's work would resonate with his personal aesthetic. One could argue that his previous forty years of collecting were expressly designed to prepare him for the immediate intuitive response he apparently

The Rothko Room in 2006 with *Green and Tangerine on Red* (1956), *Ochre and Red on Red* (1954), and *Green and Maroon* (1953)

had on first experiencing paintings by Rothko. The works that Phillips collected by Albert Pinkham Ryder, William Merritt Chase, Henri Matisse, Milton Avery, and Pierre Bonnard create the unique environment of The Phillips Collection, the "experiment station" where Phillips discovered and expressed his own collecting interests in works he described as "lived with, worked with, and loved."[2] Phillips continually demonstrated a love of color and a leaning toward a romantic and poetic temperament.

In many ways Phillips was the ideal collector of Rothko's work. A man who had always seen the advantage of direct communication with artists and who had learned a great deal from these exchanges, Phillips not only developed a sensitivity to individual artists' voices but also demonstrated in early plans for his museum a predisposition to devote an entire gallery to a single artist's work. Soon Phillips was building his collection in what he called "units." Rather than aspiring to a comprehensive view of modern art, he focused on particular individuals whose work evoked in him a deep personal response. For Phillips the Rothko Room was a culminating event in his life as a collector; for Rothko, it was a turning point in his life as an artist.

Although Phillips's first encounter with Rothko's paintings is not precisely documented, he may have learned of Rothko's work from Theodoros Stamos when Stamos stayed with the Phillipses in the 1950s.[3] Stamos recalled recommending Rothko's work to the Phillipses, pointing out a kinship with the work of Bonnard. Gifford Phillips, nephew to Duncan and Marjorie, also talked enthusiastically to them about the artist's work.[4] Years later, in a letter to Duncan Phillips from Sidney Janis dated May 8, 1956, Janis reminds Phillips of a visit the collector had made to his gallery when he "particularly admired" a work by Rothko.[5] In October of that year Phillips expressed to Janis his desire to plan an exhibition of Rothko's work, concentrating on paintings of "moderate size" since his museum, being originally a house, had ceilings too low for Rothko's largest paintings.[6] On November 12, 1956, four works were shipped to Washington.[7] In a letter of November 19, Phillips confirmed his plan to present an exhibition of "at least four" paintings by Rothko (with additional smaller ones if they could be lent), as well as his intention to purchase two works, "the large green one and the square earlier one."[8] It is here that he also first notes, "I have been told that Mr. Rothko does not like to combine his work with any other painter," a sentiment Phillips seems to have respected without question. For the second time he iterated his desire to visit the artist in his studio. In December, Janis sent two additional works for the exhibition scheduled for January 6 to February 26, 1957.[9] For the installation, which also included paintings by Bradley Walker Tomlin and Kenzo Okada, Phillips reserved a separate gallery for the six paintings by Rothko. Before the exhibition's conclusion, he communicated to Janis his desire to purchase *Green and Maroon* (1953) and *Mauve Intersection* (1949), saying he "liked them both immensely."[10]

In January of the following year Phillips declared to Janis, "we have to like our extra large pictures extra well because of our lack of space. I often wish we had room for another Rothko. He wears so well and is definitely an artist after my own heart. For such a man I would make room if I found [another Rothko] with irresistible color."[11]

Late spring of 1958 saw the commission for Rothko to produce murals for the Seagram Building in New York, designed by Philip Johnson. In many respects this may have appeared as the perfect opportunity for Rothko to achieve the dominion over the spectator he so desired. He had developed and articulated these artistic goals throughout the decade of the 1950s, further recognizing and refining his ideal over the years. In 1951, while participating in a symposium at the Museum of Modern Art on how to combine architecture, painting, and sculpture, his remarks elaborate on the ideas that he and Gottlieb stated in their famous letter to Edward Alden Jewell in 1943 in which they maintained their belief in large paintings as well as "the simple expression of the complex thought."[12] At the symposium Rothko described the "intimate and human" effect he was trying to achieve, explaining, "However you paint the larger picture, you are in it. It isn't something you command."[13] In 1954, in reference to his first solo show in an American museum, Rothko verbalized to Katharine Kuh precisely how he felt his work should be installed for maximum effect, making plain his own preference for spaces that are not institutional nor large but are "confined" and "in a scale of normal living." He expressed his intention that in installing his work, "by saturating the room with the feeling of the work, the walls are defeated and the poignancy of each single work . . . become[s] more visible."[14] He further explained his desire for the work to be "encountered at close quarters" and notes "some of the pictures do very well in a confined space."[15] The setting that Rothko described as desirable for his work corresponds closely to the room that Phillips would eventually create.

In the summer of 1959, Rothko made a trip to Europe and was deeply impressed by the Villa of the Mysteries in Pompeii as well as by the Laurentian Library and Fra Angelico's murals for San Marco in Florence. Significantly all are sites where painting intimately relates to architectural space. He was especially moved by the frescoes at San Marco, where large flat areas of color fill the space and the tonalities are richly suggestive of mood. In a large *Crucifixion* fresco by Fra Angelico, the crucified are shown against a maroon sky that fills the upper register. In three other frescoes showing the Crucifixion, the sky is black. The iconic austerity of this art and its power to move the viewer must have fortified the artist's own vision for his work. When, upon returning to New York, he visited the site designated for his work in the Seagram Building (the Four Seasons Restaurant), he declined to continue the project.

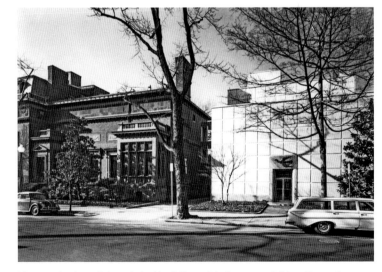

The north wing of the original building with the new addition (Annex) at 1612 Twenty-First Street, N.W., 1960s

Phillips, whose interest in the large paintings of the New York School continued to develop, recognized the inhibiting sizes of the exhibition spaces in the former house. In January of 1959, he began planning an additional building for his collection. The Annex at 1612 Twenty-First Street, a building connected to the house by a two-story bridge, was designed by Wyeth and King of New York, who

View of the glass door with transom in the north wall of the original Rothko Room in 1986 with *Green and Tangerine on Red* (1956)

worked with George L. Howe of Washington, D.C. The earliest drawings for the building already indicate the room (measuring 13 feet, 6 inches by 23 feet, 10 inches) that would eventually be dedicated to Rothko's work. North of the building is space showing a parking lot and driveway. By December of 1959, however, plans indicate a door in the north wall of the room.

While the Annex was under construction, Phillips (with his wife Marjorie) visited Rothko again, this time in his studio in New York's Bowery. Soon after, Phillips continued to demonstrate his tremendous interest in the artist's work by mounting another exhibition in the museum's Print Rooms, this time using both rooms, allowing him to exhibit a total of seven works from May 4 to 31, 1960. In addition to the two works he had purchased for the collection in 1957, he borrowed four paintings shipped directly from Rothko's studio and one from the Sidney Janis Gallery. From this exhibition he acquired for the museum two additional paintings, *Orange and Red on Red* (1957) and *Green and Tangerine on Red* (1956).[16] Significantly, a review in the *Washington Post* noted, "To be in a roomful of Rothko's is like being in a chapel."[17]

When the Annex opened in November, Phillips had installed three paintings by Rothko in the room, referring to them as the "Rothko Unit": on the north wall, *Green and Maroon*, on the east wall, *Orange and Red on Red*, and on the south wall, *Green and Tangerine on Red*. The hanging records of the museum indicate that this arrangement persisted from November 1960 to September 1965, a clear indication of Phillips's pleasure in his Rothko Unit and his desire to allow the paintings to remain in this particular space. A window in the west wall and the exterior door with a window in the north wall allowed some daylight to filter through curtains into the room. While other galleries underwent installation changes, the Rothko Room remained the same. There is no indication that Phillips's fourth Rothko painting, *Mauve Intersection*, ever hung in the room.[18] Since during this time no painting was installed on the west wall, it seems likely that the window in that wall remained uncovered.

In January 1961, Rothko, while in Washington for John F. Kennedy's inauguration, stopped in to see his work at The Phillips Collection. Although he is reputed to have been pleased with the room, he requested that the lighting be more diffused (and the paintings less spot lit) and that a simple bench be placed there.[19]

Early in 1964, Rothko made another trip to Washington, and again he visited the Phillips. In a letter to Rothko of February 17, 1964, Phillips writes, "You must remember that when you were in Washington with us it was a great surprise and joy to me to discover that your beautiful painting which was in the autumn exhibition at the Janis Gallery could be acquired directly from you on terms of delayed payments. . . . In a very generous moment you asked me whether I would like to receive the picture and enjoy it right away. Because of my advanced age that is really an inducement. If you

mean it, it would be a great privilege. . . . I cannot tell you how much we enjoyed your visit and our talks."[20]

Ochre and Red on Red (1954),[21] which arrived at the museum on March 10, 1964, did not hang in the Rothko Room right away, but in September 1965 it took the place of *Orange and Red on Red* on the north wall. A shift in the installation took place at that time, but it was not until May 1966 that a freestanding wall was installed in front of the window on the west wall so that four paintings could hang together in the room. Even with the addition of the freestanding wall, a play of daylight continued to enter from the north through the windowed door. Phillips saw the room installed with four paintings a week before he died. Since then, with the exception of a few brief interruptions, these paintings by Rothko have remained in the space.

When the building was renovated and expanded in 1989, by Arthur Cotton Moore and Associates, the room was retained, but the window was eliminated from the west wall and the expanded building resulted in two interior entrances to the room. Within a year the north door was walled in so that the room could be experienced as a destination rather than a gallery to pass through. With the addition of the Sant Building to the museum in 2005, the Rothko Room was re-created on the second floor of the building, again on the west side, away from the street. It is still entered at the east end of the south wall, opposite a window in the north wall, and the room extends lengthwise, east to west as it did in 1960.

Few collectors wrote with such sensitivity about Rothko's work as did Phillips, about the paintings' ability to "not only pervade our consciousness but inspire contemplation." Phillips wrote, "Color-atmosphere in paintings is as old as Giovanni Bellini and his mountain backgrounds before sunrise or after sunset. We think also of late Turner and of late Bonnard. But in Rothko there is no pictorial reference at all to remembered experience. What we recall are not memories but old emotions disturbed or resolved—some sense of well-being suddenly shadowed by a cloud—yellow ochres strangely suffused with a drift of gray, prevailing over an ambience of rose, or the fire diminishing into a glow of embers, or the light outside when the night descends."[22]

The sense of mood and mystery conveyed through form, composition, and light— qualities Phillips sought in works ranging from those of Ryder to Bonnard—were fully expressed in Rothko's. The paintings he chose for his museum, ranging in date from 1953 to 1957, and in hue from luminous oranges, red, and ochre to greens and maroon, predate Rothko's shift to the darker palette that characterizes the commissioned series of the late 1950s and the 1960s. The works commissioned for spaces in the Seagram Building and for Holyoke Center at Harvard University have not resulted in permanent installations. With the room at The Phillips Collection, the artist realized the first step toward a goal he had articulated for nearly a decade. It came into being over a period of years and is the result of a rare understanding between artist and patron.

View of the original Rothko Room in 1986 with *Ochre and Red on Red* (1954) on the freestanding wall in front of the window on the west and *Green and Maroon* (1953) on the north wall

1. Although work on the plans and paintings for the chapel of the Institute of Religion and Human Development in Houston was done between 1964 and 1967, the building was not complete and the paintings installed until 1971.

2. Duncan Phillips, transcript of a radio talk entitled "The Pleasures of an Intimate Art Gallery," Washington, D.C., WCFM Radio, February 24, 1954.

3. Theodoros Stamos to Grayson Harris, September 2, 1991, The Phillips Collection Archives (hereafter cited as TPC Archives).

4. Conversation with the author, Washington, D.C., n.d.

5. Sidney Janis to Duncan Phillips, May 8, 1956, TPC Archives.

6. Duncan Phillips to Sidney Janis, October 25, 1956, TPC Archives.

7. *Mauve Intersection (No. 16/No. 12)*, in David Anfam, *Mark Rothko: The Works on Canvas, Catalogue Raisonné* (New Haven, Conn.: Yale University Press, 1998; hereafter cited as Anfam, followed by the relevant catalogue number), 400, and *Green and Maroon (No. 7)*, Anfam 491, both of which would be acquired shortly. *Yellow, Red and Blue*, Anfam 496, and *Plum and Brown*, Anfam 568, were returned to the Sidney Janis Gallery by March 7, 1957. Shipping Record, September 1956–December 1957, 36, TPC Archives.

8. Duncan Phillips to Sidney Janis, November 19, 1956, TPC Archives.

9. *Yellow, Green and Black (No. 11)*, Anfam 437, and *Purple and Yellow*, Anfam 558[?], both

again returned to Janis by March 7, 1957. Shipping Record, September 1956–December 1957, 36, TPC Archives.

10. Duncan Phillips to Sidney Janis, January 29, 1957, TPC Archives.

11. Duncan Phillips to Sidney Janis, January 8, 1958, TPC Archives.

12. "Rothko's and Gottlieb's letter to the editor, 1943," in Mark Rothko, *Writings on Art* (New Haven, Conn.: Yale University Press, 2006), 35.

13. Mark Rothko, statement delivered from the floor at symposium "How to Combine Architecture, Painting and Sculpture," Museum of Modern Art, 1951, published in *Interiors* 110, no. 10 (May 1951), 104.

14. Katharine Kuh, *My Love Affair with Modern Art*, ed. and compl. Avis Berman (New York: Arcade, 2006), 147–48.

15. Letter from Mark Rothko to Katharine Kuh, Archives of the Art Institute of Chicago, quoted in Kuh, *My Love Affair with Modern Art*, 148. For further discussion of Rothko's works for an environment, see Eliza E. Rathbone, "Mark Rothko: The Brown and Gray Paintings," in *The Subjects of the Artist: American Art at Mid-Century*, exh. cat. (Washington, D.C.: National Gallery of Art, 1978); and Susan J. Barnes, *The Rothko Chapel: An Act of Faith* (Austin, Tex.: University of Texas Press, 1989).

16. *Orange and Red on Red*, Anfam 599, and *Green and Tangerine on Red (No. 16/Henna and Green)*, Anfam 562, were purchased. *Blue and Green (No. 3, Green and Blue)*, Anfam 581, went back to Sidney Janis. *Light Red over*

[Dark] Red (No. 36), Anfam 540[?], and *Black and Dark Red on Red*, Anfam 619, were picked up by Hahn and returned to Julius Lowy on June 8, 1960. Letter from Sidney Janis to Elmira Bier, June 6, 1960; Shipping Record, February 25, 1960 (and after), 12, TPC Archives.

17. Leslie Judd Ahlander, *Washington Post*, Sunday, May 15, 1960. In a review of 1957, she made similar note of this fact.

18. Regarding *Mauve Intersection* the museum's hanging records indicate that the painting was shown again in October 1959. This would be the first time after the exhibition of 1957. For a few days it hung with *Green and Maroon* in a gallery with works by John Ferren, Kenzo Okada, Tomlin, Vieira Da Silva, and Stamos for the filming of a television program in the gallery on October 16. The next time *Mauve Intersection* was on view was in the Rothko exhibition in May 1960. It seems therefore to have been shown hardly at all outside the two Rothko exhibitions.

19. Notes by Arthur Hall Smith, interviewed by Karen Schneider, August 21, 1985, TPC Archives. Smith was on staff at The Phillips Collection when the Rothko Room first opened. My thanks to Karen Schneider for assistance with archival materials. This same wood bench with cross slats is still in the room today.

20. Letter in TPC Archives.

21. *Ochre and Red on Red (The Ochre/Ochre, Red on Red)*, Anfam 517.

22. Duncan Phillips, "Mark Rothko," unpublished manuscript, 1964, TPC Archives.

FEATURED WORKS
FROM THE COLLECTION

THEMATIC TEXTS BY SUSAN BEHRENDS FRANK

Realism and Romanticism

The artist should fear to become the slave of detail. He should strive to express his thought and not the surface of it.

Albert Pinkham Ryder, 1905

The predominant aesthetic of American art, from its beginnings in the eighteenth century, is realism tinged with romanticism. By the second half of the nineteenth century young American painters were seeking alternatives to the sentimentality of American genre painting and to the grand theatricality and microscopic realism of the Hudson River School, which treated the landscape of the New World as a divine gift to humanity. In the work of independent-minded artists such as George Inness, Winslow Homer, Thomas Eakins, and Albert Pinkham Ryder, among others, American art came of age. Considered America's "modern" old masters by Duncan Phillips, they had a vision of nature and the inner psychology of the individual that ultimately shaped the emergence of a modernist sensibility in the United States.

Key to a new interpretation of American landscape was Inness, whose realist style relied more on an artistic inner vision rather than on attention to torturous detail. Trained in Paris, Inness, unlike his American contemporaries, did not believe that art must be uplifting or moral. Inness was a romantic with a mystical streak who believed that artistic form, not subject matter, was the principal carrier of meaning. Early in his career he found inspiration in the Arcadian landscapes of Italy, while the mature paintings of his last decade, many of which depict the environs of Tarpon Springs, a small Florida coastal town on the Gulf of Mexico, feature the natural world at dawn or dusk with landscape forms that are indistinct, hazy, and abstracted, suggesting an existence in both the material and immaterial worlds. Painted in the studio, Inness's landscapes are carefully considered orchestrations of luminosity, classical tranquility, and expressionistic interpretation.

A similar fascination with the pastoral is found in the early work of Arthur B. Davies, one of Phillips's favorite artists and an early mentor to the young collector. Born in upstate New York near the Erie Canal, a busy commercial waterway, Davies featured the Mohawk Valley of his childhood in his earliest landscapes, which celebrate a pastoral view of the American countryside as a place where economic

prosperity coexists in idyllic harmony with nature. His later works favor a subjective mysticism with classical allusions and mythical overtones.

These poetic interpretations of nature are matched by a visionary romanticism in the work of artists as diverse as Edward Hicks and Ryder. Hicks, an itinerant preacher turned painter, invented the motif he called "The Peaceable Kingdom." Derived from a passage in the Biblical book of Isaiah, Hicks treated the subject in more than sixty canvases. Freely employing the conventions of commercial decoration, his naive depictions incorporated naturalistic landscape elements from his environs. Hicks gave imaginative life to the spiritual message embodied in his paintings, which carry the conviction of medieval manuscript illumination.

Ryder, one of the most elusive of American artists, was a self-taught recluse who traveled to England and Europe twice. For Phillips and other critics, Ryder's "modernity" derived from two sources: one was a subjective aesthetic that created a "tragic landscape and seascape of the indwelling mind";[1] the other was his ability to use the formal elements of shape, line, and tone to give abstract organization to his canvases. A master of simplified form and abstract design, Ryder was revered in his later years by both conservative and avant-garde American artists and critics for his moonlit imagery and powerfully expressive and romantic vision of nature.

For Phillips, as for American artists who came of age in the early years of the twentieth century, Homer and Eakins were the "heroes of realism."[2] Homer's work captures the ruggedness of the Maine coast and life along those New England shores that, by the end of the nineteenth century, had assumed a central place in the epic conception of the American landscape. His canvases, as scholars have noted, enshrine a heroic mythology of hardy, virile sailors, fishermen, and their kinfolk, pitted against the brutal power of wind and sea. Although Homer's subject matter is ostensibly grounded in the everyday, he goes beyond mere storytelling with paintings that convey a sense of mystery and universality of experience—a prelude to Edward Hopper's realism in the twentieth century. Eakins, Homer's contemporary,

reveled in a blunt scientific realism gained from photography and anatomy studies, with portraiture his main preoccupation beginning in the 1870s. A gifted painter who tended to see the world with scientific detachment, Eakins also revealed the humanity of his sitters. His introspective portraits of friends and colleagues capture them in moments of reverie and reflection, the precursors to the boredom and ennui evidenced in modernist portraits of the early twentieth century.

In his embrace of late-nineteenth-century realism as both romantic and visionary, Phillips was in the forefront of recognizing the contributions made by American painters in defining the essential qualities of our native traditions.

Epigraph from Barbara Novak, *American Painting of the Nineteenth Century: Realism, Idealism and the American Experience* (New York: Praeger, 1969), 214.
 1. Duncan Phillips, "American Old Masters," *A Bulletin of the Phillips Collection* (February–May 1928), 33.
 2. Ibid., 29.

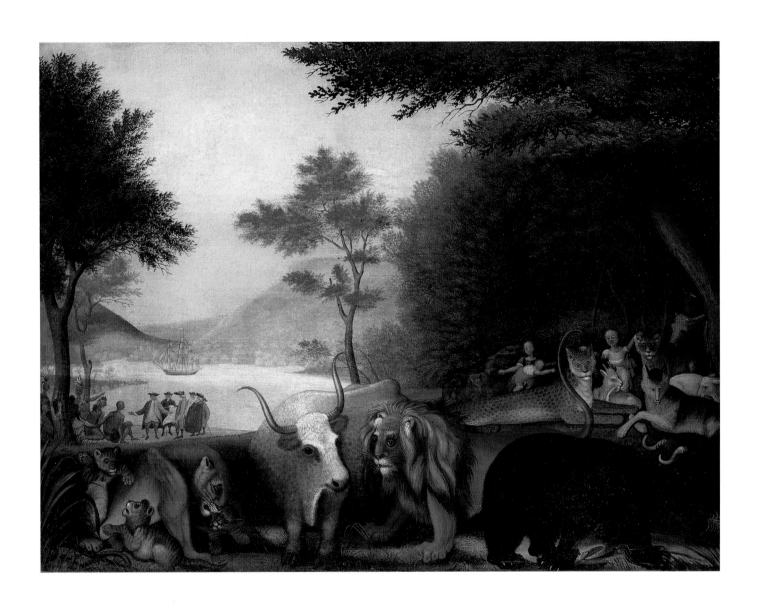

Edward Hicks, *The Peaceable Kingdom*, 1845–46

George Inness, *Lake Albano*, 1869

Winslow Homer, *Girl with Pitchfork*, 1867

George Inness, ***Moonlight, Tarpon Springs***, 1892

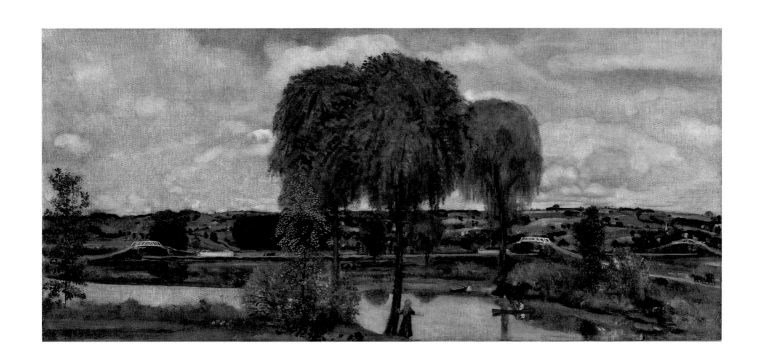

Arthur B. Davies, *Along the Erie Canal*, 1890

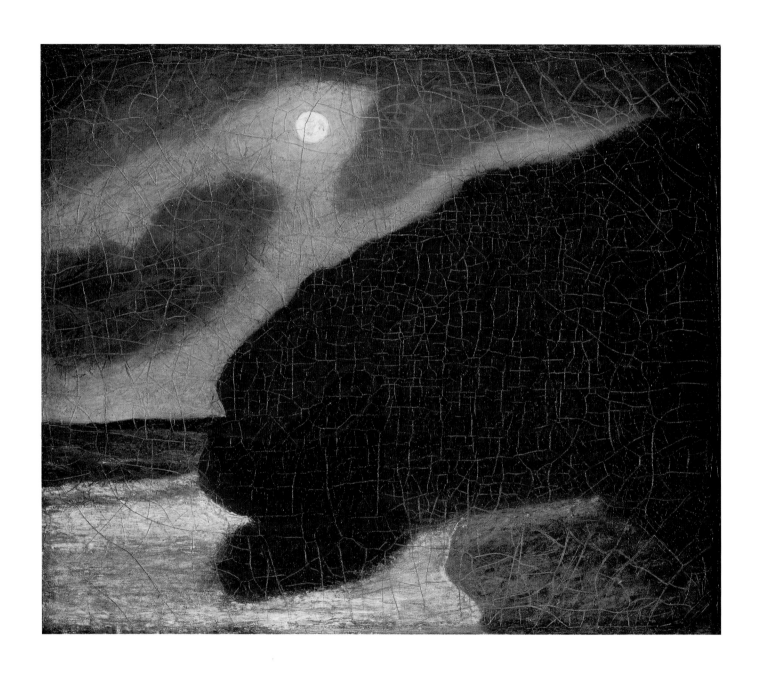

Albert Pinkham Ryder, *Moonlit Cove*, early to mid-1880s

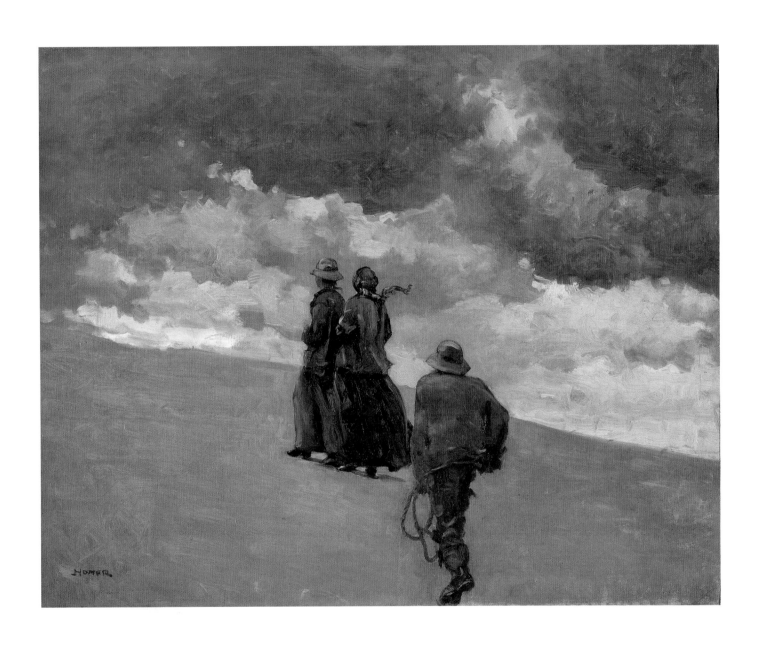

Winslow Homer, *To the Rescue*, 1886

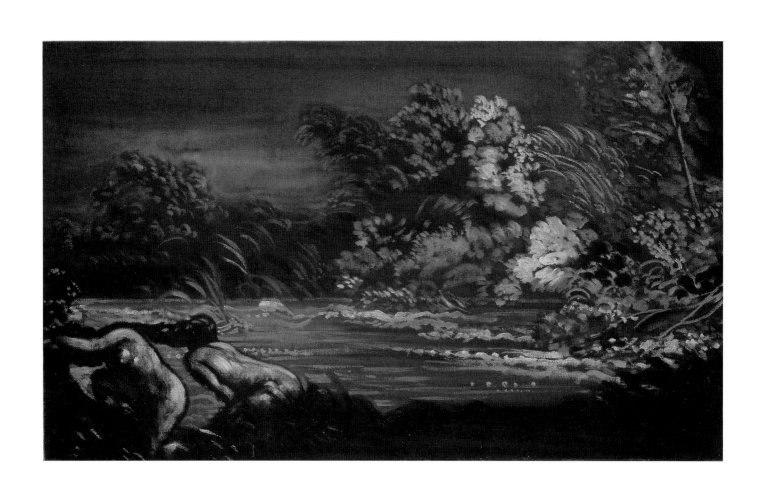

Arthur B. Davies, *The Flood*, c. 1903

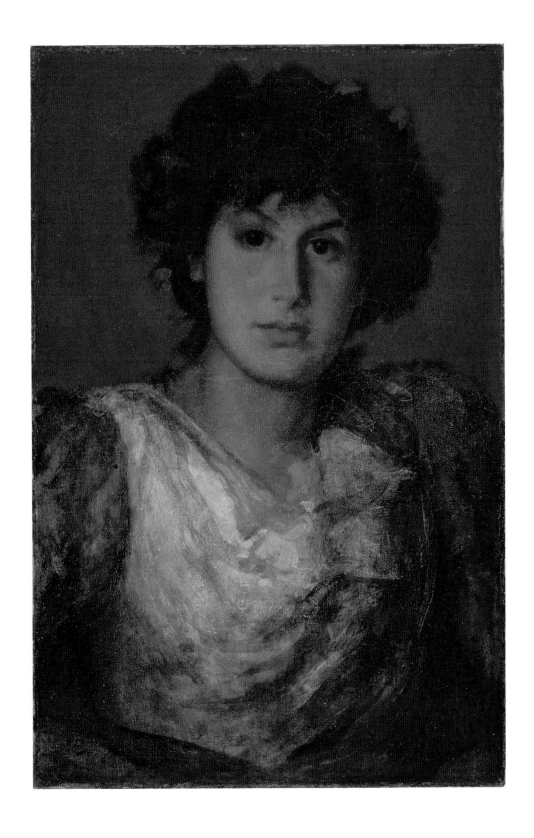

James Abbott McNeill Whistler, *Miss Lillian Woakes*, 1890–91

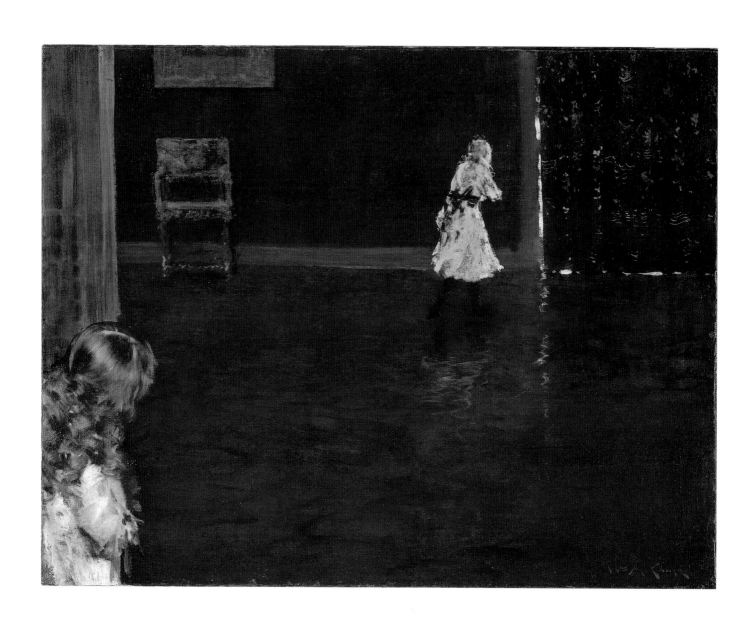

William Merritt Chase, *Hide and Seek*, 1888

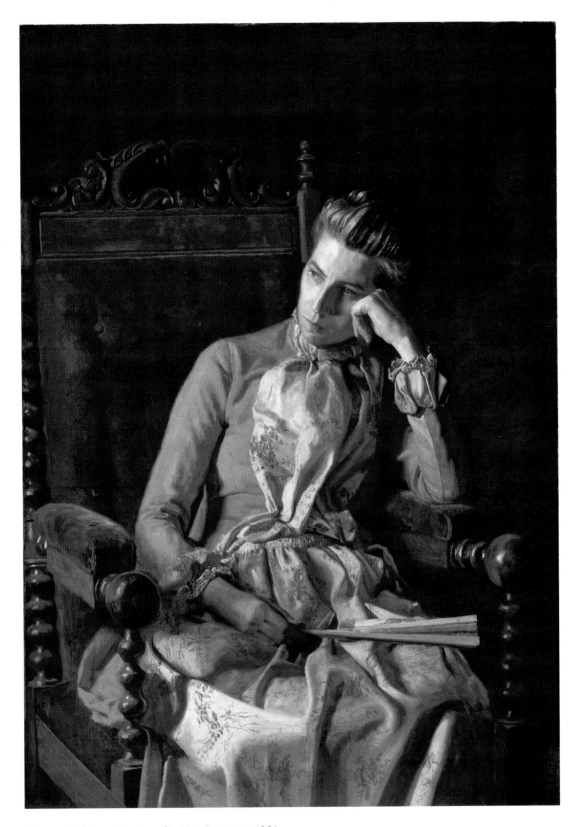

Thomas Eakins, *Miss Amelia Van Buren*, c. 1891

Impressionism

It must not be assumed that American Impressionism and French Impressionism are identical. The American painter accepted the spirit, not the letter of the new doctrine.

Christian Brinton, art critic, 1916

In 1886 the Paris art dealer Paul Durand-Ruel brought a breathtaking display of nearly three hundred paintings by the French impressionists Edgar Degas, Claude Monet, Pierre-Auguste Renoir, and others to New York. For some American artists, trained in the academies of Paris and Munich and in search of a new expressive style, exposure to French impressionism proved transformative.

The American impressionists took to painting outdoors in a variety of weather conditions (*en plein air*), working without preliminary sketches (*alla prima*). They adopted a brighter palette and substituted color for shadows, eliminating blacks and grays. They also used the impressionist technique of applying pure unmixed color on the canvas in dabs and broken brushstrokes to create a sense—an impression—of reflected light, air, and atmosphere. Like their French counterparts, they employed compositional elements borrowed from photography and Asian art, such as cropping, asymmetry, and multiple viewpoints. Even so, the American impressionists never completely lost their foundation in the realist tradition, always keeping three-dimensional volume in their forms.

These efforts to infuse American painting with a French impressionist style gave a fresh interpretation to countryside and city, transforming the heroic American landscape of the Hudson River School and the genre scenes of rural America into a modern idiom. Intimate landscape views rooted primarily in the New England countryside became the norm, as did scenes of leisure activities in parks and at the beach, as well as urban views that captured the genteel character of the city, especially New York City.

Among the first American painters to assimilate the techniques and subject matter of French impressionism were Childe Hassam, Theodore Robinson, John Henry Twachtman, and Julian Alden Weir. Robinson, an associate of Monet in Giverny, France, from 1888 to 1892, was instrumental in bringing the impressionist aesthetic to his close friends Twachtman and Weir. They, in turn, exhibited their "impressionist" landscapes alongside works by Monet at the American Art Galleries

in New York in 1893. Hassam, too, brought home an understanding of impressionism after working in Paris in the late 1880s, where he briefly occupied a studio once used by Renoir. Maurice Prendergast, by contrast, absorbed influences from both French impressionist and post-impressionist painters during his studies in Paris in the early 1890s and on frequent trips to Europe before World War I. He was the first American painter to bring back to the American art scene firsthand knowledge of the work of Paul Cézanne and the French fauves.

With a new awareness of landscape painting as an expression of a painter's intimate personal reaction to the land, artists left the city for summer retreats in rural communities throughout New England. The teaching role assumed by many of the pioneers of American impressionism helped to spread the style to a new generation of American painters, such as Ernest Lawson, and distinguishes the Americans from their French counterparts. Twachtman and Weir, for example, taught winter classes in New York but held summer classes in Connecticut, while William Merritt Chase moved out of his New York classroom to teach plein air painting at Shinnecock at the tip of Long Island. Pennsylvania impressionists such as Robert Spencer were clustered around New Hope, north of Philadelphia, emphasizing the rural countryside along the Delaware River, while the Boston impressionists, many of whom worked in France, focused in great measure on the figure. Through a network of close friendships, extensive teaching in the classroom and in outdoor summer art sessions held in various locales in the American Northeast, and the establishment of art colonies throughout New England and in Giverny, American impressionist painting became stylistically diverse in its expression, reflective of the wide variety of styles employed by such a large group of first-generation impressionists and their second-generation followers.

Epigraph from Christian Brinton, *Impressions of the Art at the Panama Pacific Exposition, with a Chapter on the San Diego Exposition and an Introductory Essay on the Modern Spirit in Contemporary Painting*, 1916, as cited in William Gerdts, *American Impressionism* (New York: Abbeville Press, 1984), 302.

Childe Hassam, **Washington Arch, Spring**, c. 1893 (inscribed *1890*)

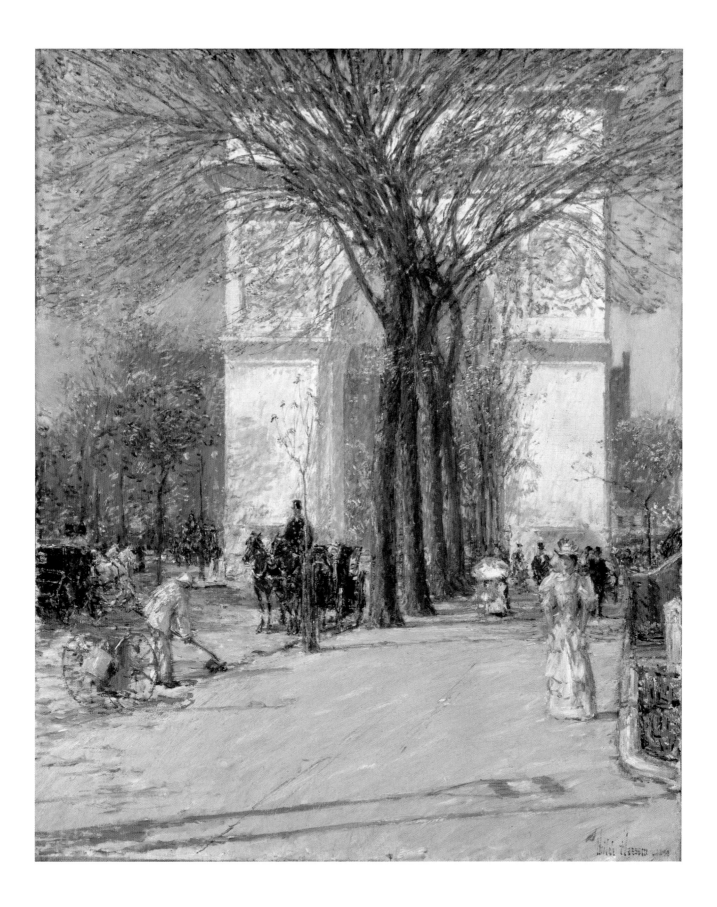

Theodore Robinson, *Giverny*, c. 1889

John Henry Twachtman, *The Emerald Pool*, c. 1895

John Henry Twachtman, *Summer*, late 1890s

Julian Alden Weir, *The High Pasture*, 1899–1902

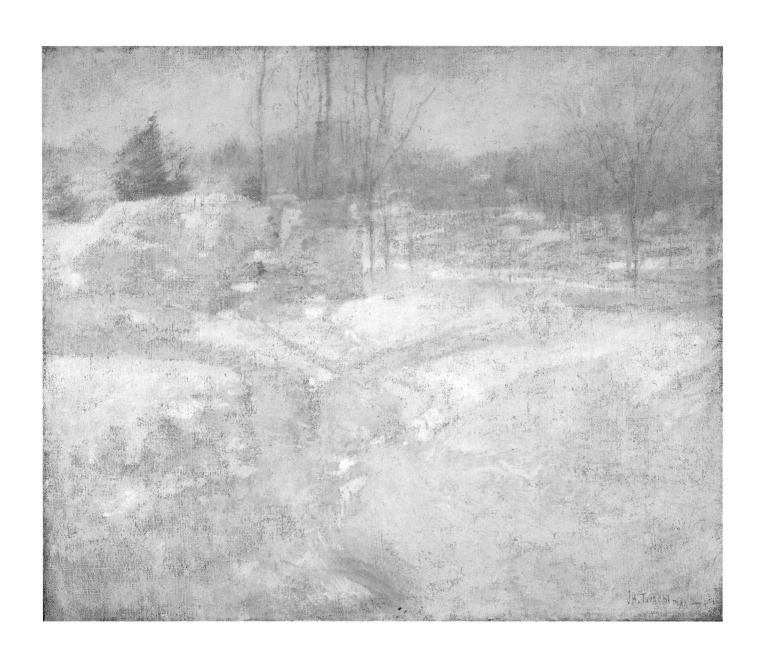

John Henry Twachtman, *Winter*, c. 1891

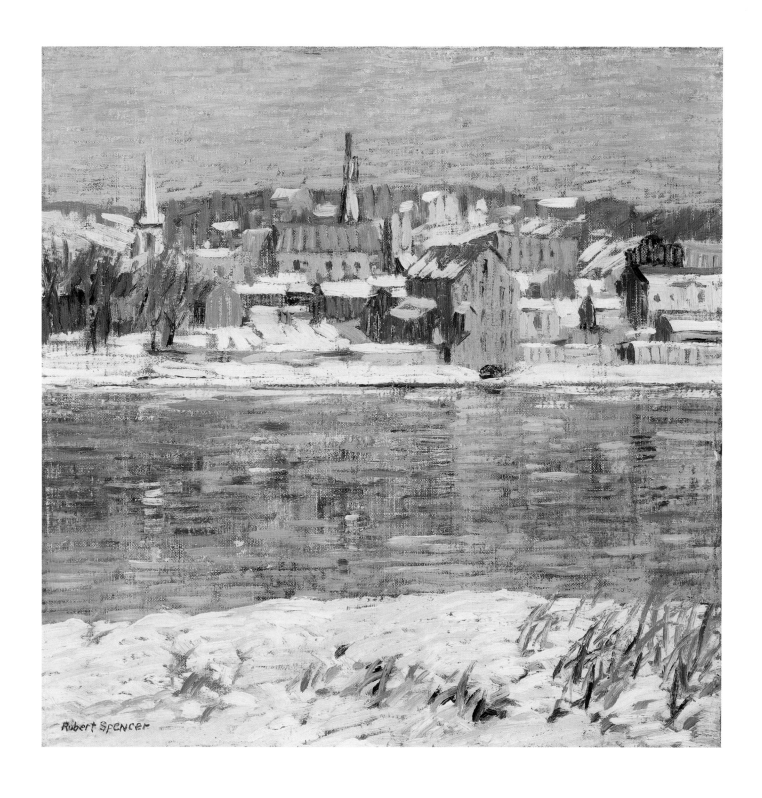

Robert Spencer, **Across the Delaware**, c. 1916

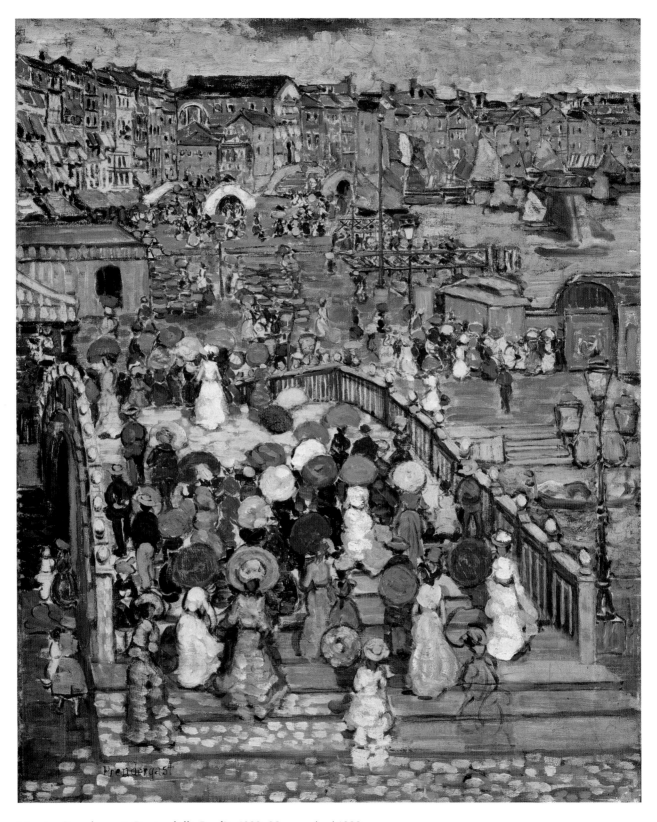

Maurice Prendergast, **Ponte della Paglia**, 1898–99, reworked 1922

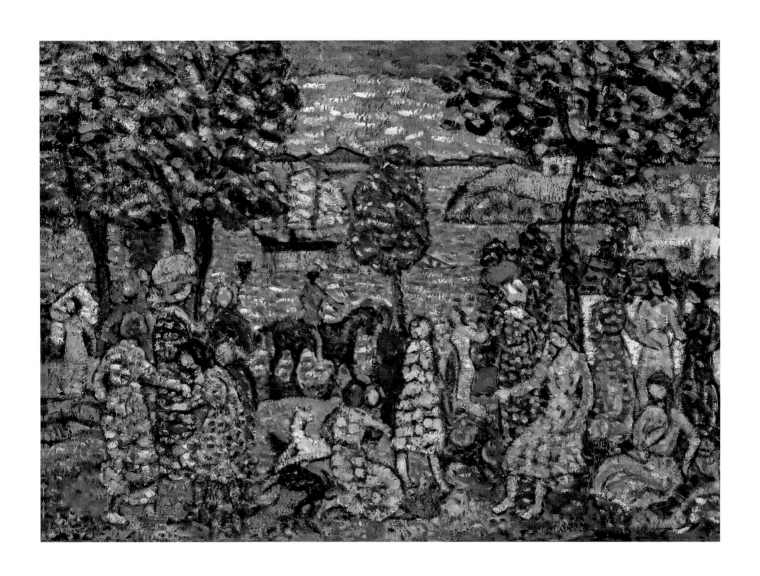

Maurice Prendergast, *Fantasy*, c. 1917

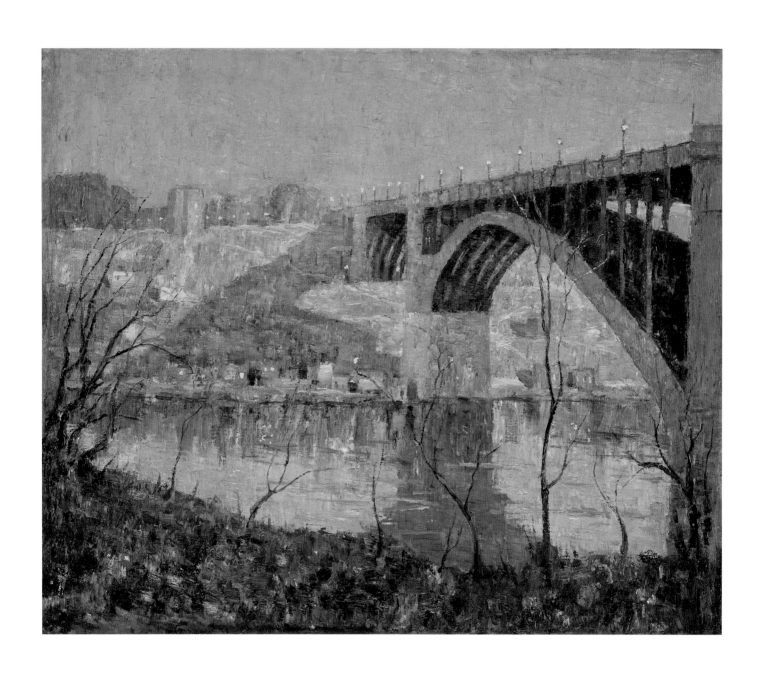

Ernest Lawson, **Spring Night, Harlem River**, 1913

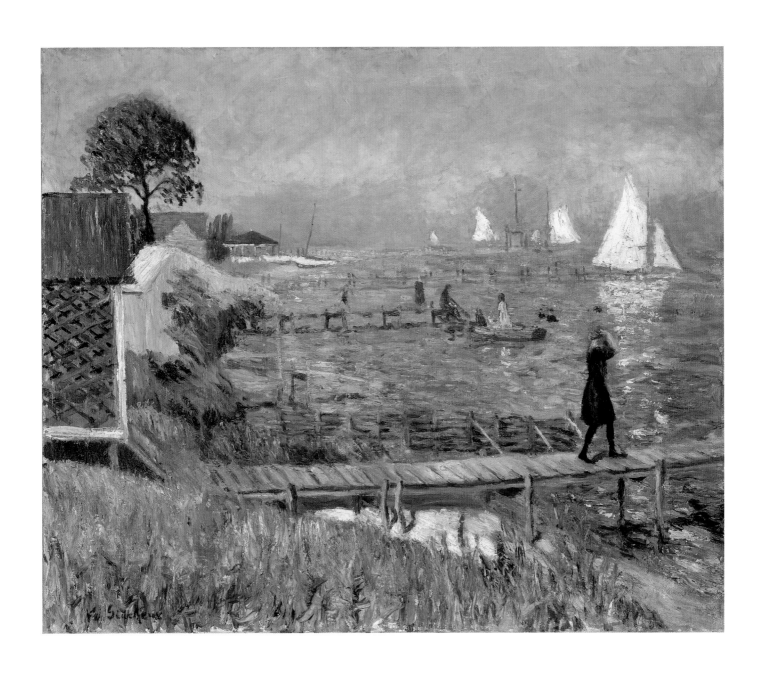

William Glackens, *Bathers at Bellport*, c. 1912

Forces
in Nature

You must be made to see that artist's scene and not nature's scene.

John Marin

Nature and the land hold a special place in American art. The countryside continued to seduce American artists in the twentieth century, as it had in the nineteenth. Twentieth-century American painters sought to reinterpret nature in a bold, expressive manner, capturing a personal response to elements seen and unseen, often in styles adapted from those of their European contemporaries. Although most American painters who came of age after the turn of the twentieth century were trained as realists in the academies of New York, Philadelphia, and Europe, many of them chose not to focus on the city, its inhabitants, and its industrialization. Instead, they experienced the modernist impulse as a utopian longing for nature experienced in isolation. Dissatisfied with impressionism's emphasis on intimate, domesticated landscape views rendered in soft, atmospheric light, a younger generation of American artists combined the heroic realism of Winslow Homer and the romantic abstraction of Albert Pinkham Ryder into an unsentimental modernism.

Remote northern areas of New England and New York continued to attract young American artists of independent spirit such as Paul Dougherty, Marsden Hartley, Rockwell Kent, John Marin, and Harold Weston. In the rugged landscapes and harsh climate of these regions, artists found an escape from the confines of civilization and experienced the extremes of nature's grandeur and beauty.

Dramatic depictions of the sea at Monhegan Island off the coast of Maine established Dougherty's reputation in the first decade of the twentieth century as a marine painter in the tradition of Homer. Kent was another artist acknowledged by critics as a direct inheritor of Homer's heroic realism. Although Kent, as a student in the early 1900s, was grounded in the urban realist tradition of both Robert Henri and Kenneth Hayes Miller, unlike his colleagues he showed little interest in depicting the city, its inhabitants, or the industrial countryside. Instead, powered by ideas of Christian socialism that valued poverty and hard work, Kent found artistic inspiration in harsh and remote locations across the globe, from the rugged terrain of Monhegan Island to Tierra del Fuego in Chile, as well as Alaska and Greenland. His paintings

often explore the theme of humanity's relative insignificance in relationship to the monumental forces of nature.

Unlike his friend and colleague Kent, Hartley, who made his first summer trips to Maine while still an art student in New York, was inspired by the mountainous terrain and changing seasons to create canvases around 1910 that interpreted his experience as a tapestry of colorful patterns. By contrast, Hartley's later paintings, from the mid-1930s until his death in 1943, have a brooding, sculptured beauty to them. Inspired by the people and landscape of Maine, where he had returned in 1937 after many years of travel, Hartley's late work was described by Duncan Phillips as "powerful and personal and wholly American."[1] These expressionistic canvases rely on simplified forms, abstract patterning, and interlocking shapes to create drama and emotion. Many are close in spirit and style to paintings by Ryder, which were admired by Hartley for their "incomparable sense of pattern and austerity of mood."[2]

Another painter of expressionist temperament, John Marin, followed Eugène Delacroix's dictum that nature must be viewed through a temperament, believing that "it is this 'moving of me' that I try to express. . . . How am I to express what I feel so that its expression will bring me back under the spells?"[3] Marin was sensitive to weather, seasons, atmospheric conditions, and geography, whether painting in the suburbs of his home state of New Jersey or in the remote reaches of Maine or western Massachusetts. His 1930s oils, painted at Cape Split in a dark palette that gives black its own depth and shape, are inhospitable and harsh. While Marin's art always starts in the visible world, his compositions become metaphors for the natural world rendered as literal reality. In Marin's own words, "the Sea that I paint may not be the sea, but it is a sea—not an abstraction."[4]

Allen Tucker, a modernist painter whom critics labeled "the American van Gogh,"[5] was a plein air painter whose mature canvases were known for their vibrant color and rhythmic brushwork. Although he lived in New York City, Tucker spent his summers in remote areas along the New England coast, as well as in Colorado and the Canadian Rockies, painting landscapes that seek to capture the natural beauty

of these rugged environments. Harold Weston, by contrast, chose a solitary, ascetic life in the rugged wilderness of the Adirondack Mountains of upstate New York. Unlike most of his contemporaries, Weston, a Harvard University graduate familiar with contemporary and historical art styles, was a self-taught artist. His Adirondack paintings of the early 1920s reveal a modernist aesthetic combined with a highly personal response to place that Phillips characterized as being in the spirit of Vincent van Gogh. Weston's compositions, begun as outdoor sketches but finished in the studio, combine stylized shapes, rhythmic lines, patterned brushwork, and unusual or distorted viewpoints to capture the essence of a remote landscape infused with the physical sensations of terrain, weather, and changing light.

Epigraph from *John Marin by John Marin*, ed. Cleve Gray (New York: Holt, Rinehart and Winston, 1977), 134.

1. Duncan Phillips, "Marsden Hartley," *Magazine of Art* 37 (March 1944), 87.
2. Marsden Hartley, *Adventures in the Arts: Informal Chapters on Painters, Vaudeville, and Poets* (New York: Boni & Liveright, 1921; reprint, New York: Hacker Art Books, 1972), 41.
3. Gray, *John Marin*, 105.
4. Ibid., 143.
5. Forbes Watson, "Allen Tucker: A Painter with a Fresh Vision," *International Studio* 52 (March 1914): xix; and Duncan Phillips, "Contemporary American Painting," *A Bulletin of the Phillips Collection Containing Catalogue and Notes of Interpretation Relating to a Tri-Unit Exhibition of Paintings & Sculpture* (February–May 1928), 47.

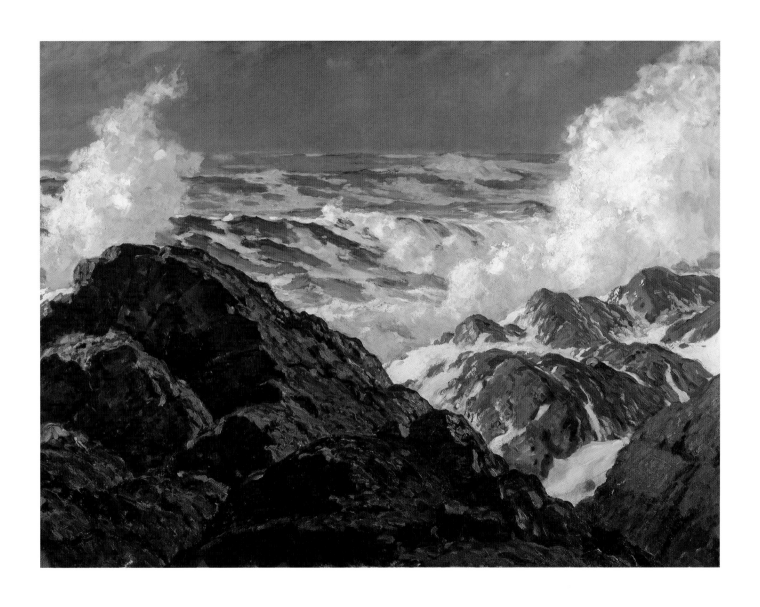

Paul Dougherty, *Storm Voices*, 1912

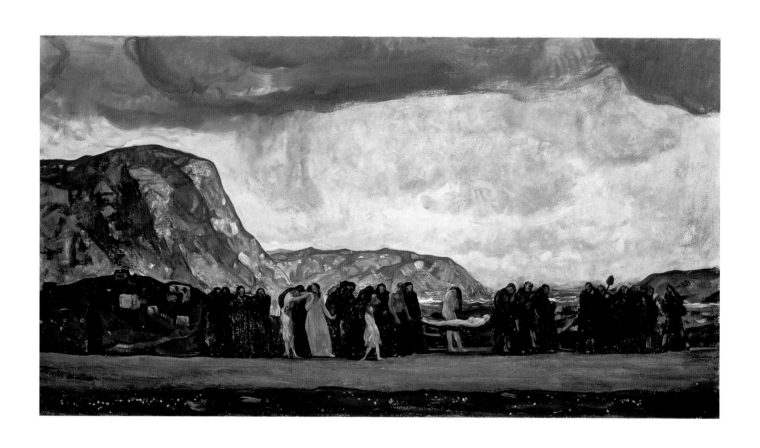

Rockwell Kent, *Burial of a Young Man*, c. 1908–11

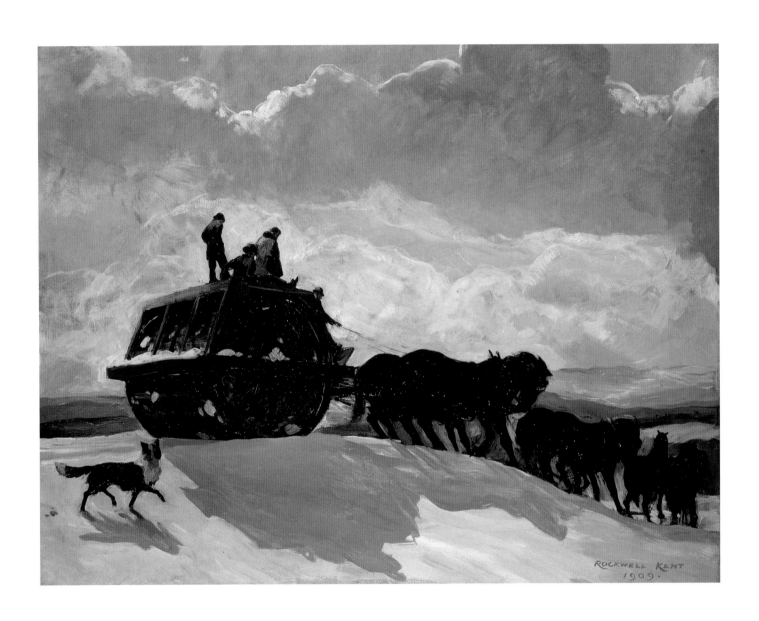

Rockwell Kent, *The Road Roller*, 1909

Allen Tucker, *The Rise*, undated

Marsden Hartley, *Mountain Lake—Autumn*, c. 1910

John Marin, *Weehawken Sequence, No. 30*, c. 1916

Harold Weston, ***Winds, Upper Ausable Lake***, 1922

Rockwell Kent, **Azopardo River**, 1922

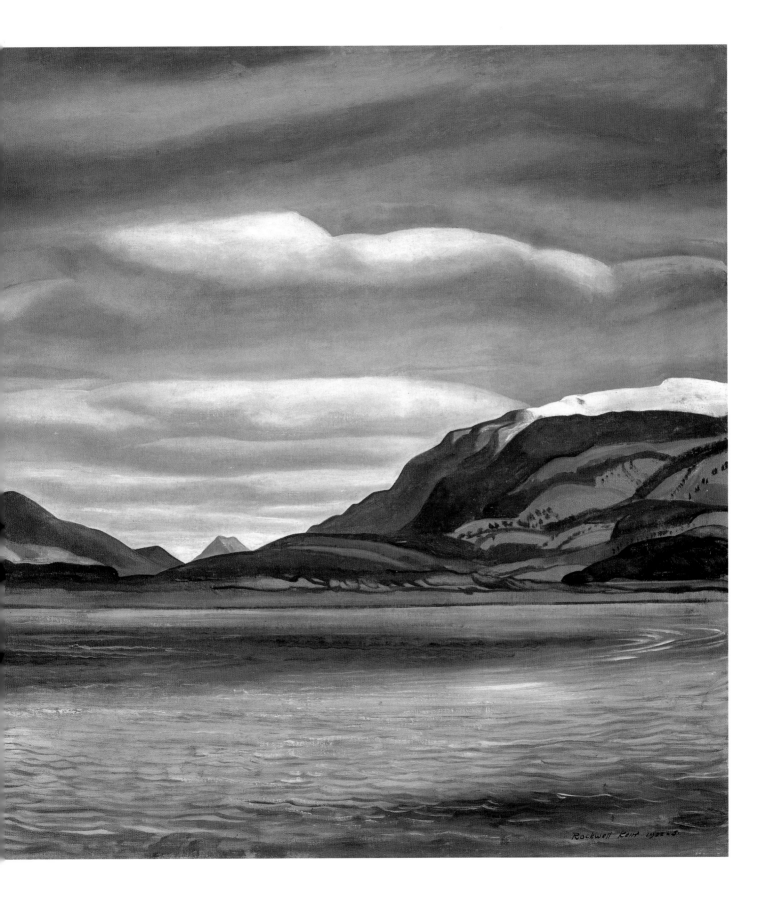

John Marin, **The Sea, Cape Split, Maine**, 1939

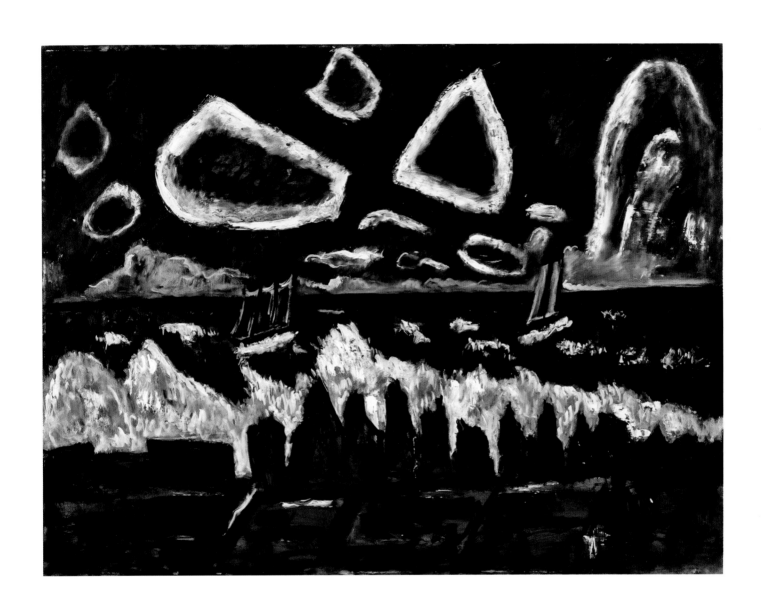

Marsden Hartley, *Off the Banks at Night*, 1942

Nature and Abstraction

Nothing is less real than realism. Details are confusing. It is only by selection, by elimination, by emphasis, that we get at the real meaning of things.

Georgia O'Keeffe, 1922

After World War I, American artists and writers struggled to define the country's modern identity. Duncan Phillips was among the most adventurous collectors and museum directors in the decade after the war, with his enthusiasm for bold, original works that signaled a clear shift in the development of a modern and uniquely American style that captured the experience of nature, which was so much a part of the nation's identity. An artist such as Charles Burchfield, for example, infused with the transcendentalist writings of John Burroughs and Henry David Thoreau, revealed a hypersensitivity to nature's varying moods and interpreted them with a bit of fantasy. In particular, Burchfield conveyed the sounds of nature and weather conditions as well as the organic spirit implicit in all life forms through a shorthand of abstracted line and color.

Augustus Vincent Tack also turned inward in search of an authentically American art. Academically trained, he began painting abstract, nonrepresentational decorations in the early 1920s that have their roots in American landscape painting and nineteenth-century transcendentalism. Tack described what he was after as "compositions of form and colors based on essential rhythms" in nature that are understood to be "mystical."[1] Phillips, Tack's lifelong patron, considered Tack's abstractions musical in their emphasis on harmonic relationships of form and color.

Nineteenth-century analogies between music and painting carried over into ideas about modern American art. The search for equivalents to different kinds of sensory experience was essential to the aesthetic debates that photographer Alfred Stieglitz published in his journal *Camera Work*, from its inception in 1903. The appearance in English in 1914 of Wassily Kandinsky's treatise on synesthesia, *Concerning the Spiritual in Art* (1911), fueled the discourse. In Stieglitz's circle, painters Arthur Dove, Marsden Hartley, John Marin, and Georgia O'Keeffe adopted a style of expressive symbolism. They believed that the experience of the natural world was a spiritual one in which nature's "inner truth" or essence could be made visible in abstract

"equivalents," in which color, form, and line must be divorced from representation. Phillips, who discovered these American originals through Stieglitz, became an ardent collector of the work of each and, notably, the first to purchase the works of Dove and O'Keeffe for a museum.

Although Dove, Hartley, and Marin had traveled in Europe before World War I, by 1919 Stieglitz celebrated their kinship with Albert Pinkham Ryder and Winslow Homer, heroes of past American painting, and argued for an American art grown from American soil. He promoted his circle as "genuine" American artists, who were progressives independent of any European avant-garde influence, and exhibited their work together until his death in 1946.

Despite their enthusiasm and admiration for Kandinsky, the artists in the Stieglitz circle never became nonobjective painters. For all their idealism and their search for an independent American aesthetic—described irreverently by O'Keeffe as "the Great American thing"[2] and intended as the antidote to European modernism—the artists of the Stieglitz group addressed subject matter that was firmly grounded in observable, objective reality and tied to place, an almost sacred concept for these artists. Where earlier generations of American painters sought out picturesque spots and pastoral views, the new American painters required intimacy with a particular place in order to understand its inner spirit. O'Keeffe identified Dove, considered America's first abstract artist, as one of her favorites because "he would get the feel of a particular place so completely that you'd know you'd been there."[3] Marin drew on the energy of New York City and the isolation of Bear Mountain and Cape Split in Maine, writing that "the true artist must perforce go from time to time to the elemental big forms—Sky, Sea, Mountain, Plain . . . to sort of re-true himself up, recharge the battery."[4]

Dove's life and subjects were rooted in rural Connecticut and upstate New York, as well as the waterways of Long Island Sound. Sensitive to place and atmospheric

conditions, he demanded of himself "the reality of the sensation"[5] in compositions that are interpretations of nature as abstract harmonies with organic forms in earthy colors. Dove, whom O'Keeffe called "the only American painter of the earth,"[6] sought to represent the unseen rhythms and nuances of his environment and to record his responses to this primal experience of nature through organic shapes, undulating lines, bands of color, and glowing light. In a 1942 diary entry Dove writes of his method as "work at that point where abstraction and reality meet,"[7] while Duncan Phillips, his most ardent patron apart from Stieglitz, recognized his striving "to suggest *the sense of things*—of both inert and living Elements."[8]

Abstracting and distilling the essence of an object through simplification and reduction of detail was an approach the artists of the Stieglitz circle shared. Dove's effort to find new forms to convey the essence of American landscape was inspired by the reductive photographs of Stieglitz and Paul Strand. O'Keeffe, too, learned from their photographs, achieving her masterful abstractions of ephemeral objects, such as leaves and flowers, through extreme close-up views, cropping, fragmentation, and shallow depth of field, thus emphasizing contour and color as abstract elements. O'Keeffe brought the same imaginative vision to northern New Mexico's architecture and monumental desert landscape. In their exaggeration, simplification, sensual gradations of light and color, and inventive adjustments to contour, her New Mexico paintings are testament to her personal response to this place and its culture.

Epigraph from Elizabeth Hutton Turner, *Georgia O'Keeffe: The Poetry of Things* (Washington, D.C., and New Haven, Conn.: The Phillips Collection and Yale University Press, 1999), xvii.

1. Augustus Vincent Tack to John Kraushaar, August 8, 1922, cited in Leslie Furth et al., *Augustus Vincent Tack: Landscape of the Spirit*, exh. cat. (Washington, D.C.: The Phillips Collection, 1993), 48.
2. Georgia O'Keeffe, *Georgia O'Keeffe* (New York: Viking Press, 1976), n.p., cited in Wanda M. Corn, *The Great American Thing: Modern Art and National Identity, 1915–1935* (Berkeley: University of California Press, 1999), xv and n3.
3. Georgia O'Keeffe, quoted in Calvin Tomkins, "The Rose in the Eye Looked Pretty Fine," *New Yorker* 50 (March 4, 1974), 62, as cited in Corn, *Great American Thing*, 250.
4. *John Marin by John Marin*, ed. Cleve Gray (New York: Holt, Rinehart and Winston, 1977), 161.
5. Arthur Dove, *Catalogue of the Forum Exhibition of American Art*, 1916, cited in Elizabeth Hutton Turner, *In the American Grain: The Stieglitz Circle at The Phillips Collection* (Washington, D.C.: Counterpoint and The Phillips Collection, 1995), 16.
6. Georgia O'Keeffe, quoted in Barbara Haskell, *Arthur Dove*, exh. cat. (San Francisco: San Francisco Museum of Art, 1974), 118, as cited in Turner, *In the American Grain*, 13.
7. Arthur Dove, unpublished diary entry, August 20, 1942, Arthur G. Dove Papers, Reel 725, Archives of American Art, Smithsonian Institution.
8. Duncan Phillips, *A Collection in the Making*, Phillips Publication No. 5 (New York and Washington, D.C.: E. Weyhe and Phillips Memorial Gallery, 1926), 63.

Charles Burchfield, **Moonlight Over the Arbor**, 1916

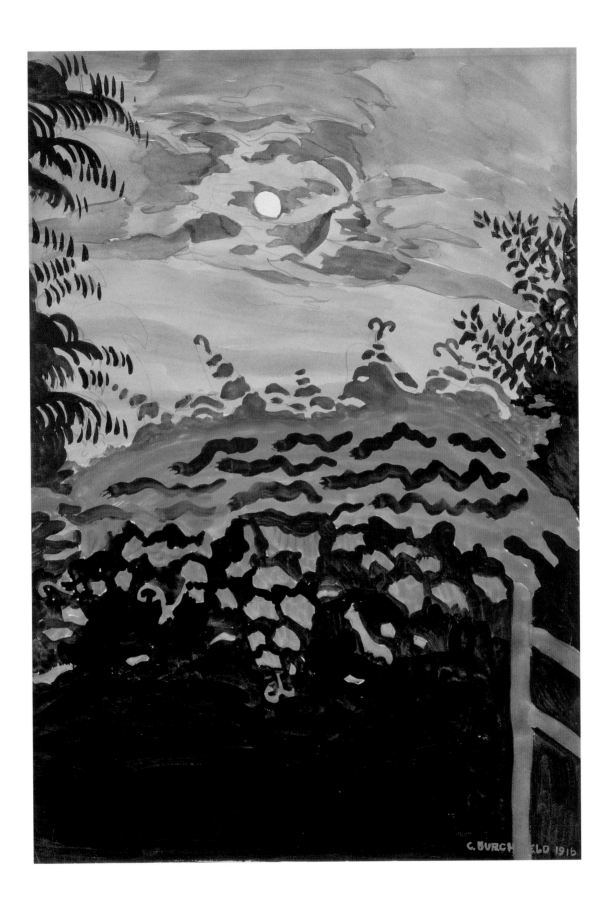

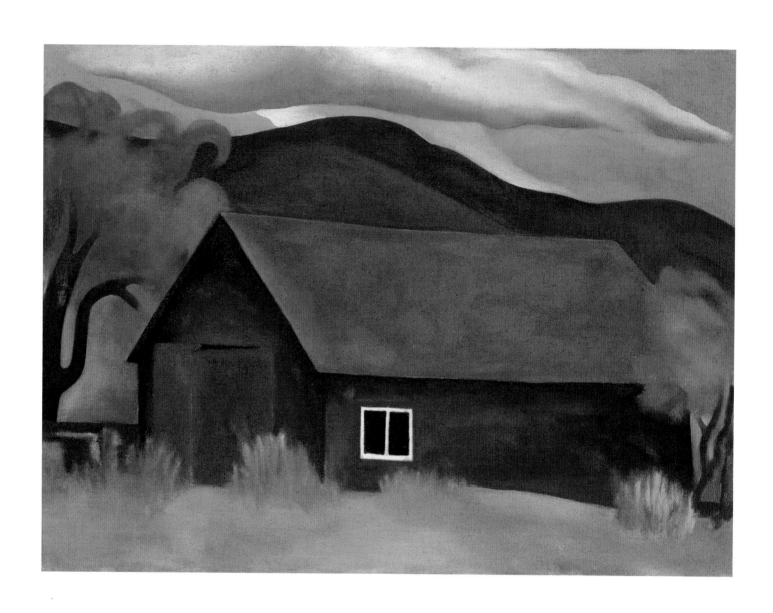

Georgia O'Keeffe, **My Shanty, Lake George**, 1922

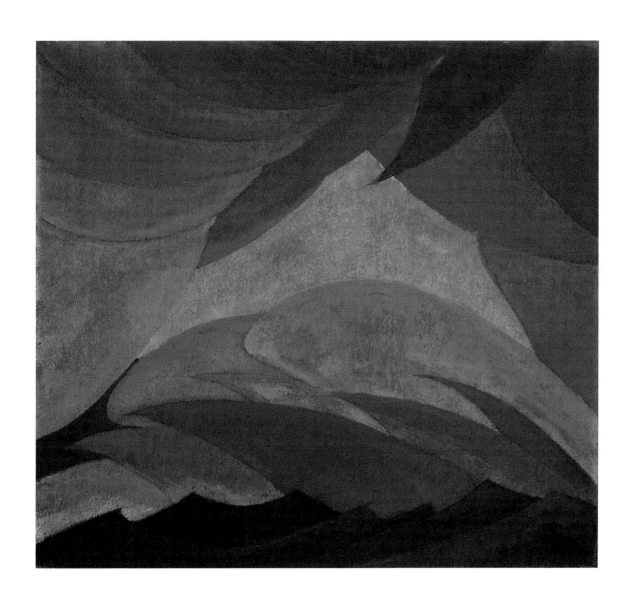

Arthur G. Dove, *Golden Storm*, 1925

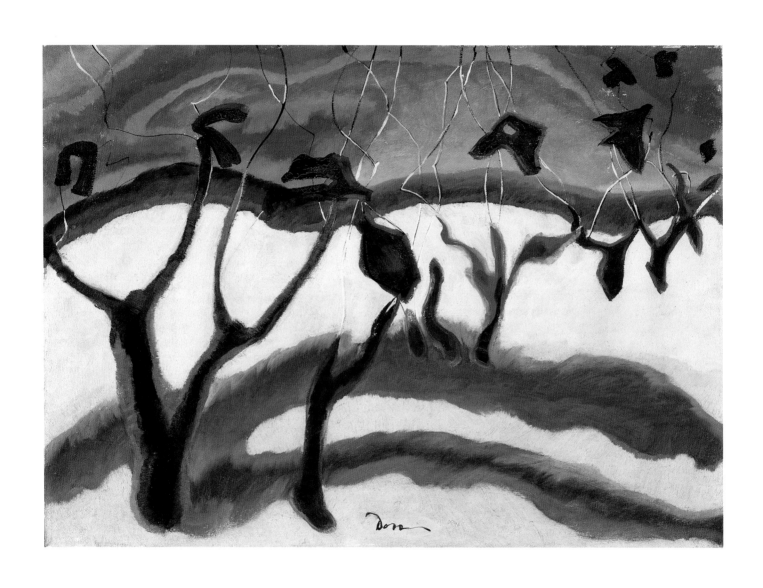

Arthur G. Dove, *Electric Peach Orchard*, 1935

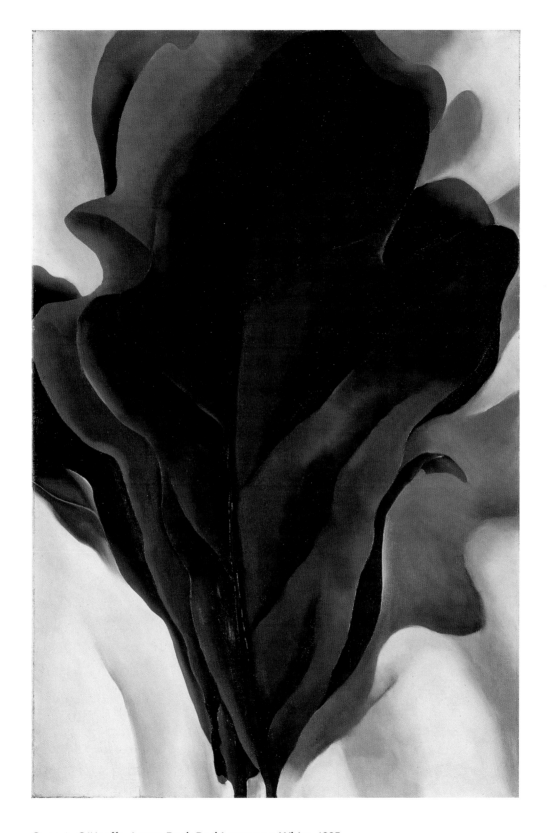

Georgia O'Keeffe, *Large Dark Red Leaves on White*, 1925

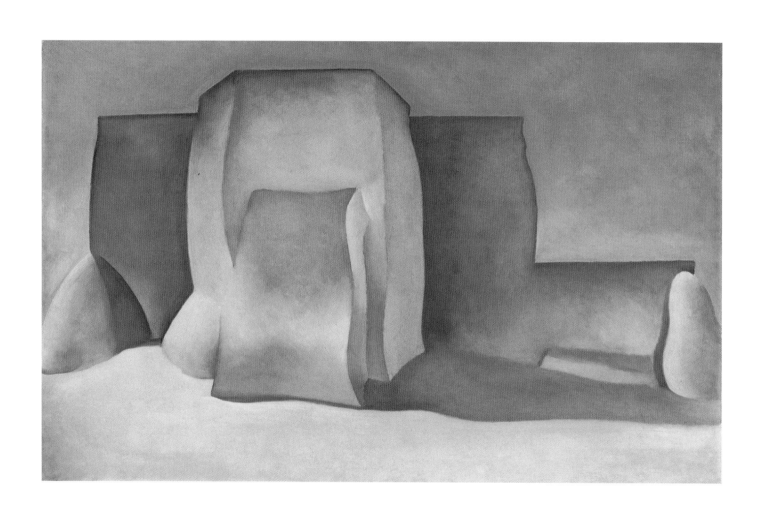

Georgia O'Keeffe, *Ranchos Church, No. II, NM*, 1929

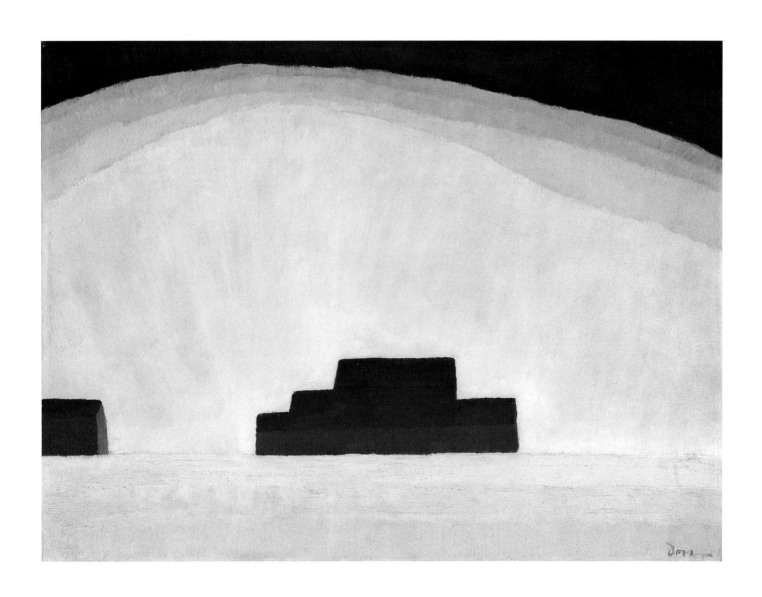

Arthur G. Dove, *Snow Thaw*, 1930

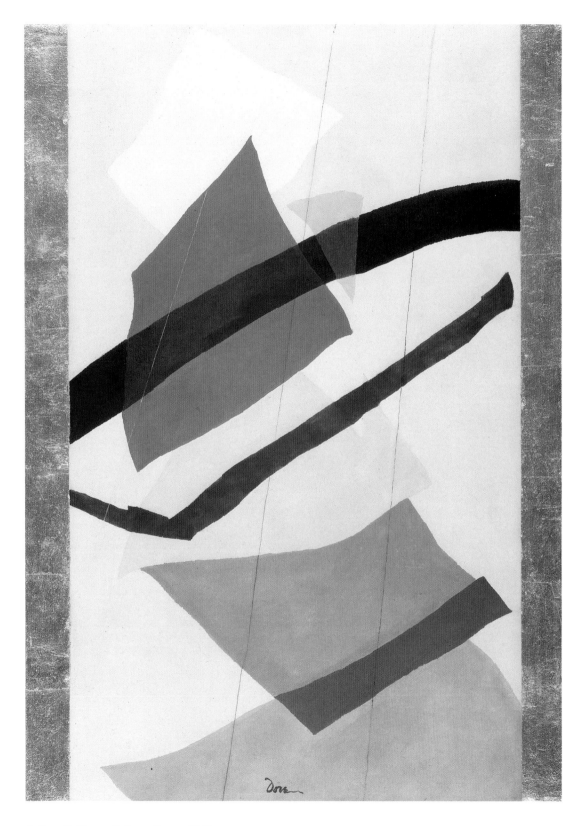

Arthur G. Dove, *Rain or Snow*, 1943

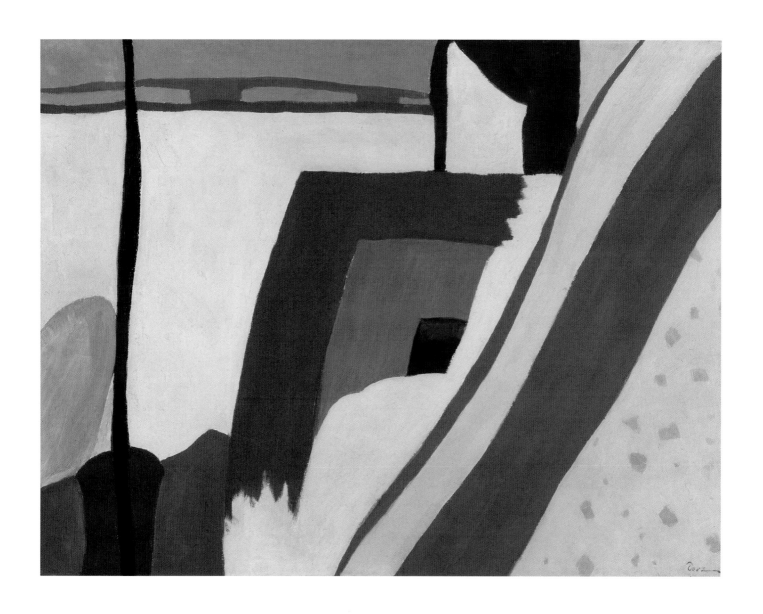

Arthur G. Dove, *Sand Barge*, 1930

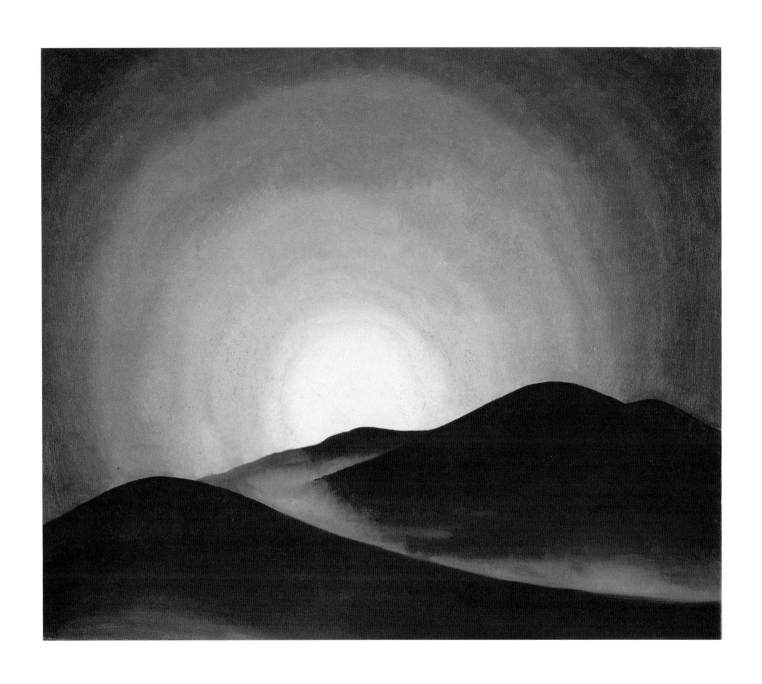

Georgia O'Keeffe, **Red Hills, Lake George**, 1927

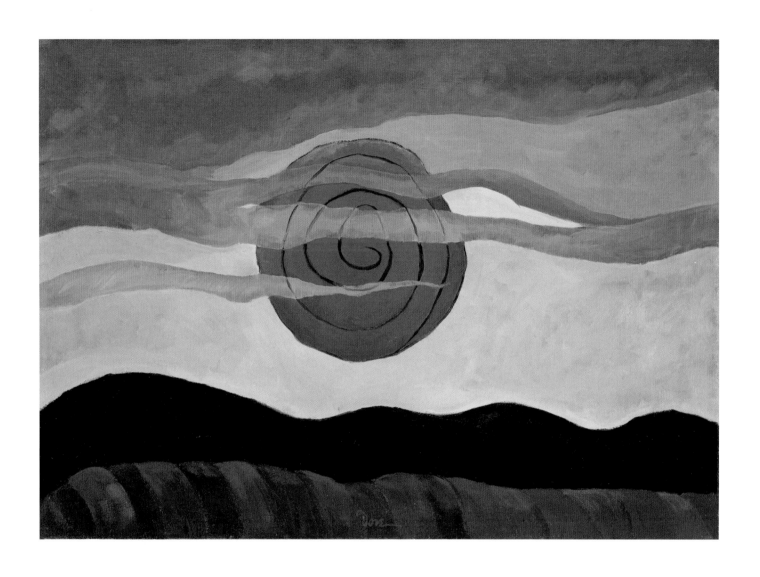

Arthur G. Dove, *Red Sun*, 1935

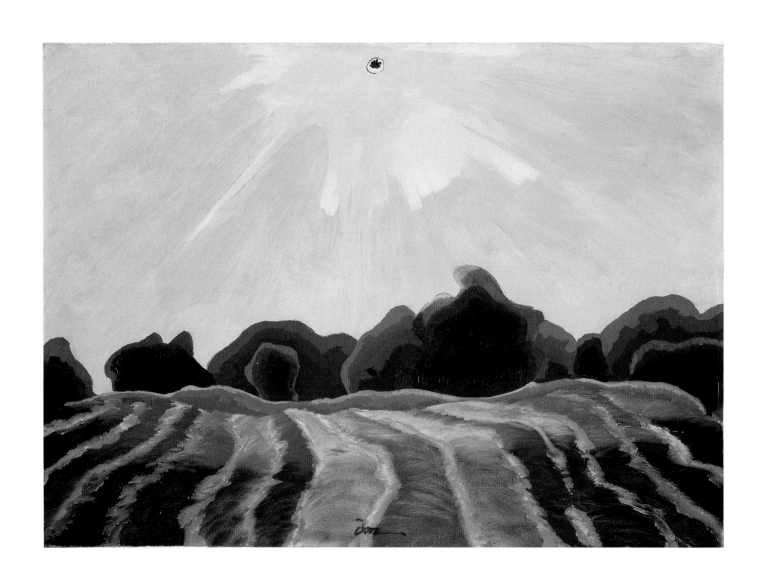

Arthur G. Dove, *Morning Sun*, 1935

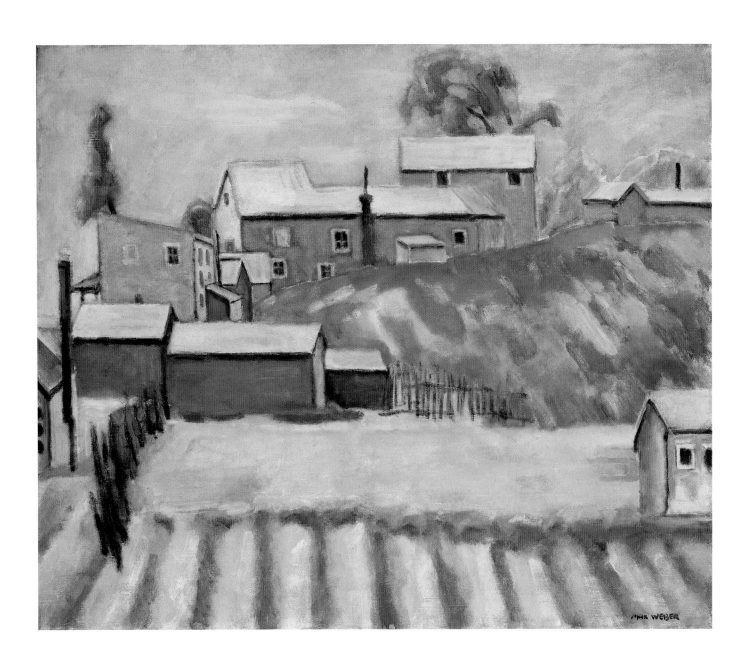

Max Weber, *High Noon*, 1925

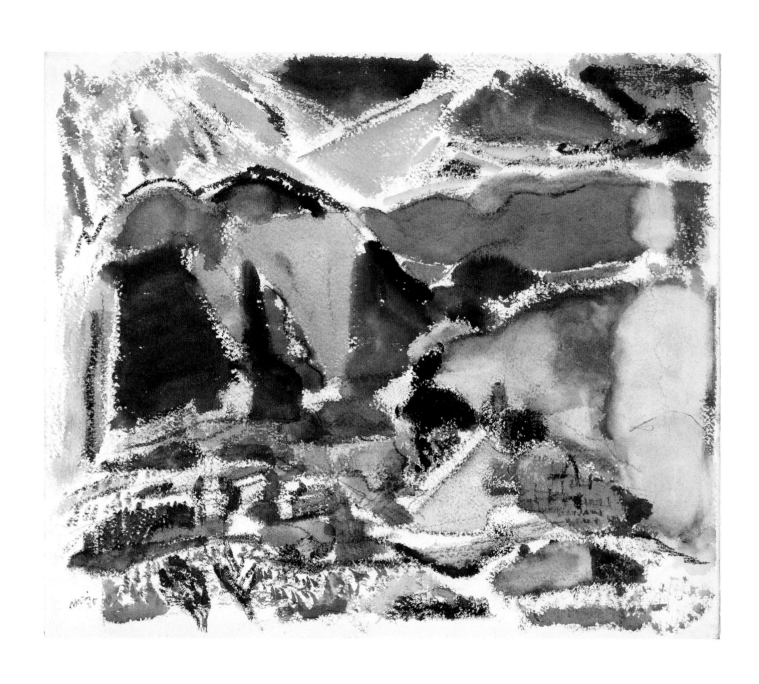

John Marin, *Back of Bear Mountain*, 1925

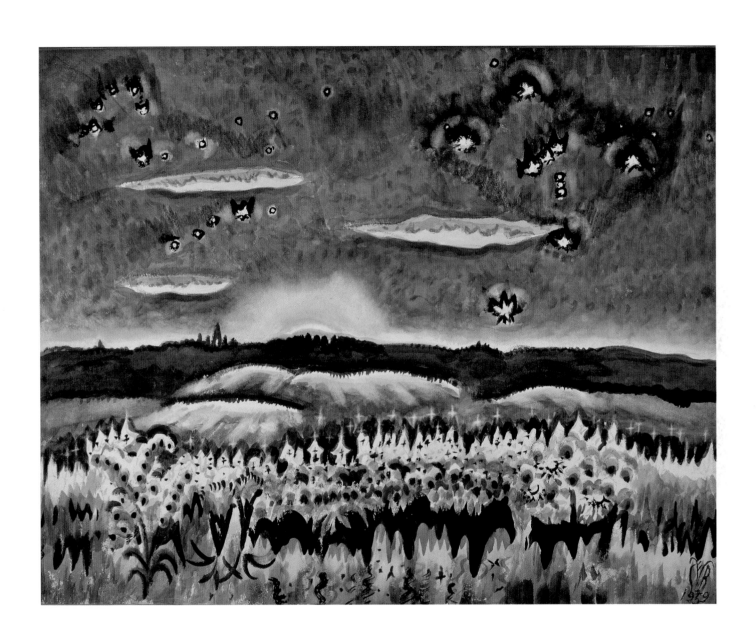

Charles Burchfield, *December Moonrise*, 1959

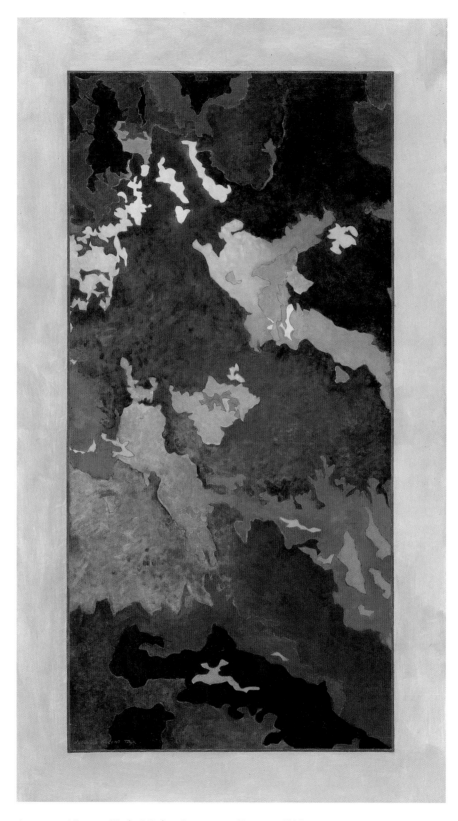

Augustus Vincent Tack, *Night, Amargosa Desert*, 1935

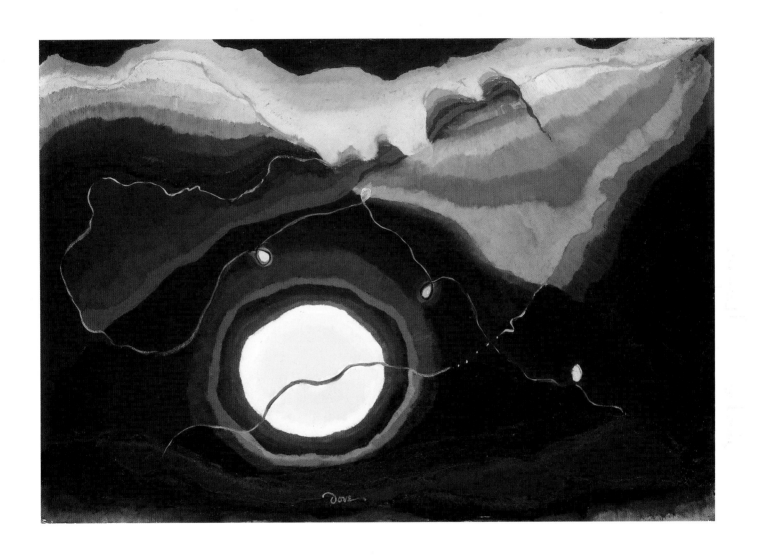

Arthur G. Dove, *Me and the Moon*, 1937

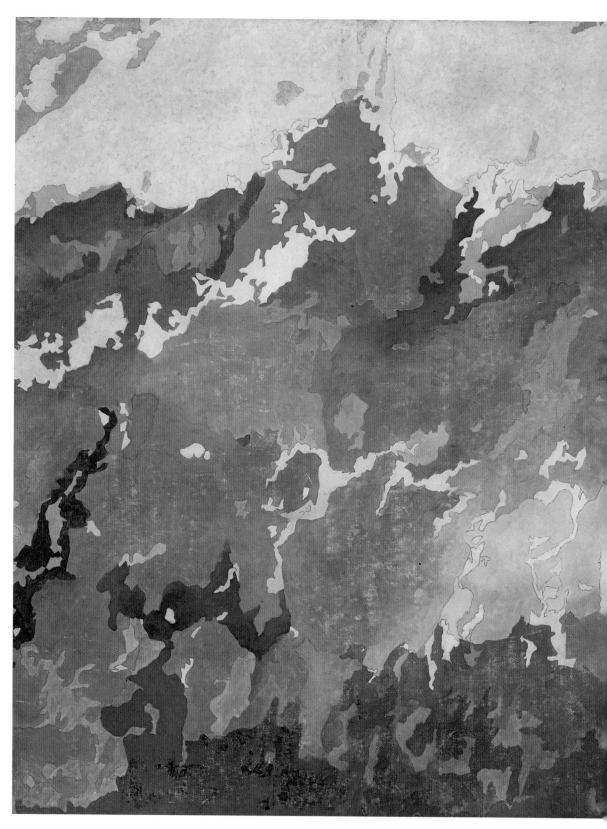

Augustus Vincent
Tack, *Aspiration*, 1931

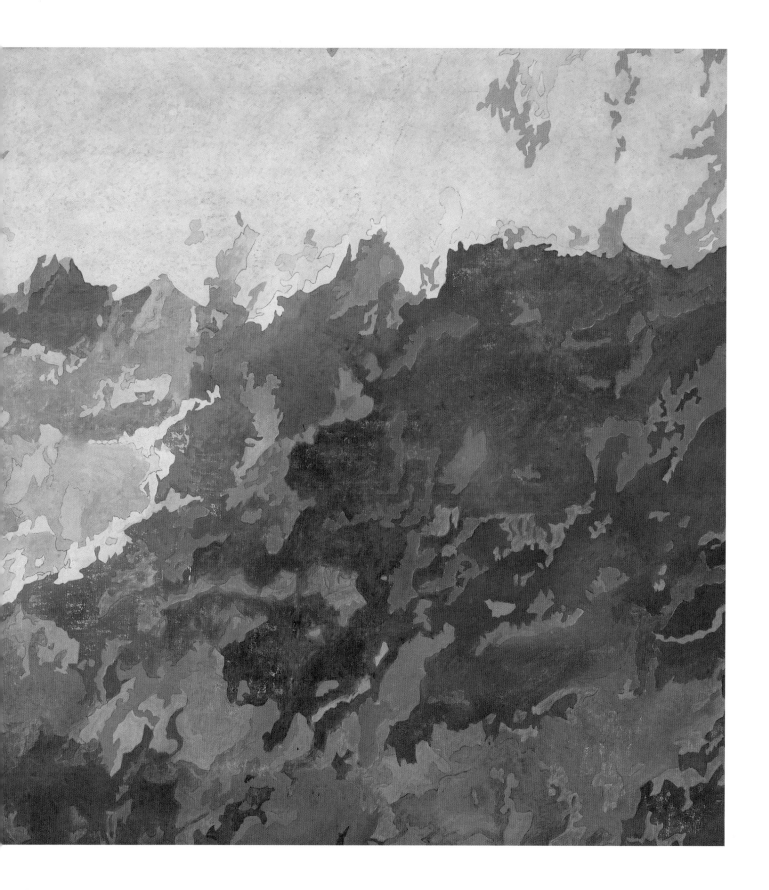

Exotic Places

I talked constantly of finding a Garden of Eden where life would be simple, where beauty might exist as a part of daily living, rather than as an escape from it.

Maurice Sterne

In the late nineteenth and early twentieth centuries, certain American artists traveled beyond Europe and North America to explore Asia, the South Seas, South America, and the islands of the Caribbean. Although Europe continued to attract American artists seeking the imprimatur of European travel and the chance to study in the continent's capitals, the lure of the unfamiliar, the remote, and the primitive proved just as compelling for a select group of adventurous artists. Dramatic climates, strikingly different landscapes, and the exoticism of people of other faiths and cultures went hand in hand with this American search for the sublime.

The eclectic American artist John La Farge visited Japan in 1886 and the South Pacific in 1890 and 1891, using his paintings to record his travels. His best-known watercolors were painted in the South Seas and precede Paul Gauguin's as records of a disappearing culture. In the late 1890s and early 1900s, Louis Michel Eilshemius also traveled extensively, not only to Europe, but also to North Africa and the South Seas. Eilshemius spent two months in Samoa in the fall of 1901 where he produced many sketches. Five years after returning from the Pacific he began translating his experience into paintings that express his fascination with the native population and the exoticism of the surrounding landscape.

The American modernist Maurice Sterne, who began his career after the turn of the century, had a predilection for exotic journeys. He left New York for Paris, where he lived from 1904 to 1907 and was part of the Gertrude and Leo Stein circle, then set out on travels that took him not only through Europe but also to India and Asia, and finally back to New York in 1915. Sterne always maintained that he was spiritually changed by his four months in Benares, India, that country's oldest and holiest city; his extensive stay in Bali and nearby islands in 1912 was his personal search for beauty in paradise.

Destinations closer to the continental United States appealed to artists as well. Gifford Beal, a realist painter known for picturesque scenes of New York and New

England, went on watercolor expeditions in 1916 and 1919 to the West Indies, traveling to the U.S. territory of Puerto Rico, as well as to Bermuda and the Bahamas. Jean Charlot, a French-born naturalized American, spent the 1920s in Mexico, the homeland of his mother's family. There he became a colleague of Diego Rivera and for several years an illustrator for the archaeological excavations conducted by the Carnegie Institute in the Yucatán at the ancient Mayan site of Chichén Itzá. Living and working in Mexico immersed Charlot in a non-Western culture, exposing him to pre-Columbian art, which had a profound effect on his work, both stylistically and imaginatively, after he moved to the United States in 1928.

Rockwell Kent was perhaps the most dedicated traveler of them all. A realist painter trained by Robert Henri and William Merritt Chase early in the twentieth century, Kent was grounded in the transcendentalism of nineteenth-century American writers Henry David Thoreau and Ralph Waldo Emerson. He sought inspiration in austere and remote locations in New England, as well as in Newfoundland, South America, Greenland, Alaska, and Russia. In 1922 Kent explored the waters near Tierra del Fuego, the archipelago off the southern tip of South America, on the other side of the Strait of Magellan. Duncan Phillips, one of Kent's foremost patrons in the late 1910s and early 1920s, was captivated by the Tierra del Fuego pictures. These landscapes, painted after Kent's return to the United States, convey the harshness of this lonely world by emphasizing nature's stark geometry through hard-edged patterns of simplified shapes, contours, and cold colors. The trip took him, literally, to the ends of the earth, in his quest to find a new paradise that was completely isolated from civilization.

Epigraph from *Shadow and Light: The Life, Friends and Opinions of Maurice Sterne*, ed. Charlotte Leon Mayerson (New York: Harcourt, Brace & World, 1965), 83.

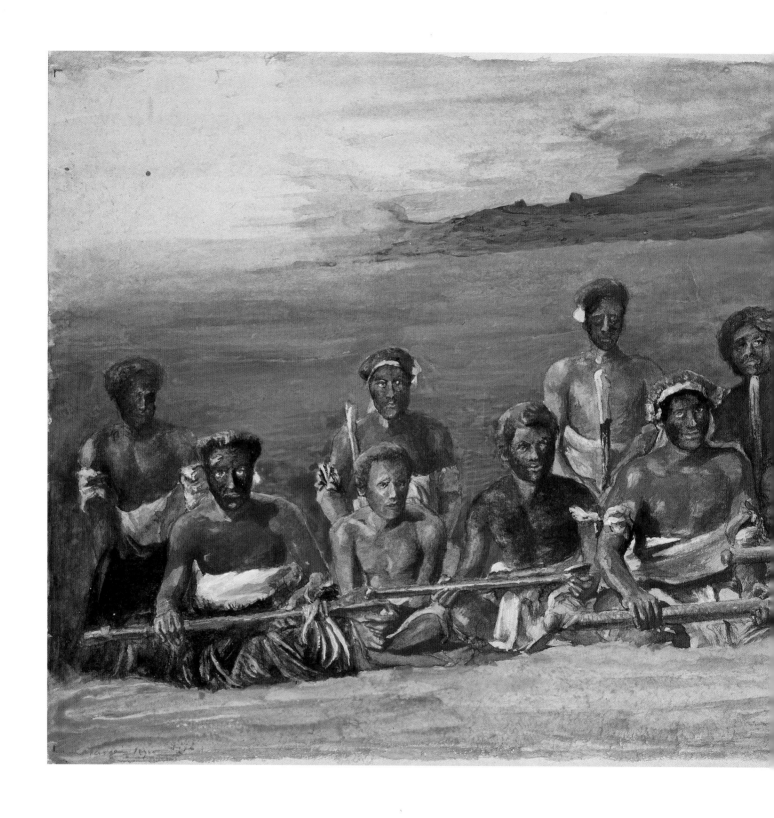

John La Farge, *Chiefs and Performers in War Dance, Fiji*, 1891

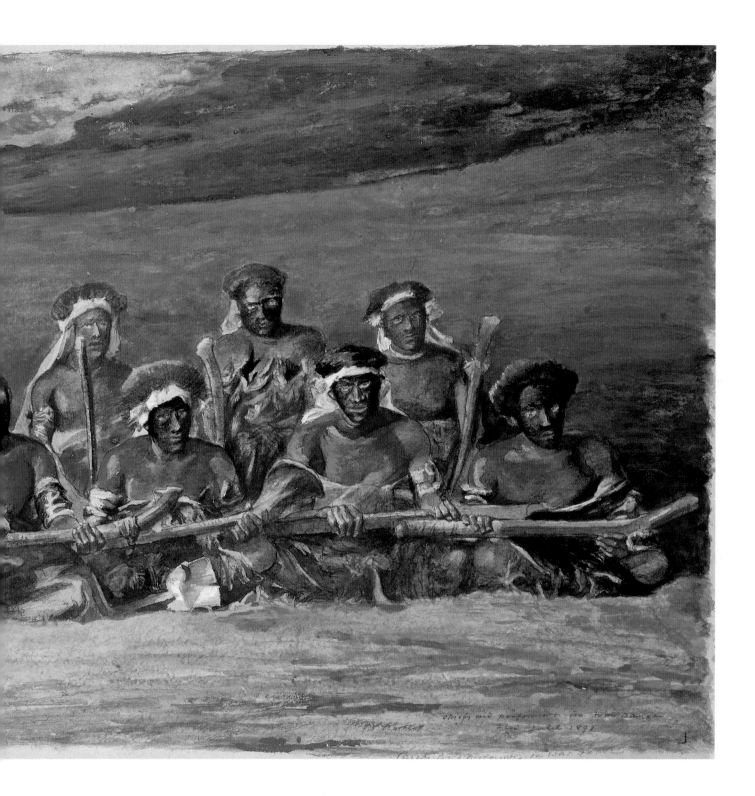

Chiefs and performers for War dance
Fiji July 1891

Louis Michel Eilshemius, *Samoa*, 1907

Rockwell Kent, **Mountain Lake—Tierra del Fuego**, between 1922 and 1925

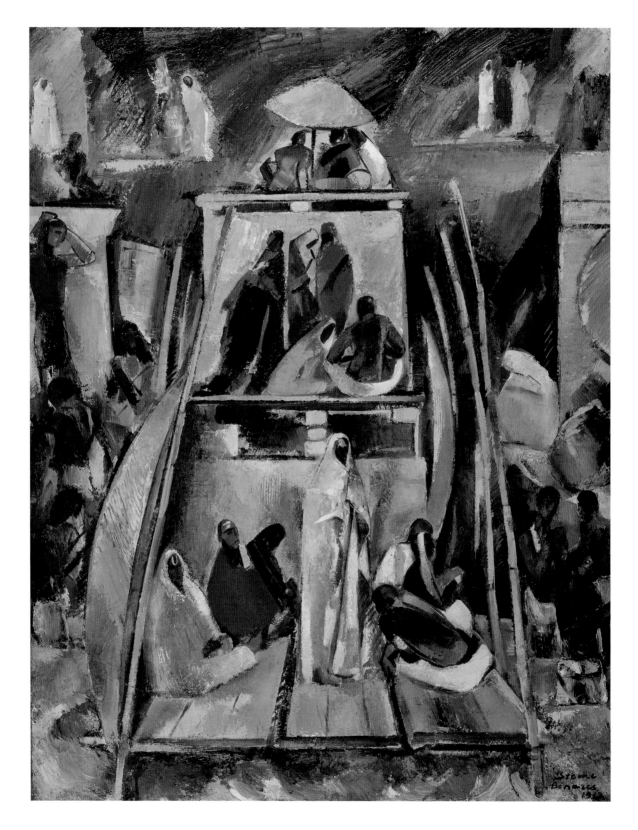

Maurice Sterne, **Benares**, 1912

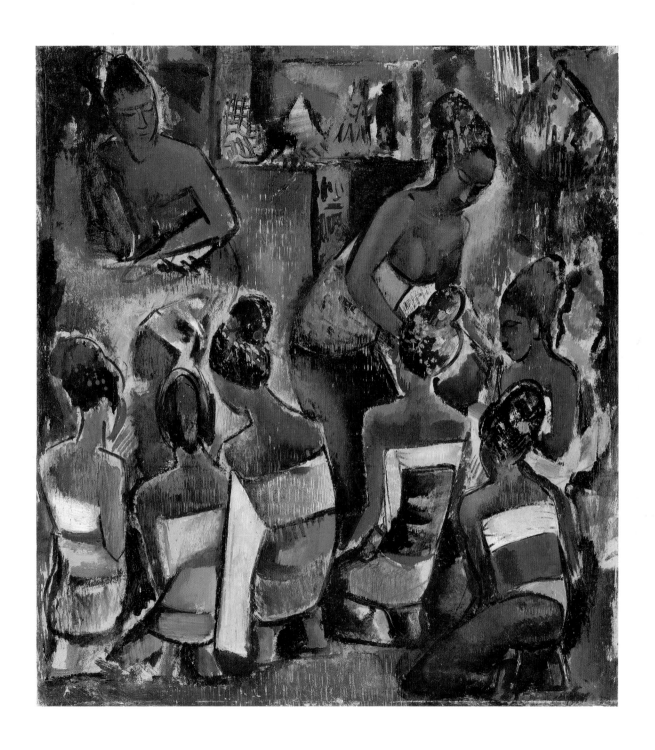

Maurice Sterne, *Temple Feast, Bali*, 1913

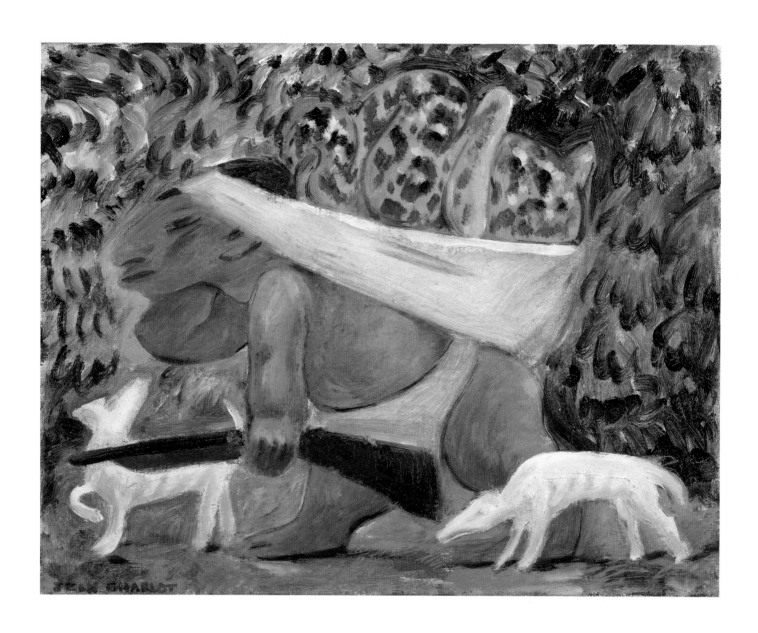

Jean Charlot, **Leopard Hunter**, undated

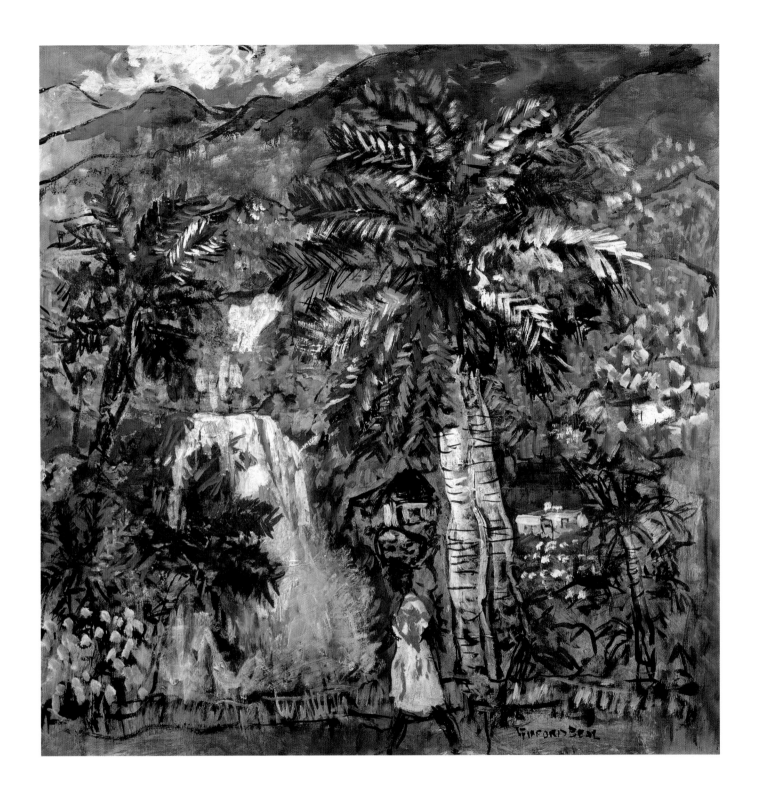

Gifford Beal, *Waterfall, Haiti*, 1954

Modern Life

The vision and expression of one day will not do for the next. Today must not be a souvenir of yesterday. And so, the struggle is everlasting.

Robert Henri

At the end of the nineteenth century, the urbanization of the United States was a transformation that challenged the very identity of a nation envisioned at its founding a hundred years earlier as an agrarian society. While American impressionists chose to ignore the industrialization that surrounded them, the seamy darkness of modern city life appealed to a younger generation of painters. Led by the charismatic Robert Henri, a passionate realist in the tradition of Thomas Eakins, these dissidents made it their mission to depict subjects of everyday life in the rough working-class neighborhoods of New York's Lower East Side, as opposed to the genteel world of Fifth Avenue, with its subdued interiors peopled by society matrons and virginal young women.

Henri and his fellow urban realists, among them George Luks, Jerome Myers, Everett Shinn, and John Sloan, looked at the city and its inhabitants with the eyes of reporters, choosing their subject matter from the mainstream of everyday experience, often from the street itself: urchins, theatrical performers, working-class men and women, or friends and family.

Few collectors and even fewer museums were attracted to the work of these revolutionary New York artists because of the subject matter, dark palette, and aggressive style. Labeled "apostles of the ugly" by the press in 1908, they were eventually nicknamed the "ashcan school" because of their subject matter.[1] Duncan Phillips was one of the few collectors and museum directors who celebrated their work. Recognizing Sloan's passionate interest in "the curiously different ways people live in different sections of the same great city," Phillips noted that Sloan "points out not only the crowd but the lonely individual caught in the maelstrom."[2] His admiration resulted in the acquisition in 1919 of *Clown Making Up* (1910), the first work by Sloan to enter a museum collection. That same year Phillips commissioned Luks to paint the portrait of the actor Otis Skinner in one of his most noted theatrical roles, and in 1926 Phillips gave Luks his first museum exhibition. Phillips, whose early taste in art included narratives and romantic subjects, was attracted by the

expressive nature and emotional content of the ashcan artists' work, as well as by their clear connection to European and American old masters, which he saw as confirmation of the universal language of art independent of chronology and nationality—the union of old masters and modern painters being a primary principal of Phillips's new museum.

Henri taught an entire generation of American realist painters in New York after the turn of the century, emphasizing contemporary subjects as revelatory of the modern urban experience, and encouraging the use of rapid brushwork to express the mood of the subject and the artist's inner emotions. He and the other "men of the rebellion"[3] (so called because they focused on New York, not Europe, and sought independence from the restrictive exhibition policies of the National Academy of Design) interpreted their subjects in a bold expressive style that combined respect for Eakins with admiration for old masters such as Diego Velázquez, Rembrandt, Frans Hals, and Francisco Goya, and with the painterly power of Edouard Manet. Henri himself rendered individuals as anonymous "types" who shared a universal humanity. His students included George Bellows, Edward Hopper, Rockwell Kent, and Guy Pène du Bois, all of whom experimented with emotive content conveyed through composition, color, and line in representational work.

To his followers Henri transmitted the power of Eakins, whom he considered America's greatest portraitist. Bellows's portraits of his family, especially of his beloved wife, Emma, are akin to Eakins's work in conveying something of the emotional strains of life. Others in Henri's circle, including Pène du Bois, Hopper, and Walt Kuhn, transformed the romantic realism of Eakins's portraits into depictions of boredom, isolation, and ennui. Kuhn, an independent artist with connections to the Henri circle, often depicted disillusionment in his mature portraits of theatrical performers and showgirls. Hopper's paintings reveal the essential isolation of the individual within the environment. His interpretations of everyday life, like those of Sloan, often establish an interplay between the familiar and the

particular, but suffused with the sense of unease and uncertainty that can accompany everyday experience. Shortly after acquiring Hopper's *Sunday* (1926) in 1926, Phillips became the first to write about the tension in Hopper's realism, describing how Hopper balanced the abstraction of his luminous architectural spaces against the "boredom of the solitary" figure and the psychological isolation of modern life in compositions that "defy our preconceptions of the picturesque."[4]

Kenneth Hayes Miller, another proponent of urban genre painting, created lively scenes of women shopping on Fourteenth Street in New York, showing them in extreme close-up view, as though he had encountered them directly on the street. His subjects were "modern," but his style and time-consuming technique, using under-painting and glazes, were the opposite of those favored by the progressive artists in Henri's circle. One of his pupils at the Art Students League, Isabel Bishop, developed a realist style that focused on working women observed in New York's Union Square area, the location of her studio. Where Miller's contemporary themes related to shopping, Bishop's mature works feature blue-collar women engaged in daily activities on Manhattan's streets.

Epigraph from Robert Henri, *The Art Spirit* (Philadelphia, 1923; reprint, Philadelphia and New York: J. B. Lippincott, 1960), 115.

1. The press responded negatively to the exhibition of The Eight at Macbeth Galleries in New York in 1908. The Eight, a term coined by the press, were led by the charismatic Robert Henri, and included Arthur B. Davies, William Glackens, Ernest Lawson, George Luks, Maurice Prendergast, Everett Shinn, and John Sloan. In 1934 Holger Cahill and Alfred Barr applied the term "ashcan school" to the larger group of urban realist painters working in New York at the turn of the century. See Elizabeth Milroy, *Painters of a New Century: The Eight & American Art* (Milwaukee: Milwaukee Art Museum, 1991), 15–16, and *Art in America in Modern Times*, ed. Holger Cahill and Alfred H. Barr, Jr. (New York: Reynal and Hitchcock, 1934).

2. Duncan Phillips, *A Collection in the Making*, Phillips Publication No. 5 (New York and Washington, D.C.: E. Weyhe and Phillips Memorial Gallery, 1926), 51.

3. A term used in "New Art Salon Without a Jury," *New York Herald*, May 15, 1907, cited in Elizabeth Hutton Turner, *Men of the Rebellion: The Eight and Their Associates at The Phillips Collection*, exh. cat. (Washington, D.C.: The Phillips Collection, 1990), 7.

4. Phillips, *Collection in the Making*, 69.

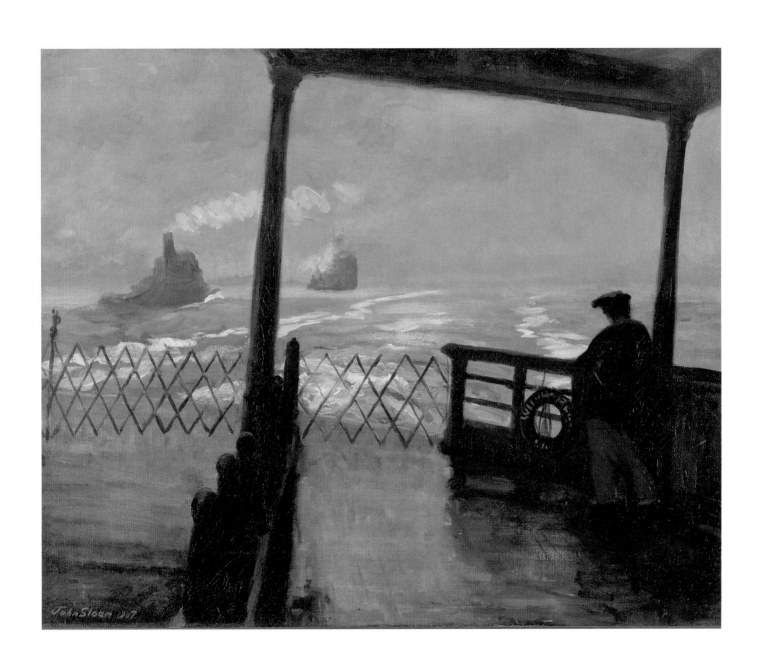

John Sloan, *The Wake of the Ferry II*, 1907

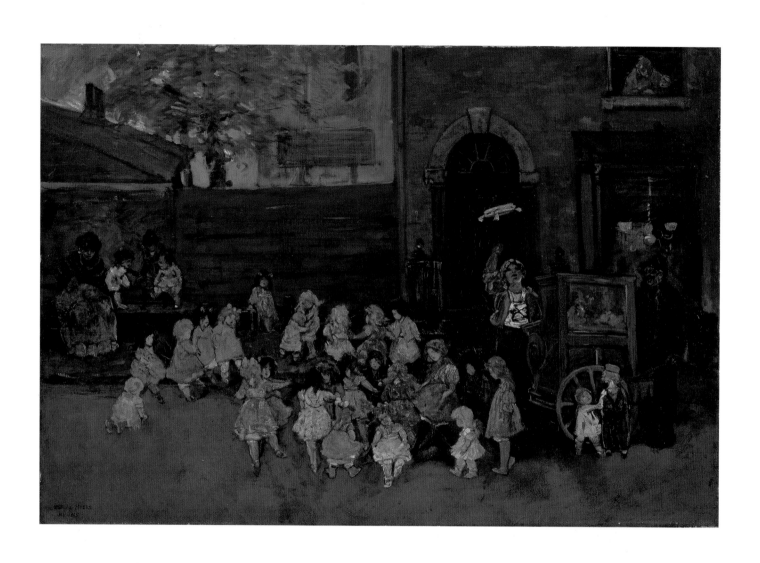

Jerome Myers, *The Tambourine*, 1905

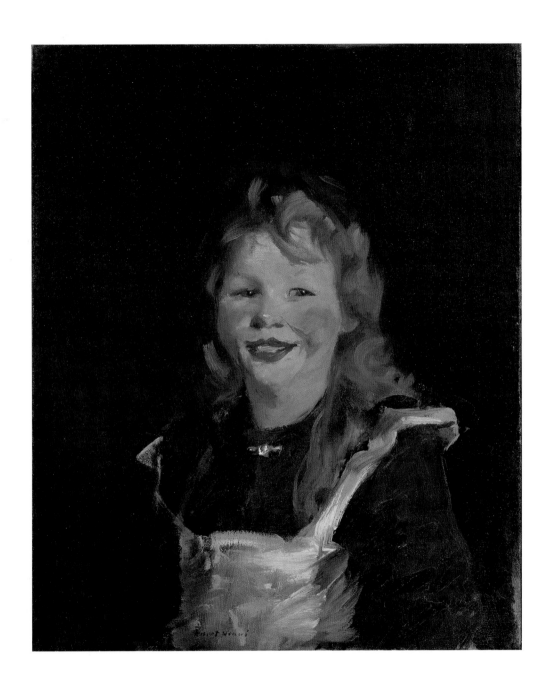

Robert Henri, *Dutch Girl*, 1910, reworked 1913 and 1919

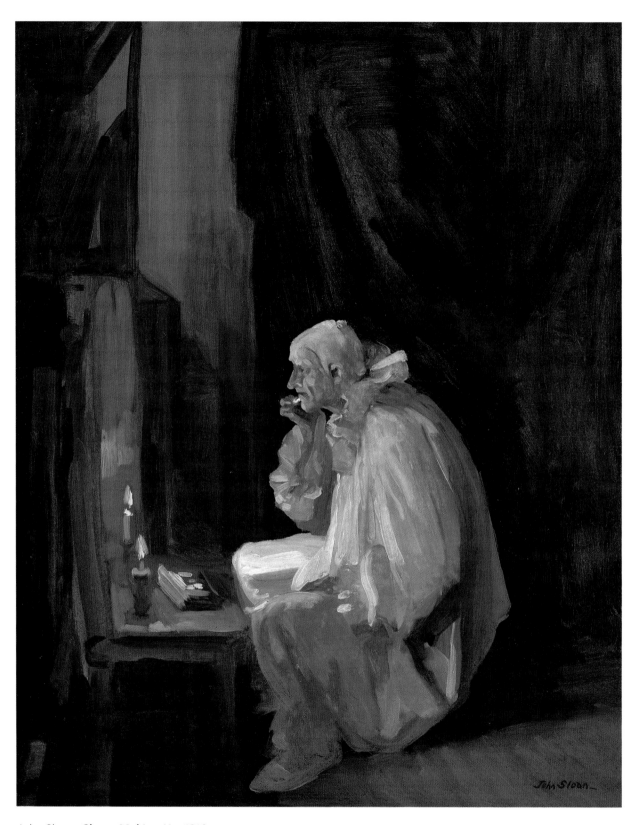

John Sloan, *Clown Making Up*, 1910

Everett Shinn, *Tenements at Hester Street*, 1900

George Luks, **Telling Fortunes**, 1914

Guy Pène du Bois, *The Arrivals*, 1918 or early 1919

Kenneth Hayes Miller, *The Shoppers*, 1920

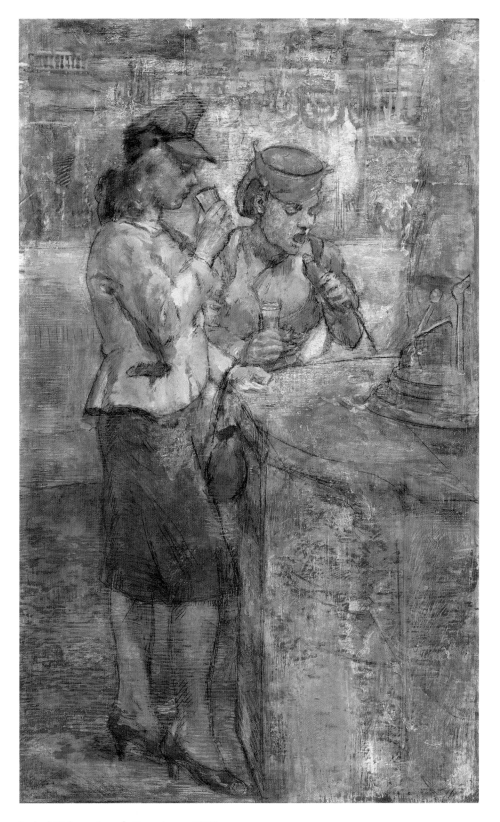

Isabel Bishop, *Lunch Counter*, c. 1940

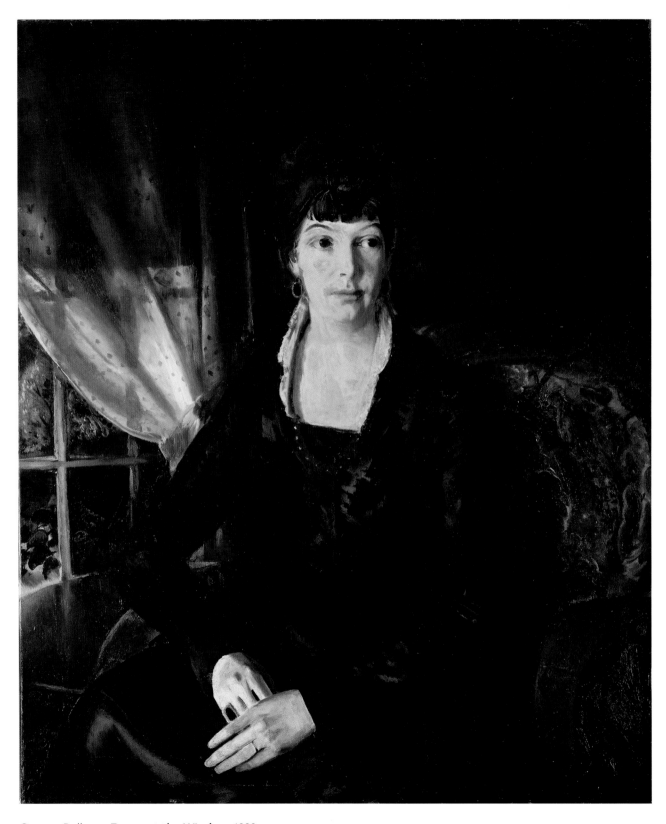

George Bellows, *Emma at the Window*, 1920

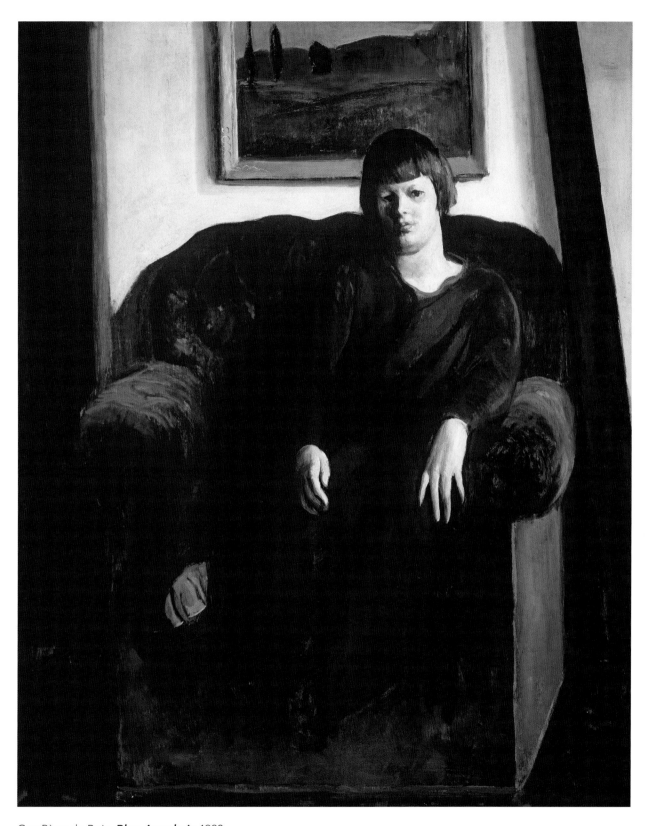

Guy Pène du Bois, *Blue Armchair*, 1923

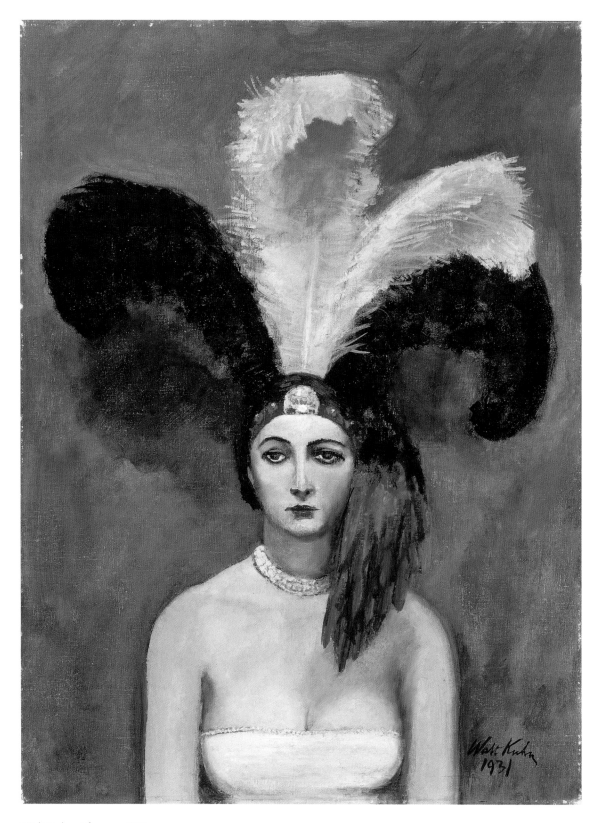

Walt Kuhn, *Plumes*, 1931

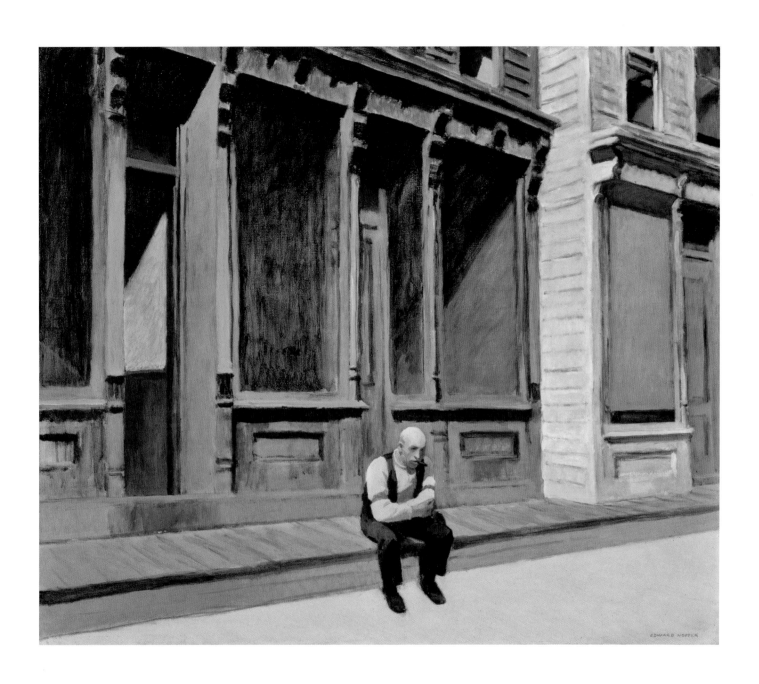

Edward Hopper, *Sunday*, 1926

The City

The whole city is alive; buildings, people, all are alive; and the more they move me the more I feel them to be alive. . . . And so I try to express graphically what a great city is doing.

John Marin, 1913

As a renewed sense of nationalism settled over the country at the end of World War I, the city became one of America's most potent symbols in the years between the two wars. Brash, young, and electrified, urban America was dominated by modern construction, its bridges and skyscrapers emblematic of the nation's advanced technology and engineering. As the city replaced wilderness and countryside as the locus for mythmaking, artists began to explore the modern industrialized landscape in cities small and large, with Manhattan's streets and skyline a primary focus.

Urban realism, understood as everyday life on the streets of the city, had been promoted before World War I by Robert Henri, John Sloan, and the "ashcan" artists. Louis Michel Eilshemius, a contemporary of Henri and Sloan, also recorded the streets and buildings of New York City in the years before the war, but with a romanticism that emphasized twilight views devoid of people. Henri's brand of down-to-earth urban realism lived on between the wars, particularly in the art of Edward Hopper, who continued to interpret life in the city in ever more reductive views that were always grounded in representation, while infused with psychological insight into the anxiety and alienation of the twentieth century.

Other modern painters, influenced by European cubism and futurism, also looked to the city and America's industrialization as subject matter. Their sensibility was quite distinct from that of the urban realists. John Marin, for example, used graphic means to express city life, depicting New York's buildings and inhabitants pushed and pulled by forces shown as jagged lines. Duncan Phillips, who believed that artists must find the underlying beauty and rhythm of the modern city, wrote that Marin "gives us the quickened sense of our intense modern life. . . . New York is sensed as a world rocking with the throb of energy."[1] William Zorach, another independent modernist, used a cubist style to interpret the city.

Others were labeled "neo-cubists" because of their hard-edged style, preference for flat color shapes, and cool colors. They responded to the modern city and the

industrialization of the United States, finding inspiration in the geometry of vertical skyscrapers and smoke stacks, as well as the cubes of factory buildings. Their hybrid style eliminates people and nature, emphasizing instead geometric schematization and flatness combined with observable reality and effects of depth and perspective.

Precisionism, as it was later called, was a uniquely American aesthetic that viewed industrial subjects as an essential part of the country's cultural heritage. Preston Dickinson, an early adherent, had direct exposure to the French avant-garde before the war while living in Paris from 1910 to 1914. After returning to New York, he lived in the Bronx, across the Harlem River from Upper Manhattan. Unlike Ernest Lawson's paintings, which romanticized the graceful bridges connecting the two New York boroughs, Dickinson's focused on the obvious industrialization on the Bronx side of the river, captured in bleak winter views that emphasize the geometry of the buildings and the bridges against the snow.

Charles Sheeler, a key initiator of precisionism, was profoundly influenced by European modernism and the French artist Marcel Duchamp. After moving to New York in 1919, Sheeler became fascinated by the skyscraper, America's newest icon of modernity. His first precisionist paintings in the early 1920s were an outgrowth of his art photography, which emphasized the abstract qualities of urban architecture. Sheeler's painted interpretations of the city combine a photographic sharpness with intense frontal light to simplify form and fact into planar abstract patterns of light and dark. Phillips, an early Sheeler collector, believed his pictures expressed the impersonal character of the time with dreamlike precision.

Ralston Crawford, a Sheeler admirer, was drawn to industrialized locales, machinery, and skyscrapers as subjects specifically associated with America. In particular, Crawford drew from his childhood in Buffalo, New York, near Lake Erie and Lake Ontario, and his brief experience as a sailor. In his paintings Crawford often idealized the docks, shipyards, bridges, and grain elevators that defined the

"new" landscape of upstate New York in a manner antithetical to Arthur B. Davies's pastoral views of the same area at the end of the nineteenth century.

Born in Germany to expatriate Americans, Stefan Hirsch moved to New York City immediately after World War I. Having received his art education at the University of Zurich, Hirsch brought a cubist-inspired style to his interpretations of New York and industrialized America. His images, however, are more expressionist and less idealized than those of Sheeler and Crawford. In paintings of factory towns, small communities transformed by industrialization and in decline, his subject is the transition from rural to industrial life, a "modernity" suspended between the past and the present. Phillips, who recognized the originality of precisionism and its American subject matter, was more emotionally drawn to Hirsch's paintings than to those of Sheeler and Crawford, perhaps because of the expressive content suggested in Hirsch's work. Phillips saw, for example, a "haunting stillness" in Hirsch's canvases of New England mill towns, and Hirsch's vision of New York prompted Phillips to write that it was a symbolic view of "the great city" as "a fortress . . . expectant of a siege."[2] That sense of emotional and psychological weight also is found in the 1920s work of the Prussian-born Oscar Bluemner, whose paintings typically show factory towns as monumental simplified forms rendered in bold colors.

By contrast, Edward Bruce—a minister's son and conservative modernist trained in Italy and in late 1933 named head of the new federal Public Works of Art Project (PWAP)—celebrated New York during the height of the Depression as America's greatest and most powerful city, depicting it as if blessed by a spiritual light streaming through dark clouds.

Epigraph from John Marin statement in *Camera Work No. 42–43* (April–July 1913) as reproduced in *The Selected Writings of John Marin*, ed. Dorothy Norman (New York: Pellegrini & Cudahy, 1949), 4–5.

1. Duncan Phillips, *A Collection in the Making*, Phillips Publication No. 5 (New York and Washington, D.C.: E. Weyhe and Phillips Memorial Gallery, 1926), 60.
2. Duncan Phillips, "Introduction," in *Exhibition of Paintings by Nine American Artists* (Washington, D.C.: Phillips Memorial Gallery, January 1–31, 1926), unpaginated brochure.

Louis Michel Eilshemius, **New York Roof Tops**, 1908

John Sloan, *Six O'Clock, Winter*, 1912

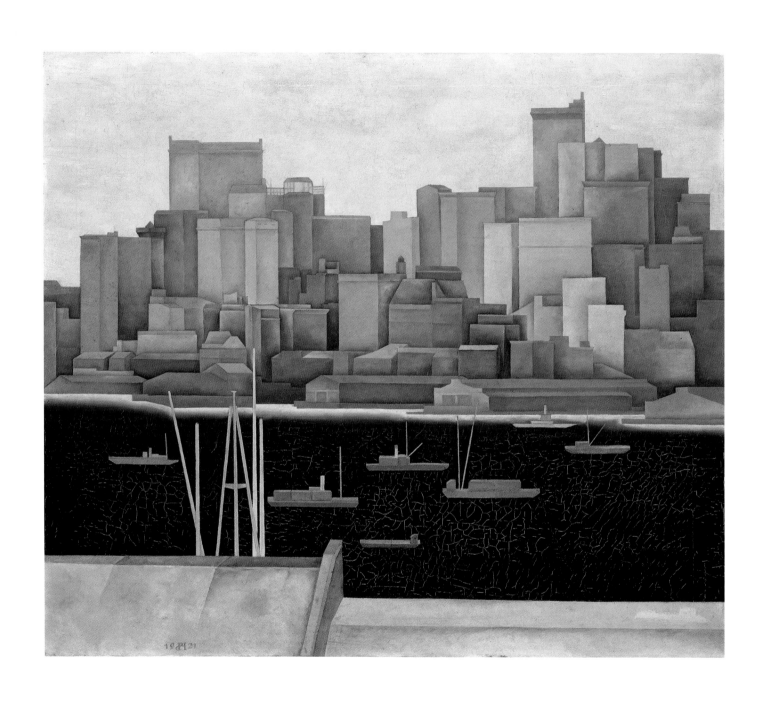

Stefan Hirsch, **New York, Lower Manhattan**, 1921

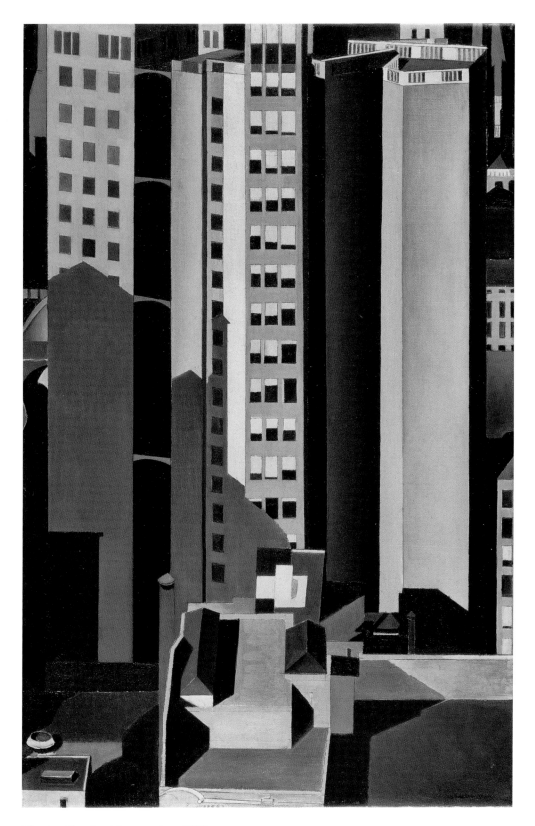

Charles Sheeler, *Skyscrapers*, 1922

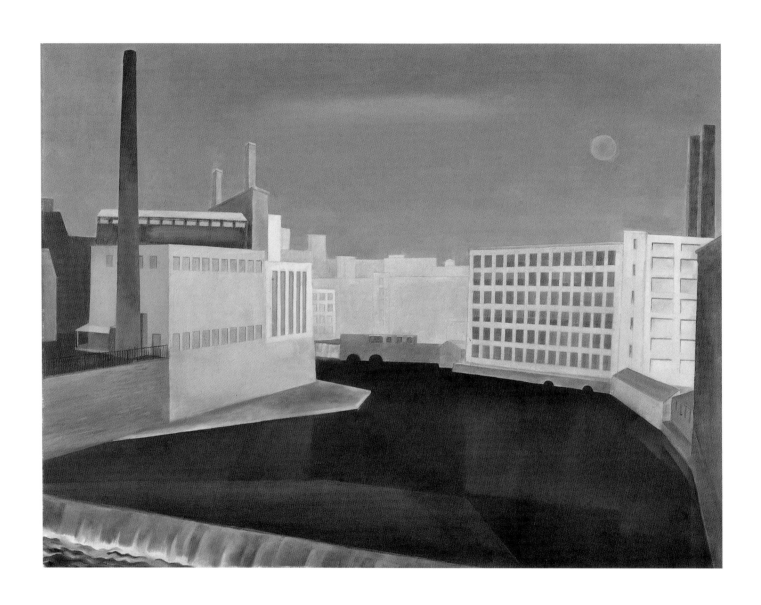

Stefan Hirsch, *Mill Town*, c. 1925

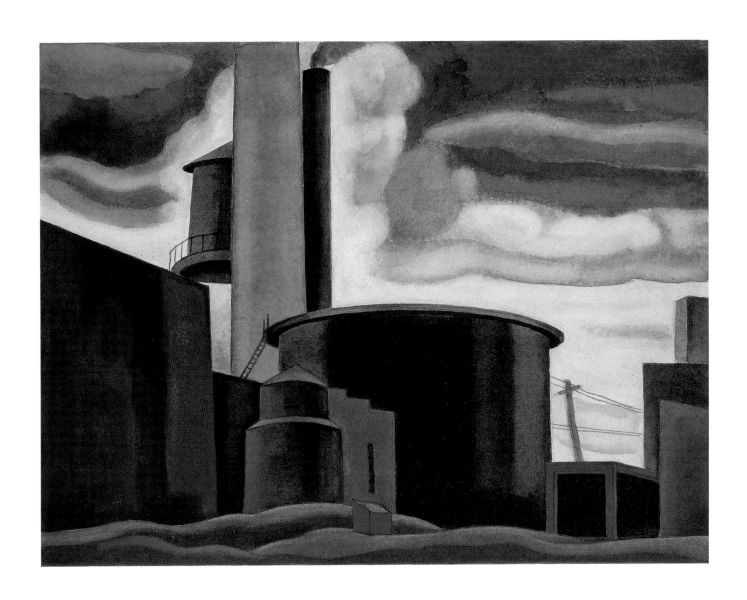

Oscar Bluemner, *Somber and Hard*, 1927

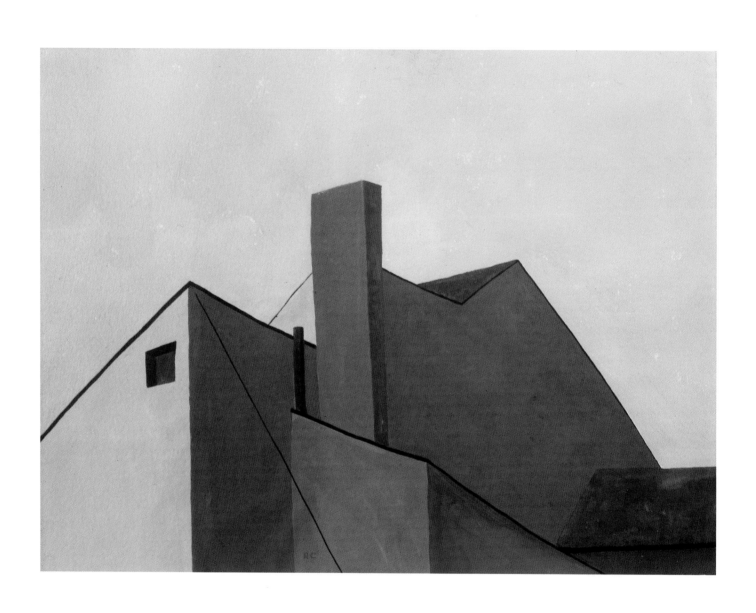

Ralston Crawford, ***Factory Roofs***, c. 1934

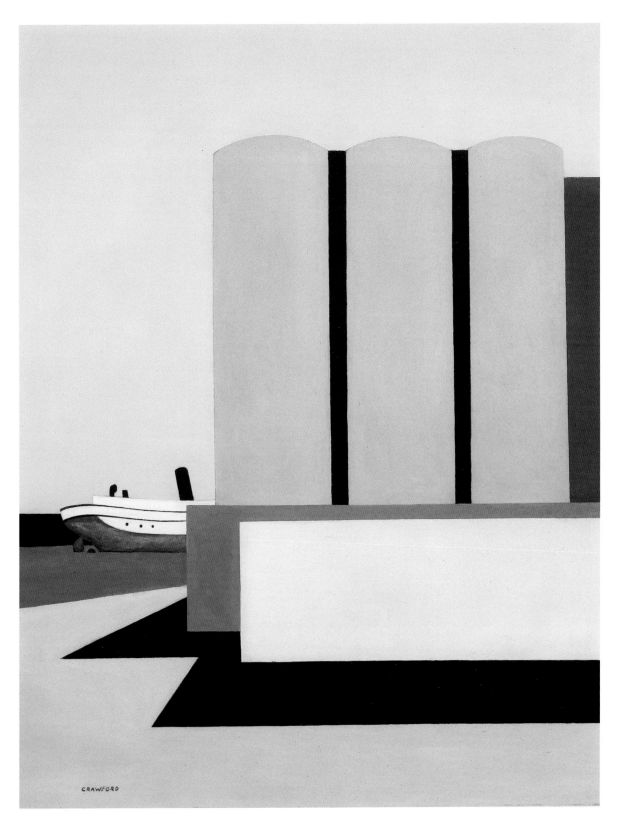

Ralston Crawford, *Boat and Grain Elevators No. 2*, 1942

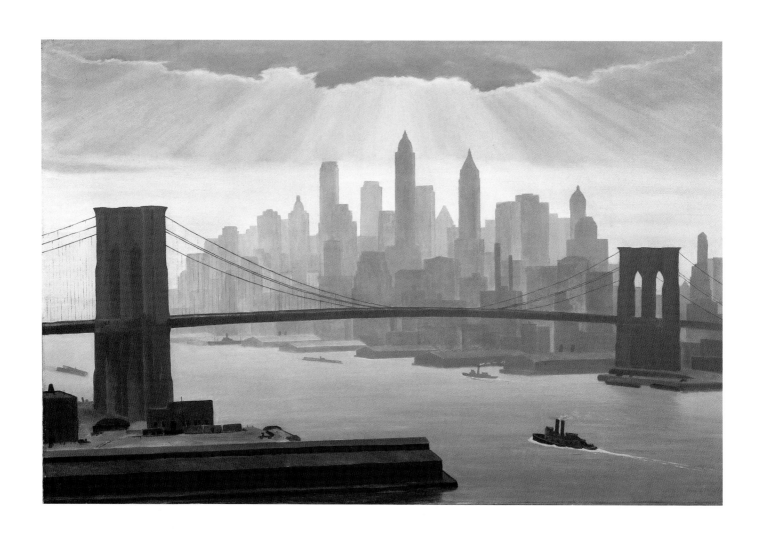

Edward Bruce, **Power**, c. 1933

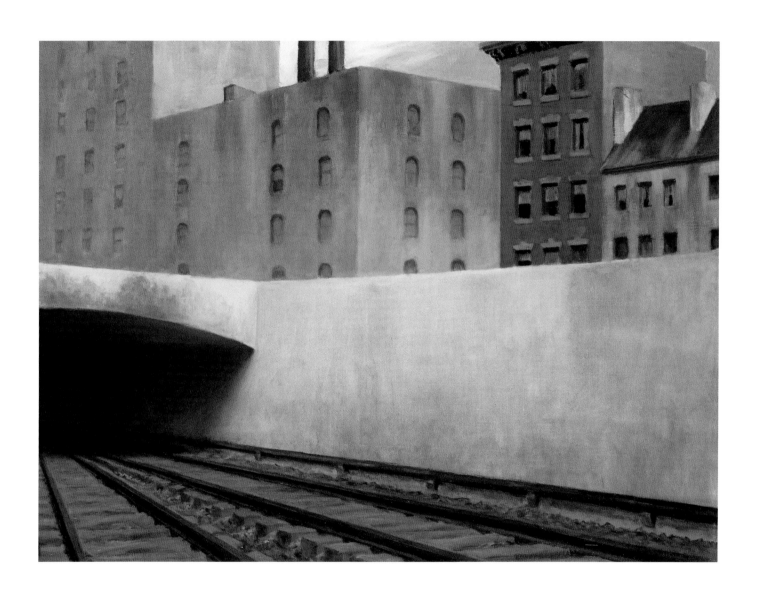

Edward Hopper, *Approaching a City*, 1946

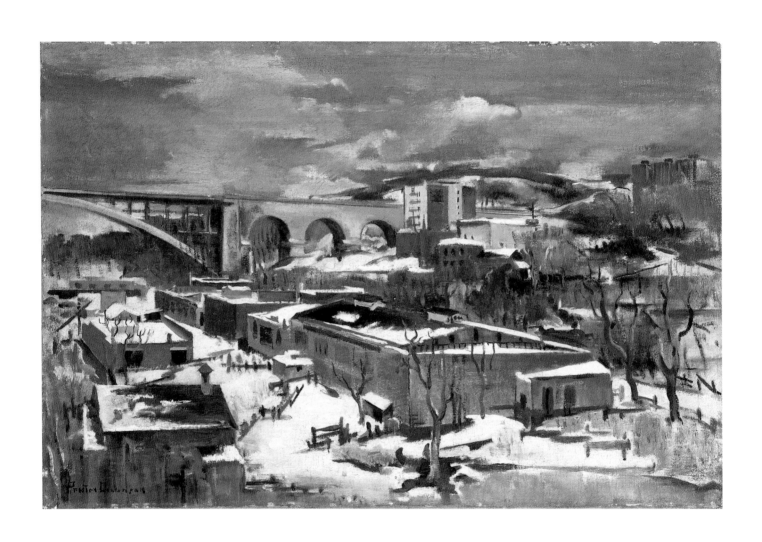

Preston Dickinson, **Winter, Harlem River**, undated

William Zorach, *New York Harbor*, 1923

John Marin, *Street Crossing, New York*, 1928

John Marin, *Pertaining to Fifth Avenue and Forty-Second Street*, 1933

Memory and Identity

What is it that makes for vitalization and progress if not new sources of inspiration from other civilizations.

Yasuo Kuniyoshi

Millions of immigrants began arriving in the United States in the late nineteenth century, remaking the racial and ethnic character of the country. The nation's demography was further reshaped from within between 1910 and 1940, when the Great Migration brought African Americans from the rural South to the cities of the North, in search of jobs, better housing, and freedom from oppression. This population shift gave birth to a generation of black artists emboldened to give voice to their community experience. Duncan Phillips, an early proponent of "a fusion of various sensitivities, a unification of differences," celebrated the assimilation of various aesthetic ideas into one national heritage known as "American."[1]

In the 1920s and 1930s representational paintings of the American Scene, which was understood to be about the experience of the people, became increasingly popular, and American art began to reflect the country's ethnic multiplicity. Artists from all over Europe, as well as from Latin America and Asia, invigorated the country's aesthetic diversity. One of America's most renowned modernists, for example, was a Japanese immigrant named Yasuo Kuniyoshi who arrived in the United States as a teenager in 1906. His figures, brushwork, and color chord of black, ivory, and lacquer red reflect his Japanese heritage, but they are combined in paintings of the scenery of Maine, where he summered throughout the 1920s, with Western modernist idioms, including the quirky figures and disjunctions of scale common to American folk art. Kuniyoshi's hybrid style quickly brought him positive critical attention as an important and serious painter. Phillips, an early enthusiast, recognized him in 1928 as an "inventor of new idioms of . . . pictorial expression."[2]

Peppino Mangravite also fascinated Phillips. Born in Italy, Mangravite first studied in Carrara, Italy, before settling in New York City with his father in 1914, where he continued his art education under Robert Henri at the Art Students League. Phillips was particularly taken by an early Mangravite picture inspired by memories from the artist's childhood on the island of Lipari (north of Sicily) where his father was a naval officer in charge of political prisoners. Other artists also

intent on recapturing experiences of childhood and family were Charles Burchfield and Bernard Karfiol. Burchfield's portraits of family members are like cherished memories, while Karfiol's distillations of adolescent innocence are subtle studies of mood, filled with nostalgia.

Unlike other foreign-born artists, Rufino Tamayo never completely abandoned his native land, Mexico, living intermittently in New York from 1926 to 1948. He is regarded as one of the outstanding modernist painters of his generation. Phillips, whose purchase of a Tamayo still life in 1930 was the first acquisition of the artist's work by a museum, was among the artist's earliest champions. A figurative artist and an avowed internationalist, Tamayo's colorful paintings celebrate Latin American life and folklore.

Phillips, who valued artistic independence, was particularly attracted to work by artists of color, women, and naive or self-taught artists. He admired the work of Doris Lee, who found success during the Depression interpreting the American experience in paintings that combine a classical sensibility in the geometry of buildings and bridges with a decorative folk art aesthetic and a humor in her figures akin to that in Pieter Brueghel's work. Her sophisticated folk paintings, inspired by her childhood in the Midwest, reveal her traditional training in France and make an interesting comparison with those by John Kane, a self-taught artist regarded by Phillips as a naive poet-painter in the American folk tradition. Kane's paintings reflect daily life in his Pittsburgh neighborhood and often include portraits of friends and neighbors. Phillips was the first museum director to acquire his work. Another self-taught artist whose work Phillips was the first to acquire was Grandma Moses. Living on a farm near the Vermont border in upstate New York, Moses began painting at the age of sixty-seven, drawing her subjects from the rural life she knew and observed directly. Her style, although inspired by popular prints and magazine illustrations, evolved into a mode of abstraction derived from her experience as an embroiderer in which forms are broken into shapes and anecdotal details are abbreviated.

Marjorie Phillips, a trained realist painter, is primarily known today for her paintings of America's national pastime—baseball. Another woman who was an American scene painter between the wars was Andrée Ruellan. She is best known for her sympathetic depictions of scenes from ordinary life observed either on the streets of New York or on her travels to the American South.

Overlooked by mainstream critics were the artists of color who captured aspects of contemporary American life in pictures. Allan Rohan Crite, Jacob Lawrence, and Horace Pippin are three of the most notable. Pippin, a self-taught artist, drew on memories of his childhood near Philadelphia, as well as of family members and friends at their everyday activities, to create a portrait in his pictures of African American life in the pre–World War II era.

Unlike Pippin, both Crite and Lawrence received training as artists. Crite, who spent most of his life in Boston and was formally trained at the Museum of Fine Arts and the Massachusetts School of Art, was of mixed African, American Indian, and European ancestry. Interested in the urban scene, he chronicled life in Boston's African American neighborhoods as filled with people, as he described, "enjoying the usual pleasures of life with its mixture of both sorrow and joys,"[3] rather than as stereotypical figures such as sharecroppers or Harlem jazz musicians.

Lawrence, the artist most closely identified with the black experience in America, trained at the Harlem Art Workshop in New York, studied the old masters at the Metropolitan Museum of Art, and was swept up by Social Realism in the 1930s, especially the work of Mexican muralists José Clemente Orozco and Diego Rivera. A sophisticated artist, Lawrence is known for his ambitious multipart narratives of black history. The most famous of these is *The Migration Series* (1940–41), a sixty-panel account of the Great Migration that encompasses historical fact with the immediacy of the artist's own experience as a child of the migration. Lawrence's treatment of the subject gives it a universality that rises above the specifics of its historical fact.

Phillips was among the few collectors, let alone museum directors, between the wars who valued and celebrated the diversity of voices that he ardently believed were essential parts of American life and seminal to our cultural heritage.

Epigraph from *American Art* (Washington, D.C.: National Museum of American Art, Smithsonian Institution, 1995), 91.
1. Duncan Philips, "Foreword," in *The American Paintings of The Phillips Collection*, exh. cat. (Washington, D.C.: Phillips Memorial Gallery, 1944), unpaginated.
2. Duncan Phillips, "The Washington Independent," *The Arts* 13 (April 1928), 243.
3. Allan Rohan Crite, "The Artist Craftsman's Work on the Church," *Commentary on the 1950s*, Vertical File, Library, Smithsonian American Art Museum, Washington, D.C., cited in Julie Levin Caro, *Allan Rohan Crite: Artist-Reporter of the African-American Community*, exh. cat. (Seattle: Frye Art Museum, 2001), 65.

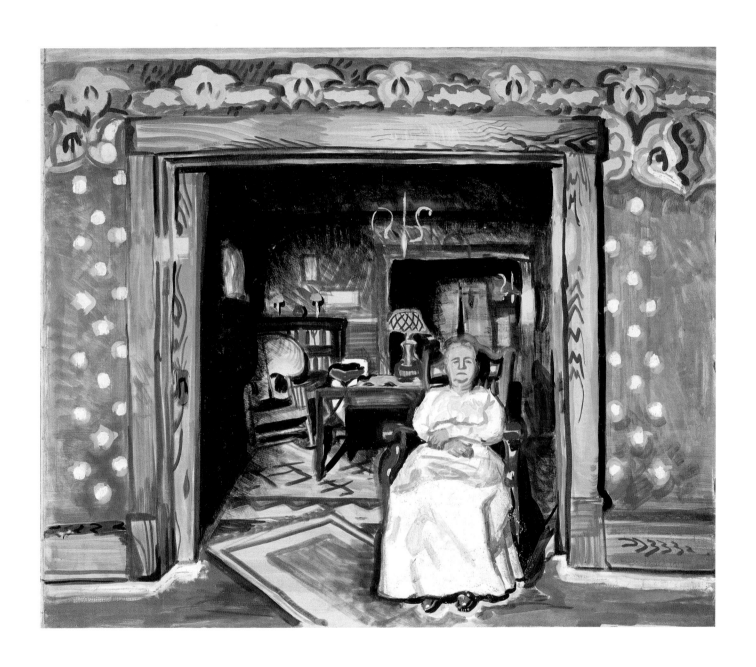

Charles Burchfield, *Woman in Doorway*, 1917

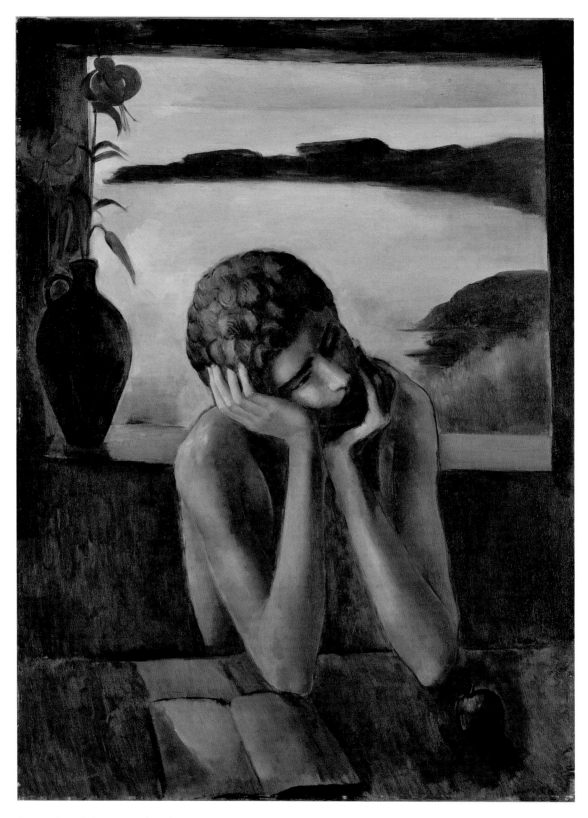

Bernard Karfiol, **Boy**, undated

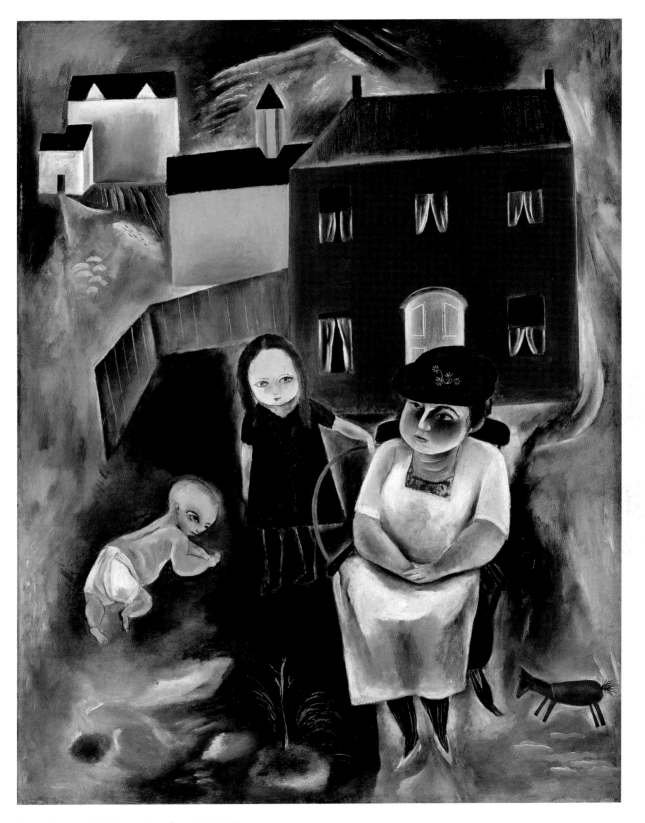

Yasuo Kuniyoshi, *Maine Family*, c. 1922–23

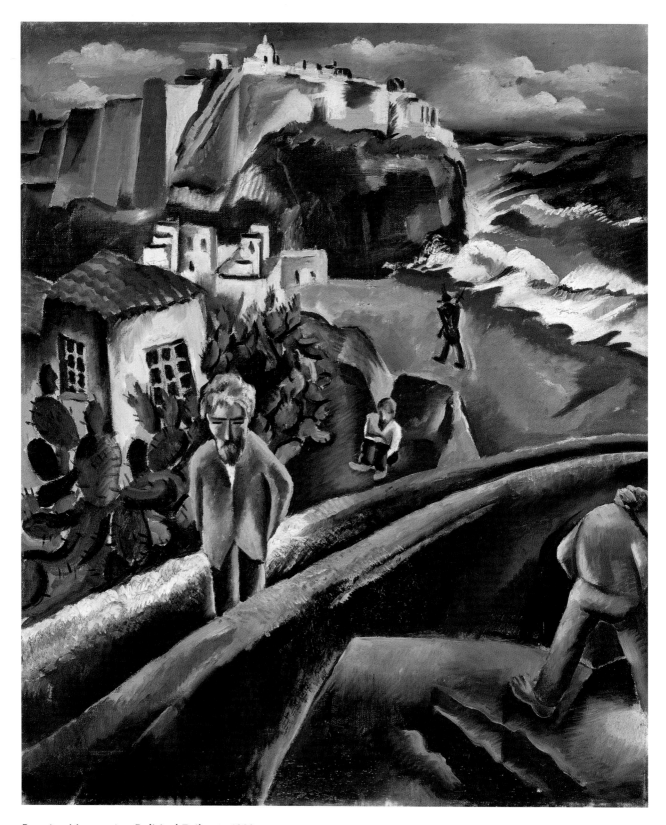

Peppino Mangravite, *Political Exiles*, c. 1928

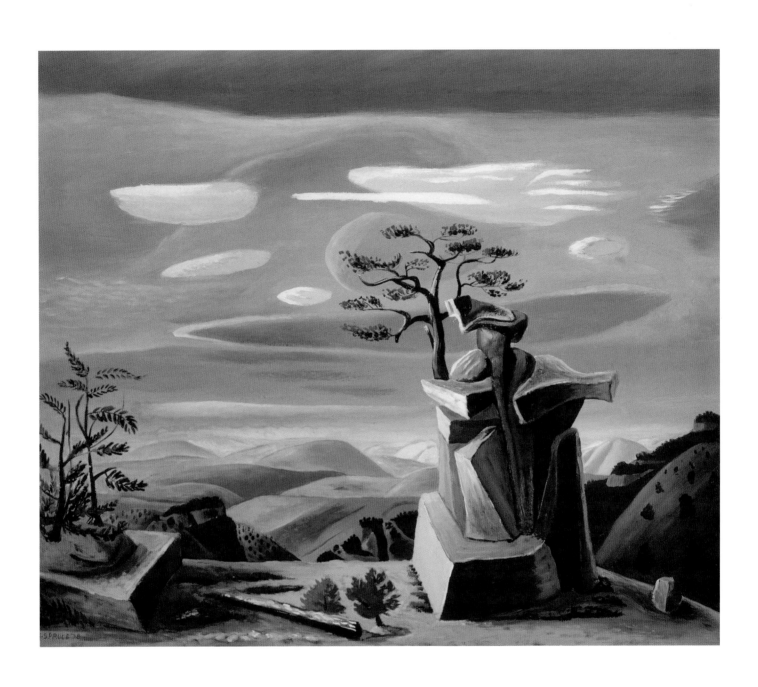

Everett Spruce, *Arkansas Landscape*, 1938

Doris Lee, *Illinois River Town*, c. 1938

Andrée Ruellan, *The Wind-Up*, undated

Marjorie Phillips, *Night Baseball*, 1951

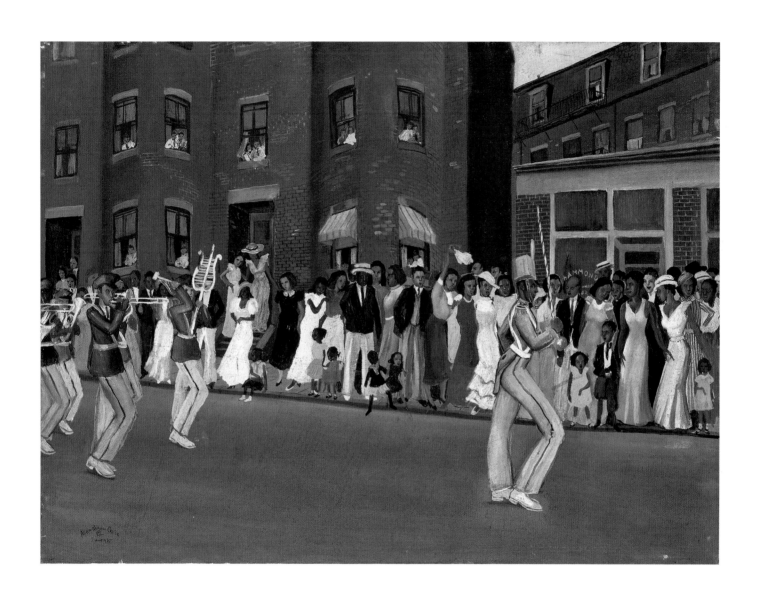

Allan Rohan Crite, *Parade on Hammond Street*, 1935

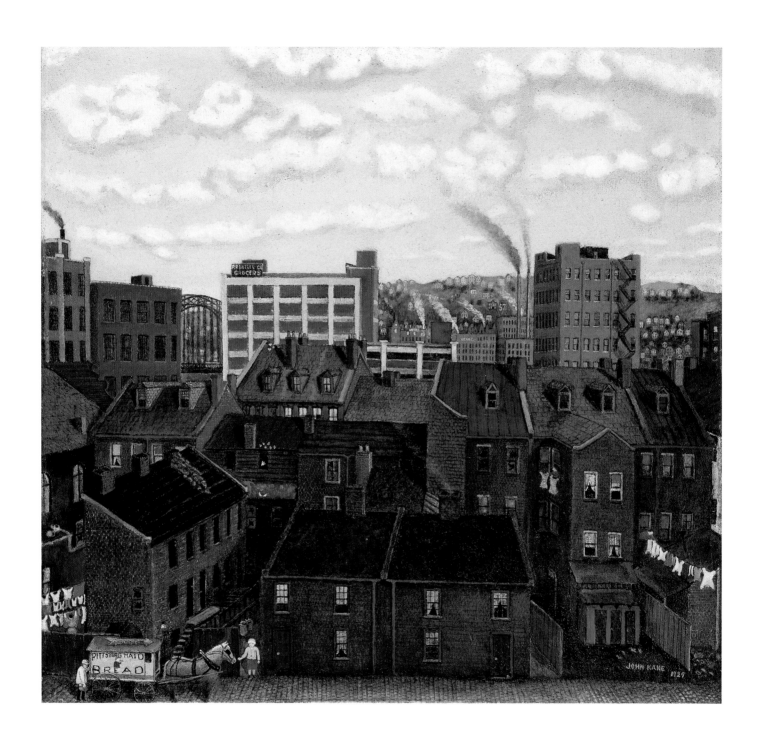

John Kane, *Across the Strip*, 1929

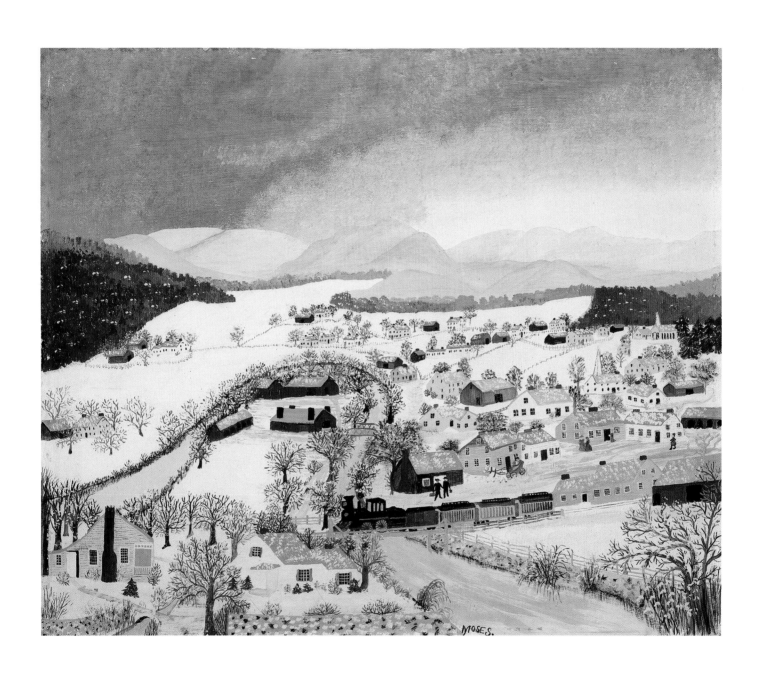

Grandma Moses, *Hoosick Falls in Winter*, 1944

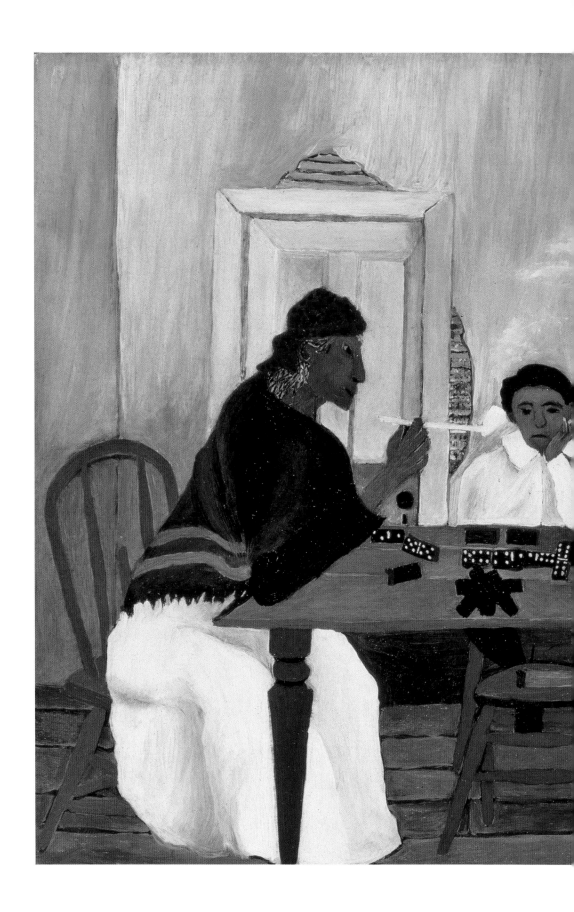

Horace Pippin,
Domino Players, 1943

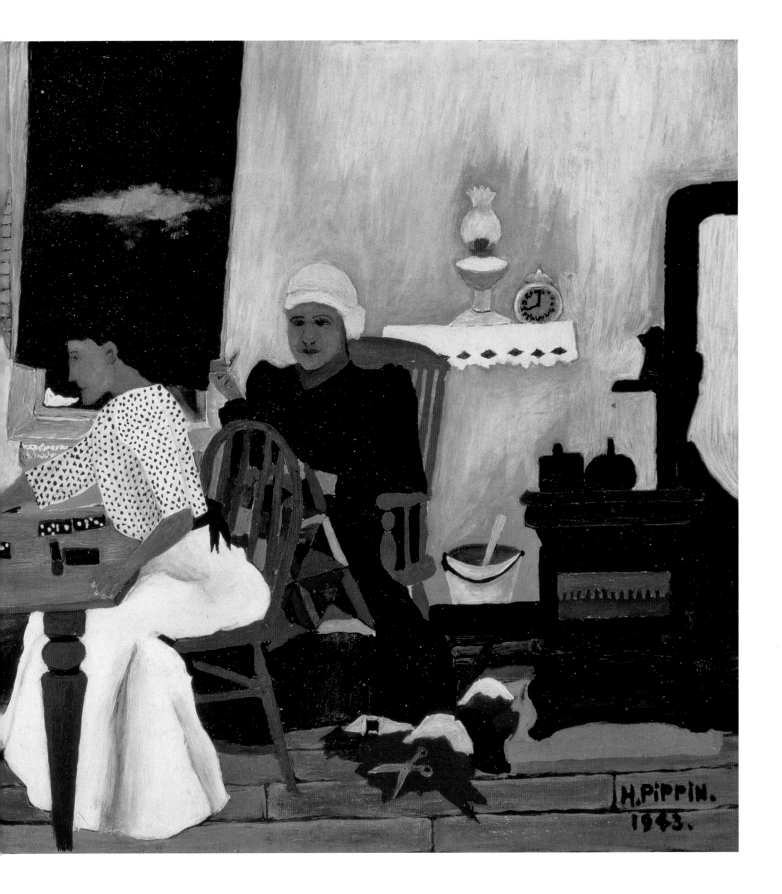

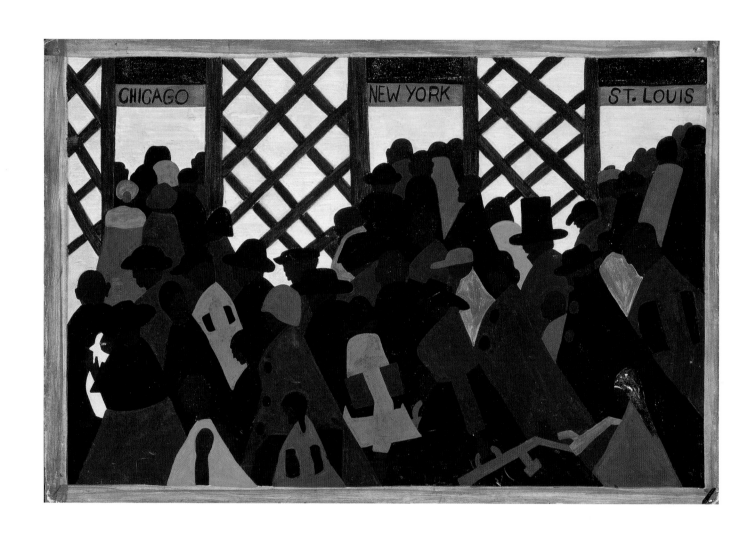

Jacob Lawrence, *The Migration Series, Panel no. 1: During the World War there was a great migration north by southern African Americans*, 1940–41

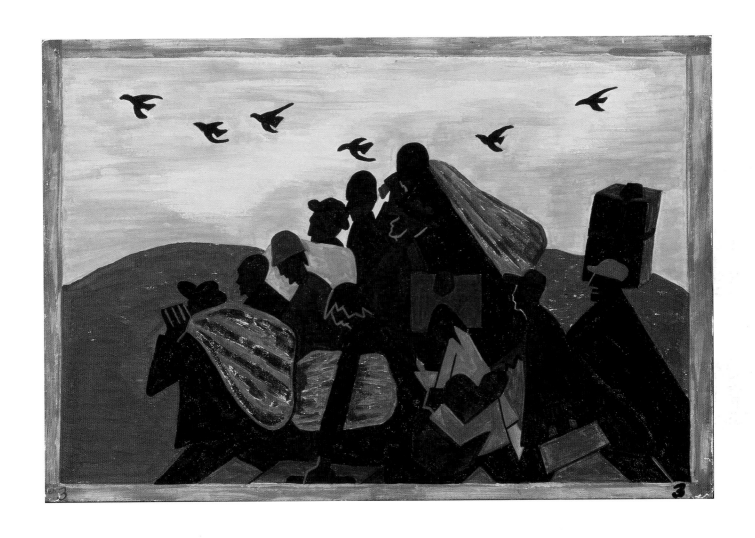

Jacob Lawrence, *The Migration Series, Panel no. 3: From every southern town migrants left by the hundreds to travel north*, 1940–41

Jacob Lawrence, *The Migration Series, Panel no. 31: The migrants found improved housing when they arrived north*, 1940–41

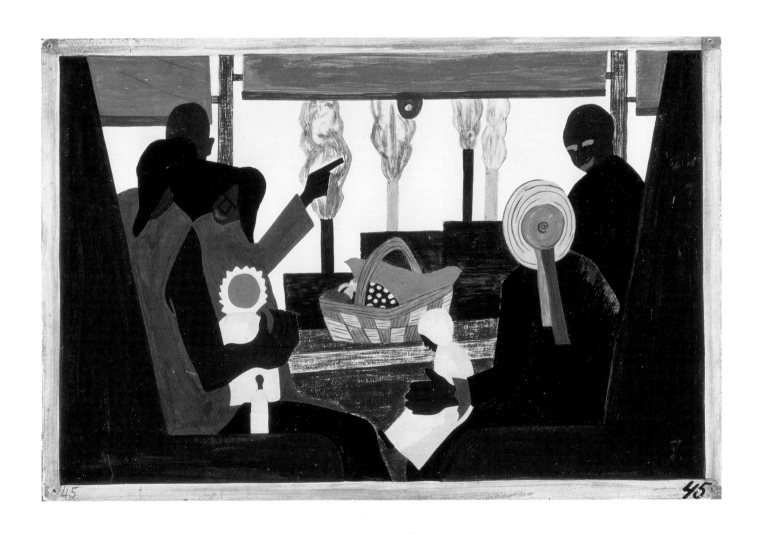

Jacob Lawrence, *The Migration Series, Panel no. 45: The migrants arrived
in Pittsburgh, one of the great industrial centers of the North*, 1940–41

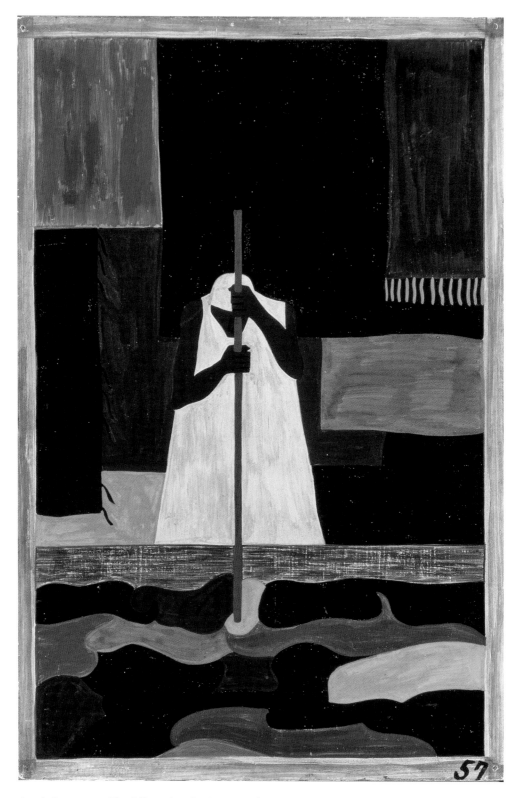

Jacob Lawrence, *The Migration Series, Panel no. 57:*
The female workers were the last to arrive north, 1940–41

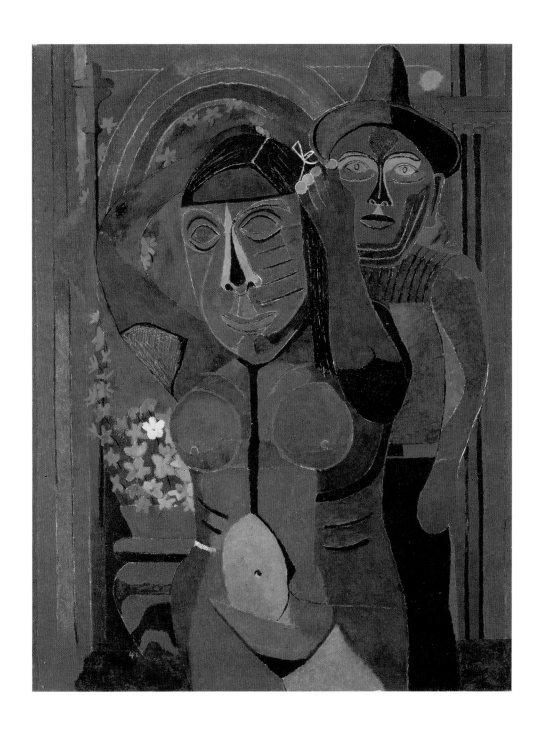

Rufino Tamayo, *Carnival*, 1941

Still Life Variations

Every day we had to paint a new still life. Then once a week William Merritt Chase came in to criticize. . . . To interest him the paintings had to be alive with paint and a kind of dash and go that kept us looking for something lively, kept us pretty well keyed up.

Georgia O'Keeffe, 1976

Still life, the genre of picture making that focuses on objects alone to carry meaning, has always given painters the opportunity to explore every aspect of their craft and, for this reason, has been a mainstay of artistic practice. With its intimate scale and self-reflective character, still life is often a microcosmic view of the world. Illusionism ruled the still life tradition from its inception in antiquity to the dawn of the modern era. Following in that tradition, a small, late-nineteenth-century group of American painters created a nearly documentary illusionism in trompe l'oeil paintings of everyday objects and bits of paper attached to flat wood-paneled walls. The fool-the-eye still lifes of John Frederick Peto, which often depicted photographs of Abraham Lincoln, focus particularly on things that are worn and torn, telling a nostalgic and somber narrative about America in the post–Civil War period.

In the modern era that began with Cézanne, however, still life was liberated from its traditional symbolic and metaphorical role. The emphasis was now placed on pure relationships of color, form, geometry, space, and line as independent entities outside of illusionism and mimeticism. Twentieth-century American artists followed their European counterparts in using still life to experiment with painting's formal language in works as varied as the artists themselves. The American modernist Arthur Beecher Carles, for example, used color expressively to create near-abstract effects in vibrant floral still lifes, juxtaposing complementary colors in compositions that distort spatial distinctions of foreground and background. For Man Ray, still life painting was a step on the way to abstraction, a means to study simplified form and contrasts of dark and light. Milton Avery turned often to still life in his studies of simplified forms and intense color, often distorting the tabletop in his compositions to give the viewer an aerial perspective on the objects. For John Graham, still life was a means to experiment with the purely formal language of painting in many styles, including cubism. Early in his career, Graham took a minimalist approach that

emphasized austerity of color and shape in close-up views of simple objects, such as eggs on a plate, that played with distortion and perspective. Stuart Davis, too, used still life to tackle the challenge of abstraction in works that visualized scale, shape, and colors outside the logic of three-dimensional space.

Although the formal concerns of picture making dominated still life in the twentieth century, the choice of objects and motifs remained a personal matter. Romanian-born Jean Negulesco, for example, adapted the colored planes of cubism to a personal style that was both abstract and representational in depicting objects connected to his homeland. Rufino Tamayo, a modernist steeped in the pre-Columbian and folk art of his native Mexico, created still lifes of fruit and musical instruments that not only are masterful simplifications of form and color, but also are resonant with cultural identity and childhood memory.

Other artists alter the viewer's experience of an object through dramatic changes of scale, among them Georgia O'Keeffe in her close-up views of natural objects like leaves and flowers and Marsden Hartley in his pictures of worn gloves and bouquets of roses. O'Keeffe's unique approach, which takes objectivity to the edge of abstraction, relies on startling enlargements, cropping, and intense color to convey highly personal meaning and emotional experience. Hartley's robust late still lifes depict objects deeply connected to his life. With their dramatic color contrasts and stark simplicity, Hartley's greatly magnified motifs, isolated from any recognizable surface or context, are imbued with an emotional power that resonates with the viewer.

Epigraph from Georgia O'Keeffe, *Georgia O'Keeffe* (New York: Viking Press, 1976), introductory essay, cited in Marjorie Balge-Crozier, "Still Life Redefined," in Elizabeth Hutton Turner, *Georgia O'Keeffe: The Poetry of Things* (Washington, D.C., and New Haven, Conn.: The Phillips Collection and Yale University Press, 1999), 43–44.

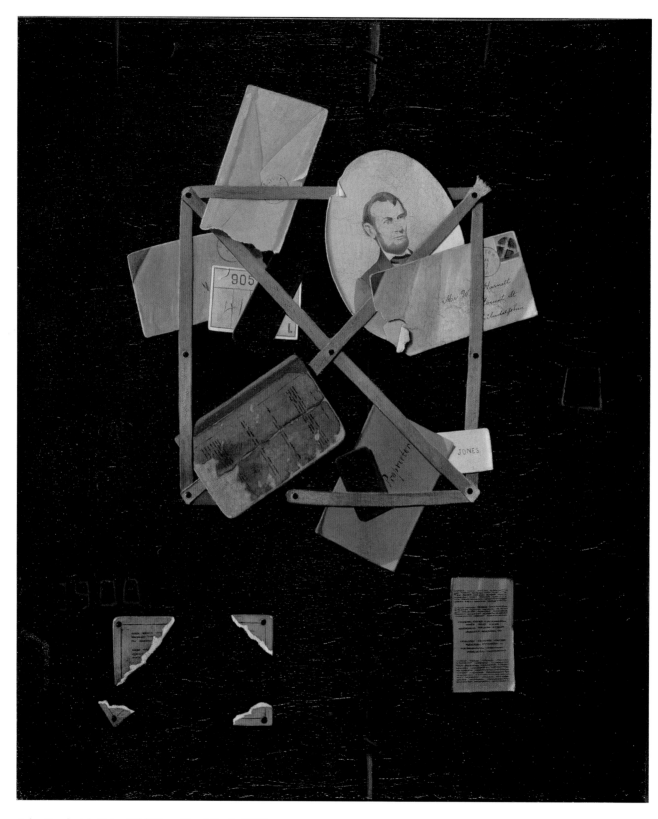

John Frederick Peto, ***Old Time Card Rack***, 1900

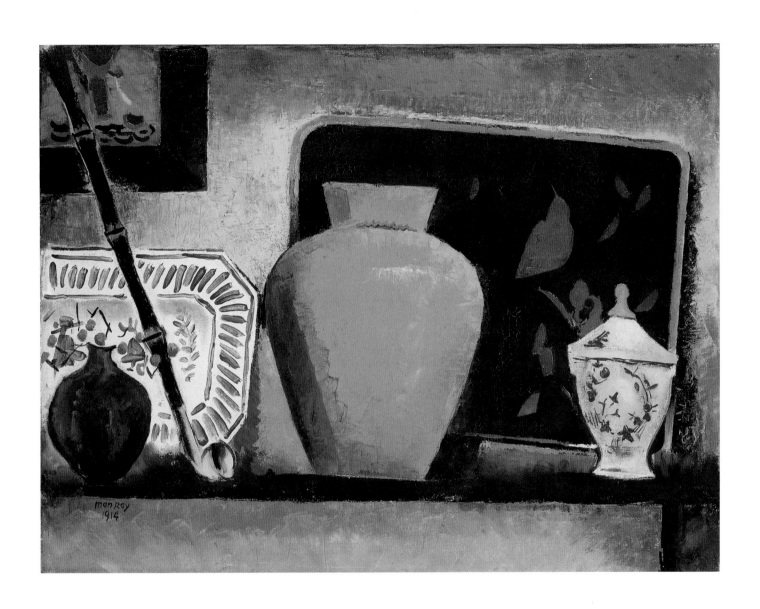

Man Ray, *The Black Tray*, 1914

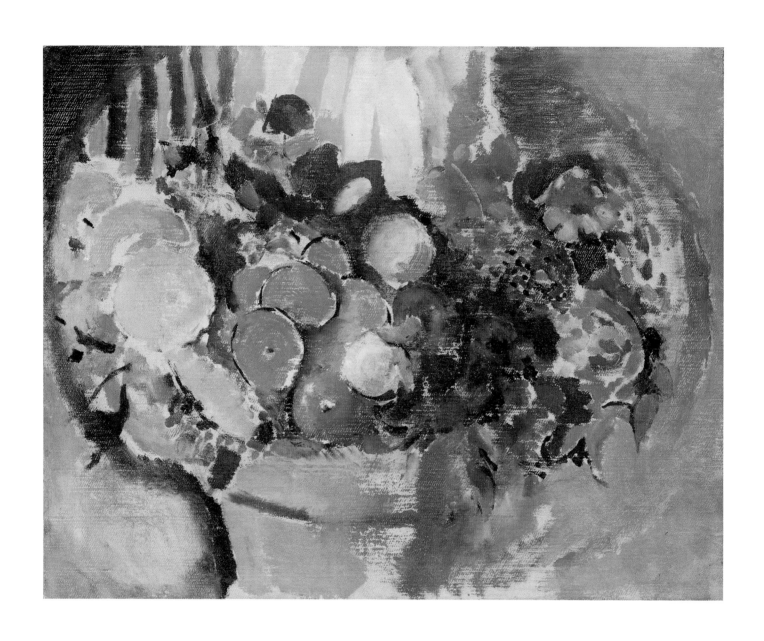

Arthur B. Carles, *Basket of Fruit and Flowers*, c. 1925

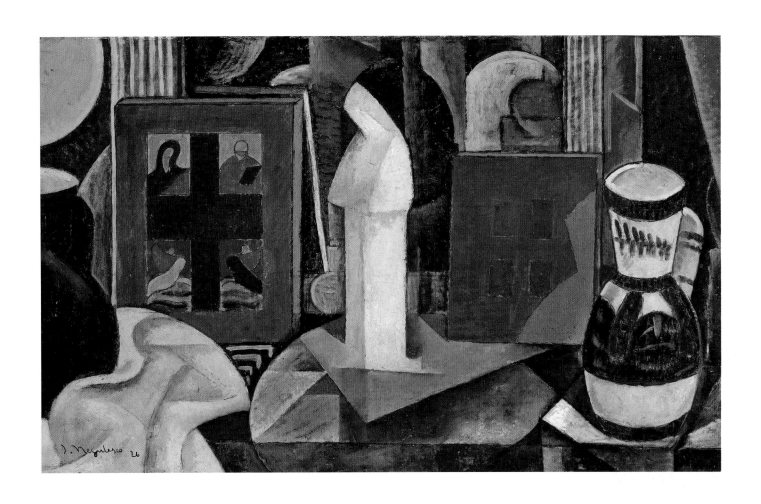

Jean Negulesco, *Roumanian Still Life*, 1926

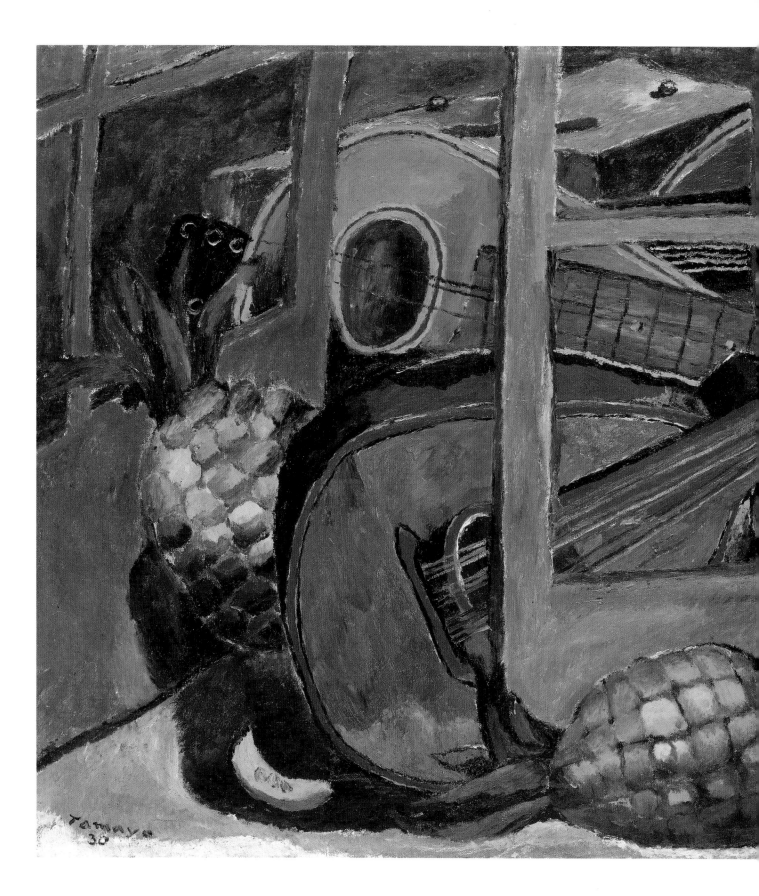

Rufino Tamayo, *Mandolins and Pineapples*, 1930

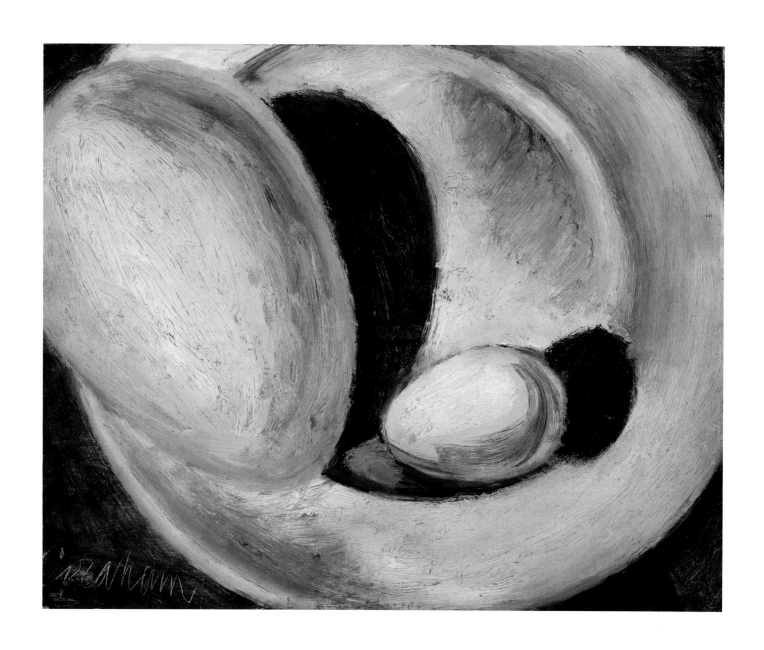

John D. Graham, *Two Eggs*, 1928

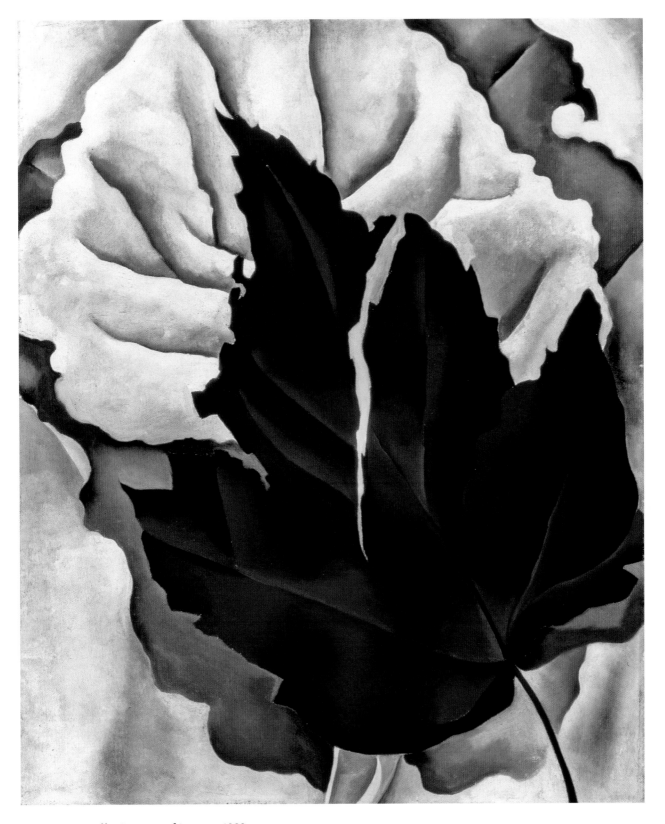

Georgia O'Keeffe, *Pattern of Leaves*, 1923

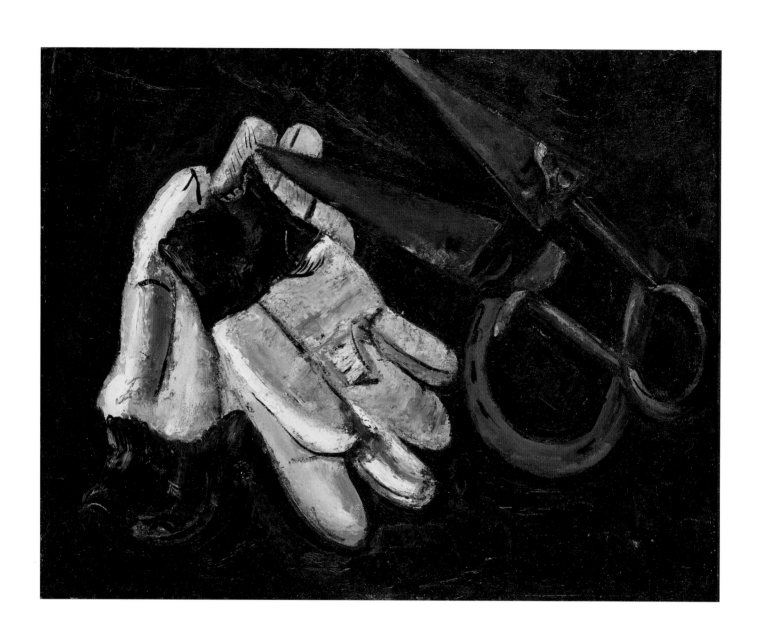

Marsden Hartley, *Gardener's Gloves and Shears*, c. 1937

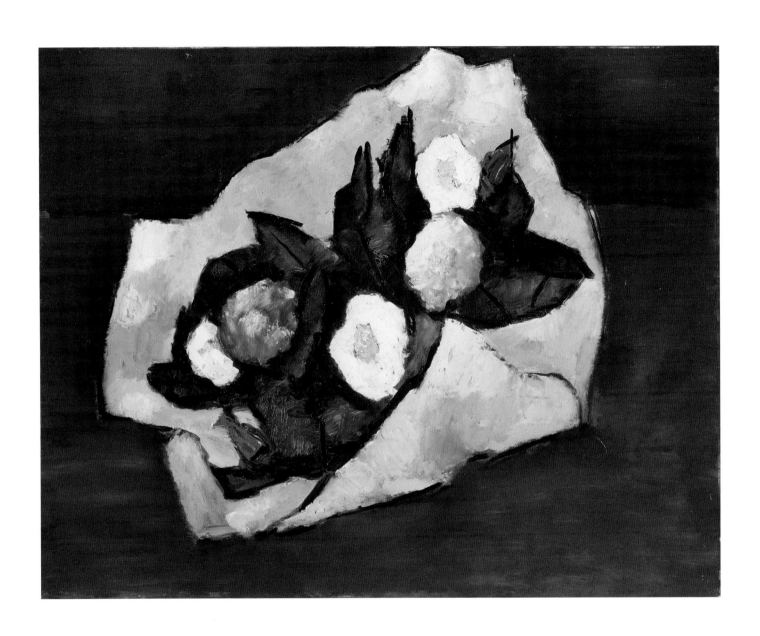

Marsden Hartley, **Wild Roses**, 1942

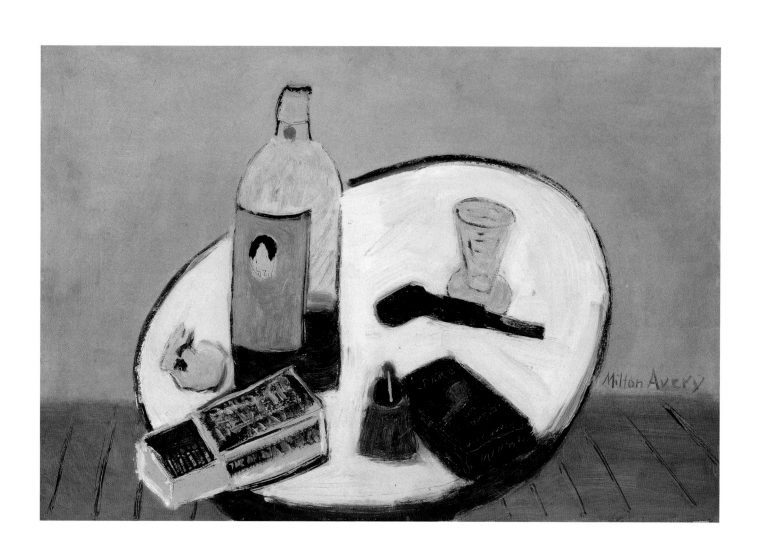

Milton Avery, *Pink Still Life*, 1938

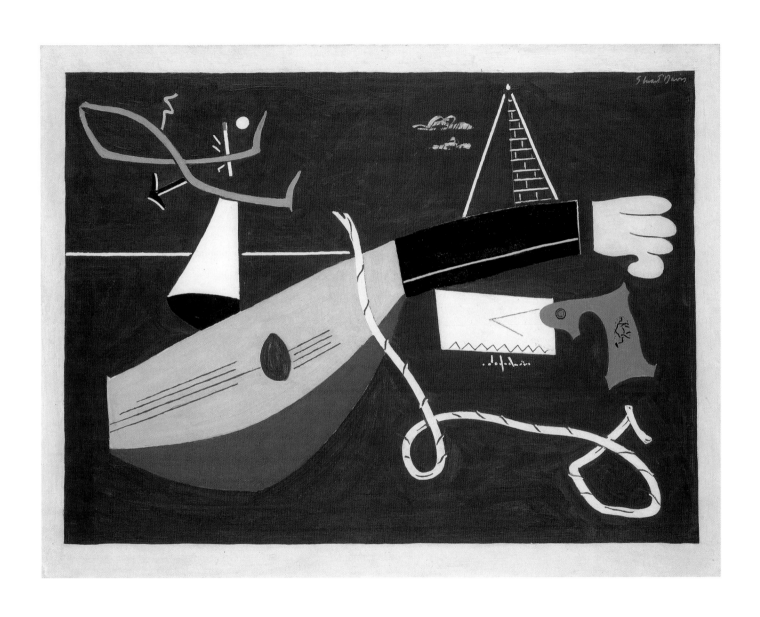

Stuart Davis, *Still Life with Saw*, 1930

Legacy
of Cubism

Cubism was . . . a discipline for the eye and for the hand, and in the end enabled the artists to liberate themselves from the confinements of representation and to launch forth into the deep and perilous waters of the abstract.

Duncan Phillips, 1926

Cubism, which developed in France around 1907, burst onto the American scene in 1913 at the *International Exhibition of Modern Art*, known as the Armory Show, an exhibition of contemporary American and European painting organized and selected by a group of progressive American artists, including Arthur B. Davies and Walt Kuhn. Shown first in New York, then Chicago, the center of the country's heartland, and finally Boston, the Armory Show comprised nearly 1,300 pieces. The French cubist paintings and other European works, particularly by Henri Matisse and Marcel Duchamp, proved to be the most controversial part of the exhibition, attracting great publicity. Headlines proclaimed "Cubist Art Is Here, As Clear As Mud."[1]

While critics ridiculed the newest European art, a small band of America's first generation of abstract artists, many of whom had spent time in Europe, embraced it, absorbing the lessons of cubism into their painting in the years following the Armory Show. By the 1920s, elements of cubist style appeared in the work of increasing numbers of American modernists. Charles Demuth, for example, was influenced by the cubists while in Paris in 1912–14, and then in 1917 he painted alongside the French cubist artist Albert Gleizes in Bermuda. Demuth became known for his cubist-derived paintings of America's cityscapes. The expatriate American painter Lyonel Feininger, who spent most of his life in Germany (from 1887 to 1936), absorbed the basic tenets of cubism and futurism early in his career. Alfred Maurer, who spent considerable time in Paris before 1914, was one of the first American artists to reflect the influence of European modernism in his work. His heavily impastoed still lifes of the late 1920s, constructed with a synthetic cubist vocabulary—compressed space, interpenetrating planes, flattened objects, and patterned decorative arrangements—are considered his most fully realized modernist works.

In the 1920s and 1930s, some American modernists tried to Americanize cubism, both in style and subject matter. Niles Spencer, for example, adopted cubist

geometric design, faceted forms, and planes of color in his depictions of New England landscapes and interiors. Karl Knaths developed what one critic called a "very American, very masculine" cubist style.[2] Working independently, Knaths developed a highly original style that used expressive line and planar arrangements of color to interpret his environment in Provincetown, Massachusetts, an artists' colony and fishing village on Cape Cod. His still lifes, especially those from the 1940s, are complex, lyrical harmonies of design and color abstracted from objects gathered from around his house. Phillips, who was the first to buy Knaths's work, valued him for his ability to create what he described as "humanizing abstraction."[3]

As the creator of some of the first American abstract paintings of the 1920s not derived from nature, Stuart Davis, whose mode of painting developed directly out of synthetic cubism, holds a special place in the development of American modernism. Like others who were inspired by the Armory Show, Davis admired the work of Paul Cézanne, Fernand Léger, and Pablo Picasso. Davis's idiosyncratic style followed closely Léger's cubism of flattened shapes, simplified designs, and bold planes of color, which he adapted to American subjects. The culmination of Davis's effort to use cubism to arrive at an original abstract style can be seen in his 1927–28 *Egg Beater* series, in which he was determined, as he put it, to "strip a subject down to the real physical source of its stimulus"[4] and concentrate on color, shape, and space relationships using only American utilitarian objects—an egg beater, an electric fan, and a rubber glove.

During his only stay in Paris (1928–29), Davis renewed his friendship with John Graham through whom he met Léger. Perhaps, as scholars have suggested, Davis and Graham exchanged ideas in Paris about how to reinvent cubist space in their canvases. Certainly their unpopulated street scenes share a similarly simplified geometrical structure, large flat areas of color, and a synthetic cubist style. Graham

immigrated to the United States from Russia in 1920, settling in Baltimore. Phillips was his first patron and provided financial support to the artist in the late 1920s. Graham spent most of his summers in Paris until the late 1930s, where he was active as both artist and dealer. Immersed in the language of Cézanne and the European moderns, he was particularly influenced and challenged by Picasso.

For some American artists, cubism led to pure geometric abstraction. George L. K. Morris, for example, studied with the French cubist painters Léger and Amédée Ozenfant in Paris, where he visited the studios of Picasso, Georges Braque, Piet Mondrian, and Jean Arp. Morris returned to the United States in 1933 convinced of the need for what he called an Americanized abstract art, and in 1936 he and his colleague Albert Eugene Gallatin were among the founders of American Abstract Artists, a group of New York painters who advocated for abstract art based on pure form and color. Morris's paintings often contain references to Native American art, an important influence on him as he sought to find his unique American voice. Another founder of American Abstract Artists was Russian-born Ilya Bolotowsky, who arrived in the United States in 1923. Introduced to the cubism of Picasso and Léger in Europe in 1932, he discovered the work of Mondrian and Joan Miró on his return to New York. By the mid-1930s, Bolotowsky was advocating for order and balance through pure geometric abstraction. Phillips acquired two early Bolotowsky abstractions directly from the artist, who had brought them to the collector's attention.

Epigraph from Duncan Phillips, "Introduction," in *Exhibition of Paintings by Nine American Artists* (Washington, D.C.: Phillips Memorial Gallery, January 1–31, 1926), unpaginated brochure.

1. "Cubist Art Is Here, As Clear As Mud," *Chicago Record-Herald*, March 20, 1913, as reproduced in *1913 Armory Show 50th Anniversary Exhibition*, exh. cat. (Utica, N.Y.: Munson-Williams-Proctor Institute, 1963), 161.

2. Ralph Flint, "Karl Knaths," *The Art News*, October 31, 1931, as reprinted in *An Exhibition of Recent Work of Karl Knaths* (Washington, D.C.: Phillips Memorial Gallery, December 1931), unpaginated brochure.

3. Duncan Phillips to Karl Knaths, November 5, 1931, cited in *The Eye of Duncan Phillips: A Collection in the Making*, ed. Erika D. Passantino (Washington, D.C., and New Haven, Conn.: The Phillips Collection and Yale University Press, 1999), 435.

4. Stuart Davis, quoted in James Johnson Sweeney, *Stuart Davis* (New York: Museum of Modern Art, 1945), 17, cited in *Stuart Davis*, ed. Philip Rylands (Boston and New York: Bulfinch Press Book, Little, Brown and Company, 1997), 116.

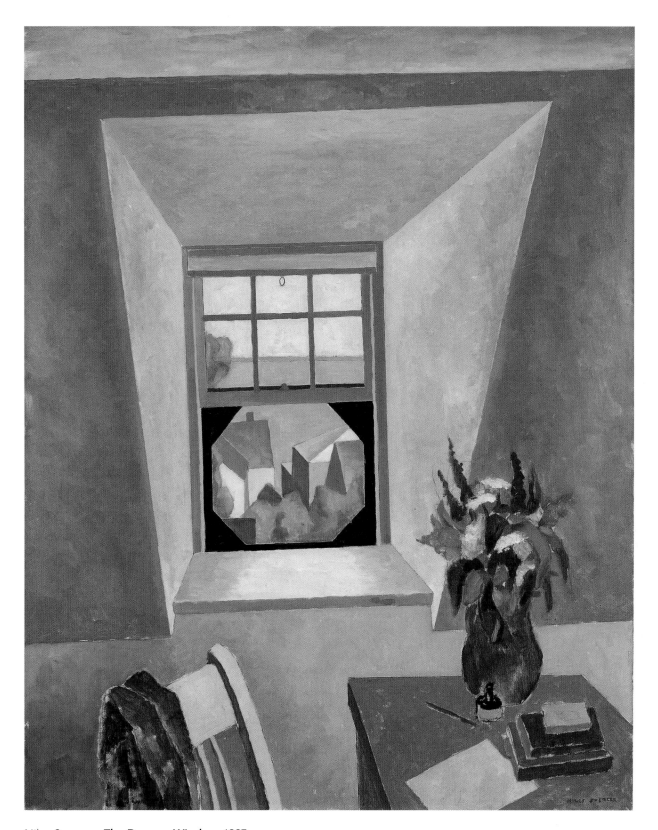

Niles Spencer, *The Dormer Window*, 1927

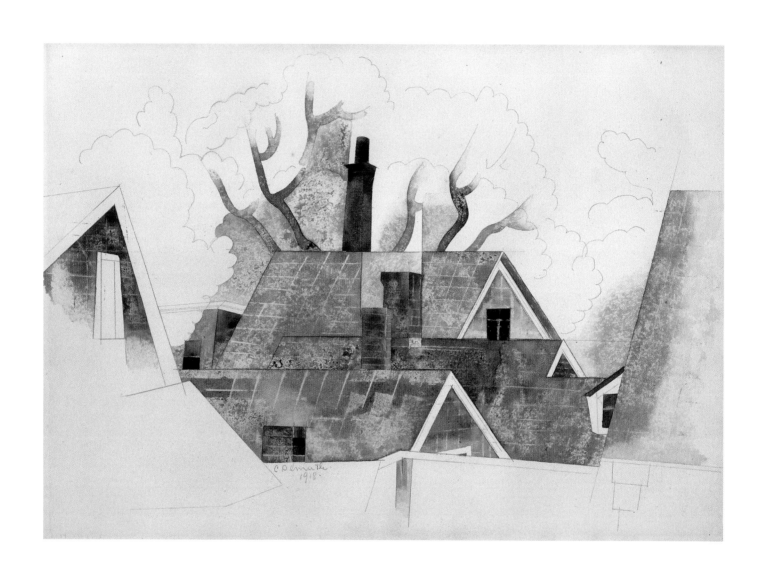

Charles Demuth, *Red Chimneys*, 1918

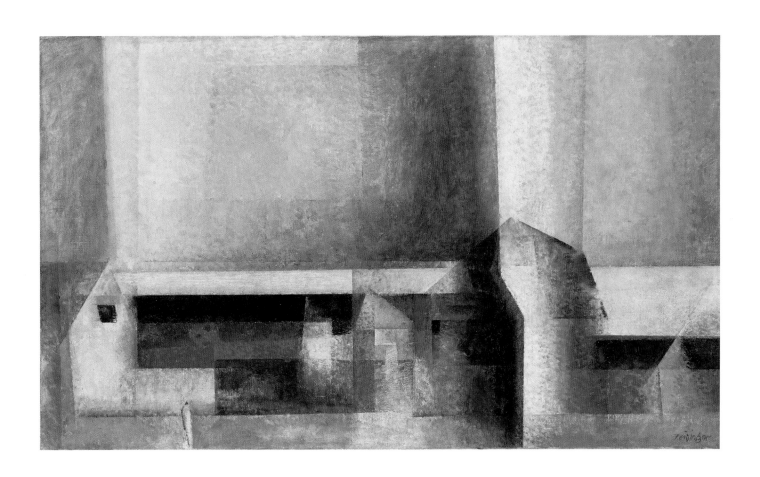

Lyonel Feininger, *Village*, 1927

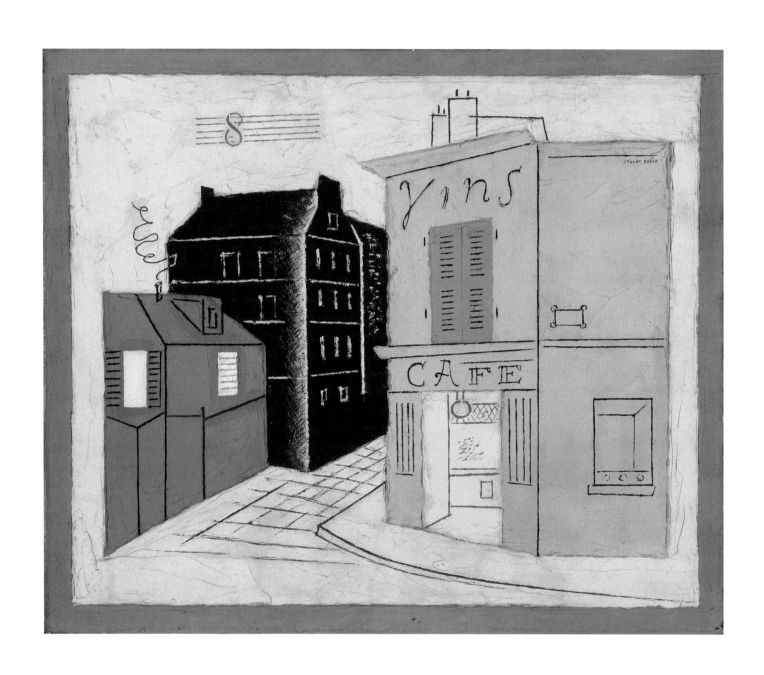

Stuart Davis, *Blue Café*, 1928

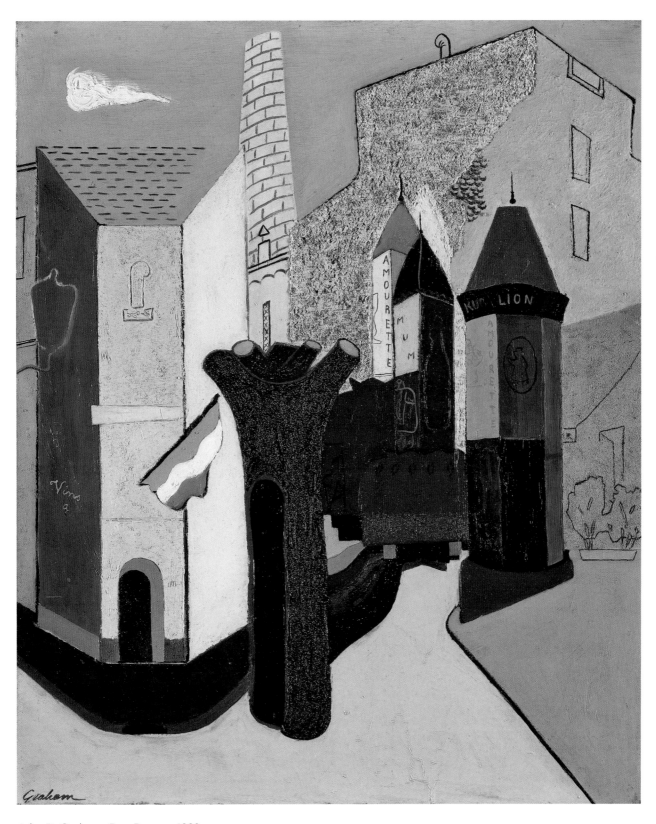

John D. Graham, *Rue Brea*, c. 1928

Stuart Davis, *Egg Beater No. 4*, 1928

Karl Knaths, *Maritime*, 1931

John D. Graham, *Blue Still Life*, 1931

Alfred Maurer, *Still Life with Doily*, c. 1930

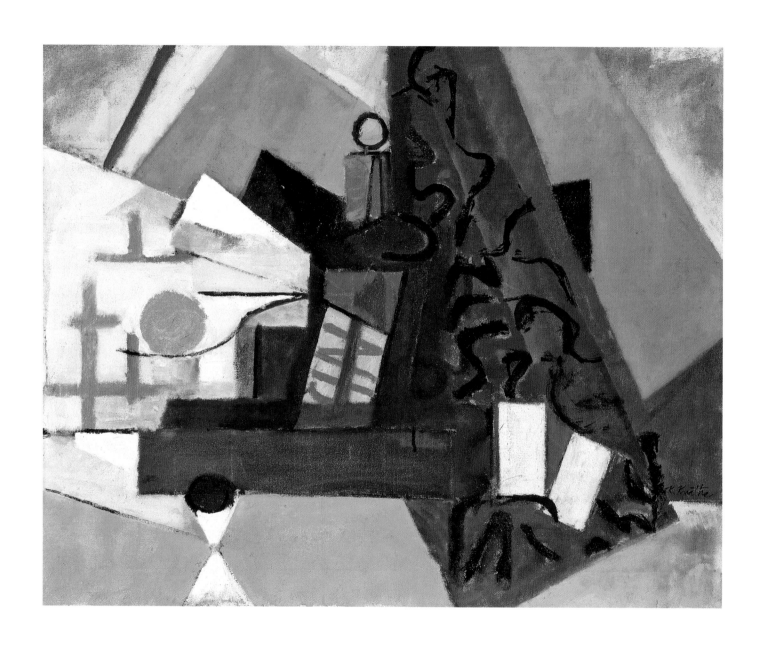

Karl Knaths, *Cin-Zin*, 1945

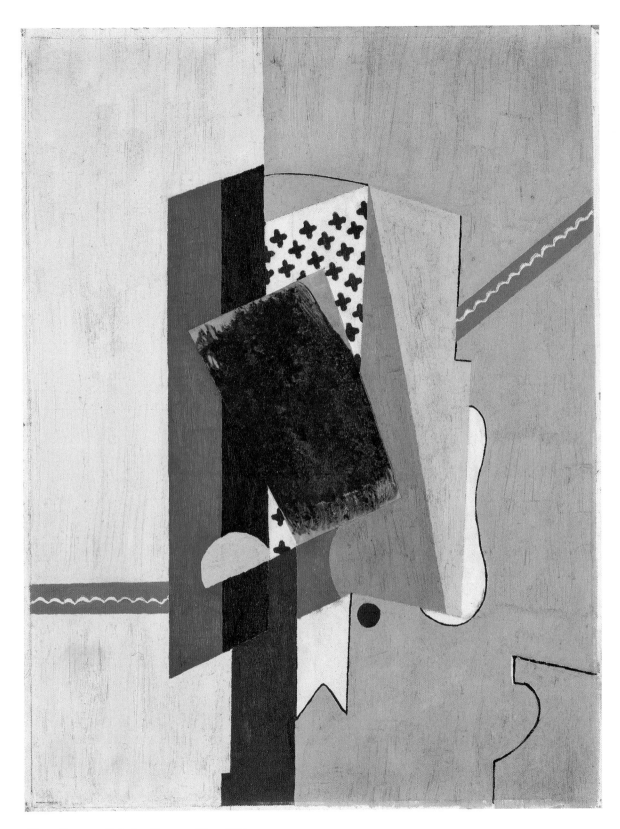

Albert Eugene Gallatin, *Composition*, 1941

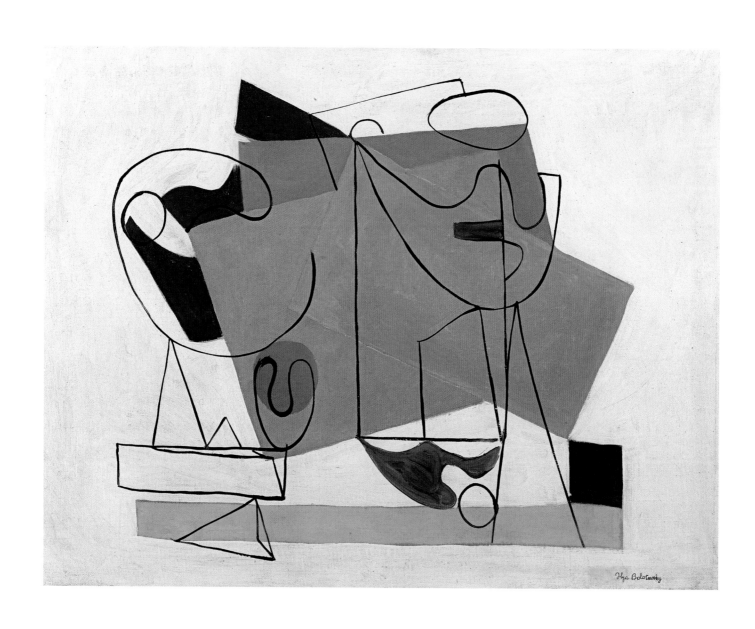

Ilya Bolotowsky, *Abstraction*, 1940

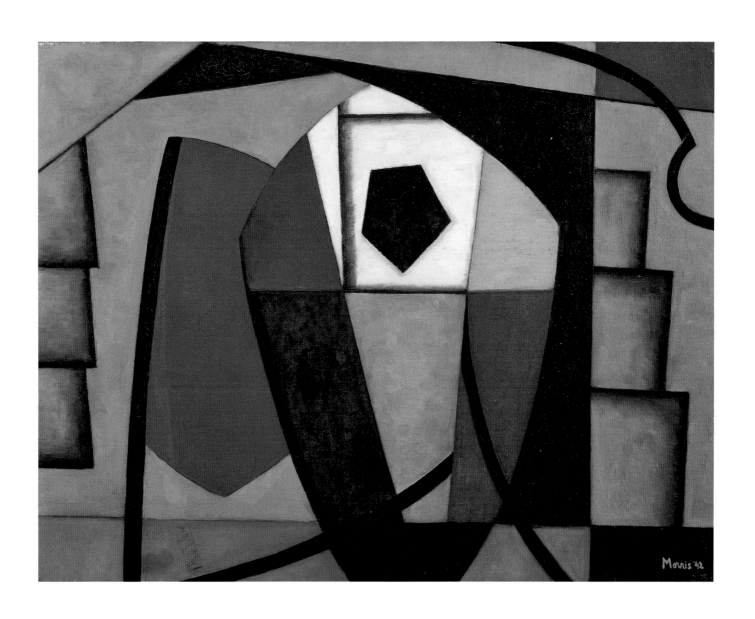

George L. K. Morris, *Heraldic Abstraction*, 1942

Degrees of Abstraction

I think I am a realist. . . . I make what I see. It's only the problem of seeing it. . . . The universe is real but you can't see it. You have to imagine it. Once you imagine it, you can be realistic about reproducing it.

Alexander Calder, 1962

By the end of the 1930s, artists in America, as in Europe, were putting increasing emphasis on abstraction as a universal visual language of pure form and color, whether divorced from nature or derived from it. Moreover, many American abstract painters looked beyond the visual arts to philosophy, mathematics, science, psychology, religion, and music to stimulate their experiments with visual reality and propel their art into new areas.

Morris Graves, for example, an artist from Seattle in the Pacific Northwest, was steeped in Far Eastern philosophies such as Zen Buddhism and Taoism and, like the French surrealists, believed in the subconscious as the locus of creativity. In all of Graves's work there is a spiritual striving committed to evocative metaphysical images, which he understood to be the vision of the "inner eye." Karl Knaths, who lived close to nature in the seaside town of Provincetown, Massachusetts, had strongly held beliefs about the spiritual qualities of the woodlands and wildlife that were nurtured by his reading of Henry David Thoreau, Ralph Waldo Emerson, and Emanuel Swedenborg. In his mature canvases Knaths combined abstracted landscape and expressive color "to conjure," as a critic wrote in 1957, "the memory of the spiritual experience, . . . an intuitive revelation of the spirit in matter."[1]

John Marin continued to paint Maine-related subjects into his eighties. His rhythmic and spontaneous brushwork, which is both free and controlled, found an echo in post-war gestural abstraction, while his colors and watercolor technique, which fused paint to support, inspired Helen Frankenthaler and other artists who developed stained color field painting in the early 1950s. Marin, who loved music, especially the abstract structural and sequential organization of Bach's compositions, created what Phillips called "musically organized" paintings in the latter part of his career. Acquiring these late canvases for his collection, Phillips wrote admiringly of the manner in which Marin "used abbreviations and formal idioms" to convey visual sensation and "glimpses of cosmic truth."[2]

Arthur Dove, one of America's most important first-generation modernists, created some of his most powerful works late in his career. Dove's late paintings, which Phillips collected in depth, are more intellectual and objective than his earlier work and reflect the artist's interest in Piet Mondrian and Robert Delaunay, among others. Although he still looked to nature and his surroundings for inspiration and continued to work intuitively, Dove eliminated descriptive detail to concentrate exclusively on spatial, geometric, and color relationships.

Another artist who had an aesthetic shift late in his career was Ben Shahn, one of America's foremost social realist painters between the wars. Proficient in many styles, all of which were more or less representational, Shahn turned to more personal, less polemical studio paintings after World War II. Although these later works often borrowed imagery from his commercial illustrations, Shahn transformed them into something new that bordered on the abstract, hoping to find images that would communicate on many levels. For example, drawings commissioned in 1948 by CBS for a radio network brochure were reinterpreted without captions for a print and a painting using a theme of "silent" or "still" music.

Joseph Solman was a devout modernist, friend of Mark Rothko, and cofounder of The Ten, a group of expressionist painters working in New York in the 1930s. Even while infusing his imagery with abstract qualities, Solman refused to abandon recognizable subject matter. The luminosity of his art is particularly evident in his poetic studio interiors of 1945 to 1951, which are filled with nuances of color, deliberate distortion, and the play of reflected light across the disorder of an abandoned room. Phillips, one of Solman's avid admirers, collected six paintings by the artist between 1943 and 1965.

Milton Avery, considered one of America's most important modernists for his bold experiments with color, found success in the 1940s, when critics embraced him as an "American Fauve," connecting him to Matisse's thinly painted canvases

of flattened color shapes and patterns. Phillips, who gave Avery his first one-person museum exhibition in 1943, recognized the artist's promise as early as 1929, when he acquired the first Avery painting to enter a museum collection. Passionate about literature, poetry, and the meanings of words, Avery has been portrayed as a poet-painter for his pared-down style in which realism is fused with abstraction and color fused with shape and spatial relationships. He described his pictures as abstract creations, "in which shapes, spaces, and colors form a set of unique relationships, independent of any subject matter,"[3] and capture on canvas his excitement and emotion about an idea. The works of his friends Adolph Gottlieb and Rothko stimulated Avery to further experimentation in his late paintings, and in his last decade he painted large-scale canvases using simplified color masses in which all detail is suppressed, arriving at paintings that are at once nonobjective and representational.

The work of Alexander Calder, one of the most acclaimed sculptors of the twentieth century, is derived from nature, yet appears to be nonobjective. The son of a figurative sculptor, Calder began using wire in the 1920s to create objects from his imagination. Influenced by science and the principles and practices of engineering, he reimagined the possibilities of sculpture. In his hands, sculpture transcended volume and mass, incorporating pure relationships of line, space, limited color (primarily black and white or red), shape, time, and motion. Each of Calder's objects is a universe in which individual parts interact with the whole in unpredictable and ever-changing ways.

Epigraph from Katharine Kuh, *The Artist's Voice: Talks with Seventeen Modern Artists* (New York: Da Capo Press, 2000), 42.

1. Paul Mocsanyi, *Karl Knaths* (Washington, D.C.: The Phillips Gallery, 1957), 25.
2. Duncan Phillips, "Foreword," in *John Marin Memorial Exhibition*, exh. cat. (Los Angeles: Art Galleries, University of California, Los Angeles, February 1955), unpaginated.
3. Milton Avery, quote from *Contemporary American Painting*, exh. cat. (Urbana, Ill.: College of Fine and Applied Arts, University of Illinois, 1951), 159, cited in Barbara Haskell, *Milton Avery*, exh. cat. (New York: Whitney Museum of American Art, 1982), 156.

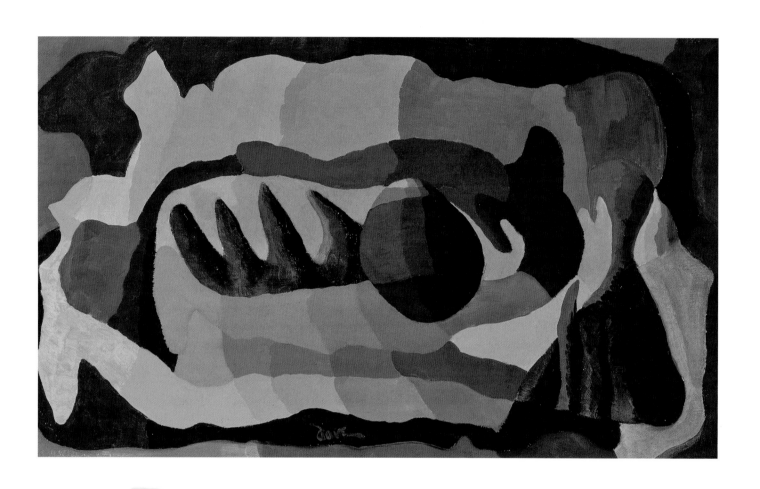

Arthur G. Dove, *Green Ball*, 1939–40

Ben Shahn, *Still Music*, 1948

Alexander Calder, *Red Polygons*, c. 1950

Karl Knaths, *Deer in Sunset*, 1946

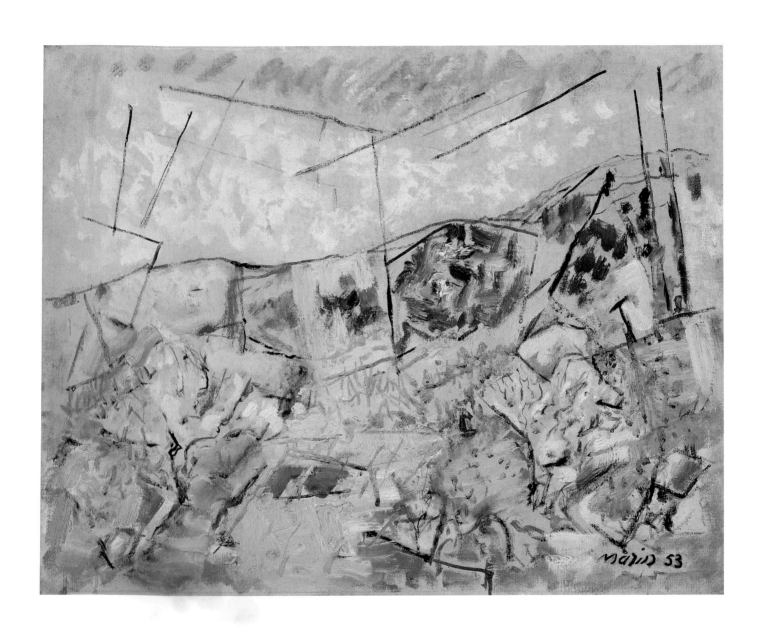

John Marin, *Spring No. 1*, 1953

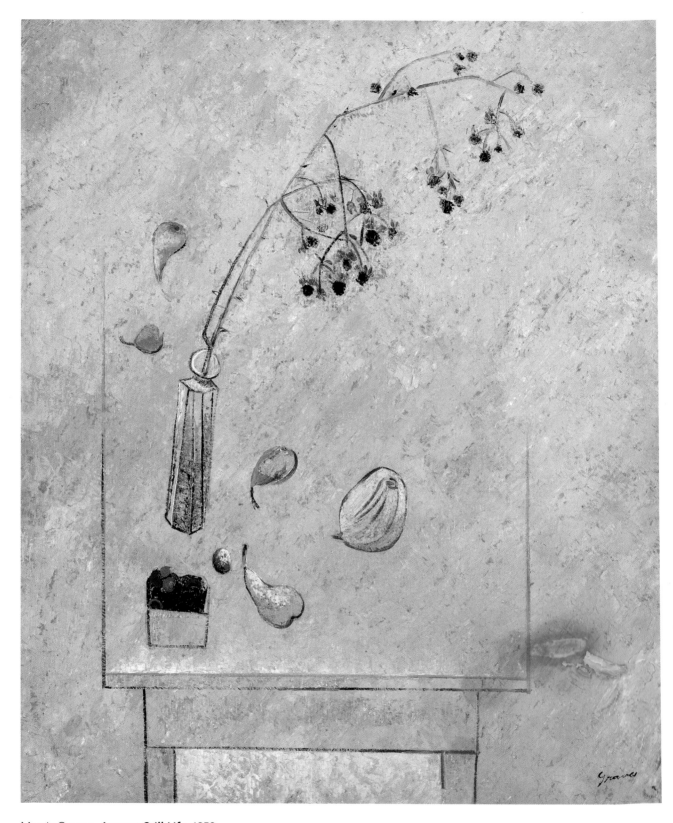

Morris Graves, *August Still Life*, 1952

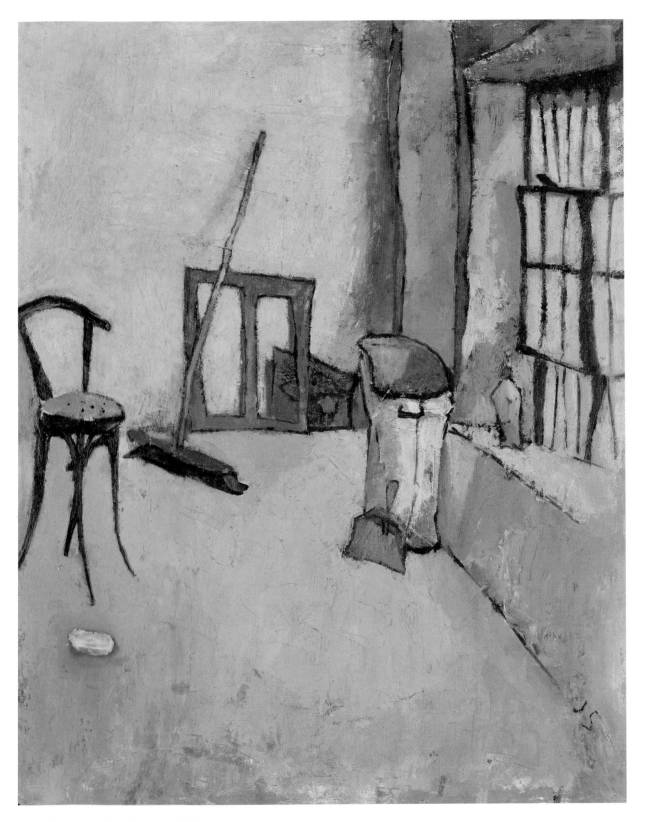

Joseph Solman, *The Broom*, 1947

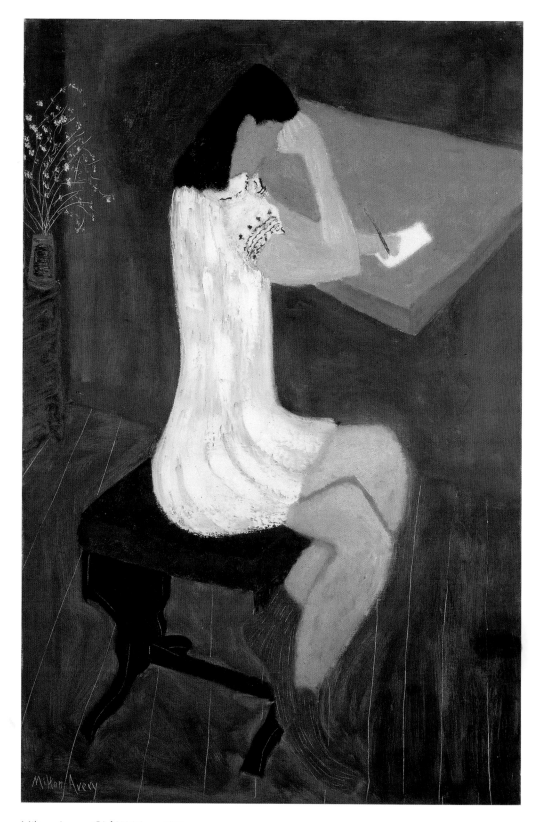

Milton Avery, *Girl Writing*, 1941

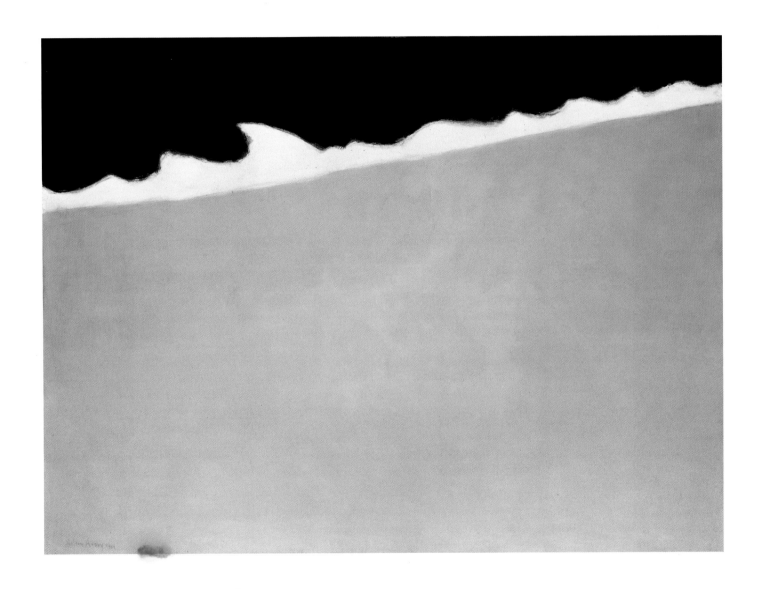

Milton Avery, **Black Sea**, 1959

Abstract Expressionism

The role of the artist, of course, had always been that of image-maker. Different times require different images. . . . To my mind certain so-called abstraction is not abstraction at all. On the contrary, it is the realism of our time.

Adolph Gottlieb, 1947

The influx of European émigrés into New York before World War II gave the city an international flavor. In the 1940s and 1950s, with the appearance of abstract expressionism, the first truly international style to emerge in the United States, New York City became the heart of avant-garde artistic activity and the art capital of the world. Abstract expressionism turned American art into a global force and, by the 1960s, was the dominant movement in this country's art.

Reacting against the sentimental figurative realism of American regionalist art in the 1930s, avant-garde painters of the 1940s sought a new visual language that was abstract and inherently American. Affected by the political turmoil of World War II and its aftermath, these young painters believed that the contemporary artist faced what they described as a crisis of subject matter.[1] Well versed in the classical past, they absorbed contemporary international styles such as European surrealism and abstraction, rapidly assimilating modernist styles from Picasso, Kandinsky, Klee, Matisse, Miró, Mondrian, and others, while also looking to non-Western sources for aesthetic inspiration. Adolph Gottlieb, for example, was profoundly influenced by so-called primitive art, including Native American art and African tribal art, which he collected. In his paintings he conjured the power of non-Western art to convey meaning and express unknown or hidden forces.

Increasingly self-aware and confident, young American artists explored an intellectual terrain that encompassed literature, philosophy, anthropology, and psychology. They were interested in Freudian psychoanalysis and in Jungian psychology's emphasis on the universal experience of the collective unconscious, as well as in anthropological studies that treated myths as windows into the individual's relationship with the universe. Theodoros Stamos, for example, was particularly interested in ancient rituals and the Greek mythological themes that supplied metaphors for the post–World War II era. Defending the new abstraction in 1947, Gottlieb wrote compellingly about the need to create images appropriate to his time.[2]

Influenced by the surrealists' taste for the irrational and belief in the creative

subconscious, the abstract expressionists looked into their own psyches for inspiration. Theirs was an essentially romantic outlook that favored personal symbols and the "authenticity" of the individual gesture that grew out of surrealism's automatism. Although they shared certain intellectual concerns and social connections, each of the post-war artists painted in his or her own style. Willem de Kooning, for example, blurred the line between abstract and representational art, while Mark Rothko, who believed his paintings were imbued with a mystical, metaphysical essence distilled from human experience, both tragic and ecstatic, explored the lyrical power of color relationships and the subtleties of measure and proportion, rather than the gestural style that was the hallmark of abstract expressionism. Others, like Bradley Walker Tomlin, experimented with automatism and gestural painting in canvases filled with layered networks or grids of brushstrokes against a field of varied color, while Jackson Pollock explored complex surface imagery by dripping and pouring paint and even working with collage. Each of these artists in their own way was exploring all-over compositions in which there is no single center of interest.

Thinking in paint was not about making abstractions or representations but about giving concrete expression to thoughts and feelings on canvas. For example, Japanese-born Kenzo Okada, who immigrated to New York in 1950, worked in an intuitive manner inspired by Zen Buddhism. He used meditation to invite creativity, a practice similar to the abstract expressionist belief in the subconscious as a primary source of creative inspiration. A painting, as Robert Motherwell stated, was a vehicle for passion, a means for making human contact.[3] As such, paintings grew in scale, Rothko claiming, for example, that the larger the picture, the more artist and observer are "in" it,[4] recognizing that his distinctive fields of hovering color play so effectively with the viewer's senses and visual perception because of their size.

Like Rothko, Clyfford Still gradually purged his paintings of all emblematic imagery, making dark, mural-size canvases that he called self-portraits in which his philosophical

and psychological concerns were expressed in large, heavily textured fields of color combined with jagged forms that stretched the eye beyond the confines of the canvas. Still's approach stands in stark contrast to the luminous palette and shimmering clusters of vigorous brushstrokes that define Philip Guston's abstractions of the 1950s.

Joan Mitchell, Sam Francis, and Richard Diebenkorn, twenty years younger than Gottlieb, Rothko, and Still, are loosely associated with a second generation of abstract expressionists who favored expressive use of color. Mitchell, who ultimately settled in France, integrated the dynamic brushwork and spatial tensions that she admired in de Kooning's work, for example, with her own sense of lyrical color infused with light. Francis's paintings, which feature splatters of bright contrasting colors on large expanses of white, conveying a sense of light and air, were shaped by his immersion in the Paris avant-garde of the 1950s and his first-hand acquaintance with the art of Monet, Bonnard, and Matisse. Diebenkorn came to distrust abstract expressionism because of its very freedom. Valuing structure and order, he turned to recognizable subject matter, exploring the tension between abstraction and representation in compositions in which the figure and its environment are conceived as abstract arrangements of form and color.

Another group of American painters in the early 1950s that included Helen Frankenthaler, Morris Louis, and Kenneth Noland experimented with a new kind of abstraction based on the power of expanses of radiant color that go beyond the edge of the canvas. Unlike the dynamic brushwork that characterizes abstract expressionism, these color field pioneers eliminated the use of thick pigment and emphasis on gesture and brushstroke, relying, instead, on a soaking and staining technique. Frankenthaler led the way with transparent stain paintings that wed color to canvas similar to the way watercolor pigments become part of the paper support, while Louis and Noland explored structural possibilities using stripes and the circle. Each gave vibrant color relationships the preeminent role in composition, an approach that was taken up and exploited by a younger generation that included Sam Gilliam, among others.

Epigraph from Adolph Gottlieb statement in "The Ides of Art: The Attitudes of Ten Artists on Their Art and Contemporaneousness," *Tiger's Eye* 1 (December 1947).

1. "There is no such thing as good painting about nothing. We assert that the subject is crucial and only that subject-matter is valid which is tragic and timeless. That is why we profess spiritual kinship with primitive and archaic art." Statement by Adolph Gottlieb and Mark Rothko, *New York Times*, June 13, 1943, Edwin Alden Jewell column, reproduced in Herschel B. Chipp, *Theories of Modern Art* (Berkeley: University of California Press, 1971), 545.

2. "If the models we use are the apparitions seen in a dream, or the recollection of our pre-historic past, is this less part of nature or realism, than a cow in the field? I think not. The role of the artist, of course, has always been that of image-maker. Different times require different images. Today when our aspirations have been reduced to a desperate attempt to escape from evil, and times are out of joint, our obsessive, subterranean and pictographic images are the expression of the neurosis which is our reality. To my mind certain so-called abstraction is not abstraction at all. On the contrary, it is the realism of our time." Gottlieb, "The Ides of Art."

3. Robert Motherwell, statement in *The New Decade* (New York: Whitney Museum and MacMillan, 1955) cited in *Master Paintings from The Phillips Collection* (Washington, D.C.: Counterpoint and The Phillips Collection, 1998), 160.

4. Mark Rothko, statement from "A Symposium on How to Combine Architecture, Painting, and Sculpture," in *Interiors* 110, no. 10 (May 1951), cited in *Master Paintings from The Phillips Collection*, 188.

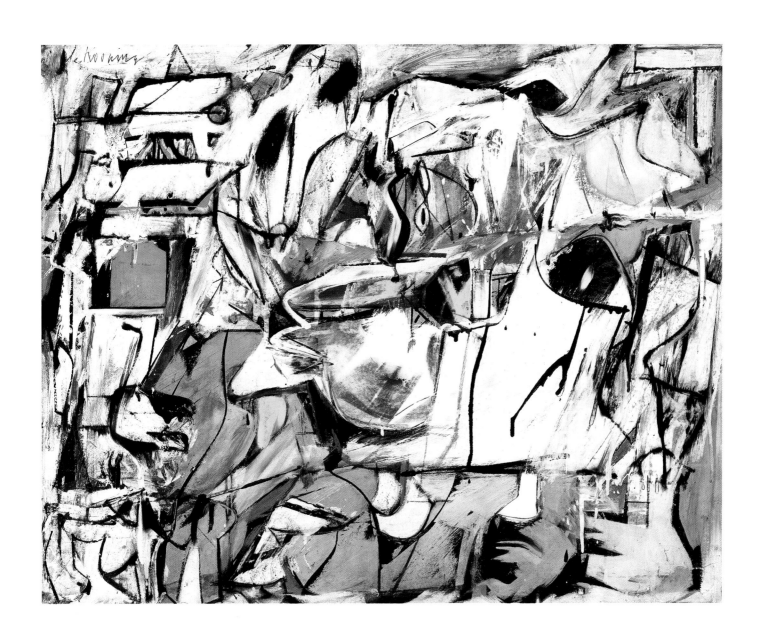

Willem de Kooning, *Asheville*, 1948

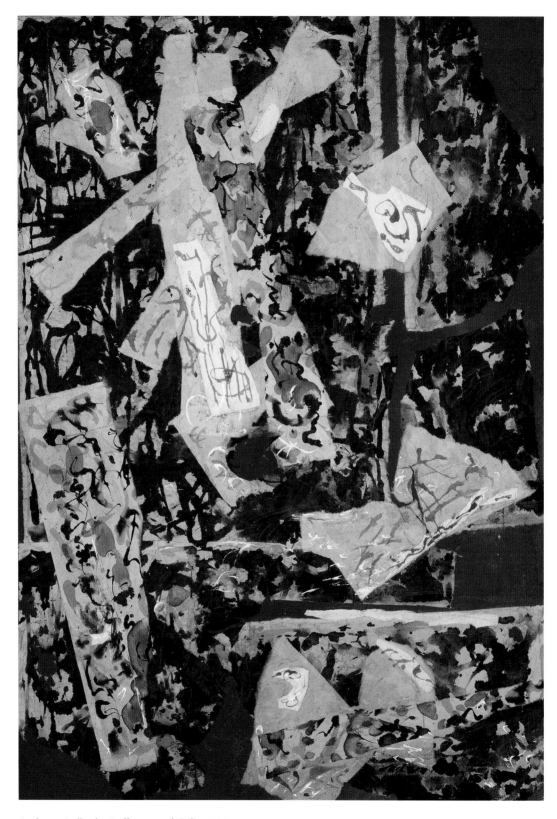

Jackson Pollock, *Collage and Oil*, c. 1951

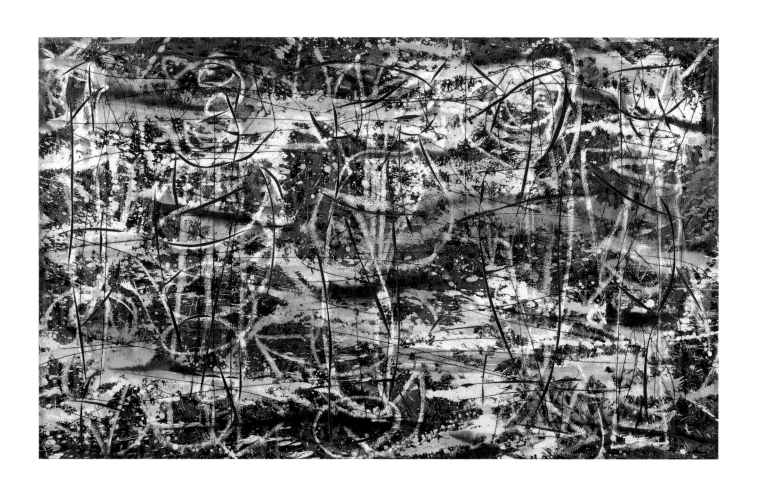

Alfonso Ossorio, *Five Brothers*, 1950

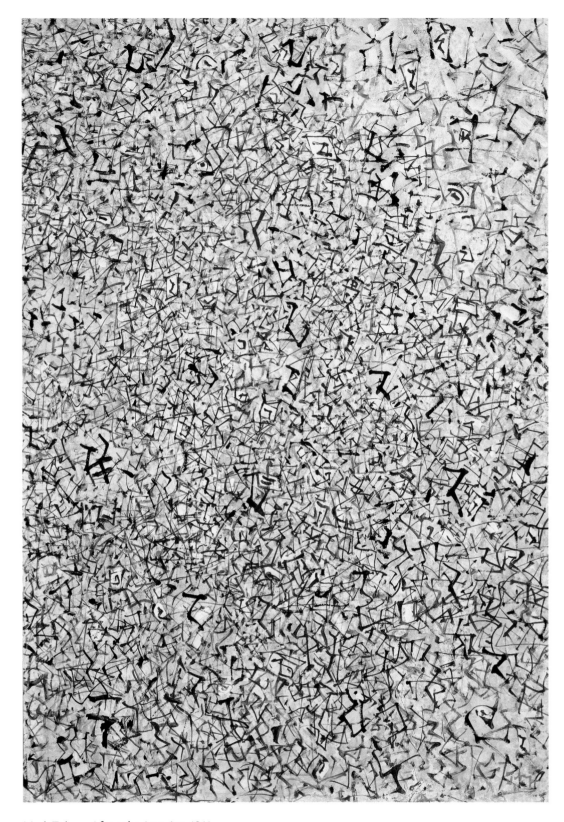

Mark Tobey, *After the Imprint*, 1961

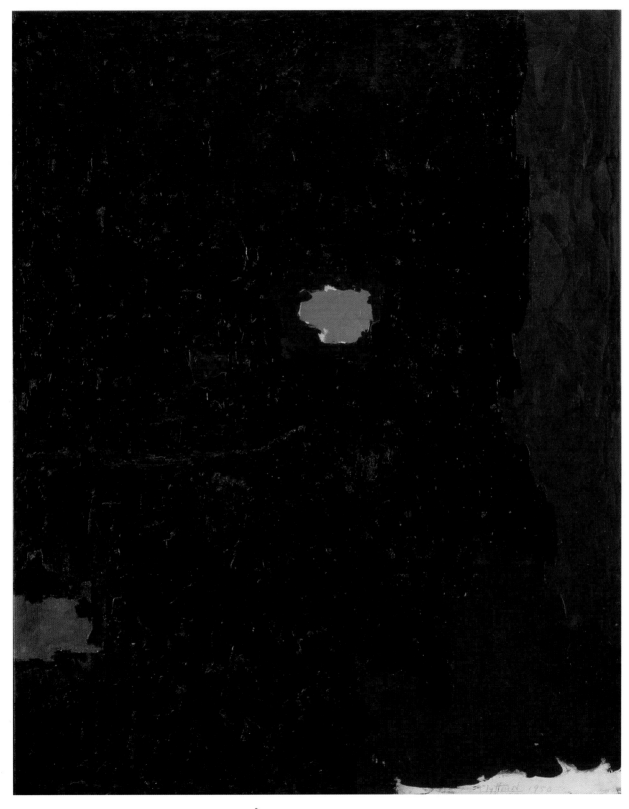

Clyfford Still, *1950-B*, 1950

stunning
in real life!

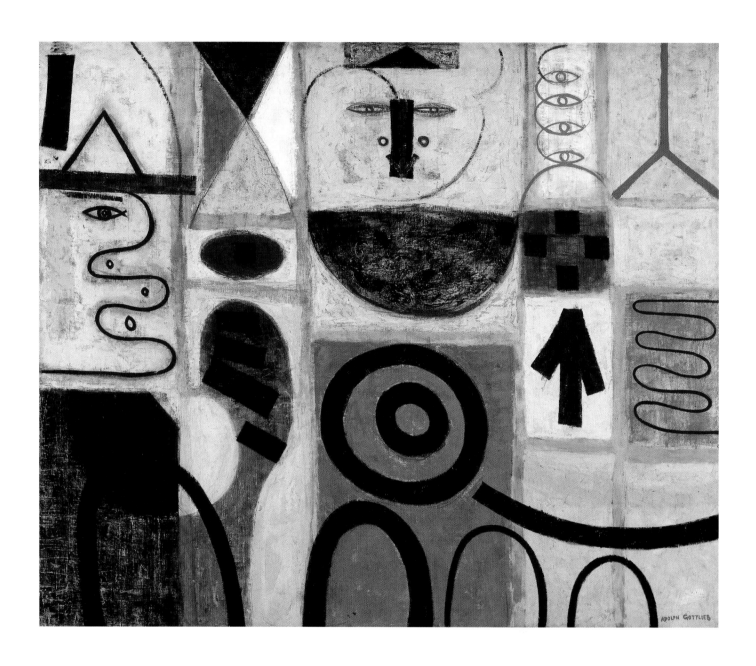

Adolph Gottlieb, *The Seer*, 1950

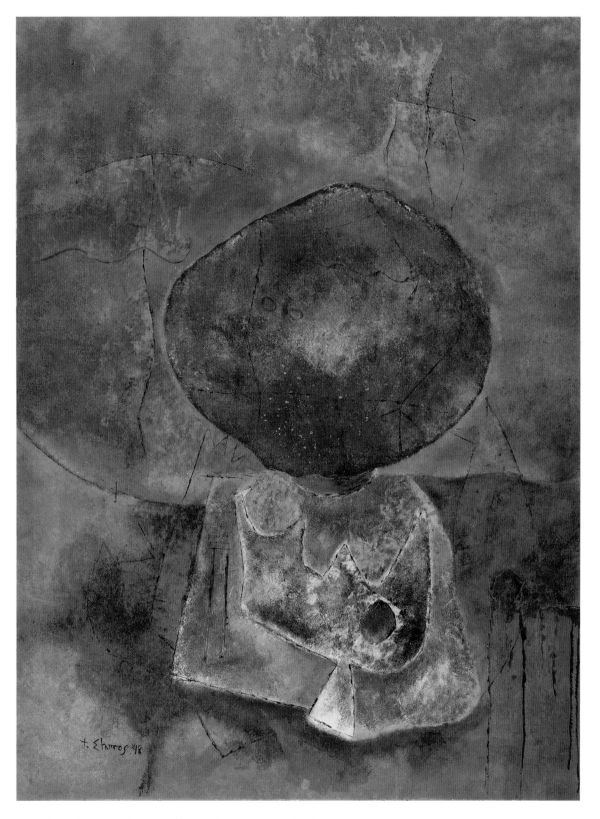

Theodoros Stamos, *The Sacrifice of Kronos, No. 2*, 1948

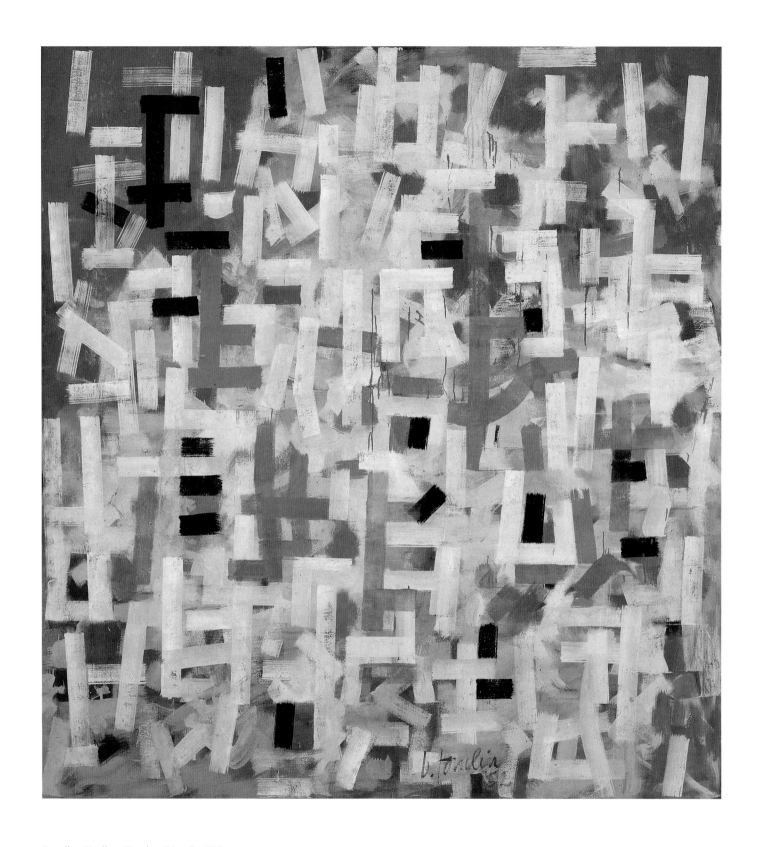

Bradley Walker Tomlin, *No. 9*, 1952

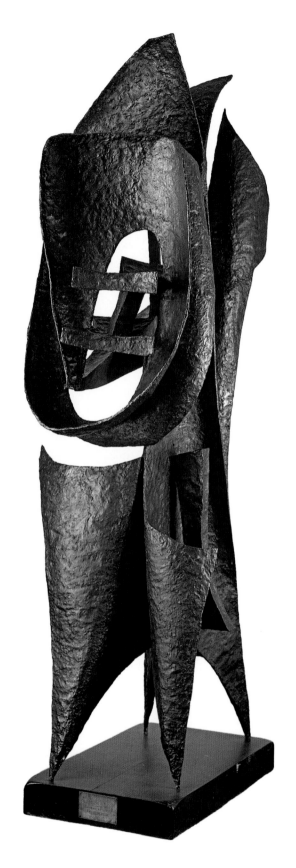

Seymour Lipton, *Ancestor*, 1958

Philip Guston, *Native's Return*, 1957

so good!

64 x 79

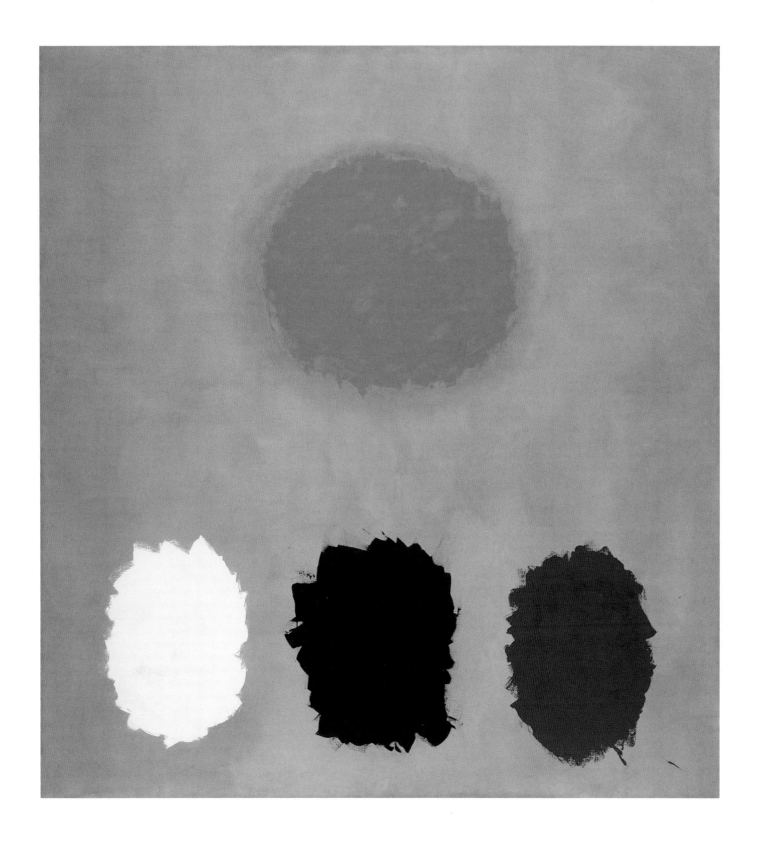

Adolph Gottlieb, *Equinox*, 1963

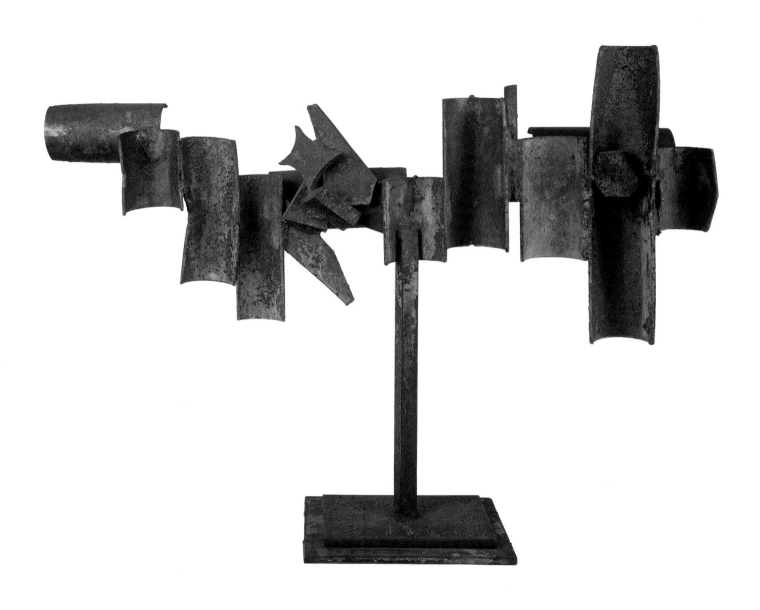

David Smith, *Bouquet of Concaves*, 1959

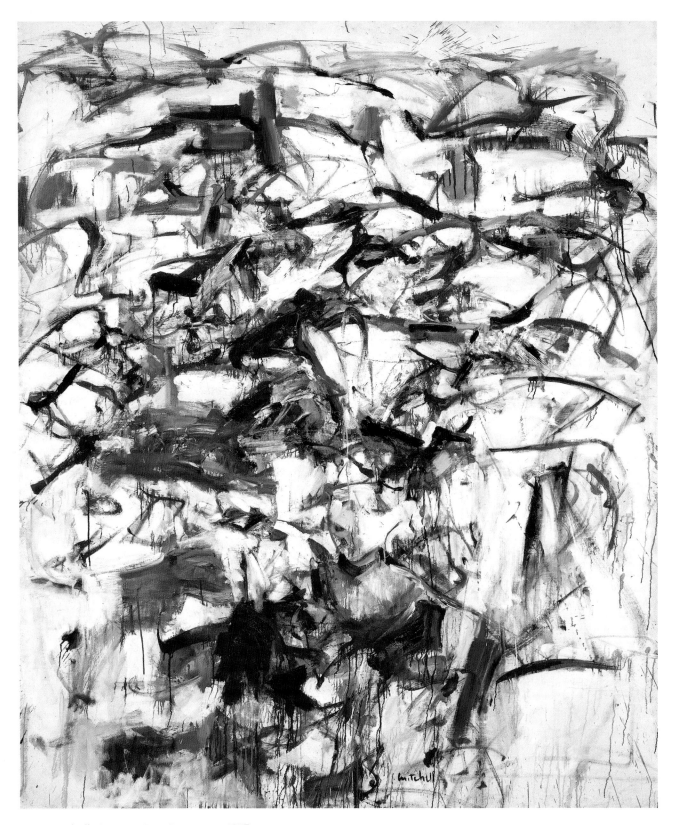

Joan Mitchell, ***August, Rue Daguerre***, 1957

fabulous

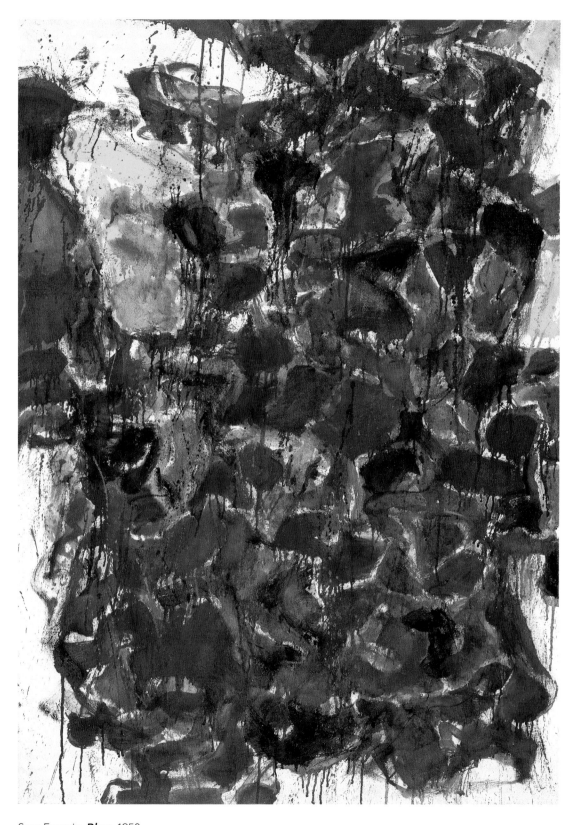

Sam Francis, *Blue*, 1958

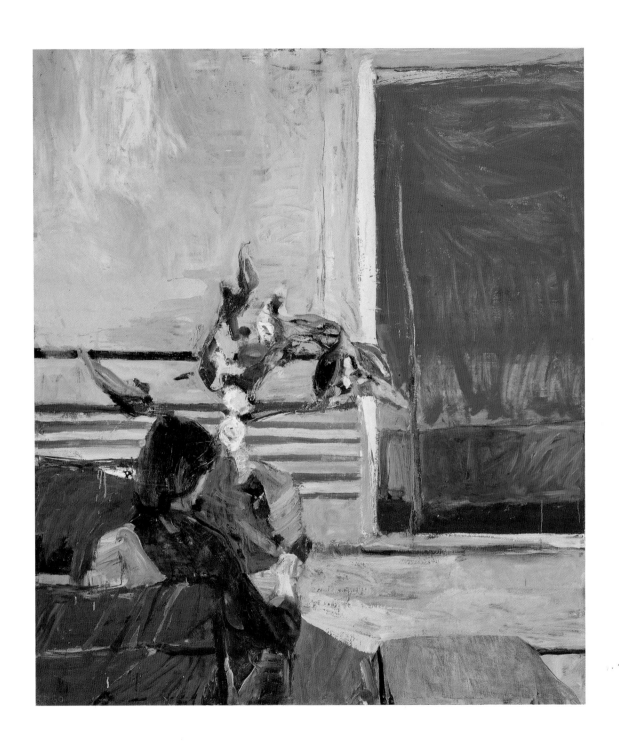

Richard Diebenkorn, *Girl with Plant*, 1960

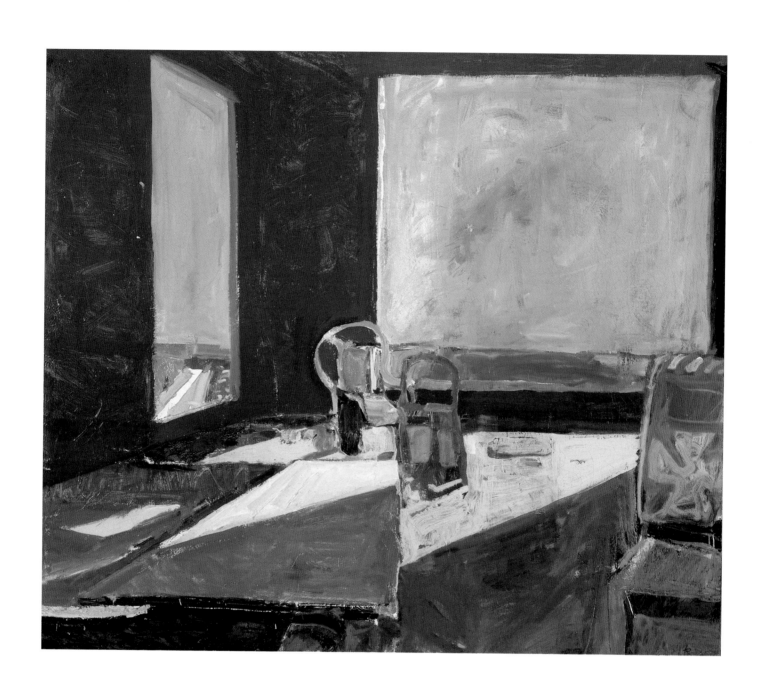

Richard Diebenkorn, *Interior with View of the Ocean*, 1957

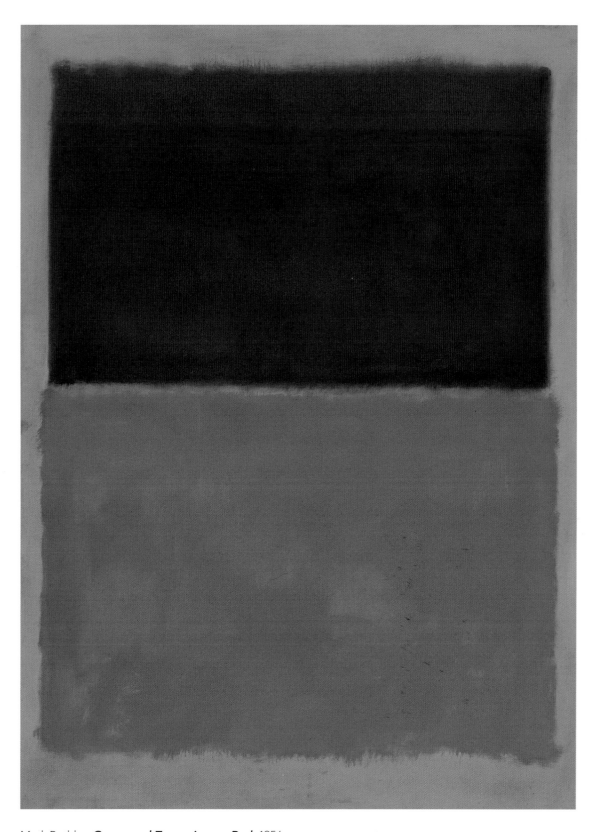

Mark Rothko, *Green and Tangerine on Red*, 1956

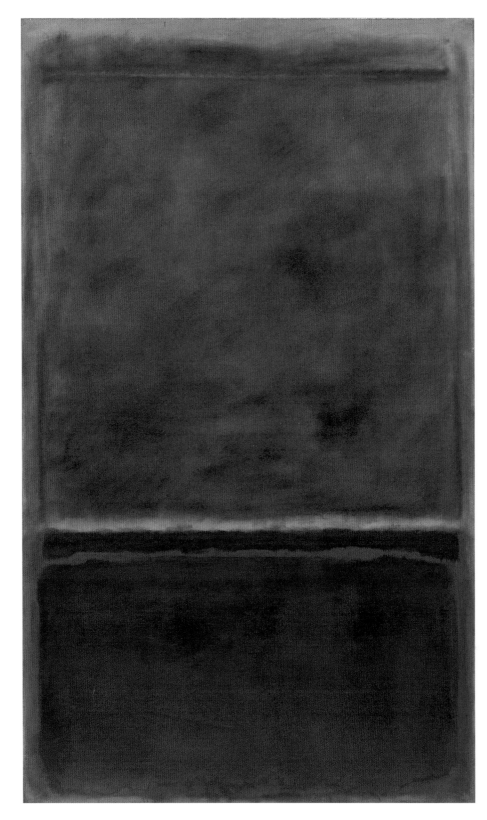

Mark Rothko, *Green and Maroon*, 1953

Kenzo Okada, *Footsteps*, 1954

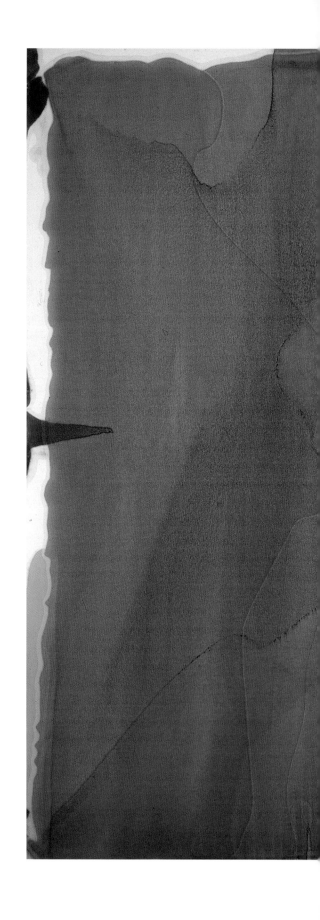

Morris Louis, *Seal*, 1959

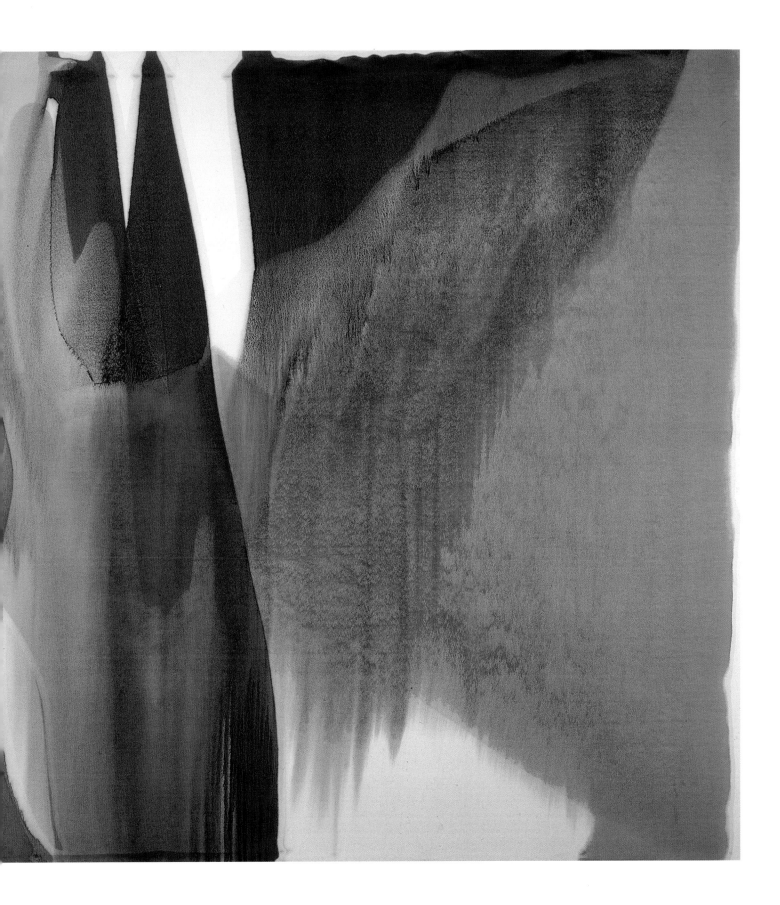

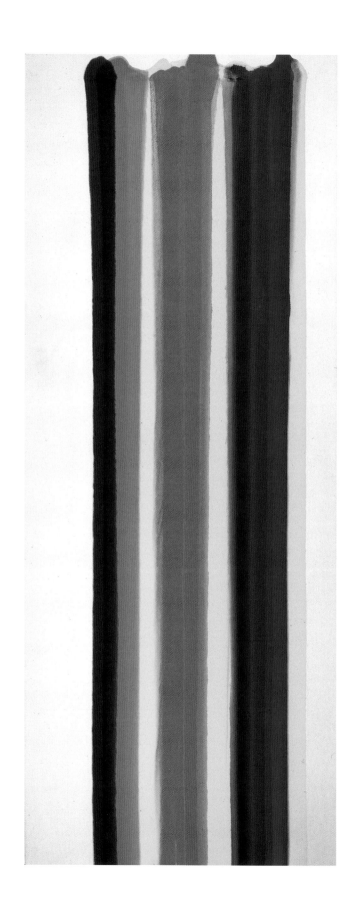

Morris Louis,
Number 182, 1961

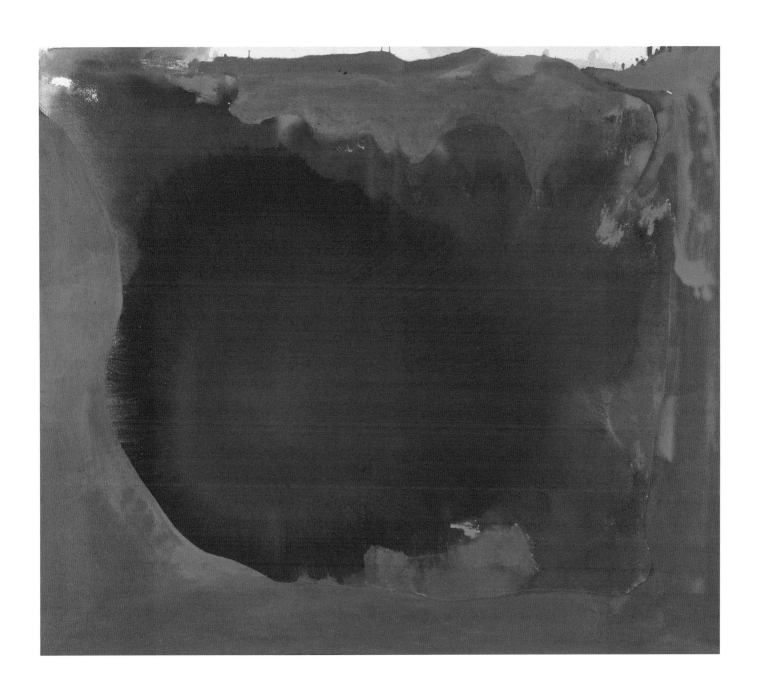

Helen Frankenthaler, *Canyon*, 1965

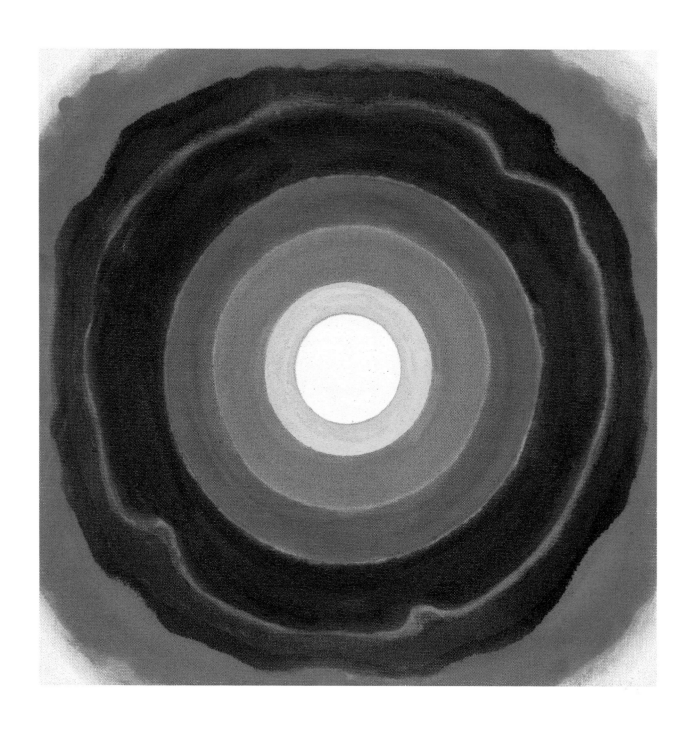

Kenneth Noland, *April*, 1960

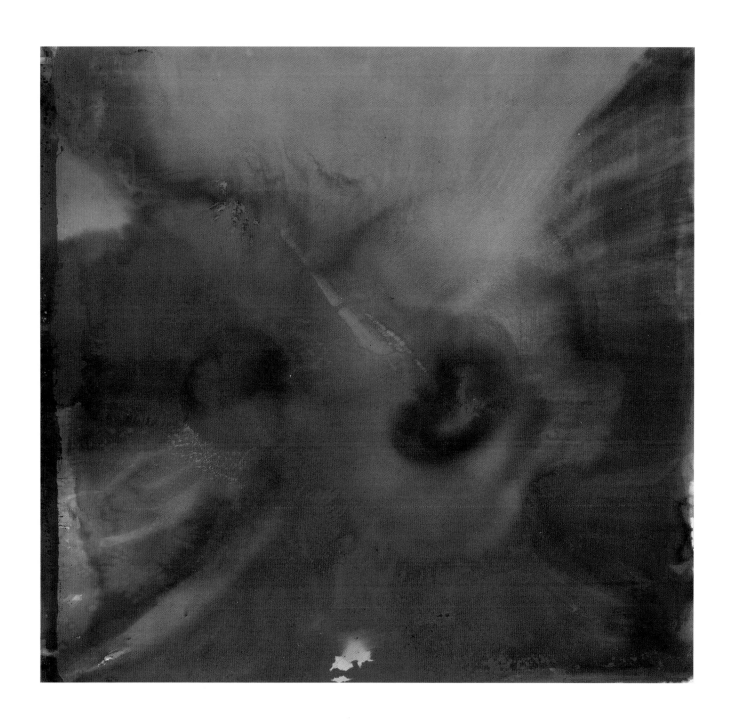

Sam Gilliam, *Red Petals*, 1967

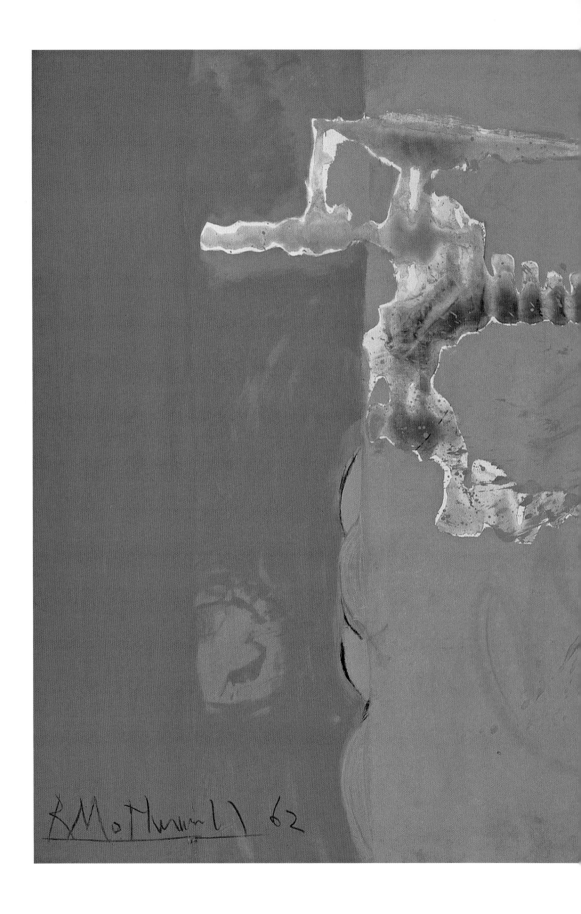

Robert Motherwell,
Chi Ama, Crede, 1962

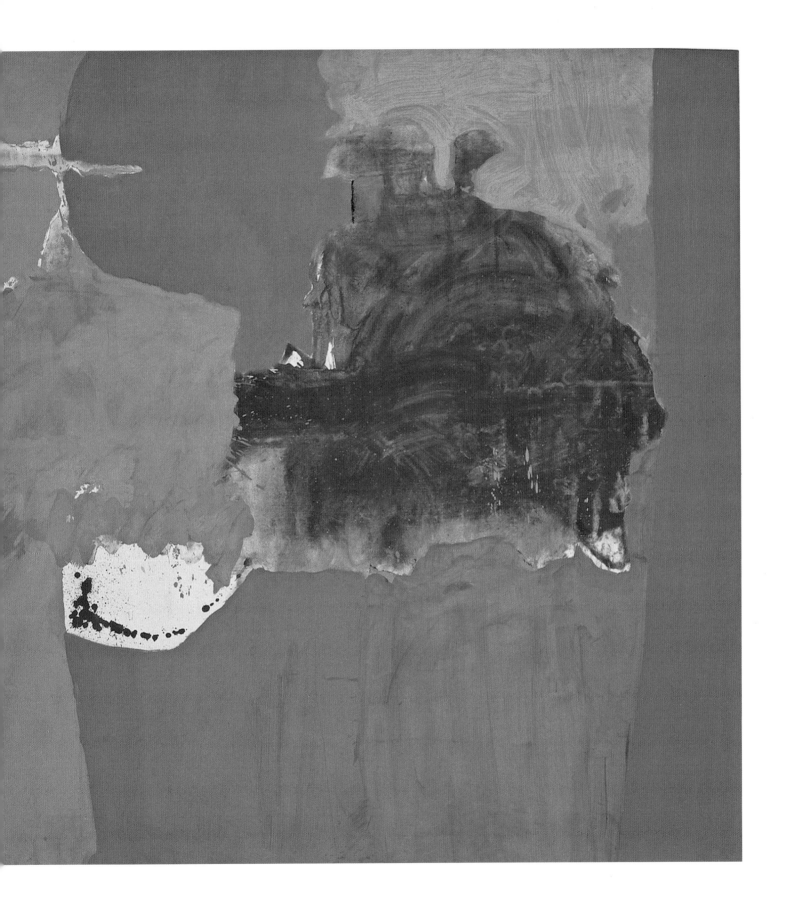

BIOGRAPHIES OF THE ARTISTS Compiled by Susan Behrends Frank

Milton Avery (b. Sand Bank [now Altmar], New York, March 7, 1885–d. New York, New York, January 3, 1965)

Milton Avery moved to Connecticut with his family in 1898. As a young man, he worked in mechanics and construction, but he became interested in art through a lettering course that he took sometime between 1905 and 1911. Avery attended the Connecticut League of Art Students until 1918 and then entered the School of the Art Society in Hartford, Connecticut. In 1925 he moved to New York, where he went to night classes at the Art Students League. He began exhibiting regularly in 1927 and developed friendships with Mark Rothko, Adolph Gottlieb, and Barnett Newman. In 1952 Avery traveled for the first and only time to London, Paris, and the French Riviera. He spent the summers of 1957 through 1960 in Provincetown, Massachusetts, where he became a friend of Karl Knaths and renewed his friendship with Gottlieb and Rothko.

Gifford Beal (b. New York, New York, January 24, 1879–d. New York, New York, February 5, 1956)

Gifford Beal was a realist painter, printmaker, and watercolorist whose subjects included the theater, the circus, seafaring life, and upper-class people enjoying leisure activities. He was drawn to art early on, studying between 1892 and 1901 with the artist William Merritt Chase on weekends and at Chase's school on Long Island during the summers. Beal attended Princeton University, where he was a friend of Edward Hopper and Rockwell Kent. After graduating in 1900, he studied from 1901 to 1903 at the Art Students League in New York with Frank V. DuMond. In 1913 he was elected to membership in the Century Association and in 1914 became a full member of the National Academy of Design. He served as president of the Art Students League from 1916 to 1930. Beal's first solo exhibition was at Kraushaar Galleries in New York in 1920. The following year his niece, Marjorie Acker, married Duncan Phillips. Beal lived in New York, but he spent his summers in remote locations in

New England, ultimately choosing the seaport of Rockport, Massachusetts, on the tip of Cape Cod, as his permanent summer home in 1923.

George Bellows (b. Columbus, Ohio, August 12, 1882–d. New York, New York, January 8, 1925)

George Bellows enrolled in the New York School of Art in 1904. His teachers included William Merritt Chase and Robert Henri. Edward Hopper and Rockwell Kent were among his fellow students. Bellows became the youngest member of the National Academy of Design in 1909 and began teaching at the Art Students League in 1910. Although he was an artist perpetually caught between the academic and progressive art movements, Bellows helped to organize the 1913 Armory Show and contributed works to it. Later in his career, Bellows spent his summers painting intimate portraits of family and friends in Maine, Rhode Island, and New Mexico, and experimenting with lithography. He died unexpectedly from peritonitis after suffering a ruptured appendix.

Isabel Bishop (b. Cincinnati, Ohio, March 3, 1902–d. New York, New York, February 18, 1988)

Isabel Bishop grew up in Detroit, where her father had various teaching jobs. It was a lonely childhood and Bishop became accustomed to watching the world around her. Interested in drawing, at sixteen Bishop moved to New York and enrolled in the School of Applied Design for Women with the intention of pursuing a career in commercial art. Not long after, she transferred to the Art Students League, where she studied under Kenneth Hayes Miller and Guy Pène du Bois. There she was inspired to create figure compositions based on real life, applying aesthetic principles derived from the Renaissance and Baroque art. Bishop is best known for sensitive images of people observed near her studio in Union Square. A realist in the spirit of Edward Hopper, Bishop chose urban working women as her special subject.

Oscar Bluemner (b. Prenzlau, Germany, June 21, 1867–d. South Braintree, Massachusetts, January 12, 1938)

Oscar Bluemner was born near Hanover, Germany, and studied painting and architecture at the Royal Academy of Design in Berlin during the 1880s. He left Germany in 1892, moving to Chicago, where he was employed as a draftsman for the World's Columbian Exposition of 1893. Failure to obtain public commissions for his architectural designs persuaded Bluemner to devote himself to painting. He exhibited in the 1913 Armory Show and soon gained entrance to the Alfred Stieglitz circle. His work reflected not only his architectural studies but also cubism and American synchromism, which emphasized the abstract use of color. In the 1930s he was employed by the Federal Art Project of the Works Progress Administration, painting rhythmic compositions inspired by music and Freud's theories of the unconscious. He committed suicide in 1938.

Ilya Bolotowsky (b. St. Petersburg, Russia, July 1, 1907–d. New York, New York, November 22, 1981)

Ilya Bolotowsky immigrated to the United States from Russia as a teenager in 1923 and settled in New York, where he attended the National Academy of Design. During the 1930s, he and his colleagues Adolph Gottlieb and Mark Rothko were associated with The Ten, a group of artists who explored the use of abstraction for expressive purposes. In 1936 he was a cofounder of American Abstract Artists. Bolotowsky was particularly influenced by Piet Mondrian and the Neoplasticist movement. His mural for the WPA Federal Art Project was one of the first to use complete abstraction. Bolotowsky worked throughout his career as a teacher at such schools as Black Mountain College (North Carolina), the University of Wisconsin, the State Teacher's College in New Paltz, New York, and Columbia University. It was not until 1974 that he received his first solo museum show, at the Guggenheim Museum in New York.

Edward Bruce *(b. Dover Plains, New York, April 13, 1879–d. Hollywood, Florida, January 27, 1943)*

Edward Bruce graduated from Columbia Law School in 1904 and went on to practice law and business until 1922, when he gave up his career as a lawyer and traveled to Italy to study art with the American painter and sculptor Maurice Sterne. In 1929, Bruce returned to the United States. Unable to sell his work during the Depression, he went back to business and lobbying. In 1933, Bruce was appointed administrator of the Public Works of Art Project, a federal program charged with organizing mural projects and easel paintings representing "The American Scene" to be done across the country in public buildings, thus creating employment for artists.

Charles Burchfield *(b. Ashtabula Harbor, Ohio, April 9, 1893–d. West Seneca, New York, January 10, 1967)*

Charles Burchfield developed an early affinity for nature through the writing of John Burroughs and Henry David Thoreau. From 1912 to 1916, Burchfield studied at the Cleveland School of Art. He was awarded a scholarship to the National Academy of Design in New York in 1916, but returned to Ohio after just one day of classes. In 1921, he moved to Buffalo, where he worked as a wallpaper designer for eight years. It was not until he became affiliated with the Frank Rehn Galleries in New York in 1929 that he was able to support his family through his fine art. Unlike many of his contemporaries, Burchfield did not travel abroad to study. He found his subjects in nature and the towns near his home. He worked almost exclusively in watercolor, using patterned and decorative effects to express multisensory experience in his highly poetic and personal work.

Alexander Calder *(b. Philadelphia, Pennsylvania, July 22, 1898–d. New York, New York, November 11, 1976)*

Alexander "Sandy" Calder was the son and grandson of prominent Philadelphia sculptors. He graduated from the Stevens Institute of Technology in Hoboken, New Jersey, in 1919 with a degree in mechanical engineering. After a series of jobs, he entered the Art Students League of New York in 1923 as a painter. Calder made his first wire sculpture in 1925. The following year he moved to Paris, where his experiments resulted in his famous *Cirque Calder*, a group of miniature wire figures with which he would perform carefully crafted shows. Calder made and exhibited wire sculptures in France and the United States in the late 1920s and early 1930s. In 1931 he created his first abstract wire sculptures and joined Abstraction-Création, a loose international alliance of artists who promoted abstract art as a counterinfluence to surrealism. He continued to explore sculptural ideas in wire and color, producing what became known as "mobiles," delicately balanced works that float through space. Calder returned to the United States in 1933. After World War II, Calder received numerous commissions, and his work became more monumental in scale. In 1953, he purchased a home in Saché, France, and divided his time between the United States and France.

Arthur B. Carles *(b. Philadelphia, Pennsylvania, March 9, 1882–d. Philadelphia, Pennsylvania, June 18, 1952)*

Arthur Beecher Carles, an important American painter who brought European modernism to America, studied at the Pennsylvania Academy of the Fine Arts from 1900 to 1907. A student of William Merritt Chase, he became interested in French impressionism and visited Paris in 1905. After this trip, scholarships allowed him to move in 1907 to France, where he stayed until 1910. In Paris, Carles became friends with John Marin and Edward Steichen, met Henri Matisse, and visited Gertrude and Leo Stein. He saw the work of modern French artists at first hand and responded especially to the paintings of Cézanne and Matisse. After returning to the United States, Carles associated with the avant-garde artists around Alfred Stieglitz in New York and became an advocate for modernism, teaching at the Pennsylvania Academy from 1917 to 1925 and privately in the 1930s. He is best known for his floral still lifes and nudes.

Jean Charlot *(b. Paris, France, February 8, 1898–d. Honolulu, Hawaii, March 20, 1979)*

Born and raised in Paris, Louis Henri Jean Charlot studied art at the École des Beaux-Arts before moving in 1921 to Mexico City, the original home of his mother's family. He spent his twenties living and working in Mexico, where he met Diego Rivera, José Clemente Orozco, and others who would become important founding artists of the Mexican mural movement. Charlot, who worked as an assistant to Rivera, was the first artist in modern Mexico to create a true fresco mural. In the mid-1920s he worked as a staff artist for the Carnegie Institute's archeological excavations at Chichén Itzá, Yucatán. Charlot followed Orozco to New York in 1928. In the 1930s and 1940s he taught at a number of schools, including the Art Students League. In 1949 Charlot began teaching at the University of Hawaii at Manoa, where he spent the rest of his long career. He developed an aesthetic sensibility that combined his understanding of cubism with the blocky forms and flat planes of Mayan and Aztec art.

William Merritt Chase *(b. Williamsburg, Indiana, November 1, 1849–d. New York, New York, October 25, 1916)*

William Merritt Chase studied with a local portrait painter before he moved to New York in 1869 and enrolled at the National Academy of Design. In 1872 he studied at the Royal Academy in Munich under Karl von Piloty. Returning to New York, Chase began a long teaching career with a post at the Art Students League. He also continued to travel abroad, teaching American students during the summers in England, Holland, Spain, and Italy. Chase was elected president of the Society of American Artists in 1885 and became a member of the National Academy of Design in 1890. He founded the Chase School in 1896 and taught at the Pennsylvania Academy of the Fine Arts in Philadelphia. In 1905 Chase was elected a member of The Ten American Painters, a group of artists who exhibited together and promoted the public acceptance of impressionism.

Ralston Crawford *(b. St. Catharines, Ontario, Canada, September 25, 1906–d. New York, New York, April 27, 1978)*

George Ralston Crawford, who was born near Niagara Falls, grew up in Buffalo, spending his childhood near Lake Erie and Lake Ontario. After a career as a sailor, he studied art from 1927 to 1932 at the Otis Art Institute in Los Angeles, the Pennsylvania Academy of the Fine Arts, the Barnes Foundation, and the Hugh Breckenridge

School in East Gloucester, Massachusetts, among others. Crawford traveled to Europe from 1932 to 1933 and attended Columbia University when he returned. He painted in rural Pennsylvania until 1939, focusing primarily on architectural forms, and taught before joining the army in 1942. In 1946 Crawford was sent by *Fortune* magazine to witness the atomic bomb test at Bikini Atoll. In 1950 he made the first of many trips to New Orleans, where he photographed black jazz musicians. He traveled extensively in the United States and Europe to paint, lecture, and teach.

Allan Rohan Crite (*b. Plainfield, New Jersey, March 20, 1910–d. Boston, Massachusetts, September 6, 2007*)

Allan Rohan Crite, a highly respected African American artist who claimed African, American Indian, and European ancestry, spent most of his life in Boston, where he took art classes at the Museum of Fine Arts and the Massachusetts School of Fine Art. He also studied business at Boston University, earned a bachelor's degree from Harvard University, and received numerous honorary doctorates. In the 1930s Crite worked for federal New Deal programs that included the Public Works of Art Project and the Works Progress Administration. In the 1940s he began a thirty-year career as a technical illustrator at the Department of the Navy. Although he was aware of modernism, Crite chose to work in a representational style because it seemed most natural to him as a storyteller.

Arthur B. Davies (*b. Utica, New York, September 26, 1862–d. Florence, Italy, October 24, 1928*)

The work of Arthur B. Davies blends late-nineteenth-century romanticism and early-twentieth-century American modernism. Davies studied at the Chicago Academy of Design and the School of the Art Institute of Chicago. After completing his education, he moved to New York, where he became a member of the Art Students League, exhibiting in New York and Boston. In 1895, he made his first trip to Italy. A leader of The Eight, a group of diverse artists opposed to the conservative style and juried exhibitions of the National Academy of Design, Davies was also an organizer of the 1913 Armory Show, which introduced European modernism to American

audiences. Toward the end of his life, Davies spent half of each year abroad.

Stuart Davis (*b. Philadelphia, Pennsylvania, December 7, 1892–d. New York, New York, June 24, 1964*)

Stuart Davis's father was the art editor of the *Philadelphia Press*, a major daily newspaper, and his mother was a sculptor. Davis attended the Robert Henri School of Art in New York from 1909 to 1912 and exhibited in the 1913 Armory Show the next year. Between 1912 and 1916 he supported himself as a magazine illustrator while experimenting with cubist abstraction. From 1928 to 1929, Davis lived in Paris, where he met the artist Fernand Léger. When he returned to New York, he taught at the Art Students League. From 1933 to 1939, he was a muralist for the federal Public Works of Art Project. Involvement with the artists' rights movement led to his election as president of the Artists' Union in the mid-1930s and as national chairman of the American Artists' Congress in 1937. After achieving success following World War II, Davis continued teaching, notably at New York's New School for Social Research (1940 to 1950) and at Yale University (1951).

Willem de Kooning (*b. Rotterdam, Netherlands, April 24, 1904–d. East Hampton, New York, March 19, 1997*)

Willem de Kooning was apprenticed at age twelve, in 1916, to a local commercial art and decorating firm in Rotterdam. For the next eight years he attended night classes at the Rotterdam Academy. In 1926 de Kooning entered the United States illegally at Newport News, Virginia; a year later he settled in New York, where he soon met John Graham, Arshile Gorky, Stuart Davis, and other avant-garde artists. Employed by the Federal Art Project of the Works Progress Administration in 1935, de Kooning was able to devote himself exclusively to painting for the first time. In the 1930s and 1940s he produced both figurative and abstract work. In 1953 he exhibited a group of controversial paintings of women at the Sidney Janis Gallery. These works secured his reputation as a leader of abstract expressionism and the New York School. He moved in 1963 to East Hampton, where he continued to be inspired by the landscape even as the subject of women returned to his work.

Charles Demuth (*b. Lancaster, Pennsylvania, November 8, 1883–d. Lancaster, Pennsylvania, October 25, 1935*)

Charles Demuth studied in Philadelphia at the Drexel Institute of Art from 1903 to 1905 and at the Pennsylvania Academy of the Fine Arts from 1905 to 1910. He made two trips to Paris before World War I; his first visit in 1907–8 introduced him to many of the current avant-garde styles. During his second time in Paris, from 1912 to 1914, he studied at the Académie Julian, the Académie Moderne, and the Académie Colarossi. In Paris, Demuth met Marsden Hartley, who became his close friend and mentor. In 1917 the two artists traveled to Bermuda, where they spent time with the French cubist painter Albert Gleizes. Demuth's cubist-inspired style emerged at this time in his precisionist architectural landscape paintings inspired by his surroundings. After his return to the United States, Demuth divided his time between his hometown of Lancaster and New York, with many summers in Provincetown, Massachusetts. Demuth also painted still life watercolors and industrial landscapes of his hometown. He was particularly well known for "poster portraits" of his artist contemporaries, a label he invented to describe his billboard style pictorial arrangements of objects, words, and letters that indirectly symbolized a person, instead of relying upon a mimetic representation.

Preston Dickinson (*b. New York, New York, September 9, 1889–d. Irun, Spain, November 25, 1930*)

William Preston Dickinson, who is known primarily as a precisionist, traced his interest in art to his father, an amateur painter who earned a living as a calligrapher and interior decorator. Between 1906 and 1910, Dickinson attended the Art Students League, where his teachers included William Merritt Chase. With the assistance of philanthropist Henry Barbey and his future dealer, Charles Daniel, Dickinson was able to live in Paris from 1910 to 1914. There he enrolled in the École des Beaux Arts and the Académie Julian and exhibited in the *Salon des Artistes Françaises* and the *Salon des Indépendants*. Dickinson's exploration of modernism was personal, varied, and empirical. His earliest precisionist works appeared around the time he started showing his art at the Daniel

Gallery in 1914. There his work was regularly featured in group exhibitions and was showcased in solo shows throughout the 1920s. Dickinson's art often celebrated technology and New York City. At the same time, personal struggles, including alcoholism, led to a series of health and financial problems. Still in the prime of his career, Dickinson died of pneumonia while traveling in Spain.

Richard Diebenkorn
(b. Portland, Oregon, April 22, 1922–d. Berkeley, California, March 30, 1993)

Richard Diebenkorn grew up in San Francisco, and attended Stanford University from 1940 to 1942 before joining the U.S. Marine Corps. Stationed near Washington, D.C., during World War II, Diebenkorn frequently visited The Phillips Collection, where he was influenced by the work of Paul Cézanne and Henri Matisse. After the war, in 1946, Diebenkorn enrolled at the California School of Fine Arts in San Francisco, where he received his degree in 1949. He earned an MFA from the University of New Mexico in Albuquerque in 1951 and briefly taught at the University of Illinois in Urbana before settling in Berkeley, California. Diebenkorn taught and worked in California for the rest of his career. He painted in an abstract expressionist style until 1955, when he began to incorporate figures into his compositions, returning to an abstract mode in 1967 with his *Ocean Park* series. In 1961 The Phillips Collection presented the first East Coast one-person museum exhibition of Diebenkorn's work.

Paul Dougherty
(b. Brooklyn, New York, September 6, 1877–d. Palm Springs, California, January 9, 1947)

Paul Dougherty expected to be a lawyer in his father's law practice. He became, instead, one of America's most important marine painters. Dougherty graduated in 1896 from Brooklyn Polytechnic Institute and attended New York Law School. Although he was admitted to the bar, he deserted the law in 1898. After studying painting briefly in New York, he left for Europe around 1900 to study the old masters. In 1902 or 1903, Dougherty returned to the United States and began to work on Monhegan Island, Maine, a summering place for painters. In 1904 he joined the Society of American Artists, younger painters who had broken away from the National Academy

of Design (NAD). Dougherty won almost every major award at the annual NAD exhibitions in New York and a Gold Medal at the 1915 Panama-Pacific International Exposition in San Francisco. He spent considerable time in the British Isles (especially at St. Ives on the Cornish Peninsula), the Caribbean, Europe, and Asia, and on both coasts of the United States. In 1928, Dougherty moved to the Monterey Peninsula in northern California, wintering in the desert at Palm Springs.

Arthur G. Dove
(b. Canandaigua, New York, August 2, 1880–d. Long Island, New York, November 22, 1946)

Arthur Dove grew up in Geneva, New York. He studied art and law at Cornell University in Ithaca, New York, graduating in 1903, after which he worked as an illustrator in New York City. From 1907 to 1909, Dove traveled in Europe, where he met Max Weber and Alfred Maurer. After returning to New York, he met Alfred Stieglitz, who became his mentor and lifelong dealer. Dove's abstractions reflect his strong connection to the natural world. Extremely poor for most of his career, Dove moved in 1921 to a houseboat on the Harlem River in Manhattan; from 1924 to 1933, he lived on a sailboat in Huntington Harbor off Long Island. In the mid-1930s he lived on the family property in Geneva, returning to Long Island in 1937. From 1930 until his death, Dove received a monthly stipend from Duncan Phillips, which allowed the artist to focus exclusively on his painting.

Thomas Eakins
(b. Philadelphia, Pennsylvania, July 25, 1844–d. Philadelphia, Pennsylvania, June 25, 1916)

Thomas Eakins studied at the Pennsylvania Academy of the Fine Arts in Philadelphia from 1862 to 1865, while also taking anatomy courses at Jefferson Medical College. In Paris in 1866 he studied at the École des Beaux-Arts under Jean-Léon Gérôme. He traveled to Italy, Germany, Belgium, Switzerland, and Spain before returning to Philadelphia in 1870 to open a studio. In 1876 Eakins began teaching at the Pennsylvania Academy of the Fine Arts, where he became director in 1882. His methods, especially the use of nude models for life drawing, came under scrutiny and he was forced to resign in 1886. In protest, his students formed the Art Students

League of Philadelphia, with Eakins as their instructor. Thereafter, Eakins concentrated on portraiture with close attention to factual detail and psychological presence. He painted regularly until his health began to fail in 1911.

Louis Michel Eilshemius
(b. North Arlington, New Jersey, February 4, 1864–d. New York, New York, December 29, 1941)

The grandson of Swiss painter Louis-Léopold Robert, Louis Michel Eilshemius was born into a wealthy, prominent family. He attended schools in Switzerland and Dresden before going to Cornell University for two years; he left Cornell to study at the Art Students League in New York and in 1886 studied in Paris at the Académie Julian. Returning to New York, Eilshemius exhibited his work at the Salmagundi Club and was accepted into two juried shows at the National Academy of Design. In the late 1890s and early 1900s he traveled throughout Europe, North Africa, the United States, and the South Seas. After he returned to New York, his work became increasingly idiosyncratic, depicting moonlit landscapes that were often populated with nymphs frolicking in forests or waterfalls or floating through the air. Praised by Marcel Duchamp in 1917, Eilshemius, with Duchamp's assistance, had his first solo exhibition at the Société Anonyme in New York in 1920. Confined to a wheelchair after an automobile accident in 1932, Eilshemius became increasingly reclusive and mentally ill, unable to appreciate the renewed interest in his work. More than twenty-five solo shows of his work were held between 1932 and his death in 1941.

Lyonel Feininger
(b. New York, New York, July 17, 1871–d. New York, New York, January 13, 1956)

A leading expressionist painter, Lyonel Feininger spent much of his career in Europe. He was born in New York to a German American violinist and composer and an American singer. His parents sent him to Germany in 1887 to study music, but he chose to focus on art, attending art schools in Hamburg, Berlin, and Liège from 1887 to 1892. He then worked as a caricaturist and began exhibiting his oils in 1910 and 1911 in Berlin and Paris. Feininger met the artists of Die Brücke before exhibiting with the Blaue Reiter group in Munich and the avant-garde Der Sturm

gallery in Berlin. In 1919 he was appointed the first master of the Bauhaus School at Weimar. Along with Paul Klee, Wassily Kandinsky, and Alexei Jawlensky, Feininger formed the exhibiting group known as the Blaue Vier (Blue Four) in 1924. In honor of his sixtieth birthday, the National Gallery in Berlin gave him his first retrospective. Five years later, after the Nazi Party declared him a "degenerate artist," Feininger accepted a summer teaching position at Mills College in California in 1936. He permanently returned to America in 1937, ultimately settling in New York. In 1944 the Museum of Modern Art gave him his first U.S. retrospective.

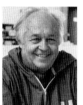

Sam Francis (*b. San Mateo, California, July 25, 1923– d. Santa Monica, California, November 4, 1994*)

Sam Francis was a medical student at the University of California, Berkeley, when he joined the U.S. Army Air Corps in 1943. During flight training he injured his spine, and while recuperating he began to paint in watercolors. Encouraged by the painter David Park, an instructor at the California School of Fine Arts, who visited him in the hospital, Francis ultimately returned to Berkeley in 1948 and earned his Master of Arts degree. He subsequently moved to Paris, where he enrolled briefly at the Académie Fernand Léger. The art of Claude Monet, Pierre Bonnard, and Henri Matisse was essential to his stylistic development. In the 1950s, Francis was considered the foremost American painter in Paris. His first museum show was in 1955 at the Kunsthalle in Bern, Switzerland; American success soon followed. In 1962, Francis moved to Santa Monica, California, but he maintained studios in Paris, Tokyo, and Bern.

Helen Frankenthaler (*b. New York, New York, December 12, 1928–d. Darien, Connecticut, December 27, 2011*)

A widely acclaimed member of the New York School and a leading figure among the second-generation abstract expressionists, Helen Frankenthaler was born into a wealthy Manhattan family. She studied under the artist Rufino Tamayo at the exclusive Dalton School on the Upper East Side and then at Bennington College in Vermont. In 1950 she studied with Hans Hofmann and met the critic Clement Greenberg, as well as Jackson Pollock, Lee Krasner, David Smith, Willem de Kooning, and other New York School artists. Her breakthrough painting, *Mountains and Sea* (1952), relied on a staining technique that involved pouring thinned pigment onto unprimed canvas, creating effects reminiscent of watercolor on a monumental scale. Frankenthaler's mature style developed away from gestural abstraction and inspired artists such as Morris Louis and Kenneth Noland. From 1958 to 1971 Frankenthaler was married to Robert Motherwell. In 2001 she was awarded the National Medal of Arts.

Albert Eugene Gallatin (*b. Villanova, Pennsylvania, July 23, 1881–d. New York, New York, June 15, 1952*)

Descended from a distinguished family that founded New York University, Albert Eugene Gallatin is remembered as an influential collector and connoisseur of modern painting as well as one of the Park Avenue Cubist painters. Financially independent after his father's death in 1902, Gallatin left law school to devote himself to collecting and writing about art. At that time New York had no museum of modern art; in 1927 Gallatin used his collection to found the Gallery of Living Art (later renamed the Museum of Living Art) at New York University, a gallery devoted exclusively to works by contemporary American and European artists. Having studied with Robert Henri in Paris in 1926, Gallatin returned to painting in 1936, especially inspired by his appreciation for the cubist works of Pablo Picasso, Georges Braque, and Juan Gris. In 1937 he joined the American Abstract Artists group. Faced with faculty opposition at New York University and financial problems, Gallatin later closed the Museum of Living Art, transferring the collection to the Philadelphia Museum of Art in 1943.

Sam Gilliam (*b. Tupelo, Mississippi, November 30, 1933*)

One of America's foremost lyrical abstractionists, Sam Gilliam grew up in Louisville, Kentucky, where his family had moved shortly after his birth. He began painting as a child. After receiving a master's degree in fine arts from the University of Louisville, Gilliam moved to Washington, D.C., in 1962. Following an early figurative period, he sought to find his voice in color abstraction. Influenced by the German expressionists and the major figures of the New York School, Gilliam became friends in Washington with Thomas Downing, one of the artists of the Washington Color School. Around 1965 Gilliam began experimenting with the idea of unsupported canvas and in 1968 he established his place among the American avant-garde with the creation of color-stained draped works suspended from walls and ceilings. For many years Gilliam taught at the Corcoran School of Art in Washington, the Maryland Institute College of Art in Baltimore, and the University of Maryland, among other institutions. He lives and works in Washington.

William Glackens (*b. Philadelphia, Pennsylvania, March 13, 1870–d. Westport, Connecticut, May 22, 1938*)

William Glackens attended high school in Philadelphia with the painter John Sloan and the collector Albert C. Barnes. While he worked as an artist-reporter for Philadelphia newspapers, he took night classes at the Pennsylvania Academy of the Fine Arts. For a time, he shared a studio with Robert Henri, whom he met through Sloan. Glackens traveled to France and the Netherlands in 1895 before moving to New York. In 1898 he accompanied the U.S. Army to Cuba to document the Spanish-American War for *McClure's* magazine. Glackens gave up illustration in 1904 to focus on painting, exhibiting with The Eight, including Henri and Sloan, in 1908 at Macbeth Galleries in New York. His change to a more impressionist style was influenced by his frequent trips to France, including a 1912 journey to purchase contemporary French art for Barnes. Glackens served on the selection committee for American art for the 1913 Armory Show. From 1925 to 1932 he divided his time between New York and France.

Adolph Gottlieb (*b. New York, New York, March 14, 1903–d. East Hampton, New York, March 4, 1974*)

A native New Yorker, Adolph Gottlieb attended the Art Students League in New York, traveled in Europe from 1921 to 1922, and resumed his studies at the Art Students League with John Sloan in 1923. Gottlieb developed friendships with Mark Rothko, John Graham, and Milton Avery, who became his mentor during the 1930s. In 1935, Gottlieb became a founding member of The Ten, a group of artists, including Rothko,

who were interested in exploring abstraction for expressive purposes. He worked in 1936 and 1937 for the WPA's Federal Art Project, and in 1936 joined the Artists' Union and became a founding member of the American Artists' Congress. A trip to Arizona in 1937–38 stimulated his interest in Native American art; he also began to collect African art at this time. These interests, along with the influence of surrealism, led Gottlieb to develop his unique pictographs. In the 1950s and 1960s Gottlieb's large-scale abstractions showed his interest in color field painting and abstract symbolism.

John D. Graham (*b. Kiev, Russia, January 8, 1887–d. London, England, June 27, 1961*)

John Graham, a seminal figure in American modernism, was baptized in Kiev, Russia, but may have been born in Warsaw. He fought in the Russian Revolution on the side of the czar before fleeing to the United States in 1920. In 1923 he enrolled at the Art Students League in New York, where he worked as an assistant to John Sloan for a short time. In 1925, Graham exhibited in the *Tenth Whitney Studio Annual Exhibition* and moved to Baltimore to teach. His first solo museum exhibition was at The Phillips Collection in 1929. Graham, who divided his time between New York and Paris, was instrumental in the transfer of European modernist ideas to the United States, acting as an art connoisseur, collector, and mentor. He was close friends with Stuart Davis and Adolph Gottlieb and was a significant influence on the abstract expressionists Willem de Kooning and Jackson Pollock, among others.

Morris Graves (*b. Fox Valley, Oregon, August 28, 1910–d. Loleta, California, May 5, 2001*)

Morris Graves, who moved with his family to Seattle, Washington, at the age of two, formed spiritual ties with the culture and terrain of the Pacific Northwest that affected his art for his whole career. A brief service in the merchant marine at the age of seventeen took him to Asia, which also had lasting effects on his work. Back in the United States, Graves received his first art education while finishing high school in Beaumont, Texas. He returned to Seattle, where he began painting full time. He first received national recognition in 1942, when thirty of his paintings were included in an exhibition at the

Museum of Modern Art. Graves traveled widely in Europe, Japan, and Mexico, living in Ireland on and off for eight years, starting in 1954, before settling in northern California in 1964. His art was shaped by surrealism, the work of Mark Tobey, Zen Buddhism, and aspects of Asian art. In the 1960s he experimented with three-dimensional work.

Philip Guston (*b. Montreal, Canada, June 27, 1913–d. Woodstock, New York, June 7, 1980*)

Philip Guston moved to Los Angeles in 1919 with his family. He attended the Manual Arts High School in 1927, where he became friends with Jackson Pollock. In 1930 Guston received a scholarship to Otis Art Institute in Los Angeles, but he left after three months because it limited him to drawing from plaster casts. In the winter of 1935–36, he moved to New York and worked on murals for the Works Progress Administration through the Federal Art Project. His first teaching position was at the State University of Iowa from 1941 to 1945. In 1945 he had his first solo exhibition at a New York gallery. From 1948 to 1949, the Prix de Rome took Guston to Europe. Afterward, he moved to New York, where his circle included Willem de Kooning, Franz Kline, Mark Rothko, and John Cage. Guston's paintings were figurative and contained social commentary until the early 1950s, when he began painting dense, colorful abstractions. He returned to Europe in 1960 and Italy in 1970. In 1967, he moved to Woodstock, New York, in the Catskill Mountains. In the same year he shocked the art world with a figurative, symbolic, cartoon-inspired style of painting.

Marsden Hartley (*b. Lewiston, Maine, January 4, 1877–d. Ellsworth, Maine, September 2, 1943*)

Marsden Hartley grew up in Ohio, where he studied at the Cleveland School of Art. He received a five-year stipend to study in New York in 1898. For a year Hartley studied under William Merritt Chase. He then attended the National Academy of Design until 1904, painting landscapes in Maine during the summers. Alfred Stieglitz gave Hartley his first solo exhibition in 1909, and another in 1912. This enabled Hartley to travel widely in Europe, where he remained until 1915. He met many European modernists and

exhibited with the Blaue Reiter group in Berlin in 1913. When he returned to New York, he became associated with avant-garde art circles and traveled to New Mexico, as well as Bermuda. He also wrote critical essays, which were published in his book *Adventures in the Arts* (1921). Hartley returned to Europe in 1921, remaining until 1930. He lived in New York off and on in the 1930s, ultimately settling in his home state of Maine in 1937. Hartley found inspiration in the rugged wilderness of Maine, where he pursued his original vision of the landscape and its people.

Childe Hassam (*b. Dorchester, Massachusetts, October 17, 1859–d. East Hampton, New York, August 27, 1935*)

Frederick Childe Hassam began his career as a commercial lithographer and illustrator in Boston before studying at the Boston Art Club and the Lowell Institute and taking private painting lessons. In 1886, Hassam made his first trip to Europe, settling in Paris for the next three years, where he studied at the Académie Julian under Gustave Boulanger and Jules Lefebvre. Upon his return to the United States in 1889, he moved from Boston to New York, where he became well known for his impressionist city views. He returned to Europe twice between 1897 and 1910, visiting Pont-Aven in France, where many post-impressionists were painting. In 1897, Hassam, Julian Alden Weir, and John Henry Twachtman cofounded The Ten American Painters, a group of artists who exhibited together and promoted the public acceptance of impressionism. After spending summers at various seaside resorts since 1882, in 1920 he established a permanent summer studio at East Hampton, Long Island. He painted and exhibited regularly throughout his long life.

Robert Henri (*b. Cincinnati, Ohio, June 24, 1865–d. New York, New York, July 12, 1929*)

Robert Henri, born Robert Henry Cozad, moved at a young age to Cozad, Nebraska, a town founded by his father. In 1886 Henri studied at the Pennsylvania Academy of the Fine Arts in Philadelphia under Thomas P. Anshutz, a former pupil of Thomas Eakins. Henri then studied in Paris at the Académie Julian and the Académie des Beaux-Arts from 1888 to 1891. In 1892 he began teaching at the Philadelphia School of Design for Women. A trip to Europe in

1895 introduced him to the work of Frans Hals and Diego Velázquez. Henri's following soon included William Glackens, George Luks, Everett Shinn, and John Sloan. In 1900 Henri moved to New York. There he established his own school and became a popular teacher of such artists as Edward Hopper, Rockwell Kent, George Bellows, Stuart Davis, and Yasuo Kuniyoshi. Henri broke with the National Academy of Design in 1907 and became the driving force behind the 1908 exhibition at the Macbeth Galleries of The Eight, a group of American artists who challenged the academy's authority over exhibitions, and the 1910 *Exhibition of Independent Artists*. Henri's book *The Art Spirit* (1923) had a tremendous impact on young artists in America and Europe.

Edward Hicks
(b. Attleborough [now Langhorne], Pennsylvania, April 4, 1780–d. Newtown, Pennsylvania, August 23, 1849)

Edward Hicks was raised by a Quaker family after the death of his mother when he was eighteen months old. At age thirteen, he was apprenticed to the Tomlinson brothers, who were coachbuilders. Unhappy in the rough company of the coachmen, Hicks formally joined the Religious Society of Friends (Quakers) in 1803. Soon recognized as a minister within the Quaker faith, he traveled thousands of miles to spread the word, uncompensated in any way. Eventually he established himself in Milford, Pennsylvania, where he painted coaches and signs and decorated household objects. By 1920 he had begun easel painting. Scenes based on the biblically inspired theme of "the peaceable kingdom" became his specialty.

Stefan Hirsch
(b. Nuremberg, Germany, January 2, 1899–d. New York, New York, September, 29, 1964)

Stefan Hirsch, a modern artist closely aligned in style with the precisionists, was born in Germany to American parents. While growing up, he frequented museums and galleries in Europe, becoming familiar with the old masters and the innovations of contemporary painters. After studying law and art in Switzerland at the University of Zurich, Hirsch settled in New York in 1919. Attracted to the manufactured world and the American machine aesthetic, Hirsch painted images of industrial subjects in the 1920s in a hard-edged

geometric style. These highly structured early works reveal his debt to Paul Cézanne, Charles Demuth, and Charles Sheeler. In 1929 Hirsch traveled to Mexico, where he was befriended by muralists David Siqueiros and Diego Rivera. Their works influenced Hirsch's social realist paintings of the 1930s, which became increasingly painterly and luminous. In the 1930s and 1940s, Hirsch taught at Bennington College in Vermont and the Art Students League in New York. In 1942, he joined the faculty at Bard College in Annandale-on-Hudson, New York, where he remained until retiring in 1961 as the chair of the art department.

Winslow Homer
(b. Boston, Massachusetts, February 24, 1836–d. Prout's Neck, Maine, September 29, 1910)

Winslow Homer, one of America's great realist painters of the nineteenth century, was raised in rural Cambridge, Massachusetts. Encouraged by his mother, a watercolorist, he began to discover the moods and look of the natural environment. Apprenticed at age nineteen to a commercial lithographer, Homer began a prolific career as an illustrator that took him to the battlefields of the Civil War and continued into the 1870s. In 1862 he began to work in oil, using as his subjects sketches made on the battlefront. Homer was elected to the National Academy of Design in New York in 1865; the next year, he traveled to Paris, where he was influenced by the naturalism of the Barbizon school. He traveled to England's Northumberland coast in 1881 and settled in 1883 on the coast of Maine in Prout's Neck, a town where his father and brother had built large summerhouses. Both experiences led him to concentrate on the heroism of the fishermen and women who struggled to survive nature at its fiercest. Homer made limited trips to New York, preferring the isolation of Maine's rocky coast. By 1900, his paintings focused increasingly on the ferocity of nature alone.

Edward Hopper
(b. Nyack, New York, July 22, 1882–d. New York, New York, May 15, 1967)

Edward Hopper showed an early interest in art and was encouraged to become an illustrator by his parents. He studied at the New York School of Art under Robert Henri and Kenneth Hayes Miller, both of whom emphasized truthful, contemporary

subjects; their influence was vital to Hopper's development as a realist artist. Hopper made three long visits to Paris between 1906 and 1910, but he was not inspired by modern art. Although he sold his first oil painting at the 1913 Armory Show, he was obliged to continue working as a commercial illustrator. In 1920 Hopper had his first one-person exhibition at the Whitney Studio Club in New York; in 1924 he sold all his works from a solo show at a New York gallery, which allowed him to dedicate himself solely to his painting. Throughout his life, Hopper lived and worked in a small apartment in Greenwich Village, New York, with regular trips to New England. He continued to paint in a realist style that synthesized and distilled his observations of the isolation of contemporary life into hauntingly familiar scenes.

George Inness
(b. Newburgh, New York, May 1, 1825–d. Bridge of Allan, Central Scotland, August 3, 1894)

George Inness, one of America's foremost landscape painters of the late nineteenth century, studied art in New York with Régis Gignoux, a French landscape painter. In 1851, Inness made a fifteen-month trip to Italy, and in 1853 he traveled to France, where he discovered Barbizon landscape painting. After working in New York from 1854 to 1859, Inness moved to Medford, Massachusetts, and then to New Jersey. At this time he developed an interest in the religious theories of Emanuel Swedenborg. Inness's paintings of the 1860s show sweeping panoramic views of the Catskill Mountains, the Delaware Valley, and the New Jersey countryside. In 1868 Inness was elected to the National Academy of Design. He returned to Europe in 1870 and lived in Rome from 1871 to 1875. Two years later he returned to New York, where he helped found the Society of American Artists. In 1878 he settled in Montclair, New Jersey, but continued to travel around the southern and eastern United States, Cuba, and California to paint evocative landscapes. He made his last trip abroad in 1894, visiting France, Germany, and Scotland, where he died.

John Kane
(b. West Calder, Midlothian [now Lothian], Scotland, August 19, 1860–d. Pittsburgh, Pennsylvania, August 10, 1934)

John Kane, born to Irish parents in Scotland, left

school at age nine to work in the coal mines. He immigrated to western Pennsylvania in 1879, eventually settling in Alabama, where he worked as a coal miner and bricklayer for two years. He began sketching local scenery and drew crude landscapes. By 1890, he was paving streets in Pittsburgh, where his family lived. After losing his leg in a train accident in 1891, Kane worked as a watchman and was later employed painting freight cars. He often sketched landscapes on the cars before covering them with paint. The death of an infant son in 1904 led him into years of wandering, working as an itinerant house painter and carpenter. By the end of World War I, Kane was back in Pittsburgh, where he spent the rest of his life. In 1927 he submitted work to the jury of the *Carnegie International Exhibition* in Pittsburgh and had one of his paintings accepted. Eventually he gained recognition for his characteristic folk style, which features meticulous detail and flat color. Before his death in 1934 he received numerous honors and museum exhibitions.

Bernard Karfiol (*b. Budapest, Hungary, May 6, 1886– d. Irvington-on-Hudson, New York, August 16, 1952*)

Known especially for his romanticized images of youth, Bernard Karfiol was born in Budapest to American parents of Austrian and Hungarian ancestry. He grew up on Long Island near his father's business, Royal Lace Paper Work. A precocious teenager, he was admitted to the National Academy of Design when he was just fourteen. In 1902 Karfiol moved to Paris to study at the Académie Julian. In Paris he was exposed to early European modernism and associated with Gertrude and Leo Stein and their circle. When he returned to the United States in 1906, Karfiol devoted himself to painting, and his work was included in the 1913 Armory Show. He taught art at Gertrude Vanderbilt Whitney's Eighth Street Studio. In 1914, at the invitation of the painter Hamilton Easter Field, Karfiol began summering in Ogunquit, Maine. The New England landscape and the rocky coast became backgrounds for his figure subjects.

Rockwell Kent (*b. Tarrytown, New York, June 21, 1882–d. Au Sable Forks, New York, March 13, 1971*)

Rockwell Kent first studied painting in the summer of 1900 under William Merritt Chase while attending Columbia University's School of Architecture. In 1904 he enrolled in the New York School of Art, where he studied with the realist painters Robert Henri and Kenneth Hayes Miller. Kent's many interests included architecture, painting, carpentry, illustration, and writing, which were enhanced by his travels, often to exotic locales such as Newfoundland, Alaska, Tierra del Fuego, France, Ireland, Greenland, and the Soviet Union. Although grounded in the American realist tradition, Kent rarely painted urban scenes like those by his contemporaries George Bellows and John Sloan. Instead he drew inspiration from nature's grandeur and humanity's relationship to nature's forces. He participated in most of the progressive exhibitions of the time, except the 1913 Armory Show. Duncan Phillips was one of Kent's first patrons, providing material support as early as 1918. In 1935 the federal Works Progress Administration commissioned Kent to paint two murals for the Washington, D.C., post office building. Although Kent enjoyed acclaim as a major American artist during the 1930s, his artistic achievements were ultimately overshadowed by his political activities. In 1960 Kent presented the Soviet Union with eighty of his paintings.

Karl Knaths (*b. Eau Claire, Wisconsin, October 21, 1891–d. Hyannis, Massachusetts, March 10, 1971*)

An early modernist who worked in a cubist idiom, Karl Knaths studied at the Art Institute of Chicago from 1912 to 1916. As a guard at the Chicago presentation of the 1913 Armory Show, Knaths was exposed to modern painting and began to incorporate a progressive style, especially influenced by Paul Cézanne, into his own work. After a stay in New York in 1919, he became a lifelong resident of Provincetown, Massachusetts, a fishing village and artists' colony at the tip of Cape Cod, where he exhibited regularly with the Provincetown Art Association. In 1927, Knaths and a group of artists broke with the association and began to present the *Provincetown Modern Art* exhibitions. Knaths also exhibited in New York frequently. Influenced by Wassily Kandinsky, Knaths became interested in music and believed that there were correspondences between musical intervals and spatial proportions. From 1934 to 1935 he worked as a muralist for the federal Works Progress Administration. An outstanding teacher, Knaths taught and lectured at several institutions, including The Phillips Collection, where he led an annual six-week summer course from 1938 to 1945. The Phillips Collection holds the largest collection of Knaths's work, which includes representative works from his entire oeuvre in all media.

Walt Kuhn (*b. Brooklyn, New York, October 27, 1877–d. White Plains, New York, July 13, 1949*)

Walt Kuhn was not only a well-known painter but also a cartoonist, sculptor, printmaker, writer, teacher, and producer of vaudeville shows. Educated in private schools until he was sixteen, Kuhn traveled in 1899 to San Francisco to work as a cartoonist for the political and literary magazine *Wasp*. He went to Europe in 1901 to study at the Académie Colarossi in Paris and later at the Munich Academy. Returning to New York in 1903, Kuhn established a studio in Manhattan and helped arrange the 1910 *Exhibition of Independent Artists*. He was a founding member of the Association of American Painters and Sculptors, the organization responsible for mounting the 1913 Armory Show, and in this role he traveled through Europe in 1912 looking at art and helping to select works for that exhibition. Seeing paintings by Paul Cézanne, André Derain, Raoul Dufy, Jules Pascin, and the cubists affected his style. Kuhn abandoned his theatrical work to focus exclusively on his painting in 1925. Many of his mature works depict performers, reflecting his experience as a vaudeville producer.

Yasuo Kuniyoshi (*b. Okayama, Japan, September 1, 1893–d. New York, New York, May 14, 1953*)

Yasuo Kuniyoshi migrated from Japan to the United States as a teenager in 1906, working as a porter in a Seattle office building before he relocated the next year to study at the Los Angeles School of Art in California. In 1910 Kuniyoshi moved to New York, where he studied with Robert Henri at the National Academy of Design and the Independent School of Art. From 1916 to 1920, he worked with Kenneth Hayes Miller at the Art Students League. In the early 1920s, Kuniyoshi spent summers in Ogunquit, Maine. He traveled to Europe in 1925 and 1928, spending most of his time in Paris, Venice, and other parts of Italy. In 1933, Kuniyoshi began teaching at the Art Students League and worked on the Federal Art Project of the Works Progress Administration. He won a Guggenheim fellowship in 1935 and

was a founding member of the American Artists' Congress before serving as the first president of the Artists Equity Association from 1947 to 1951. In 1947 Kuniyoshi was the first living artist to have a one-artist exhibition at the Whitney Museum of American Art; he exhibited at the 26th Venice Biennale in 1952.

John La Farge (b. New York, New York, March 31, 1835–d. Newport, Rhode Island, November 14, 1910)

Born in New York to wealthy parents, John La Farge was brought up speaking both English and French. He received his first artistic training at age six and learned to use watercolors while still in grammar school. At age twenty-four he went to Paris to study painting under Thomas Couture and discovered the work of the English pre-Raphaelite painters Gabriel Dante Rossetti and John Everett Millais. La Farge returned to the United States in 1859, beginning his career as an artist in Newport, Rhode Island. In 1876 he was commissioned to design the mural and stained glass interior of Trinity Church in Boston, Massachusetts. La Farge traveled widely and is well known for watercolor paintings made during his travels, particularly his visit to the South Seas in 1890–91. These watercolors were produced *en plein air* and are characterized by exotic subjects, spontaneous brushwork, and delicately defined figures.

Jacob Lawrence (b. Atlantic City, New Jersey, September 7, 1917–d. Seattle, Washington, June 9, 2000)

Jacob Lawrence was born to parents originally from the rural South. After his parents separated, he lived in settlement houses and foster homes until his mother could support him and his two younger siblings in New York. Lawrence discovered art after moving to New York in 1930. His art education included after-school workshops where he studied under Charles Alston. Lawrence received a scholarship to the American Artists School and gained notice for his portrayals of historical events and African American urban life. In 1938 he had his first solo exhibition at the Harlem YMCA and started work as an easel painter for the Works Progress Administration. In 1941 Lawrence exhibited his series *The Migration of the Negro* (a title he later changed to *The Migration Series*) at the Downtown Gallery in New York. Lawrence was the first artist of color to be represented by a major New York gallery, and the exhibition gave him national prominence. Lawrence taught at Black Mountain College, the Skowhegan School of Painting and Sculpture, and the New School for Social Research. In 1971 he joined the faculty of the University of Washington in Seattle.

Ernest Lawson (b. Halifax, Nova Scotia, March 22, 1873–d. Miami, Florida, December 18, 1939)

Ernest Lawson, who painted in an impressionist style, was born in Nova Scotia. He studied at the Art Students League in New York from 1891 to 1892, taking summer classes in plein air painting at Cos Cob, Connecticut, from Julian Alden Weir and John Henry Twachtman. From 1893 to 1896, Lawson lived in France, where he briefly attended the Académie Julian, but mostly developed his technique as an outdoor painter; while there, he met the artist Alfred Sisley. Returning to New York in 1898, Lawson joined the rebellion against the National Academy of Design when his work was rejected for exhibition in 1905. Through his friend William Glackens, he became associated with the artists known as The Eight, dedicated to challenging the dominance of the academy. Lawson joined the *Exhibition of Independent Artists* in 1910 and exhibited at the 1913 Armory Show. Lawson won gold medals at the Pennsylvania Academy of the Fine Arts in 1907 and at the Panama Pacific Exposition in 1915. In 1916 he spent the year in Spain. In later life, Lawson's alcoholism damaged his health, private life, and career.

Doris Lee (b. Aledo, Illinois, February 1, 1905–d. Woodstock, New York, June 16, 1983)

One of the most successful Depression-era female artists, Doris Emrick Lee was born in western Illinois near the Mississippi River. Raised in a large family of amateur artists, she began painting as a child. She studied at the Kansas City Art Institute with Ernest Lawson, in Paris with cubist painter André Lhote, who encouraged her to explore abstraction, and in San Francisco at the California School of Fine Arts with Arnold Blanch, whom she later married. Settling in New York City, Lee and her husband spent summers in Woodstock, New York. Blanch convinced Lee to choose subjects of personal appeal and collaborated with her on some projects.

During the Depression, Lee's lively paintings were popular for their decorative qualities and positive emphasis on American experiences. In 1935 she was awarded the Logan Prize at the Art Institute of Chicago. She was successful throughout her career as a painter of the American scene, as well as an author, illustrator, and textile designer. Lee retired from painting at the end of the 1960s.

Seymour Lipton (b. New York, New York, November 6, 1903–d. Glen Cove, New York, December 5, 1986)

One of the foremost abstract sculptors of the twentieth century, Seymour Lipton originally trained as a dentist, graduating from Columbia University in 1927. Soon after, however, he began experimenting with wood sculpture. From 1942 to 1944 he taught at the Cooper Union. In the mid-1940s, Lipton began using metal, both because of its greater flexibility and because he considered it more suited to the machine age. In 1951 he discovered Monel, an industrial alloy available in thin sheets that could be transformed into abstract shapes. Onto the Monel he fused or hammered thin amounts of other metals such as silver, nickel, lead, or copper to create textured surfaces. Through his metal sculpture, he strove to portray the inner complexities of the human psyche. Lipton taught from 1950 to 1965 at the New School for Social Research.

Morris Louis (b. Baltimore, Maryland, November 28, 1912–d. Washington, D.C., September 7, 1962)

A member of the Washington Color School, Morris Louis Bernstein was the son of Russian-Jewish immigrants. He graduated from the Maryland Institute of Fine and Applied Arts in 1932 and moved to New York in 1936, at which time he dropped his surname. During the Depression, Louis worked for the Works Progress Administration before returning to Maryland in the early 1940s. In 1952 he moved to Washington, D.C., where he secured a teaching position at the Washington Workshop Center of the Arts and became friends with Kenneth Noland. A trip to New York in April 1953 with Noland and the critic Clement Greenberg exposed Louis to Helen Frankenthaler's method of applying liquid paint onto unprimed canvas. Louis soon embraced this technique, creating abstract works distinctly his

own, achieving international recognition and commercial success in New York and Paris.

George Luks (*b. Williamsport, Pennsylvania, August 13, 1866–d. New York, New York, October 29, 1933*)

An American realist artist admired for his true-to-life depictions of modern life, George Luks studied art in 1884 at the Pennsylvania Academy of the Fine Arts in Philadelphia and then at the Staatliche Kunstakademie in Düsseldorf in 1889. Preferring to study on his own, Luks traveled to Paris and London in 1889 and 1890. In 1894, he became an illustrator for the *Philadelphia Press*, befriending William Glackens, Robert Henri, Everett Shinn, and John Sloan. By 1896 Luks had moved to New York to draw illustrations for the *New York World*. After his painting was rejected by the National Academy of Design in 1907, he exhibited in 1908 with Glackens, Henri, Shinn, Sloan, and others as a member of The Eight; he also exhibited at the 1913 Armory Show. His paintings of pigs and other supposedly low subjects made him the most subversive member of what contemporary critics called the "ashcan school." In the early 1920s Luks made several painting trips to the coal region of Pennsylvania, where he once worked as a breaker boy. From 1920 to 1924 he taught at the Art Students League, then started the George Luks School of Painting in New York.

Peppino Mangravite (*b. Lipari, Italy, June 28, 1896–d. Westport, Connecticut, October 2, 1978*)

Peppino Mangravite moved from Italy to New York with his father in 1914 at age eighteen, having already completed six years of traditional art training at the Scuole Tecniche di Belle Arti in Carrara and a brief period of study in Paris. In New York, Mangravite enrolled in the art school at the Cooper Union in 1914, then transferred to the Art Students League in 1917, where he studied under Robert Henri. From 1926 to 1928 he taught at the Potomac School in Washington, D.C. In Washington, Mangravite met Duncan Phillips, who became his first important patron. Recognition and success came in the 1930s, a decade in which Mangravite received two Guggenheim fellowships and was included in the 1938 Venice Biennale in Italy. He was also active in New Deal art programs,

receiving commissions from the U.S. Treasury Department to paint murals for the Department of Labor and for post offices in Hempstead, New York, and Atlantic City, New Jersey. A prominent art teacher for over fifty years, Mangravite held teaching positions at the Art Institute of Chicago, Sarah Lawrence College, and Columbia University. He was also a noted critic who regularly contributed reviews and articles to art journals.

Man Ray (*b. Philadelphia, Pennsylvania, August 25, 1890–d. Parks, France, November 18, 1976*)

Born Emmanuel Radnitzky in Philadelphia, Man Ray was a pioneer of modernism and photography. The Radnitzky family moved to Brooklyn when he was seven, changing their surname to "Ray" in 1912 in an effort to de-ethnicize themselves. Man Ray went a step further by shortening his first and last names into one new persona. Man Ray studied at the Art Students League, the National Academy of Design, and the Ferrer School. Influenced by New York dada and Marcel Duchamp, who was then living in New York, Man Ray abandoned conventional painting around 1917 in order to make objects and assemblages, while also developing new ways of making mechanical and photographic images. In 1921 he moved to Paris, where he became a distinguished photographer. He influenced other avant-garde photographers with his many photographic innovations, which included the "rayograph," a photograph created by exposing objects directly on photosensitive paper. Man Ray returned to the United States during World War II and lived in Hollywood. In 1951 he moved back to France, where he worked for the remainder of his life.

John Marin (*b. Rutherford, New Jersey, December 23, 1870–d. Cape Split, Maine, October 2, 1953*)

An early American modernist, John Marin grew up in New Jersey. From 1899 to 1901, he studied at the Pennsylvania Academy of the Fine Arts with realist painters Hugh Breckinridge and Thomas P. Anshutz. After only a few weeks in 1905 at the Art Students League in New York, Marin headed to Europe. In Paris in 1908 he met photographer Edward Steichen, who referred his work to Alfred Stieglitz in New York. When Marin returned to the United States in 1911, Stieglitz gave

him an annual stipend so that he could concentrate on his painting. In 1913 Marin exhibited at the Armory Show. The following year, he discovered coastal Maine, and for the rest of his life he split his time between New Jersey in winter and Maine in summer. Influenced by cubism, futurism, and Asian aesthetic styles, Marin developed a style of painting that interpreted the rhythms of the city and the countryside. Duncan Phillips, who acquired his first Marin watercolors in 1926, became Marin's most important patron. By the end of World War II, Marin was considered one of America's greatest modern masters. He was given a retrospective in the U.S. Pavilion at the 1950 Venice Biennale.

Alfred Maurer (*b. New York, New York, April 21, 1868–d. New York, New York, August 4, 1932*)

Alfred Maurer, one of the first American painters to reflect the importance of European modernism in his painting, left school at age sixteen to work in his father's lithography business. Maurer studied in 1884 at the National Academy of Design in New York. From 1897 to 1914 he lived in Paris, where he became acquainted with fellow Americans Arthur Dove and Gertrude and Leo Stein. He moved in avant-garde circles in Paris and met Henri Matisse in the Steins' salon. Widely respected by his contemporaries, Maurer exhibited at Alfred Stieglitz's Gallery 291 in 1909 and the 1913 Armory Show and was an associate member of the modernist Salon d'Automne in Paris. In 1914, on the eve of World War I, Maurer returned permanently to New York. He exhibited frequently in New York with the Society of Independent Artists and was elected its president in 1919. Maurer continued to assimilate aspects of cubism and even abstraction into his painting. Unable to support himself from his painting, in 1924 he achieved some financial security when the dealer Ernest Weyhe acquired the contents of his studio and became his exclusive representative. Maurer committed suicide in 1932.

Kenneth Hayes Miller (*b. Oneida, New York, March 11, 1876–d. New York, New York, January 1, 1952*)

A leading proponent of urban genre painting, Kenneth Hayes Miller was an influential teacher whose pupils included George Bellows, Edward Hopper, Rockwell Kent, and Yasuo Kuniyoshi.

Miller moved to New York City in 1880 when he was four years old. He enrolled at the Art Students League in 1892. In 1897 he studied under William Merritt Chase at the New York School of Art, where he became an instructor in 1899 after returning from his first trip to Europe. After the New York School of Art closed, Miller taught intermittently at the Art Students League for most of his life, from 1911 to 1951. A supporter of modern art, Miller exhibited at the 1913 Armory Show. His early works are romantic depictions of nudes in dreamlike landscapes, reminiscent of the work of his close friend Albert Pinkham Ryder. Around 1920 he began to concentrate on contemporary themes of consumer culture, often depicting lively scenes of women shopping. In 1923 he moved his studio to Fourteenth Street in New York, the heart of the city's shopping district. His figure compositions in these later works were greatly influenced in style and technique by the Renaissance masters.

Joan Mitchell (*b. Chicago, Illinois, February 12, 1925– d. Paris, France, October 30, 1992*)

An abstract expressionist painter, Joan Mitchell studied art at Smith College for two years before training from 1944 to 1947 at the School of the Art Institute of Chicago. In 1947 she moved to New York, where she was influenced by the paintings of Arshile Gorky and Jackson Pollock. From 1948 to 1950 she lived in Paris, where she met Philip Guston; when she returned to New York she frequented the Cedar Tavern and became friends with Franz Kline and Willem de Kooning. Mitchell returned to France in 1955, meeting Sam Francis and Jean-Paul Riopelle, who was her companion until 1979. She moved permanently to France in 1959, establishing her home at an estate in Vétheuil, west of Paris, in 1968. Landscape, poetry, and music were important influences on her work, as were the paintings of Vincent van Gogh, Henri Matisse, Wassily Kandinsky, and others.

George L. K. Morris (*b. New York, New York, November 14, 1905–d. Stockbridge, Massachusetts, June 26, 1975*)

Born into a wealthy New York family, George L. K. Morris graduated in 1928 from the Yale School of Art. Like most American abstract artists of the period, Morris began his career in the realist

tradition. He studied at the Art Students League in 1929 under John Sloan and Kenneth Hayes Miller. He was particularly influenced, however, by Paul Cézanne, Pablo Picasso, Juan Gris, Fernand Léger, and other School of Paris modernists. In about 1930, Morris went to Paris to study with Léger and Amédée Ozenfant at the Académie Moderne. Accompanied by Albert Eugene Gallatin, Morris visited many artists' studios, including those of Picasso, Georges Braque, Constantin Brancusi, Jean Arp, and Piet Mondrian. By the mid-1930s Morris had developed his own cubist style and was one of the first artists to look seriously at Native American art for inspiration. In 1933, shortly after his return to the United States, where he lived mainly in New York, the Curt Valentin Gallery gave him his first solo show. Inspired by Mondrian's writings, in 1936 Morris helped found American Abstract Artists. This group championed geometrical abstraction as a way to achieve a purified aesthetic and included the artists Ilya Bolotowsky, Joseph Albers, Burgoyne Diller, and Mondrian himself.

Grandma Moses (*b. Greenwich, New York, September 7, 1860–d. Hoosick Falls, New York, December 13, 1961*)

Grandma Moses, born Anna Mary Robertson in upstate New York, began painting in her seventies. She had little formal education and left her parents' farm at the age of twelve to work for neighboring families. In 1887 she married a farmer, Thomas Moses, and moved with him to Staunton, Virginia, where she had ten children, five of whom survived. The family later returned to New York State to run a dairy farm. Moses's interest in painting began after her husband died in 1927. When arthritis limited her ability to do needlework, she began painting in oil. Over time, she developed her own sense of color and design, producing landscapes that captured farm activities. In 1938 a New York collector saw several of her works in a local store. In 1939 she was included in the exhibition *Contemporary Unknown American Painters* at the Museum of Modern Art; the next year, she had a one-person show at the Galerie St. Etienne in New York. Moses's popularity grew after her first Christmas cards were issued in 1946 and Gimbel's department store displayed her work at Thanksgiving. Befriended by presidents and awarded numerous accolades, she died at the age of 101.

Robert Motherwell (*b. Aberdeen, Washington, January 24, 1915– d. Provincetown, Massachusetts, July 16, 1991*)

Robert Motherwell took his first trip to Europe in the mid-1930s, when he was a student at Stanford University. After graduating from Stanford in 1937, Motherwell did graduate work in philosophy at Harvard University. During a 1938–39 trip to Europe, he had his first one-person exhibition in Paris. In 1940 he moved to New York, where he studied art history at Columbia University under Meyer Schapiro. Throughout his studies, Motherwell practiced art, but after 1941 he began to devote most of his time to painting. He was the youngest member of a group of American abstract expressionists, including Jackson Pollock, Willem de Kooning, William Baziotes, and Hans Hofmann, whose work was influenced by the surrealists' ideas of making art through subconscious free association. Motherwell held his first New York solo exhibition in 1944 at Peggy Guggenheim's Art of This Century gallery. By 1949 he had reached his mature style, creating large paintings that employed simple shapes, often with a strong political and literary content. Known as a leading art theorist, Motherwell was also an important teacher at Black Mountain College in North Carolina and Hunter College in New York. From 1958 to 1971 Motherwell was married to painter Helen Frankenthaler.

Jerome Myers (*b. Petersburg, Virginia, March 20, 1867–d. New York, New York, June 29, 1940*)

Known for his sympathetic portrayals of the inhabitants of New York's Lower East Side, Jerome Myers was born amid the devastation of post–Civil War Virginia in a small community south of Richmond. At age twelve he left school to help support his family. In 1881 the family moved to Baltimore. Myers began formal art training at night at the Cooper Union in New York in 1888, while working by day as a sign and scene painter. In 1889 he enrolled in the evening class of George de Forest Brush at the Art Students League. He made a brief trip to Paris in 1896 but returned to New York after only a few months. Myers, who was associated with The Eight, was good friends with John Sloan and a force behind the independent exhibitions in New York, including the 1910 *Exhibition of Independent*

Artists and the 1913 Armory Show. In 1919 he was elected to the National Academy of Design. Myers spent his career in his adopted city of New York, where he died in his Carnegie Hall studio in 1940.

Jean Negulesco (*b. Craiova, Romania, February 26, 1900– d. Marbella, Spain, July 18, 1993*)

Born in Romania in 1900, Jean Negulesco moved to Vienna in 1915 and then in 1919 to Bucharest, where he worked as a painter. He then went to Paris to further pursue his passion for the arts. In Paris he met the Romanian sculptor Constantin Brancusi, who served as his mentor. During the 1920s, Negulesco continued to paint, even as he began working as a stage designer. After going to New York in 1927 for an exhibition of his paintings, he decided to stay in the United States. Initially he earned his living as a portrait painter, but soon he began working as a sketch artist for Paramount Studios in New York. In the early 1930s, Negulesco gave up painting and moved to Los Angeles to work in the movies; he directed such classic films as *How to Marry a Millionaire* (1953), *Three Coins in the Fountain* (1954), and *Daddy Long Legs* (1955). He died at his home in Spain at age 93.

Kenneth Noland (*b. Asheville, North Carolina, April 10, 1924–d. Port Clyde, Maine, January 5, 2010*)

Kenneth Noland, an important American color field abstractionist of the postwar period, was encouraged to pursue his interest in art by his father, a pathologist and amateur painter. From 1946 to 1948, Noland used the G.I. Bill to finance his studies at Black Mountain College in North Carolina, where he was influenced by geometric abstractionists Ilya Bolotowsky and Josef Albers and the work of Paul Klee. In 1948 Noland went to Paris to study under the sculptor Ossip Zadkine. When he returned to the United States in 1949, Noland moved to Washington, D.C. He worked first at the Institute of Contemporary Art in 1949 and 1950 and then at the Catholic University of America from 1951 to 1960. From 1952 to 1956, Noland also taught night classes at the Washington Workshop Center for the Arts, where he met Morris Louis. Noland, like Louis, was greatly influenced after 1953 by Helen Frankenthaler's staining technique with liquid paint on unprimed canvas. In 1961 Noland moved

to New York, then relocated in 1963 to South Shaftsbury, Vermont, where he was associated with Bennington College for many years. His final years were spent in Port Clyde, Maine.

Kenzo Okada (*b. Yokohama, Japan, September 28, 1902– d. Tokyo, Japan, July 24, 1982*)

The first Japanese American artist working in the abstract expressionist style to receive international acclaim, Kenzo Okada was the son of a wealthy industrialist in Yokohama, Japan. In 1922, upon the death of his father, Okada enrolled in the Tokyo Fine Arts University. In 1924 he moved to Paris, where he came under the influence of European modernism. He exhibited in Paris at the 1927 *Salon d'Automne* and then returned to Japan, where he painted landscapes and figural compositions in a European manner. From 1940 to 1944 Okada taught at the School of the Fine Arts at Nippon University in Tokyo and in 1947 he began teaching at the Musashino Art Institute in Tokyo. Despite his success in Japan, in 1950 Okada moved to New York, where he began to paint abstractions. In 1953 he was given his first American one-person exhibition at the Betty Parsons Gallery in New York. Okada divided the rest of his career between Japan and New York.

Georgia O'Keeffe (*b. Sun Prairie, Wisconsin, November 15, 1887–d. Santa Fe, New Mexico, March 6, 1986*)

Georgia O'Keeffe grew up in Virginia. She briefly attended the Art Institute of Chicago and the Art Students League in New York, where she studied under William Merritt Chase. In the summer of 1912, O'Keeffe studied at the University of Virginia, where she encountered the compositional theories of Arthur Wesley Dow. After teaching for two years in Amarillo, Texas, in 1916 she enrolled in the Teachers College at Columbia University to study under Dow himself. In 1916, Alfred Stieglitz saw O'Keeffe's sketches and exhibited them in New York at his Gallery 291. Although she was teaching in West Texas, O'Keeffe moved to New York in June 1918 to be with Stieglitz, and married him in 1924. In 1929, O'Keeffe began traveling to the American Southwest most summers, moving permanently to northern New Mexico after Stieglitz's death in 1946. With retrospectives in 1943 at the Art Institute of Chicago and in 1946

at the Museum of Modern Art, her reputation was confirmed as one of America's foremost painters of nature and the southwestern landscape. Her legacy continued to grow in the decades that followed as she continued to paint into her ninety-eighth year.

Alfonso Ossorio (*b. Manila Bay [Luzon], Philippines, August 2, 1916–d. East Hampton, New York, December 5, 1990*)

Born to wealthy parents in the Philippines, Alfonso Angel Ossorio y Yangco belonged to the first generation of abstract expressionist painters, rejecting descriptive images while stressing spontaneous expression. He attended school in England from the age of eight to thirteen before moving to the United States, where he became a citizen in 1933. He studied fine art at Harvard University and the Rhode Island School of Design and became a medical illustrator in the U.S. Army during World War II. In 1949 he met Jackson Pollock and Lee Krasner and in 1951 acquired property next to them in East Hampton, Long Island, where he lived for the next forty years. By the early 1950s, Ossorio was pouring oil and enamel paints onto his canvases. From 1952 to 1962, he housed Jean Dubuffet's collection of *art brut* in his home and arranged for its exhibition in American venues. Ossorio is well known for his "congregations," assemblages of objects attached to panel. He was among the featured artists in the Museum of Modern Art's landmark exhibition *The Art of Assemblage* in 1961.

Guy Pène du Bois (*b. Brooklyn, New York, January 4, 1884–d. Boston, Massachusetts, July 18, 1958*)

A painter who presented witty and mocking views of New York society, Guy Pène du Bois enrolled in the New York School of Art in 1899, where he studied under William Merritt Chase, Kenneth Hayes Miller, and Robert Henri. In 1905, Pène du Bois traveled to Paris, studying at the Académie Colarossi and in the studio of Théophile Steinlen, then returned to New York the following year after his father's death. Required to support his family, Pène du Bois found a job as an illustrator, and as a music and art critic for the *New York American*, his father's former employer. He advocated for new movements in art and served

on the publicity committee for the 1913 Armory Show. Throughout his career he painted and wrote about art and was regarded as an astute critic. To supplement his income Pène du Bois began teaching at the Art Students League in 1920. In the 1930s, he founded an art school in Stonington, Connecticut, where he spent most summers. Active in the Society of Independent Artists, Pène du Bois lived and painted intermittently in France.

John Frederick Peto
(b. Philadelphia, Pennsylvania, May 21, 1854–d. Island Heights, New Jersey, November 23, 1907)

Not much is known of John Frederick Peto's early years in Philadelphia except that he was raised by his maternal grandmother and played the cornet in the city's fire department band. He first appeared as a painter in the 1876 Philadelphia city directory. Although he studied briefly at the Pennsylvania Academy of the Fine Arts in 1876, Peto is described as self-taught in the academy's exhibition listings. He was a friend of the artist William Harnett, whose influence on his composition and style was very strong. A master of trompe l'oeil pictures that simulate wooden bulletin boards, Peto did not find much of an audience for his paintings because his depicted objects were generally worn and shabby. In 1889 he moved to Island Heights, New Jersey, where he played the cornet at camp revival meetings.

Marjorie Acker Phillips
(b. Bourbon, Indiana, October 25, 1894–d. Washington, D.C., June 19, 1985)

Marjorie Acker Phillips was the wife of Duncan Phillips, founder of The Phillips Collection. She was a trained artist before their marriage in 1921 and remained a painter her entire life. Encouraged to become an artist by her maternal uncles, the painters Gifford Beal and Reynolds Beal, by 1918 she was commuting to New York City from Ossining-on-the-Hudson to study at the Art Students League. She regularly visited the commercial galleries, the Metropolitan Museum of Art, and the Société Anonyme. When her uncle Gifford Beal introduced her to Duncan Phillips in New York in January 1921, Marjorie recognized that she and Phillips were kindred spirits. They married later that year. She became associate director of the Phillips Memorial Gallery (now The Phillips Collection) in 1925, a position she held for forty-one years. Upon her husband's death, she was director of The Phillips Collection for six years. She was Duncan Phillips's partner in the shaping of the museum as a vital place committed to the contemporary world and the art of both men and women. Her works over her long career focused on what her husband described in his 1926 *Collection in the Making* as figures set within "luminous and rhythmical landscapes."

Horace Pippin *(b. West Chester, Pennsylvania, February 22, 1888–d. West Chester, Pennsylvania, July 6, 1946)*

Horace Pippin, a self-taught African American painter, moved as a child to Goshen, New York, where he attended a segregated, one-room school. When he was ten years old, he answered a magazine advertisement and received a box of crayon pencils, paint, and brushes. Pippin left school in 1903 to support his sick mother. After her death in 1911, he moved to Paterson, New Jersey, where he worked packing and crating pictures and furniture; he later worked as an iron molder. In 1917 Pippin enlisted in the army; he was gravely wounded in France. He returned home to West Chester, Pennsylvania, with a crippled arm. About 1931 he began making oil paintings and was the first African American painter to express his concerns about war and sociopolitical injustices in his art. He was also the first African American painter to have works accepted into the West Chester County Art Association. His subject matter ranged from depictions of trench warfare to historical, religious, and genre paintings, all executed with personal interpretations. Pippin became well known in the greater Philadelphia region. He also briefly took formal training at the Barnes Foundation in Merion, Pennsylvania.

Jackson Pollock *(b. Cody, Wyoming, January 28, 1912–d. Southampton, New York, July 11, 1956)*

Jackson Pollock was born to an impoverished family in Cody, Wyoming. In 1928 he lived in Los Angeles, where he attended Manual Arts High School with Philip Guston. After two years Pollock was expelled. In 1930 he enrolled at the Art Students League in New York, studying for three years under Thomas Hart Benton, a major influence on his work. Pollock had his first exhibition in 1935 and was thereafter represented by major New York galleries. Under the influence of Pablo Picasso's cubist-surrealist paintings and Carl Jung's concept of the collective unconscious, Pollock began to develop a new pictorial approach. During the 1930s Pollock also was involved in the Works Progress Administration's Federal Art Project as a mural assistant to the Mexican painter David Siqueiros. He had his first one-person exhibition in 1943 at Peggy Guggenheim's Art of This Century Gallery in New York. In 1945 Pollock's painting reached a stylistic turning point as he developed his highly acclaimed technique of pouring and dribbling paint with brushes and sticks onto large canvases. Suffering from alcoholism, Pollock began to paint sporadically in the 1950s, especially after 1954. He died in a car crash on Long Island in 1956.

Maurice Prendergast
(b. St. John's, Newfoundland, October 10, 1858–d. New York, New York, February 1, 1924)

Known for his colorful, decorative scenes of leisure, Maurice Prendergast was born in Newfoundland but moved to Boston in 1868 at the age of ten. From 1891 to 1894, he studied in Paris, attending the Académie Julian and the Académie Colarossi, while also absorbing contemporary art movements such as post-impressionism. He returned to Boston, where he successfully exhibited his watercolors. A friendship with the painter Arthur B. Davies brought him into the New York art world around 1906. He became friends with William Glackens and Ernest Lawson and exhibited with them as one of The Eight at the Macbeth Galleries in New York in 1908. Between 1898 and 1914, Prendergast made four trips to Europe, assimilating the influence of Paul Cézanne and Henri Matisse; he was the first American artist to bring their influence back to the United States. In 1914 Prendergast settled permanently in New York, where he enjoyed great success with collectors, among them Duncan Phillips. Prendergast's compositions serve primarily as a vehicle for the development of different color harmonies, freely built up in an embroidery of brushstrokes and patches of varied hues.

Theodore Robinson
(b. Irasburg, Vermont, July 3, 1852–d. New York, New York, April 2, 1896)

Theodore Robinson, generally considered the first American impressionist, grew up in

rural Wisconsin. He studied at the Art Institute of Chicago from 1869 to 1870 and the National Academy of Design in New York from 1874 to 1876. Robinson was a founding member of the Art Students League. In 1876, he went to Paris to study with Carolus-Duran and, later, at the École des Beaux-Arts under Jean-Léon Gérôme. In Venice in 1879, Robinson befriended James Abbott McNeill Whistler. Throughout his life, Robinson spent much time in France. In 1887 he began traveling to Giverny, where Claude Monet had established his home and studio. Robinson became friends with Monet and returned to Giverny every spring and summer for the next five years. He also made trips back to New York, where he maintained friendships with John Henry Twachtman and Julian Alden Weir and served as an informal conduit to the United States for impressionist precepts. In 1892, Robinson returned permanently to New York to work and teach. He died of an asthma attack at the peak of his career. Five of his paintings were posthumously included in the 1913 Armory Show, in which he and Twachtman, also deceased, represented American impressionism.

Mark Rothko (b. Dvinsk, Russia [now Daugavpils, Latvia], September 25, 1903–d. New York, New York, February 25, 1970)

Born Marcus Rothkowitz in Russia, Mark Rothko immigrated at age ten with his mother and sister to Portland, Oregon, where they reunited with his father and brother. In 1925, after art training and two years at Yale University, Rothko moved to New York, where he studied at the Art Students League under Max Weber. This was Rothko's only formal artistic training. In 1928 he became friends with Milton Avery, whose simplified forms and flat color areas informed Rothko's art. In 1929 Rothko took a teaching position at the Center Academy of the Brooklyn Jewish Center, which he kept until 1952. His first one-person show in New York was in 1933. He participated in the formation of the Artists' Union in 1934 and joined the Gallery Secession and the artists' group known as The Ten. From 1936 to 1937 Rothko was employed by the Works Progress Administration. The late 1940s mark the beginning of Rothko's work on color field paintings. From 1958 to 1969 Rothko worked on three major commissions: monumental canvases for the Four Seasons Restaurant at the Seagram Building in New York; murals for Harvard University; and canvases for the chapel at

the Institute of Religion and Human Development in Houston.

Andrée Ruellan (b. New York, New York, April 6, 1905–d. Kingston, New York, July 15, 2006)

A noted realist painter of the 1930s and 1940s who continued to paint throughout her life, Andrée Ruellan was born in Manhattan to parents of French descent who were politically allied with the socialist movement. Ruellan exhibited her first work at the age of nine in 1914, after meeting Robert Henri; he invited her to join a group show in Manhattan's East Village, to which she contributed watercolors and drawings of urban street life. In April 1914, she had an illustration published in *The Masses*, a major left-wing magazine. She studied in New York at the Art Students League. From 1922 to 1929 Ruellan lived with her mother in Europe, where she studied in Rome under Maurice Sterne and then attended the Académie Suédoise and the Académie de la Grande Chaumière in Paris. Although influenced by the work of Pablo Picasso and Henri Matisse, her style remained figurative. In 1925 she had her first one-person show in Paris. She returned to the United States in 1929 after marrying John Taylor, an American painter. The couple lived near Woodstock, New York. During the 1930s Ruellan and her husband traveled in the South, which resulted in her depictions of African Americans in their daily lives.

Albert Pinkham Ryder (b. New Bedford, Massachusetts, March 19, 1847–d. Elmhurst, New York, March 28, 1917)

Albert Pinkham Ryder, a romantic painter whose themes of humanity in the grip of supernatural forces were expressed in powerful formal designs, had a lasting influence on subsequent American artists, including Jackson Pollock and Marsden Hartley. Ryder's brief formal education ended with grammar school. When he was about twenty years old, sometime between 1867 and 1868, he moved to New York with his family. There he studied with William E. Marshall, a former student of French painter Thomas Couture. From 1870 to 1875 Ryder continued his studies at the National Academy of Design. He developed a close friendship with Julian Alden Weir. Ryder made three trips to Europe, the first

in 1882, where he absorbed much from the old masters and contemporary art, including works by Jean-Baptiste-Camille Corot, the Barbizon painters, and Adolph Monticelli. Ryder was elected to the National Academy of Design in 1906, and numerous works, including *Moonlit Cove* (1880–85), now at The Phillips Collection, were exhibited at the 1913 Armory Show. Ryder's work of the 1890s, considered the culmination of his career, includes haunting marine scenes, as well as turbulent images from opera and literature.

Ben Shahn (b. Kovno [now Kaunas], Lithuania, September 12, 1898–d. New York, New York, March 14, 1969)

Born in what was then a part of the Russian Empire, Ben Shahn emigrated as a child with his family in 1906 because of his father's anti-czarist activities. Shahn grew up in a working class Jewish neighborhood in Brooklyn, finishing high school at night while he worked at a Manhattan lithographic firm. Shahn, who drew constantly, saw his art as a means to combat injustice and raise social awareness. He took classes at New York University, City College of New York, and the National Academy of Design. His 1932 paintings, inspired by the trial and execution of Sacco and Vanzetti, made him famous. Diego Rivera, an admirer, invited Shahn to assist with painting Rivera's controversial mural in the RCA Building at Rockefeller Center. Shahn also created other murals, including at the Federal Security Building (then known as the Social Security Building) in Washington, D.C. Between 1935 and 1938, Shahn was a painter and photographer for the Farm Security Administration. His work in the later 1940s moved away from the social realism that had brought him recognition.

Charles Sheeler (b. Philadelphia, Pennsylvania, July 16, 1883–d. Dobbs Ferry, New York, May 7, 1965)

Charles Sheeler studied art in Philadelphia from 1900 to 1906 at the Pennsylvania School of Industrial Art, then at the Pennsylvania Academy of the Fine Arts under William Merritt Chase. Trips to Europe between 1904 and 1909 heightened his awareness of European modernism, influencing him to develop a style that emphasized geometric structure, order, hard edges, and pristine surfaces with no visible brushwork. Sheeler

exhibited in New York at the 1913 Armory Show, the 1916 *Forum Exhibition of Modern American Painters*, and, in 1917, at the exhibition of the newly formed Society of Independent Artists. In 1917 he became lifelong friends with Walter and Louise Arensberg, who introduced him to Marcel Duchamp and Francis Picabia. Sheeler's move to New York in 1919 brought him closer to the city's art scene. Sheeler became associated with Alfred Stieglitz and his circle, collaborating in 1920 with Paul Strand on the film *Manhatta*. A solo exhibition at a New York gallery in 1922 defined Sheeler as a central proponent of precisionism. Commissions to photograph the Ford Motor Company's plant at River Rouge, Michigan, in 1927 and 1928 brought Sheeler international acclaim for his pristine view of American industry. A retrospective at the Museum of Modern Art in 1939 testified to his growing success and critical acclaim.

Everett Shinn (b. *Woodstown, New Jersey, November 7, 1876–d. New York, New York, May 1, 1953*)

A member of The Eight best known for his images of the theater, Everett Shinn was a student at the Pennsylvania Academy of the Fine Arts beginning in 1893. There he studied under the realist painter Thomas Anschutz. He supported himself as an artist-reporter for the *Philadelphia Press*, where he became friends with William Glackens, George Luks, and John Sloan. Shinn moved to New York in 1897 to continue his career as a newspaper and magazine illustrator. In 1899 he began work on drawings for a William Dean Howells book entitled *New York by Night*. The next year Shinn traveled to England and France, where he was introduced to artistic themes related to the theater, which came to dominate his own subject matter. He participated in various New York group shows during the first decade of the twentieth century, including the 1908 exhibition of The Eight at Macbeth Galleries and the 1910 *Exhibition of Independent Artists*. Between 1911 and 1937 Shinn rarely exhibited; he pursued other interests, including as an art director for motion pictures.

John Sloan (b. *Lock Haven, Pennsylvania, August 2, 1871– d. Hanover, New Hampshire, September 7, 1951*)

John Sloan studied briefly at the Pennsylvania Academy of the Fine Arts before becoming

an illustrator for the *Philadelphia Enquirer* in 1892. His friend and fellow painter Robert Henri encouraged him to pursue painting. Sloan's fellow newspaper artists in Philadelphia included William Glackens and George Luks. In 1904 Sloan, like Henri, Glackens, and Luks before him, moved to New York, where he continued working as an illustrator and also began depicting working-class neighborhood life. Sloan participated in the 1908 exhibition of The Eight at Macbeth Galleries, the 1910 *Exhibition of Independent Artists*, the 1913 Armory Show, and the 1917 exhibition of the Society of Independent Artists. He was president of the Society of Independent Artists from 1918 to 1944. In 1910 Sloan joined the Socialist Party and contributed illustrations to its publications; he resigned from the party at the beginning of World War I. Sloan spent his summers in Gloucester, Massachusetts, from 1914 through 1919, and then in Santa Fe, New Mexico. In 1916, Sloan had his first one-person exhibition and began teaching at the Art Students League. Duncan Phillips was the first to acquire Sloan's work for a museum collection, purchasing *Clown Making Up* (1910) in 1919.

David Smith (b. *Decatur, Indiana, March 9, 1906–d. South Shaftsbury, Vermont, May 23, 1965*)

One of the foremost sculptors of the twentieth century, David Smith spent his early childhood in Indiana before moving to Ohio with his family in 1921. He attended Ohio University in Athens for one year in 1924–25 and the University of Notre Dame for two weeks, dropping out because there were no art courses. In 1927 he moved to New York and took painting classes at the Art Students League with John Sloan and the Czech modernist Jan Matulka, who introduced him to the work of Pablo Picasso, Piet Mondrian, Wassily Kandinsky, and the Russian constructivists. The welded sculptures of Julio González and Picasso led Smith to combine painting with constructions. In 1940 he moved to upstate New York, settling in Bolton Landing near Lake George. There Smith built a large studio where he could weld metal sculptures unlike anything that had been tried before, such as sculptural landscapes and still lifes. He died in 1965 at age 59 in a car crash, at the height of his career.

Joseph Solman (b. *Vitebsk, Belarus, January 25, 1909– d. New York, New York, April 16, 2008*)

A Jewish American painter, Joseph Solman immigrated to the United States from Vitebsk, Belarus, then a part of Russia, in 1912 at the age of three. The family settled in Queens, New York, where, as a teenager, Solman did quick sketches of people on the city streets. He attended the Art Students League and the National Academy of Design. In the 1930s and early 1940s he was an artist for the Works Progress Administration; during this time he began to document the streets of New York, incorporating elements of cubism into his urban scenes, interiors, and portraits. Along with Mark Rothko, Solman was a co-leader in the mid-1930s of The Ten, a group of expressionist painters that included Adolph Gottlieb and Ilya Bolotowsky and championed modernism over social realism. Solman, who actively painted into his ninety-ninth year, was a vivid colorist concerned with space and light, infusing his New York scenes with abstract qualities without ever abandoning recognizable subject matter.

Niles Spencer (b. *Pawtucket, Rhode Island, May 16, 1893–d. Dingman's Ferry, Pennsylvania, May 15, 1952*)

Niles Spencer is known for the simplicity of his architectural images. His family owned a textile mill in Pawtucket, Rhode Island, and this early relationship with industry provided Spencer with a subject that fascinated him throughout his career. From 1913 to 1915 Spencer attended the Rhode Island School of Design in Providence. He moved in 1916 to New York, where he continued his artistic education under Kenneth Hayes Miller at the Art Students League and with George Bellows and Robert Henri at a private art school in the Bronx. Spencer divided his time between New York and Ogunquit, Maine, where he spent summers with other artists who had gathered around Hamilton Easter Field, founder of *The Arts* magazine. During the 1920s Spencer traveled to Europe and later lived in Provincetown, Massachusetts. After moving back to New York, he focused on dynamic city scenes that featured clearly drawn architectural forms of skyscrapers, factories, and machinery. These works of the early 1930s and 1940s most closely align Spencer with

the precisionist painter Charles Sheeler. From the mid-1940s until about 1951, the year before his death, Spencer went further toward abstraction, creating complex compositions that combined simplified architectural forms found mainly in the industrial United States.

Robert Spencer (*b. Harvard, Nebraska, December 1, 1879– d. New Hope, Pennsylvania, July 10, 1931*)

Robert Spencer was a founding member of the New Hope Group, a branch of American impressionism associated with Pennsylvania artists around Philadelphia and the Delaware River. His father was a Swedenborgian minister who moved the family frequently. Spencer attended classes at the National Academy of Design in New York and from 1903 to 1905 he studied under William Merritt Chase and, probably, Robert Henri at the New York School of Art. He spent three years in the Delaware River region, coming into contact with the artists Edward Willis Redfield and William Lathrop. In the summer of 1909 he studied with the Pennsylvania impressionist Daniel Garber and moved permanently to New Hope (north of Philadelphia) that fall. Spencer focused primarily on depictions of working-class life in and around New Hope, with some views of the Delaware River. In 1931, he committed suicide in his studio.

Everett Spruce (*b. Holland, Arkansas, December 25, 1908– d. Austin, Texas, October 18, 2002*)

One of the most prominent Texas regionalist painters of the 1930s and 1940s, Everett Spruce was born in Arkansas to a farming family that lived for a time in the Ozark Mountains. Spruce began sketching as a boy, and in 1926 he won a scholarship to the newly formed Dallas Art Institute, where he studied from 1926 to 1929. In 1931 he became a gallery assistant at what became the Dallas Museum of Fine Arts; he was promoted to registrar in 1936. Spruce's landscape paintings were directly inspired by his childhood in the Ozarks, as well as the austere Texas landscape. When he exhibited with other Texas regional artists in a 1932 Dallas exhibition, he became identified with the group known as the Dallas Nine. In the late 1930s Spruce's paintings gained national attention as his work was exhibited across

the country. He joined the faculty at the University of Texas at Austin in 1940 and retired in 1974 as an emeritus professor.

Theodoros Stamos (*b. New York, New York, December 31, 1922–d. Ioannina, Greece, February 2, 1997*)

The youngest of the first-generation abstract expressionists, Theodoros Stamos was born in New York to Greek immigrant parents. At thirteen, he studied sculpture at the American Artists School while attending high school. After dropping out of school in 1939 he held odd jobs and concentrated on his painting. During the early 1940s he also visited Alfred Stieglitz's gallery, where he admired the work of Arthur Dove, and frequently visited the American Museum of Natural History. In 1943 he met the painters Adolph Gottlieb and Barnett Newman. Stamos was twenty years old when he had his first solo exhibition in 1943 at the Wakefield Gallery in New York. In 1947 he met collector Peggy Guggenheim and the artists John Graham and Mark Rothko. In 1948 and 1949 he spent six months traveling in France, Italy, and Greece. His first one-person museum show was in 1950 at The Phillips Collection. In 1951 he moved to East Marion, New York, where he developed a color field technique. For twenty-two years, beginning in 1955, he taught at the Art Students League. Starting in 1970, he split his time between New York and the island of Lefkada, Greece. He traveled extensively after leaving teaching in 1977.

Maurice Sterne (*b. Libau, Latvia, August 8, 1878–d. Mount Kisco, New York, July 23, 1957*)

Born in Latvia on the Baltic Sea, Maurice Sterne lived in Moscow as a child from 1885 to 1889 before his family immigrated to New York. From 1894 to 1899 Sterne attended the National Academy of Design, where he met Alfred Maurer and studied briefly with Thomas Eakins. From 1904 to 1907 Sterne lived a bohemian life in Paris and first saw the art of Paul Cézanne and other French modernists. His extensive travels took him to locales as varied as Paris, Rome, Berlin, Moscow, Greece, Egypt, India, Java, and Bali, before he returned to New York in 1915. After a stormy marriage to Mabel Dodge from 1916 to 1918, Sterne lived in the Italian village of Anticoli Corrado, occasionally

returning to New York to teach at the Art Students League. He moved to San Francisco in 1934, but returned to teaching in New York in the early 1940s. In 1944 he began spending his summers in Provincetown, Massachusetts.

Clyfford Still (*b. Grandin, North Dakota, November 30, 1904–d. Baltimore, Maryland, June 23, 1980*)

Although he was a major figure in the abstract expressionist movement, Clyfford Still developed his abstract art apart from his colleagues. Still, who drew and painted from a young age, spent his early life in Spokane, Washington, and on the prairies of southern Alberta, Canada. He studied briefly at the Art Students League in New York in 1925 and then enrolled at Spokane University in 1926, graduating in 1933. Two years later he received a master's degree in fine arts from Washington State College, where he joined the faculty. After moving to California in 1941, Still had his first one-artist exhibition at the San Francisco Museum of Art in 1943. Around that time Still met painter Mark Rothko and moved to Richmond, Virginia, to teach. In 1945, Still moved to New York, where Rothko introduced him to Peggy Guggenheim, who gave him a solo show at her gallery in 1946. Still subsequently taught at the California School of Fine Arts (now the San Francisco Art Institute), returned to live in New York briefly in 1950, and continued to move around the country, teaching for short periods at various schools. Still moved in 1961 to rural Maryland, where he could paint in seclusion.

Augustus Vincent Tack (*b. Pittsburgh, Pennsylvania, November 9, 1870–d. New York, New York, July 21, 1949*)

Augustus Vincent Tack, a painter of decorative, semi-abstract landscapes, moved to New York with his family in 1883 when he was thirteen years old. He graduated from Francis Xavier College in New York in 1890, then studied until 1895 at the Art Students League under John Henry Twachtman. Tack traveled often to France in the 1890s, painting in Normandy and working with a French mural painter. In 1897 Tack moved to an artists' colony in Deerfield, Massachusetts, although he maintained a New York studio. Tack had frequent exhibitions at

New York galleries after his first solo exhibition in 1896. From 1900 until the 1920s, his work was shown regularly at the Worcester Art Museum, the Carnegie International exhibitions in Pittsburgh, and the Pennsylvania Academy of the Fine Arts in Philadelphia. From 1906 to 1910 he taught at the Art Students League and from 1910 to 1913 at Yale University. Around 1914 his work attracted the interest of Duncan Phillips, who became his close friend and chief patron. From 1941 on, Tack maintained a studio in Washington, D.C., where he produced portraits of political and military leaders, including Harry Truman and Dwight Eisenhower, while he continued to paint his poetic abstractions.

Rufino Tamayo (*b. Oaxaca, Mexico, August 26, 1899– d. Mexico City, Mexico, June 24, 1991*)

Rufino Tamayo moved to Mexico City from southwestern Mexico to live with his aunt after he was orphaned at the age of twelve. He enrolled at the San Carlos Academy of Fine Arts in 1917, but he left to study painting on his own. In 1921 he became the head of the Department of Ethnographic Drawing in the National Archeology Museum. In 1926 Tamayo went to New York City, where he had his first U.S. solo gallery show. He returned to Mexico City in 1928 and taught at the National School of Fine Arts. Starting in 1930, Tamayo divided his time between Mexico and New York. He taught at the Dalton School in New York for nine years, starting in 1938, and at the Brooklyn Museum Art School for two years. In 1948 the Palacio de Bella Artes in Mexico City gave him his first large retrospective. Tamayo first went to Europe in 1949 and spent twelve years in Paris. He returned to Mexico in 1964. In 1971 he gave his collection of pre-Columbian art to the Rufino Tamayo Museum of Pre-Hispanic Art in Oaxaca. The Rufino Tamayo Museum of Contemporary Art opened in Mexico City in 1981.

Mark Tobey (*b. Centerville, Wisconsin, December 11, 1890–d. Basel, Switzerland, April 24, 1976*)

Mark Tobey was predominantly self-taught, although he attended some classes at the Art Institute of Chicago after his family moved there from Wisconsin in 1909. An introduction to the Bahá'í faith around 1918 changed the development of Tobey's art. He moved to Seattle in 1922 to teach art and while there he learned Chinese calligraphy. For the next seven years Tobey divided his time among New York, Chicago, and Seattle, traveling in Europe in 1925 through 1927. He taught art in Devon, England, from 1930 to 1938, with the exception of a year he spent in 1934 studying philosophy and art in China and living in a Zen monastery in Japan. After returning to Seattle in 1938, Tobey worked for the federal Works Progress Administration. In 1958 he became the second American, after James Whistler, to win the International Grand Prize at the Venice Biennale. He moved to Switzerland in 1960, returning in the summers to the United States.

Bradley Walker Tomlin (*b. Syracuse, New York, August 19, 1899–d. New York, New York, May 11, 1953*)

Bradley Walker Tomlin became interested in art early, receiving a scholarship to study sculpture at age fourteen. He later studied painting at Syracuse University, graduating in 1921 with a fellowship to study abroad. At first he moved to New York, working as a book and magazine illustrator, but he used the fellowship in 1923 to study in Paris at the Académie Colarossi and Académie de la Grande Chaumière. Returning to New York in 1924, he continued to do commercial illustration until 1929 but also began exhibiting at the Whitney Studio Club as a representational painter. He received his first one-person exhibition in 1926 at Montross Gallery in New York and traveled to Europe again the following year. In 1929 the Pennsylvania Academy of the Fine Arts became the first museum to acquire his work. From 1932 to 1941, Tomlin also taught, first at New York's preparatory schools and then at Sarah Lawrence College. From 1939 to 1944 he worked in a cubist mode. After meeting Adolph Gottlieb in 1945, and subsequently meeting Robert Motherwell, Philip Guston, and Jackson Pollock, he turned to a more spontaneous, abstract expressionist style. He joined the Betty Parsons Gallery around 1948.

Allen Tucker (*b. Brooklyn, New York, July 28, 1866–d. New York, New York, January 26, 1939*)

A plein air painter, Allen Tucker graduated from the School of Mines of Columbia University with a degree in architecture. While working as a draftsman at his father's architectural firm, Tucker studied painting at the Art Students League under John Henry Twachtman. He also took summer classes from Twachtman at Cos Cob, Connecticut, in 1892. Tucker also was influenced by Robert Henri and Maurice Prendergast. Around 1904, at age thirty-eight, Tucker became a full-time painter. A charter member of the Association of American Painters and Sculptors in 1911, he helped to organize and exhibited in the 1913 Armory Show. He cofounded the Society of Independent Artists in 1917 and met Duncan Phillips the same year through the Century Club. In 1918 he had his first large one-person show. Tucker taught at the Art Students League from 1921 to 1928. A landscape painter with a pantheist's view of nature, he spent his summers painting outdoors on the New England coast and in New Mexico, Colorado, the Canadian Rockies, and Europe. Tucker was also a writer, publishing a book of verse in 1919 as well as *Design and Idea* (1930) and *John Henry Twachtman* (1931).

John Henry Twachtman (*b. Cincinnati, Ohio, August 4, 1853–d. Gloucester, Massachusetts, August 8, 1902*)

John Henry Twachtman, one of America's most important impressionist painters, began his career decorating window shades. At the same time, he studied at night at the Ohio Mechanics Institute. He then enrolled at the McMicken School of Design (later the Art Academy of Cincinnati), where he studied under Frank Duveneck, who urged Twachtman to attend Munich's Royal Academy of Fine Arts. In 1875 Twachtman went to Munich; while there, he accompanied Duveneck and William Merritt Chase on a painting trip to Venice. Twachtman returned to the United States in 1878 and exhibited in New York with the Society of American Artists, becoming a member the following year. In 1879 Twachtman met Julian Alden Weir, who became his lifelong friend and colleague. Twachtman made a trip to Europe in 1881, joining Weir on a painting expedition to Holland and Belgium. Between 1883 and 1885, Twachtman worked in France. In 1889 he began teaching at the Art Students League in New York. He purchased a home in Greenwich, Connecticut, not far from Weir's farm. In 1897, with Weir, he withdrew from the Society of American Artists to form The Ten American Painters, a group of artists with predominantly impressionist tendencies.

Max Weber (*b. Bialystok, Russia [now Bialystock, Poland], April 18, 1881–d. Great Neck, New York, October 4, 1961*)

Max Weber, who helped transmit European modernist ideas to the United States, was born to a Jewish family in an area that is now part of Poland, but was then Russia. When Weber was ten years old, his family immigrated to Brooklyn, where he enrolled at the Pratt Institute in 1898. In 1905, he traveled to Paris to study at the Académie Julian, the Académie Colarossi, and the Académie de la Grande Chaumière. He also exhibited at the *Salon des Indépendants* and the *Salon d'Automne*. Weber moved in avant-garde circles in Paris, where he became friends with Henri Rousseau, frequented the studios of Henri Matisse and Pablo Picasso, and helped to organize a class by Matisse. In 1909, Weber returned to New York. After a brief association with Alfred Stieglitz, he supported himself by teaching, first at the Clarence H. White School of Photography and later at the Art Students League. He became the director of the Society of Independent Artists in 1917. Duncan Phillips was the first to purchase a Weber painting for a museum collection, acquiring *High Noon* (1925) in 1925. The Museum of Modern Art selected Weber for a one-person exhibition in 1930, its inaugural year.

Julian Alden Weir (*b. West Point, New York, August 30, 1852–d. New York, New York, December 8, 1919*)

Julian Alden Weir, a leading American impressionist, was the son of a drawing instructor at the U.S. Military Academy at West Point, New York, and the younger half-brother of John Ferguson Weir, the first director of the art program at Yale University. Weir studied at the National Academy of Design in New York. In 1870, he went to Paris to study with the noted French academician Jean-Léon Gérôme and later at the École des Beaux-Arts. On a second trip to Europe in 1880, Weir won an honorable mention at the Paris Salon and purchased works by Edouard Manet and Rembrandt for an American friend and collector. In 1883, Weir married and acquired a farm in western Connecticut, where he summered regularly and entertained guests such as Albert Pinkham Ryder and John Henry Twachtman, a close friend who had a farm nearby. Weir became a member of the National Academy of Design in 1886 and was a founding member of the Society of American Artists, the Tile Club, and the artists' group known as The Ten American Painters, whose works were primarily impressionist in style. The recipient of numerous honors, Weir was president of the National Academy from 1905 to 1917.

Harold Weston (*b. Merion, Pennsylvania, February 14, 1894–d. New York, New York, April 10, 1972*)

Born into a prosperous family, Harold Weston was encouraged by his parents to become active in art and public service. Despite an early bout with polio, Weston led a full life, graduating in 1916 with a degree in fine arts from Harvard University. During World War I, he volunteered to do relief work for the YMCA, which sent him to Mesopotamia (now Iraq) with the British Mesopotamia Expeditionary Force. By 1918, Weston found time to paint. After traveling extensively, including to Persia (now Iran) and Asia, he returned in January 1920 to the United States, where he briefly lived in New York, studied at the Art Students League, attended modernist exhibitions, and explored the Metropolitan Museum of Art. Later that year Weston retreated to the Adirondack Mountains and built a primitive studio in Saint Huberts, New York. There he painted in isolation for three years, developing an expressionist style that featured bold, simplified forms and exaggerated rhythms. Weston had his first solo show in New York in 1922 and for the next eighteen years exhibited widely. He also completed murals for the Treasury Department in Washington, D.C., in 1938, which brought him acclaim.

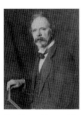

James Abbott McNeill Whistler (*b. Lowell, Massachusetts, July 11, 1834–d. London, England, July 17, 1903*)

As a boy, James Abbott McNeill Whistler, born in Massachusetts, moved to St. Petersburg, Russia, with his family in 1843, while his father supervised the construction of a railroad line. There Whistler received his first art instruction. In 1851, he returned to the United States, where he entered the U.S. Military Academy at West Point, New York, but was dismissed for poor grades. To earn a living, Whistler briefly worked as a draftsman for the U.S. Coast and Geodetic Survey. He then moved to Paris, where he was influenced by his study of Japanese prints and his friendship with Gustave Courbet. His first etchings resulted from a sketching tour of the Rhineland in 1853. In 1859, after moving to London, Whistler began a series of etchings along the River Thames, and by the mid-1860s, he began to incorporate Asian design and tonalities into his work. Whistler went bankrupt after a successful libel suit against the critic John Ruskin in 1878. From 1879 to 1880, he left London for an extended trip to Venice to work on his etchings. Retrospectives in 1889 and 1892 made him popular again with the British public; Whistler returned to England in 1895.

William Zorach (*b. Eurburg [now Yurbarkas], Lithuania, February 28, 1887–d. Bath, Maine, November 15, 1966*)

William Zorach was born Zorach Gorfinkel in Lithuania. In 1891, at the age of four, he immigrated to the United States with his family, settling in Cleveland, Ohio. Zorach was apprenticed to a lithographer at fifteen, but he took night classes at the Cleveland School of Art. In 1908 he moved to New York to study at the National Academy of Design. He continued his studies in Paris in 1910 at the Acadèmie de la Palette. In Paris, Zorach was introduced to European modernist painting and was particularly attracted to the cubist works of Pablo Picasso and the fauvist paintings of Henri Matisse. In 1912 he returned to New York, where his work was included in the 1913 Armory Show. Zorach is often credited as one of the American artists who introduced European modernism to American artists and audiences at that time. In the 1920s he gave up painting to become a self-taught sculptor, carving simple, solid figures in stone and wood that are notable for their compactness and monumentality. For thirty years, beginning in 1929, he taught at the Art Students League.

SELECTED CHRONOLOGY

American Art at The Phillips Collection to 1970 | Compiled by Susan Behrends Frank

1886

June 26
Duncan Clinch Phillips, Jr., the second son of Major Duncan Clinch Phillips and Eliza Irwin Laughlin, is born in Pittsburgh, Pennsylvania. His older brother, James (Jim) Laughlin, was born in 1884.

Duncan and Jim Phillips with their father, Major Duncan Clinch Phillips, c. 1900

1895–97

Major and Mrs. Phillips spend winter 1895–96 in Washington, D.C., and decide to move to the city. They build a house at Twenty-First and Q Streets in northwest Washington. Duncan and Jim attend the Washington School for Boys on Wisconsin Avenue.

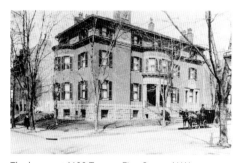

The house at 1600 Twenty-First Street, N.W., Washington, D.C., c. 1900

1908

Duncan and Jim graduate from Yale University.

1912

Duncan, who is twenty-six years old, uses his living allowance to acquire his first painting, a work by American Ernest Lawson; by 1921 the collection has thirteen paintings by the artist.

Duncan Phillips in 1908 at the time of his graduation from Yale University

1914

Jim and Duncan settle in an apartment at 104 East 40th Street in New York.

Duncan begins a lifelong friendship with painter Augustus Vincent Tack. The collection will ultimately include more than seventy works by Tack.

Duncan likely acquires his first Marsden Hartley painting, *After Snow* (c. 1908).

1915

Duncan and his brother Jim meet the painter Julian Alden Weir. By 1921 the Collection has thirteen works by Weir, including nine landscapes.

1916

January 6
Jim writes to his father about both brothers' enthusiasm for collecting; he requests a yearly

stipend of $10,000 for art purchases. A fund is established.

Duncan publishes articles on Albert Pinkham Ryder, William Merritt Chase, and Arthur B. Davies.

1917

The Century Club, a private men's club in New York composed of critics, artists, and collectors, accepts Duncan Phillips as a member; he is sponsored by Tack. "Centurians" Weir and Davies, painters a generation older than Duncan, become his mentors. Centurians befriended by Phillips include the critic and art historian Frank Jewett Mather and artist Gifford Beal.

Duncan publishes essays on Weir and Lawson; he buys his first painting by Childe Hassam and his first work by Maurice Prendergast, *Fantasy* (c. 1917). Works by Davies and George Inness are acquired, as is a first painting by Weir.

September 13
Major Phillips dies suddenly.

1918

Duncan buys two works by contemporary realist Rockwell Kent, *The Road Roller* (1909) and *Burial of a Young Man* (c. 1908–11); the first of six by Kent to enter the collection.

October 21
Duncan's brother, Jim, dies unexpectedly of the Spanish influenza.

Duncan and his mother decide to found the Phillips Memorial Art Gallery as a living memorial to Major Phillips and James.

December
Duncan acquires an early landscape by William Merritt Chase, *Outskirts of Madrid* (1882), which he later gives to Yale University Art Gallery.

1919

Phillips begins a correspondence with Hassam and likely meets him this year.

February
Duncan publishes "Twachtman—An Appreciation" in *The International Studio*.

Duncan compiles a handwritten list of his "15 best purchases of 1918–19" that includes one work by Ryder, Twachtman's *Summer* (late 1890s), and

two each by Claude Monet, Hassam, Lawson, and Weir. He purchases a late painting by Twachtman and John Sloan's *Clown Making Up* (1910) and commissions George Luks to paint *Otis Skinner as Col. Philippe Bridau* (1919).

1920

July 23
The Phillips Memorial Art Gallery is incorporated.

Phillips identifies Twachtman's *Winter* (c. 1891) and Weir's *The High Pasture* (1899–1902) among the "15 Best Purchases Since January 1920." He buys Theodore Robinson's *Giverny* (c. 1889).

Other purchases include Robert Henri's *Dutch Girl* (1910, reworked 1913 and 1919) and George Inness's *Lake Albano* (1869), as well as the Winslow Homer watercolor, *Rowing Home* (1890), that was previously owned by Weir.

November 20–December 20
Phillips lends forty-three paintings to the Century Club in New York for the exhibition *Selected Paintings from the Phillips Memorial Art Gallery*, including works by Monet, Honoré Daumier, Ryder, Twachtman, and Weir. Phillips adopts the practice of hanging European and American works together without regard to chronology or nationality.

Marjorie Acker, a young painter, visits the exhibition at the Century Club and is impressed by Phillips.

1921

May
Marjorie Acker accompanies her uncle, painter Gifford Beal, and his wife on a visit to the Phillips home; she sees the Main Gallery and the North Library (now the Music Room) installed with paintings.

June
Phillips and Marjorie Acker become engaged.

October 8
Duncan Phillips marries Marjorie Acker at her family home in Ossining, New York. They spend early winter in New York City and visit the studio of Maurice and Charles Prendergast. As a friendly gesture, Maurice gives Phillips one of his painted sketches of Luxembourg Gardens (c. 1907); in 1926 Phillips buys a Charles Prendergast screen as a gift for Marjorie.

Late Fall
The Phillips Memorial Art Gallery quietly opens to the public.

Marjorie and Duncan Phillips in the Main Gallery, c. 1922. Photograph by Clara Sipprel

Phillips buys his fourth painting by Twachtman, *The Emerald Pool* (c. 1895).

1922

January
The first two Phillips Collection Publications appear: *Julian Alden Weir* (New York, 1922), and *Honoré Daumier, Appreciations of His Life and Works* (New York, 1922).

February 15
William Mitchell Kendall, of McKim, Mead & White, head of the gallery's committee on architecture, submits recommendations for a new museum building to be constructed in Washington. It is never built; instead, the family moves to a new residence in 1930, leaving the entire house at 1600 Twenty-First Street for the collection.

July 10
Daughter Mary Marjorie is born in New York.

Phillips buys additional paintings by Lawson, Luks, Prendergast, and Sloan; he buys his first work by Guy Pène du Bois.

1923
Phillips acquires Tack's *Storm* (c. 1922–23), one of the artist's first abstractions.

March
Phillips buys Chase's *Hide and Seek* (1888) from the artist's retrospective at the Corcoran Gallery of Art.

June 6
Phillips buys Pierre-Auguste Renoir's *Luncheon of the Boating Party* from dealer Joseph Durand-Ruel in Paris; it is exhibited at the museum for the first time in December.

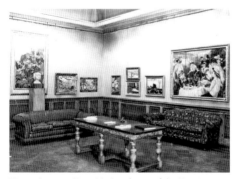

Pierre-Auguste Renoir's *Luncheon of the Boating Party* (1880–81) in the Main Gallery in late 1929 along with works by Augustus Vincent Tack, Paul Cézanne, Maurice Prendergast, Pierre Bonnard, and others

1924

January

The 14th Venice Biennale is the first in which the United States participates with a large group of exhibitors and is a shared project organized by the American Federation of Arts. The project's directors include Charles Moore and Leila Mechlin, both members of Phillips's Committee on Scope and Plan for the museum. Among the seventy-five U.S. entries are eight paintings lent by the Phillips Memorial Gallery, including works by Davies, Kent, Prendergast, and Sloan.

Phillips buys George Bellows's *Emma in Black* (1920).

March

Phillips's memorial essay on Maurice Prendergast, who died February 1, is published in *Arts*.

March 26–April 26

The Phillips Memorial Gallery opens *Exhibition of Recent Decorative Paintings by Augustus Vincent Tack*. The sixteen works represent the first museum showing for the artist. Phillips buys four additional abstractions by Tack for the museum, including *The Voice of Many Waters* (c. 1923–24).

The museum publishes *Arthur B. Davies: Essays on the Man and His Art* as Phillips Publication No. 3.

October 20

Son Laughlin Phillips is born in Washington, D.C.

Phillips purchases Ryder's *Moonlit Cove* (early to mid-1880s).

1925

Phillips buys Max Weber's *High Noon* (1925) and Niles Spencer's *Gray Buildings* (1925); for both artists, these are the first of their works to enter a museum. He also acquires a first work by Louis Michel Eilshemius, *Samoa* (1907).

January

Phillips inaugurates a series of small one-artist exhibitions for living artists in the newly opened Little Gallery, focusing on Americans such as Davies, Charles Demuth, Hassam, Lawson, and Kenneth Hayes Miller.

The Main Gallery continues to feature newly acquired works by European and American masters.

Phillips visits Rockwell Kent's apartment in New York and expresses interest in *Mountain Lake— Tierra del Fuego* (between 1922 and 1925); Phillips grants Kent a $300 per month stipend in exchange for his choice of paintings, an arrangement that continues through 1926.

November

Phillips acquires two works by Stefan Hirsch, *New York, Lower Manhattan* (1921) and *Mill Town* (c. 1925), the first works by the artist to enter a museum.

December 12–26

Phillips presents *Exhibition of Paintings by Bernard Karfiol* in the Little Gallery, the artist's first solo museum exhibition; from it four paintings are acquired for the collection.

1926

January

Exhibition of Paintings by Nine American Artists includes works by Fiske Boyd, Vincent Canadé, Demuth, Preston Dickinson, Hirsch, Charles Sheeler, Niles Spencer, Maurice Sterne, and William Zorach. This is the first Washington showing by these cubist-realist painters.

An Arthur Dove exhibition is held at Alfred Stieglitz's Intimate Gallery in New York. Phillips buys two paintings, *Golden Storm* (1925) and *Waterfall* (1925), the first of Dove's works purchased for a museum.

February

Phillips sees paintings by Georgia O'Keeffe at Stieglitz's New York gallery. He immediately purchases *My Shanty, Lake George* (1922) and one other, which he soon exchanges for *Pattern of Leaves* (1923). These are the first O'Keeffes to enter a museum.

Phillips includes Dove and O'Keeffe in *Exhibition of Paintings by Eleven Americans and an Important Work by Odilon Redon*, which also features Hartley, Kent, Karl Knaths, Alfred Maurer, Walt Kuhn, Tack, and Weber, as well as Canadé and Eugene Speicher.

March

Georgia O'Keeffe visits the Phillips Memorial Gallery.

Phillips buys Charles Sheeler's *Skyscrapers* (1922) from the Daniel Gallery, the first work by Sheeler to enter a museum.

Phillips acquires a first painting by Knaths; it is the artist's first sale. Phillips becomes his patron.

A major seascape by Winslow Homer, *To the Rescue* (1886), is acquired for the collection, along with a first work by Charles Burchfield.

March 1–31

Phillips presents *Exhibition of Recent Paintings by Maurice Sterne* in the Little Gallery, the artist's first

one-person museum exhibition; from it Phillips buys three works. Sterne, in appreciation, gives Phillips a fourth painting, the first gift to the museum. A friendship ensues with Sterne visiting the Phillipses in the 1930s while serving on the National Fine Arts Commission.

April

Phillips buys Edward Hopper's *Sunday* (1926) from a group show held at Frank Rehn's gallery in New York that includes work by Bellows, William Glackens, and Kent. Critics single out *Sunday* as the most striking work; Phillips buys it for $600— the highest price paid to date for a Hopper oil painting.

September

The French artist Pierre Bonnard visits the Gallery while in the United States as a juror for the *Carnegie International Exhibition* in Pittsburgh. Among the American paintings on view, Bonnard admires Twachtman's *Summer* and *The Emerald Pool*.

November 2–19

The museum presents *Exhibition of Paintings by George Luks*, the artist's first museum exhibition.

December

Kent, acknowledging Phillips's financial support, gives him Marsden Hartley's *Mountain Lake— Autumn* (c. 1910), a small landscape Hartley gave to Kent in 1912.

Phillips's book, *A Collection in the Making* (New York and Washington, D.C.: E. Weyhe and Phillips Memorial Gallery, 1926), is published.

Phillips, who discovered John Marin's work in March, sees an exhibition of Marin watercolors at Stieglitz's gallery. He agrees to buy two watercolors, *Back of Bear Mountain* (1925) and *Hudson River Near Bear Mountain* (1925). Stieglitz believes he has sold *Back of Bear Mountain* to Phillips for $6,000 and publicizes the sale. Phillips resents Stieglitz's lack of discretion; a rift between the two men lasts until the end of 1927. Phillips plans his own exhibition of Marin watercolors for early 1927. By 1954, Phillips's Marin holdings have grown to fifteen watercolors and five oils.

December 4–28

The Little Gallery features *Exhibition of Paintings by Jerome Myers*.

1927

January

Phillips learns that Thomas Eakins's *Portrait of Miss Amelia Van Buren* (c. 1891) is available; he acquires it directly from Miss Van Buren.

In the exhibition *American Themes by American Painters*, Phillips chooses artists whom he believes "comprise the rich ore of American painting"[1] up to that time. Among those featured are Burchfield, Hopper, Homer, Sheeler, Sloan, and Zorach. With the addition of work by Eakins, Dove, and Marin, among others, an enlarged version of this exhibition moves to the Baltimore Museum of Art in April.

February 5 through April
The museum presents the first of five Tri-Unit Exhibitions. In the Main Gallery, Phillips installs twelve Marin watercolors opposite a wall of contemporary French paintings by Bonnard, Henri Matisse, André Dunoyer de Segonzac, and Maurice Utrillo. Titled *Sense and Simplification in Ancient Sculpture and Contemporary Painting*, the installation also features works by Paul Cézanne, Prendergast, Tack, and Twachtman, along with an Eighteenth Dynasty Egyptian head that Phillips has recently acquired.

February 9
Phillips writes to the artist John D. Graham for the first time, inviting him "to see our remarkable Tri-Unit Exhibition. . . . There is a whole wall of Marins and it is simply thrilling."[2] Phillips also buys three paintings by Graham and commissions him to do a landscape, *Blue Bay* (1927).

April
An Exhibition of Expressionist Painters from the Experiment Station of the Phillips Memorial Gallery is on view at the Baltimore Museum of Art (April 8–May 1). Alongside works by Matisse and Utrillo, Phillips features the Americans Davies, Graham, Hirsch, Maurer, O'Keeffe, Spencer, Tack, and Weber, among others.

Phillips purchases a second work by Spencer, *The Dormer Window* (1927).

1928
Phillips buys his first Harold Weston painting. A lifelong friendship develops between the artist and the collector, who eventually acquires twenty-seven works by the artist.

February–May
The second *Tri-Unit Exhibition of Paintings and Sculpture* includes works by Eakins, Homer, Ryder, and Whistler, among others, in "American Old Masters," and paintings by Bellows, Davies, Demuth, Hopper, Kent, Marin, O'Keeffe, Pène du Bois, Prendergast, Robinson, Sloan, Spencer, Tack, Twachtman, Weber, Weir, and others in "Contemporary American Painting."

October
Phillips pays the first of four stipends to Graham ($200 in October and December 1928 and February 1930; $600 in August 1930). Over time, Phillips purchases numerous works from the artist.

November
The Art Gallery of Toronto presents *An Exhibition of Paintings Lent by the Phillips Memorial Gallery, Washington: French Paintings from Daumier to Derain and Contemporary American Paintings.*

December
Phillips commissions Tack to do a series of decorative panels for the Lower Gallery of the museum.

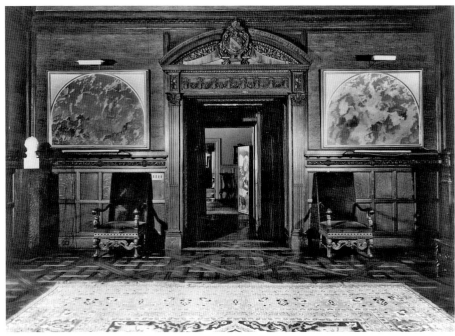

The Lower Gallery (now Music Room) with Augustus Vincent Tack's *Liberation* (1929) and *Ecstasy* (1929), and screen by Charles Prendergast visible in dining room beyond, c. 1931–32

1929
Phillips begins paying a stipend to Tack. The payments continue through 1944, eventually totaling $61,000.

Phillips, who has been searching for a Glackens, buys *Bathers at Bellport* (c. 1912); he also acquires a painting by David Burliuk, the first of nine for the collection.

Phillips acquires Milton Avery's *Winter Riders* (1929), the first work by Avery to enter a museum. Phillips sees great promise in Avery and links his work with Dove and Marin.

February 2
Marin's first solo museum exhibition is installed in the Little Gallery, occasioning Marin's first meeting with Duncan and Marjorie Phillips in April. A lifelong friendship develops. The Lower Gallery features *A Retrospective Exhibition of Paintings by Arthur B. Davies.*

March 11–31
Exhibition of Paintings by John D. Graham is featured in the Little Gallery; this is Graham's first solo museum exhibition.

October 1–November 11
A Group of Watercolors by John Marin is the artist's second solo exhibition. All of the works are drawn from the collection.

October 25
Phillips is elected to the board of trustees of the newly chartered Museum of Modern Art (MoMA), New York. MoMA opens to the public on November 8.

Intimate Decorations in the Little Gallery shows still lifes by Georges Braque and Matisse alongside works by Man Ray, O'Keeffe, and others.

December
Phillips gives Knaths his first solo museum exhibition. Their relationship grows into a thirty-five year friendship; Knaths eventually joins the

faculty of the museum's art school as a guest instructor (1938), continuing his visits and master classes until 1950.

1930

Phillips begins to refer to the Phillips Memorial Gallery as "a museum of modern art and its sources."[3]

Phillips begins paying Dove a monthly stipend in return for first choice of paintings from his annual exhibitions organized by Stieglitz. Although he meets the artist only once (spring 1936), Phillips corresponds with Dove and supports him until Dove's death (1946).

February 3

Graham urges Phillips to see Stuart Davis's work at the Downtown Gallery in New York, writing "I believe you ought to have an example of his work in your collection."[4] Phillips buys *Blue Café* (1928), the first of seven works by Davis to enter the collection.

March–June

Phillips exhibits Tack's sixteen decorative panels in the Lower Gallery and publishes a pamphlet that outlines the themes of the room's mural program.

April 1–30

In the Little Gallery, Phillips holds Harold Weston's first solo exhibition in Washington, D.C.

Fall

The Phillips family moves to a new house at 2101 Foxhall Road. The former residence on Twenty-First Street, N.W., becomes solely dedicated to the museum with living areas now converted into galleries, offices, and storage spaces.

October 5, 1930–January 25, 1931

Phillips installs eight exhibitions and gallery hangings with several focused on American art: *Twelve Americans* includes Dove and O'Keeffe; another is *America from Eakins to Kantor*, while the Stieglitz circle artists, sans Hartley, are featured in *Marin, Dove, and Others*.

1931

February 2–April 5

Twentieth Century Lyricism includes the museum's newly acquired still life by the Mexican artist Rufino Tamayo, *Mandolins and Pineapples* (1930), the first work by the artist to enter a museum.

September 27, 1931–January 1932

Phillips opens the exhibitions *Calligraphy in Modern Occidental Art*, with twelve works primarily by Knaths and Marin; *Modern Wit and Two-Dimensional Design*, featuring work by Davis, Raoul Dufy, Graham, Paul Klee, Walt Kuhn, and Sheeler; and *Un-Selfconscious America*, including Burchfield, Bellows, Hopper, Sloan, and Spencer.

December

An Exhibition of Recent Work by Karl Knaths includes the artist's latest canvas, newly acquired by the museum, *Maritime* (1931).

1932

January

Phillips publishes "Original American Painting Today" in *Formes* magazine.

Weston lectures on the theme "Beyond the Known: The Artist's Abnormality of Vision," in conjunction with an exhibition of his work at the Phillips.

February and March

Recent Paintings by Walt Kuhn includes *Plumes* (1931), the fourth work by the artist to enter the collection; it is Kuhn's first solo exhibition in Washington, D.C. Kuhn visits the museum and meets Phillips for the first time. Phillips visits Kuhn's studio in New York on March 2.

February–June

Phillips opens *Daumier and Ryder* and *American and European Abstractions*. The latter includes Dove's *Golden Storm* and Knaths's *Maritime*, alongside works by Braque, Juan Gris, and Picasso.

In the Lower Gallery Phillips installs the mural cycle of sixteen decorative paintings commissioned from Tack; the installation now includes the monumental *Aspiration* (1931).

Fall

Because of the Depression, the museum opens only on Saturdays from 11 a.m. to 6 p.m. A full schedule does not resume until October 1933.

October 19

Phillips writes a letter declining Yale University Art Gallery's request that the entire Phillips Collection be given to Yale.

1932–33

Artist Edward Bruce heads the new federal agency known as the Public Works of Art Project (PWAP). Artists are commissioned to paint murals and easel paintings representing "The American Scene." Phillips is chairman of Regional Committee No. 4 Public Works of Art Project [Maryland, Virginia, and the District of Columbia]. Phillips, who had to end his stipend to Graham in 1930, helps Graham get employment with PWAP.

1933

January

Phillips sends emergency funds to Dove.

Phillips purchases Burchfield's *Moonlight Over the Arbor* (1916) and *Woman in Doorway* (1917); he also acquires additional works by Dove and Graham as well as Weston.

In appreciation of Phillips's support, Graham gives him a major figurative painting, *Harlequin in Gray* (1928).

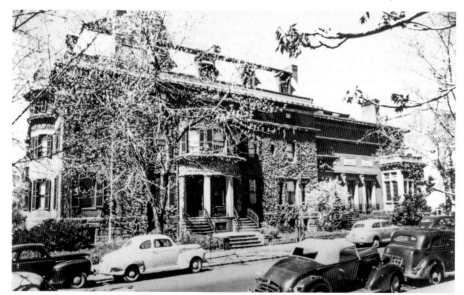

Exterior of the Phillips Memorial Gallery in the 1930s

November 5, 1933–February 12, 1934

Phillips organizes a tri-part exhibition entitled *Freshness of Vision in Painting* that includes a loan exhibition of twenty-three early watercolors by Burchfield and a separate installation of eight works by Eilshemius.

1934

January–March

Phillips urges Dove to work in the Public Works of Art Project; Stieglitz objects, and Dove refuses the offer.

December 29

Gertrude Stein delivers her lecture "Pictures" at the Phillips Memorial Gallery.

1935

October 6, 1935–February 1937

Contemporary American and European Paintings from the Phillips Memorial Gallery Selected by Mr. Phillips to Show the "Center" of the Recent Art Movement Rather than Extreme "Right" or "Left," a traveling exhibition, is circulated to twelve venues by the American Federation of Arts.

November

Phillips delivers an address in Washington (likely at the museum) on the Public Works of Art Project (PWAP), pleading for continued funding.[5] The lecture overlaps with an exhibition at the Phillips Memorial Gallery entitled *Work of Artists from Washington, Virginia, and Maryland* (November 16, 1935–January 1, 1936) that features works by local PWAP artists and is the first sales exhibition held at the museum.

1936

April 25

Phillips meets Dove for the first and only time at Stieglitz's New York gallery.

1937

February

A portion of Marin's retrospective at MoMA travels to the Studio House at the Phillips. From it Phillips purchases *Pertaining to Fifth Avenue and Forty-Second Street* (1933) and a watercolor, *Quoddy Head, Maine Coast* (1933).

March 23–April 18

The Gallery presents *Retrospective Exhibition of Works in Various Media by Arthur G. Dove.* This is Dove's first museum retrospective and the only one during his lifetime.

1938

Through Stieglitz, Phillips pays Marin a monthly stipend of one hundred dollars.

Spring

Stuart Davis visits the museum.

April 10–May 1

Phillips organizes the exhibition *Picasso and Marin.* It contrasts three Picasso Blue Period canvases (1901–4) with twenty-one Marin watercolors and oils (1910–38).

1939

September

Davis, in financial difficulty, writes to Phillips asking him to buy additional examples of his work; Phillips purchases two paintings, *Boats* (1930) and *Eggbeater No. 4* (1928), which Davis believes to be the best example from the series. Davis visits the museum on October 12 to see them on view.

1940

Phillips becomes a trustee and member of the acquisition committee of the National Gallery of Art in Washington, D.C.; it opens to the public on March 17.

Phillips, who has admired the work of Yasuo Kuniyoshi since 1928, buys his first Kuniyoshi, *Maine Family* (c. 1922–23).

September

The abstract artist Ilya Bolotowsky, who has never met Phillips, arrives unannounced at the Phillips summer home in Ebensburg, Pennsylvania; Phillips purchases two paintings.

1941

MoMA acquires its first work by Arthur Dove, *Willows* (1940), through a gift from Phillips.

Phillips purchases O'Keeffe's *From the White Place* (1940), one of her recent New Mexico canvases.

1942

January 11–February 1

Modern Mexican Painters, a traveling exhibition organized by the Institute of Modern Art, Boston, is on view at the museum. Tamayo's work is included in the show. In December, Phillips buys his second Tamayo painting, *Carnival* (1941).

February 14–March 3

The Phillips Memorial Gallery is the first museum to exhibit Jacob Lawrence's sixty-panel work *The Migration Series* (1940–41);[6] this is the artist's first solo museum exhibition. Phillips purchases the

odd-numbered panels, while the thirty even-numbered ones are acquired by MoMA, which organizes a fifteen venue national tour (1942–44) for *The Migration Series* that includes all sixty panels.

March 15–April 15

Phillips organizes the loan show *Cross Section Number One of a Series of Specially Invited American Paintings and Water Colors with Rooms of Recent Work by Max Weber, Karl Knaths, Morris Graves.* He includes Graham's *Blue Still Life* (1931), which he had admired at the San Francisco World's Fair. Phillips purchases it for the collection.

Spring

Phillips purchases the first of eleven works by Graves.

Having acquired a work by Grandma Moses in 1941 for his personal enjoyment, Phillips buys *Cambridge Valley* (1942) for the collection, the first work by Moses to enter a museum.

1943

January 17–February 15

Avery's first solo museum exhibition is held at the museum. Phillips purchases four works, including *Girl Writing* (1941) and *Pink Still Life* (1938).

August 1–September 30

John Marin: A Retrospective Loan Exhibition of Paintings is organized by Phillips.

October 24–November 23

Paintings by Marsden Hartley is organized by Phillips. It is the first major retrospective of Hartley's work following his death on September 2. From the exhibition Phillips purchases *Off the Banks at Night* (1942) and *Wild Roses* (1942).

Phillips purchases his first Ralston Crawford, *Boat and Grain Elevators, No. 2* (1942). He also acquires O'Keeffe's *Large Dark Red Leaves on White* (1925).

1944

February 27–March 27

Solo exhibitions on Kuhn and Knaths are on view.

March

Phillips publishes an essay in *Magazine of Art* celebrating Hartley as one of America's great masters.

April 9–May 30 (extended to June 18)

The American Paintings of the Phillips Collection is an exhibition of nearly 200 works designed to show the extent of the museum's holdings.

Summer–Fall

The artist Richard Diebenkorn visits the Phillips Memorial Gallery on weekends while stationed at Quantico Marine Base in Virginia; he admires Matisse's *Studio, Quai St. Michel* (1916), as well as work by Crawford, Dove, Hartley, Marin, Ryder, Sheeler, and Tack.

Phillips purchases a first work by Bradley Walker Tomlin, *Still Life* (1940).

1945

On view are various installations of American art, along with exhibitions on Eugène Delacroix and Pierre Bonnard, as well as Georges Rouault and Daumier lithographs.

Phillips buys O'Keeffe's *Red Hills, Lake George* (1927), as well as Eilshemius's *New York Roof Tops* (1908).

1946

Phillips is chair of a committee charged with selecting an exhibition of contemporary American paintings for the Tate Gallery, London.

October

Dove writes his last letter to Duncan and Marjorie Phillips before dying in Huntington, Long Island, New York, on November 22.

November 3–24

The museum shows *Pioneers of Modern Art in America*, a traveling exhibition of sixty-four works, circulated by the American Federation of Arts.

1947

April 18–September 22

A Retrospective Exhibition of Paintings by Arthur G. Dove is installed; Phillips buys three watercolors and two paintings by Dove from the Downtown Gallery, increasing his Dove holdings to more than forty works in various media.

May

Phillips publishes a tribute to Dove in *Magazine of Art*.

December

In *Magazine of Art* Phillips writes of Morris Graves as a poet painter with a mystic spirit that bridges East and West.

Phillips acquires a second major Hopper work, *Approaching a City* (1946).

1948

A Paul Klee Room is installed at the museum featuring the collection's twelve works by the artist.

The Paul Klee "unit" installed in a small second floor gallery at 1600 Twenty-First Street, N.W., 1963

A cornerstone of the museum until 1982, it inspires such artists as Morris Louis and Kenneth Noland.

March 7–April 6

Recent Paintings by Karl Knaths includes *Deer in Sunset* (1946), a newly acquired work.

June–October

Some Contemporary American Paintings from the Collection includes works by Avery, Bolotowsky, Crawford, Dove, Hopper, Knaths, and Kuniyoshi.

1949

Phillips purchases three biomorphic abstractions by Theodoros Stamos, including *The Sacrifice of Kronos, No. 2* (1948), the first of eight works by Stamos to enter the collection.

May 8–June 9

A loan exhibition of thirty-one works, *Paintings by Grandma Moses*, is shown in the Print Rooms. Phillips purchases *Hoosick Falls in Winter* (1944).

Summer

O'Keeffe, who is managing Stieglitz's estate, gives the Phillips Gallery a special set of nineteen cloud photographs (two *Songs of the Sky* and seventeen *Equivalents*) by the late photographer.

November 6–29

Stieglitz's *Equivalents* are exhibited in the Print Rooms.

1950

January 15–31

Paintings and Watercolors by Theodoros Stamos features twenty-five works; it is Stamos's first solo

Alfred Stieglitz, *Equivalent (Bry no. 167A)* (1929), gelatin silver print, The Alfred Stieglitz Collection, gift of Georgia O'Keeffe, 1949

museum exhibition. Stamos visits Washington and stays with the Phillips family; he mentions Mark Rothko to Phillips, pointing out the artist's kinship with Bonnard.

June 25–September 16

As a tribute to Tack, who died June 21, 1949, Phillips installs nine works for *Memorial Exhibition: Abstractions by Augustus Vincent Tack*.

Half of the U.S. Pavilion at the Venice Biennale is dedicated to a Marin retrospective, comprising fifty-five works. The museum lends eight of them. It also lends two paintings by Lee Gatch to the Biennale. Phillips writes the catalogue statement on Marin.

1951

Phillips purchases Noland's *Inside* (1950), the artist's first work in a public collection. He also purchases his first Alexander Calder, *Red Polygons* (c. 1950).

1952

Phillips buys a major Adolph Gottlieb painting, *The Seer* (1950), and Willem de Kooning's *Asheville* (1948). He also acquires a second work by Noland.

The U.S. Pavilion at the Venice Biennale features the artists Calder, Davis, Hopper, and Kuniyoshi. The Gallery lends Davis's *Eggbeater No. 4* (1928) and Hopper's *Approaching a City* (1946).

October

John Marin dies at age 83.

1954

Phillips acquires his last Marin, a late work, *Spring No. 1* (1953).

November or December

Duncan and Marjorie Phillips visit Betty Parsons Gallery in New York and select three Kenzo Okada paintings, which are sent to them on approval. They settle on *Number 2* (1954).

December 1, 1954–January 3, 1955

Stamos has a second solo exhibition at the Phillips and gives the lecture "Why Nature in Art?," in which he praises American artists who convey emotion and spirituality through direct experience with nature, including Dove, Hartley, and Ryder.

1955

March 6–May 3

Phillips honors Tomlin, who died in 1953, by organizing his first solo museum show. Phillips buys a second work by the artist, *No. 8* (1952).

May 15–June 30

John Marin Memorial Exhibition, a traveling show organized by UCLA Art Galleries, features 122 works; Duncan Phillips writes the foreword to the catalogue.

September

Okada and his wife visit The Phillips Collection on the occasion of his exhibition organized by the Institute of Contemporary Art (ICA), Washington, D.C., and held at the Corcoran Gallery of Art; the Okadas stay with Phillips's close friend and former associate director, C. Law Watkins.

1956

April 15–May 7

Morris Graves Retrospective Exhibition, a traveling show organized by UCLA Art Galleries, features ninety-four works; Phillips contributes an essay on Graves to the catalogue.

Fall

The dealer Sidney Janis lends four Rothko paintings to Phillips, who is searching for a Rothko to add to the collection.

Early November

Phillips goes to the Okada exhibition at Betty Parsons Gallery in New York, where he meets up with the Okadas; he buys his second Okada painting, *Footsteps* (1954).

1957

January–February 26

A small exhibition entitled *Paintings by Tomlin,* *Rothko, Okada* is held in the Print Rooms; it is the first showing of Rothko's work at the Gallery. From this show Phillips purchases two Rothkos, *Green and Maroon* (1953) and *Mauve Intersection* (1949).

Phillips buys a third Tomlin for the collection, *No. 9* (1952).

1958

Spring

Phillips purchases Philip Guston's *Native's Return* (1957).

October

Phillips makes his first and only purchase of a Jackson Pollock, *Collage and Oil* (c. 1951).

October 19–November 20

Phillips organizes *Paintings by Sam Francis*, the artist's first major exhibition in Washington, D.C. It features twenty works; Phillips acquires *Blue* (1958) from the exhibition.

Phillips buys Joan Mitchell's *August, Rue Daguerre* (1957) and Richard Diebenkorn's *Interior with View of the Ocean* (1957).

1959

April 24

As part of its fiftieth anniversary, the American Federation of Arts gives out awards for outstanding contributions to art and artists in America.

Honorees are Alfred Barr, Robert Woods Bliss, Phillips, and Paul J. Sachs.

1960

Phillips and Marjorie visit Rothko's studio in New York to select works for the artist's upcoming show at the museum.

May 4–31

Paintings by Mark Rothko opens at the Phillips; *Green and Tangerine on Red* (1956) and *Orange and Red on Red* (1957) are acquired from this show.

July

From Jefferson Place Gallery in Washington, Phillips acquires Noland's *April* (1960), an example from the artist's *Concentric Circles* series.

November 5

A new wing of the museum opens to the public. The Braques are displayed together downstairs, and a small room is designated for three paintings by Rothko. A fourth painting, *Ochre and Red on Red* (1954), is added in 1964.

1961

January

Rothko is in Washington for John F. Kennedy's inauguration and visits The Phillips Collection.

Phillips continues his practice of introducing the work of contemporary artists in small, solo

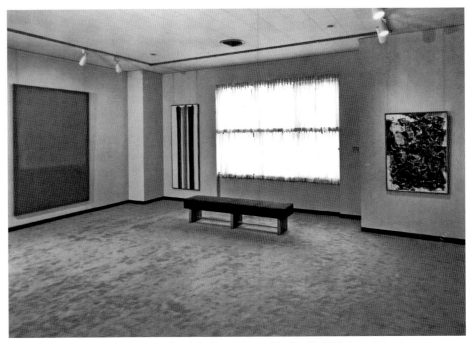

Installation in 1964 in the new Annex of Mark Rothko, *Ochre and Red on Red* (1954), Morris Louis, *Number 182* (1961), and Sam Francis, *Blue* (1958)

exhibitions in the Print Rooms. He buys Avery's *March on the Balcony* (1952).

May 19–June 26
A loan exhibition in the Print Rooms, *Richard Diebenkorn*, includes eighteen works. This is the first East Coast solo museum exhibition for the California artist; Phillips acquires *Girl with Plant* (1960) from the exhibition, the second Diebenkorn for the collection.

July
The museum's name is officially changed to The Phillips Collection.

1962

January 28–February 28
Paintings by Josef Albers, a loan exhibition of twenty works, is installed in the Print Rooms; Phillips acquires Albers's *Homage to the Square: Temprano* (1957).

View of *David Smith* (loan exhibition) in the new Annex, 1962

March 11–April 30
With the showing of *David Smith* organized by MoMA, the Phillips begins a series of large, important sculpture exhibitions. Smith visits the exhibition and lunches with the Phillipses.

May 6–July 1
The entire museum is used for a Mark Tobey exhibition. Organized by Phillips, the loan show presents forty-five works. Phillips buys his second Tobey, *After the Imprint* (1961).

1963
A second work by Gottlieb is added to the collection, *Equinox* (1963), and a first by Morris Louis, *Number 182* (1961).

1964

January 12–February 24
Phillips organizes an exhibition of Seymour Lipton's sculpture; from it he purchases *Ancestor* (1958).

August 11
Marjorie Phillips, on behalf of Duncan, writes to Clyfford Still, then living outside Baltimore, offering him a solo exhibition at the museum. Still declines.

1965
Following Avery's death in January, Phillips acquires the artist's late masterpiece, *Black Sea* (1959), the eleventh work by the artist to enter the collection. Although Phillips never met Avery, he steadily assembled a comprehensive array of his work that included oils and works on paper from all periods of his career.

January 2–February 15
Phillips organizes the first exhibition of Robert Motherwell's collages in the United States; two works are purchased from the exhibition. Motherwell and his wife, the artist Helen Frankenthaler, attend the show.

Phillips buys one of Jack Tworkov's gestural canvases, *Highland* (1959).

1966

April 9–May 30
Phillips installs *Paintings by Arthur G. Dove from the Collection*.

May 9
Phillips falls ill and dies at his home in Washington.

1967
In memory of Duncan Phillips, Marin's son gives the museum Marin's *Weehawken Sequence, No. 30* (c. 1916).

October 7–November 14
Marjorie Phillips organizes *Paintings by Sam Gilliam*, the artist's first solo museum exhibition; from it *Red Petals* (1967) is purchased, the first work by Gilliam to enter a museum.

1968
Marjorie gives the museum Thomas Mehring's *Interval* (1967), one of the artist's Z-format works from his last series of paintings.

April 20–May 31
Marjorie organizes the exhibition *Recent Paintings and Drawings: [Jack] Youngerman* for which she writes the catalogue essay. From the show she acquires Youngerman's *Ultramarine Diamond* (1967) for the museum.

1969

May 10–June 22
Marjorie organizes *Loan Exhibition of Contemporary Paintings* from which Still's *1950-B* (1950) is acquired for the museum. She also purchases Cleve Gray's *Winter* (1968) and David Hare's *Mountain Night* (1969) for the collection.

1970
Marjorie publishes her book *Duncan Phillips and His Collection* (Boston: Little, Brown and Company, 1970).

After Duncan Phillips's death in 1966, Marjorie Phillips serves as director of The Phillips Collection until 1972. Their son, Laughlin, serves as director from 1972 to 1992, at which time the museum comes under its first director who is not a family member (Charles Moffett). Marjorie Phillips dies in 1985.

1. Duncan Phillips, "American Themes by American Painters," in *American Themes by American Painters Lent by Phillips Memorial Gallery* (Baltimore: Friends of Art, April 12–May 3, 1927), unpaginated brochure.
2. Letter in The Phillips Collection Archives.
3. Duncan Phillips, "Free Lance Collecting," *Space* 1 (June 1930), 7.
4. "There is an interesting show of Stuart Davis on now, fine paintings, and I believe you ought to have an example of his work in your collection." Letter in The Phillips Collection Archives.
5. Duncan Phillips's lecture notes the successes of the PWAP in the Washington area: "Seventeen projects have been approved, including eight fresco panels and two decorations for the auditorium of Eastern High School." Erika Passantino and Sarah Martin, "Chronology," in Eliza E. Rathbone, *Duncan Phillips Centennial Exhibition*, exh. cat. (Washington, D.C.: The Phillips Collection, 1986), 39.
6. The series was originally titled *The Migration of the Negro*, but the artist changed it to *The Migration Series* in 1993; Lawrence also changed the narrative captions for each panel at the same time. See *Jacob Lawrence: The Migration Series*, ed. Elizabeth Hutton Turner, exh. cat. (Washington, D.C.: The Rappahannock Press and The Phillips Collection, 1993), 165.

CHECKLIST OF FEATURED WORKS FROM THE COLLECTION

MILTON AVERY (1885–1965)

Black Sea, 1959
Oil on canvas, 50 × 67¾ in. (127 × 172.1 cm)
Acquired 1965

Girl Writing, 1941
Oil on canvas, 48 × 31¼ in. (121.9 × 80.7 cm)
Acquired 1943

Pink Still Life, 1938
Oil on cardboard, 15 × 22 in. (38.1 × 55.9 cm)
Acquired 1943

GIFFORD BEAL (1879–1956)

Waterfall, Haiti, 1954
Oil and egg tempera on canvas, 36 × 36 in.
(91.4 × 91.4 cm)
Acquired 1955

GEORGE BELLOWS (1882–1925)

Emma at the Window, 1920
Oil on canvas, 41¼ × 34⅜ in. (104.8 × 87.3 cm)
Acquired 1924

ISABEL BISHOP (1902–1988)

Lunch Counter, c. 1940
Oil and egg tempera on Masonite, 23 × 14 in.
(58.4 × 35.6 cm)
Acquired 1941

OSCAR BLUEMNER (1867–1938)

Somber and Hard, 1927
Gouache on paper, 9⅜ × 12½ in. (23.8 × 31.8 cm)
Acquired 1937

ILYA BOLOTOWSKY (1907–1981)

Abstraction, 1940
Oil on canvas, 19 × 24⅞ in. (48.3 × 63.2 cm)
Acquired 1940

EDWARD BRUCE (1879–1943)

Power, c. 1933
Oil on canvas, 30 × 45 in. (76.2 × 114.3 cm)
Gift of Mrs. Edward Bruce, 1957

CHARLES BURCHFIELD (1893–1967)

December Moonrise, 1959
Watercolor on paper, 30 × 36 in. (76.2 × 91.4 cm)
Gift of B. J. and Carol Cutler, 2009

Moonlight Over the Arbor, 1916
Watercolor and gouache on paper, 19¼ × 13½ in.
(49 × 34.3 cm)
Acquired 1933

Woman in Doorway, 1917
Gouache on canvas adhered to cardboard,
25 × 30 in. (63.5 × 76.2 cm)
Acquired 1933

ALEXANDER CALDER (1898–1976)

Red Polygons, c. 1950
Painted sheet metal and wire mobile, 34 × 61 in.
(86.4 × 155 cm)
Acquired 1951

ARTHUR B. CARLES (1882–1952)

Basket of Fruit and Flowers, c. 1925
Oil on canvas, 16 × 20⅜ in. (40.6 × 51.8 cm)
Acquired 1959

JEAN CHARLOT (1898–1979)

Leopard Hunter, undated
Oil on canvas, 11 × 14 in. (28 × 35.6 cm)
Acquired 1930

WILLIAM MERRITT CHASE (1849–1916)

Hide and Seek, 1888
Oil on canvas, 27⅝ × 35⅞ in. (70.1 × 91.1 cm)
Acquired 1925

RALSTON CRAWFORD (1906–1978)

Boat and Grain Elevators No. 2, 1942
Oil on hardboard, 20⅛ × 16 in. (51.1 × 40.6 cm)
Acquired 1943

Factory Roofs, c. 1934
Watercolor on paper, 12 × 16 in. (30.5 × 40.6 cm)
Gift of Linda Lichtenberg Kaplan, 1994

ALLAN ROHAN CRITE (1910–2007)

Parade on Hammond Street, 1935
Oil on canvas board, 18 × 24 in. (45.7 × 60.9 cm)
Acquired 1942

ARTHUR B. DAVIES (1862–1928)

Along the Erie Canal, 1890
Oil on canvas, 18⅛ × 40⅛ in. (46 × 102 cm)
Acquired 1920

The Flood, c. 1903
Oil on canvas, 18⅛ × 30 in. (46 × 76.2 cm)
Acquired 1924

STUART DAVIS (1892–1964)

Blue Café, 1928
Oil on canvas, 18⅛ × 21⅝ in. (46 × 55 cm)
Acquired 1930

Egg Beater No. 4, 1928
Oil on canvas, 27⅛ × 38¼ in. (68.9 × 97.2 cm)
Acquired 1939

Still Life with Saw, 1930
Oil on canvas, 26 × 34 in. (66 × 86.4 cm)
Acquired 1946

WILLEM DE KOONING (1904–1997)

Asheville, 1948
Oil and enamel on cardboard, 25½ × 31⅞ in. (65 × 81 cm)
Acquired 1952

CHARLES DEMUTH (1883–1935)

Red Chimneys, 1918
Watercolor on paper, 10⅛ × 14 in. (24.7 × 35.6 cm)
Acquired 1925

PRESTON DICKINSON (1889–1930)

Winter, Harlem River, undated
Oil on canvas, 20⅛ × 30 in. (51.1 × 76.2 cm)
Acquired 1923

RICHARD DIEBENKORN (1922–1993)

Girl with Plant, 1960
Oil on canvas, 80 × 69½ in. (203.2 × 176.5 cm)
Acquired 1961

Interior with View of the Ocean, 1957
Oil on canvas, 49½ × 57⅞ in. (125.7 × 147 cm)
Acquired 1958

PAUL DOUGHERTY (1877–1947)

Storm Voices, 1912
Oil on canvas, 36 × 48 in. (91.4 × 121.9 cm)
Acquired 1912

ARTHUR G. DOVE (1880–1946)

Electric Peach Orchard, 1935
Wax emulsion on canvas, 20¼ × 28 in.
(51.4 × 71.1 cm)
Acquired 1935

Golden Storm, 1925
Oil and metallic paint on plywood panel, 18⅝ × 20½ in.
(47.2 × 52.1 cm)
Acquired 1926

Green Ball, 1939–40
Wax emulsion on canvas, 12½ × 20 in.
(31.8 × 50.8 cm)
Acquired 1940

Me and the Moon, 1937
Wax emulsion on canvas, 18 × 26 in. (45.7 × 66 cm)
Acquired 1939

Morning Sun, 1935
Oil on canvas, 20 × 28 in. (50.8 × 71.1 cm)
Acquired 1935

Rain or Snow, 1943
Oil, wax emulsion, and silver leaf on canvas, 35 × 25 in.
(88.9 × 63.5 cm)
Acquired 1944

Red Sun, 1935
Oil on canvas, 20¼ × 28 in. (51.4 × 71.1 cm)
Acquired 1935

Sand Barge, 1930
Oil on cardboard, 30⅛ × 40¼ in. (76.5 × 102.2 cm)
Acquired 1931

Snow Thaw, 1930
Oil on canvas, 18 × 24 in. (45.7 × 61 cm)
Acquired 1930

THOMAS EAKINS (1844–1916)

Miss Amelia Van Buren, c. 1891
Oil on canvas, 45 × 32 in. (114.3 × 81.3 cm)
Acquired 1927

LOUIS MICHEL EILSHEMIUS (1864–1941)

New York Roof Tops, 1908
Oil on cardboard on wood panel, 30½ × 25⅝ in.
(77.5 × 65.1 cm)
Acquired 1945

Samoa, 1907
Oil on cardboard, 23¼ × 27 in. (59.1 × 68.6 cm)
Acquired 1927

LYONEL FEININGER (1871–1956)
Village, 1927
Oil on canvas, 16⅞ × 28½ in. (42.9 × 72.4 cm)
Acquired 1943

SAM FRANCIS (1923–1994)
Blue, 1958
Oil on canvas, 48¼ × 34¾ in. (122.6 × 88.3 cm)
Acquired 1958

HELEN FRANKENTHALER (1928–2011)
Canyon, 1965
Acrylic on canvas, 44 × 52 in. (111.8 × 132.1 cm)
The Dreier Fund for acquisitions and funds given by
Gifford Phillips, 2001

ALBERT EUGENE GALLATIN (1881–1952)
Composition, 1941
Oil and paper collage on canvas board,
18⅞ × 14⅜ in. (48 × 36.5 cm)
Acquired 1945

SAM GILLIAM (B. 1933)
Red Petals, 1967
Acrylic on canvas, 88 × 93 in. (223.5 × 236.2 cm)
Acquired 1967

WILLIAM GLACKENS (1870–1938)
Bathers at Bellport, c. 1912
Oil on canvas, 25 × 30 in. (63.5 × 76.2 cm)
Acquired 1929

ADOLPH GOTTLIEB (1903–1974)
Equinox, 1963
Oil on canvas, 90 × 84 in. (228.6 × 213.4 cm)
Acquired 1963

The Seer, 1950
Oil on canvas, 59¼ × 71⅝ in. (151.8 × 182 cm)
Acquired 1952

JOHN D. GRAHAM (1887–1961)
Blue Still Life, 1931
Oil on canvas, 25⅝ × 36⅛ in. (65.1 × 91.8 cm)
Acquired 1942

Rue Brea, c. 1928
Oil on canvas, 25 × 20½ in. (63.5 × 52.1 cm)
Gift of Judith H. Miller, 1990

Two Eggs, 1928
Oil on canvas board, 12¾ × 16 in. (32.4 × 40.6 cm)
Acquired 1929

MORRIS GRAVES (1910–2001)
August Still Life, 1952
Oil on canvas mounted on hardboard, 48 × 40¾ in.
(122 × 104 cm)
Acquired 1954

PHILIP GUSTON (1913–1980)
Native's Return, 1957
Oil on canvas, 64⅞ × 75⅞ in. (164.8 × 192.7 cm)
Acquired 1958

MARSDEN HARTLEY (1877–1943)
Gardener's Gloves and Shears, c. 1937
Oil on canvas board, 15⅞ × 20 in. (40.3 × 50.8 cm)
Acquired 1939

Mountain Lake—Autumn, c. 1910
Oil on academy board, 12 × 12 in. (30.5 × 30.5 cm)
Gift of Rockwell Kent, 1926

Off the Banks at Night, 1942
Oil on hardboard, 30 × 40 in. (76.2 × 101.6 cm)
Acquired 1943

Wild Roses, 1942
Oil on hardboard, 22 × 28 in. (55.9 × 71.1 cm)
Acquired 1943

CHILDE HASSAM (1859–1935)
Washington Arch, Spring, c. 1893 (inscribed *1890*)
Oil on canvas, 26⅛ × 21⅝ in. (66.4 × 55 cm)
Acquired 1921

ROBERT HENRI (1865–1929)
Dutch Girl, 1910, reworked 1913 and 1919
Oil on canvas, 24¼ × 20¼ in. (61.6 × 51.4 cm)
Acquired 1920

EDWARD HICKS (1780–1849)
The Peaceable Kingdom, 1845–46
Oil on canvas, 24⅛ × 32⅛ in. (61.3 × 81.6 cm)
Acquired 1939

STEFAN HIRSCH (1899–1964)
Mill Town, c. 1925
Oil on canvas, 30 × 40 in. (76.2 × 101.6 cm)
Acquired 1925

New York, Lower Manhattan, 1921
Oil on canvas, 29 × 34 in. (73.7 × 86.4 cm)
Acquired 1925

WINSLOW HOMER (1836–1910)
Girl with Pitchfork, 1867
Oil on canvas, 24 × 10½ in. (61 × 26.7 cm)
Acquired 1946

To the Rescue, 1886
Oil on canvas, 24 × 30 in. (61 × 76.2 cm)
Acquired 1926

EDWARD HOPPER (1882–1967)
Approaching a City, 1946
Oil on canvas, 27⅛ × 36 in. (68.9 × 91.4 cm)
Acquired 1947

Sunday, 1926
Oil on canvas, 29 × 34 in. (73.7 × 86.4 cm)
Acquired 1926

GEORGE INNESS (1825–1894)
Lake Albano, 1869
Oil on canvas, 30⅜ × 45⅛ in. (77.2 × 115.3 cm)
Acquired 1920

Moonlight, Tarpon Springs, 1892
Oil on canvas, 30 × 45½ in. (76.2 × 115.6 cm)
Acquired 1911; sold 1928; reacquired 1939

JOHN KANE (1860–1934)
Across the Strip, 1929
Oil on canvas, 32¼ × 34¼ in. (81.9 × 87 cm)
Acquired 1930

BERNARD KARFIOL (1886–1952)
Boy, undated
Oil on canvas, 37⅛ × 27⅜ in. (94.3 × 69.5 cm)
Acquired 1925

ROCKWELL KENT (1882–1971)
Azopardo River, 1922
Oil on canvas, 34⅛ × 44 in. (86.7 × 111.8 cm)
Acquired 1925

Burial of a Young Man, c. 1908–11
Oil on canvas, 28⅛ × 52¼ in. (71.4 × 132.7 cm)
Acquired 1918

Mountain Lake—Tierra del Fuego, between 1922 and 1925
Oil on wood panel, 15⅝ × 20⅛ in. (39.7 × 51.1 cm)
Acquired 1925

The Road Roller, 1909
Oil on canvas, 34⅛ × 44¼ in. (86.7 × 112.4 cm)
Acquired 1918

KARL KNATHS (1891–1971)
Cin-Zin, 1945
Oil on canvas, 24 × 30 in. (61 × 76.2 cm)
Acquired 1945

Deer in Sunset, 1946
Oil on canvas, 36 × 42⅛ in. (91.4 × 107 cm)
Acquired 1948

Maritime, 1931
Oil on canvas, 40 × 32 in. (101.6 × 81.3 cm)
Acquired 1931

WALT KUHN (1877–1949)
Plumes, 1931
Oil on canvas, 40 × 30 in. (101.6 × 76.2 cm)
Acquired 1932

YASUO KUNIYOSHI (1893–1953)
Maine Family, c. 1922–23
Oil on canvas, 30¼ × 24⅛ in. (76.8 × 61.3 cm)
Acquired 1940

JOHN LA FARGE (1835–1910)
Chiefs and Performers in War Dance, Fiji, 1891
Watercolor and gouache on illustration board, 9⅜ × 21 in.
(23.8 × 53.3 cm)
Acquired 1921

JACOB LAWRENCE (1917–2000)
*The Migration Series, Panel no. 1: During the World War
there was a great migration north by southern African
Americans*, 1940–41
Casein tempera on hardboard, 12 × 18 in. (30.5 × 45.7 cm)
Acquired 1942

*The Migration Series, Panel no. 3: From every southern
town migrants left by the hundreds to travel north*, 1940–41
Casein tempera on hardboard, 12 × 18 in. (30.5 × 45.7 cm)
Acquired 1942

The Migration Series, Panel no. 31: The migrants found improved housing when they arrived north, 1940–41
Casein tempera on hardboard, 12 × 18 in. (30.5 × 45.7 cm)
Acquired 1942

The Migration Series, Panel no. 45: The migrants arrived in Pittsburgh, one of the great industrial centers of the North, 1940–41
Casein tempera on hardboard, 12 × 18 in. (30.5 × 45.7 cm)
Acquired 1942

The Migration Series, Panel no. 57: The female workers were the last to arrive north, 1940–41
Casein tempera on hardboard, 18 × 12 in. (45.7 × 30.5 cm)
Acquired 1942

ERNEST LAWSON (1873–1939)
Spring Night, Harlem River, 1913
Oil on canvas mounted on panel, 25⅛ × 30⅛ in. (63.8 × 76.5 cm)
Acquired 1920

DORIS LEE (1905–1983)
Illinois River Town, c. 1938
Oil on canvas, 32 × 50 in. (81.3 × 127 cm)
Acquired 1939

SEYMOUR LIPTON (1903–1986)
Ancestor, 1958
Nickel-silver on Monel metal, 87 × 19½ × 32 in. (221 × 49.5 × 81.3 cm)
Acquired 1964

MORRIS LOUIS (1912–1962)
Number 182, 1961
Acrylic on unprimed canvas, 82¼ × 33¼ in. (209 × 84.5 cm)
Acquired 1963

Seal, 1959
Acrylic on canvas, 101⅛ × 140¼ in. (256.9 × 357.5 cm)
Gift of Marcella Brenner Revocable Trust, 2011

GEORGE LUKS (1866–1933)
Telling Fortunes, 1914
Oil on canvas, 20 × 16 in. (50.8 × 40.6 cm)
Acquired 1922

PEPPINO MANGRAVITE (1896–1978)
Political Exiles, c. 1928
Oil on canvas, 24 × 20¼ in. (61 × 51.4cm)
Acquired 1928

MAN RAY (1890–1976)
The Black Tray, 1914
Oil on canvas, 18 × 24¼ in. (45.7 × 61.6 cm)
Acquired 1927

JOHN MARIN (1870–1953)
Back of Bear Mountain, 1925
Watercolor and charcoal on paper, 17 × 20 in. (43.2 × 50.8 cm)
Acquired 1926

Pertaining to Fifth Avenue and Forty-Second Street, 1933
Oil on canvas, 28 × 36 in. (71.1 × 91.4 cm)
Acquired 1937

The Sea, Cape Split, Maine, 1939
Oil on canvas, 24¼ × 29¼ in. (61.6 × 74.3 cm)
Acquired 1940

Spring No. 1, 1953
Oil on canvas, 22 × 28 in. (55.9 × 71.1 cm)
Acquired 1954

Street Crossing, New York, 1928
Watercolor, black chalk, and graphite on watercolor paper, 26¼ × 21¾ in. (66.7 × 55.3 cm)
Acquired 1931

Weehawken Sequence, No. 30, c. 1916
Oil on canvas board, 11¾ × 9 in. (29.8 × 22.9 cm)
Gift of John Marin, Jr., in memory of Duncan Phillips, 1967

ALFRED MAURER (1868–1932)
Still Life with Doily, c. 1930
Oil on hardboard, 17⅞ × 21½ in. (45.4 × 54.6 cm)
Acquired 1940

KENNETH HAYES MILLER (1876–1952)
The Shoppers, 1920
Oil on canvas, 24⅛ × 20⅛ in. (61.3 × 51.1 cm)
Acquired 1928

JOAN MITCHELL (1925–1992)
August, Rue Daguerre, 1957
Oil on canvas, 82 × 69 in. (208.3 × 175.3 cm)
Acquired 1958

GEORGE L. K. MORRIS (1905–1975)
Heraldic Abstraction, 1942
Oil on canvas, 12 × 16 in. (30.5 × 40.6 cm)
Acquired 1944

GRANDMA MOSES (ANNA MARY ROBERTSON MOSES, 1860–1961)
Hoosick Falls in Winter, 1944
Oil on hardboard, 19¾ × 23¾ in. (50.2 × 60.3 cm)
Acquired 1949

ROBERT MOTHERWELL (1915–1991)
Chi Ama, Crede, 1962
Oil on canvas, 82 × 141 in. (208.3 × 358.1 cm)
Purchased by The Phillips Collection through funds donated by Special Director's Discretionary Grant from the Judith Rothschild Foundation, Mr. and Mrs. Gifford Phillips, The Chisholm Foundation, The Whitehead Foundation, Mr. and Mrs. Laughlin Phillips, Mr. and Mrs. Marc E. Leland, and the Honorable Ann Winkelman Brown and Donald A. Brown, 1998

JEROME MYERS (1867–1940)
The Tambourine, 1905
Oil on canvas, 22 × 32 in. (55.9 × 81.3 cm)
Acquired 1942

JEAN NEGULESCO (1900–1993)
Roumanian Still Life, 1926
Oil on cardboard, 15¾ × 24⅞ in. (40 × 63.2 cm)
Acquired 1931

KENNETH NOLAND (1924–2010)
April, 1960
Acrylic on canvas, 16 × 16 in. (40.6 × 40.6 cm)
Acquired 1960

KENZO OKADA (1902–1982)
Footsteps, 1954
Oil on canvas, 60⅜ × 69⅞ in. (153.4 × 177.5 cm)
Acquired 1956

GEORGIA O'KEEFFE (1887–1986)
Large Dark Red Leaves on White, 1925
Oil on canvas, 32 × 21 in. (81.3 × 53.3 cm)
Acquired 1943

My Shanty, Lake George, 1922
Oil on canvas, 20 × 27⅛ in. (50.8 × 68.9 cm)
Acquired 1926

Pattern of Leaves, 1923
Oil on canvas, 22⅛ × 18⅛ in. (56.2 × 46 cm)
Acquired 1926

Ranchos Church, No. II, NM, 1929
Oil on canvas, 24⅛ × 36⅛ in. (61.3 × 91.8 cm)
Acquired 1930

Red Hills, Lake George, 1927
Oil on canvas, 27 × 32 in. (68.6 × 81.3 cm)
Acquired 1945

ALFONSO OSSORIO (1916–1990)
Five Brothers, 1950
Watercolor, ink, and wax on illustration board, 18⅜ × 30¼ in. (46.7 × 76.8 cm)
Acquired 1951

GUY PÈNE DU BOIS (1884–1958)
The Arrivals, 1918 or early 1919
Oil on plywood panel, 24 × 20 in. (60.9 × 50.8 cm)
Acquired 1922

Blue Armchair, 1923
Oil on plywood panel, 25 × 20 in. (63.5 × 50.8 cm)
Acquired 1927

JOHN FREDERICK PETO (1854–1907)
Old Time Card Rack, 1900
Oil on canvas, 30 × 25 in. (76.2 × 63.5 cm)
Acquired 1939

MARJORIE ACKER PHILLIPS (1894–1985)
Night Baseball, 1951
Oil on canvas, 24¼ × 36 in. (61.6 × 91.4 cm)
Gift of the artist, 1951 or 1952

HORACE PIPPIN (1888–1946)
Domino Players, 1943
Oil on composition board, 12¾ × 22 in. (32.4 × 55.9 cm)
Acquired 1943

JACKSON POLLOCK (1912–1956)
Collage and Oil, c. 1951
Oil, ink, and paper collage on canvas, 50 × 35 in. (127 × 88.9 cm)
Acquired 1958

MAURICE PRENDERGAST (1858–1924)
Fantasy, c. 1917
Oil on canvas, 22⅝ × 31⅝ in. (57.5 × 80.3 cm)
Acquired 1921

Ponte della Paglia, 1898–99, reworked 1922
Oil on canvas, 27⅞ × 23⅛ in. (70.8 × 58.7 cm)
Acquired 1922

THEODORE ROBINSON (1852–1896)
Giverny, c. 1889
Oil on canvas, 16 × 22 in. (40.6 × 55.9 cm)
Acquired 1920

MARK ROTHKO (1903–1970)
Green and Maroon, 1953
Oil on canvas, 91⅛ × 54⅞ in. (231.5 × 139.4 cm)
Acquired 1957

Green and Tangerine on Red, 1956
Oil on canvas, 93⅜ × 69¼ in. (237.8 × 175.9 cm)
Acquired 1960

ANDRÉE RUELLAN (1905–2006)
The Wind-Up, undated
Oil on canvas, 20⅛ × 30 in. (51.1 × 76.2 cm)
Acquired 1941

ALBERT PINKHAM RYDER (1847–1917)
Moonlit Cove, early to mid-1880s
Oil on canvas, 14⅛ × 17⅛ in. (35.9 × 43.5 cm)
Acquired 1924

BEN SHAHN (1898–1969)
Still Music, 1948
Casein on fabric mounted on plywood panel,
48 × 83½ in. (121.9 × 212 cm)
Acquired 1949

CHARLES SHEELER (1883–1965)
Skyscrapers, 1922
Oil on canvas, 20 × 13 in. (50.8 × 33 cm)
Acquired 1926

EVERETT SHINN (1876–1953)
Tenements at Hester Street, 1900
India ink and pastel on gray paper, 8¼ × 12⅞ in.
(21 × 33 cm)
Acquired 1943

JOHN SLOAN (1871–1951)
Clown Making Up, 1910
Oil on canvas, 32⅛ × 26 in. (81.6 × 66 cm)
Acquired 1919

Six O'Clock, Winter, 1912
Oil on canvas, 26⅛ × 32 in. (66.4 × 81.3 cm)
Acquired 1922

The Wake of the Ferry II, 1907
Oil on canvas, 26 × 32 in. (66 × 81.3 cm)
Acquired 1922

DAVID SMITH (1906–1965)
Bouquet of Concaves, 1959
Steel, painted, 27½ × 38½ × 8 in. (69.9 × 97.8 × 20.3 cm)
Gift of Gifford and Joann Phillips, 2008

JOSEPH SOLMAN (1909–2008)
The Broom, 1947
Oil on mat board, 20 × 16 in. (50.8 × 40.6 cm)
Acquired 1949

NILES SPENCER (1893–1952)
The Dormer Window, 1927
Oil on canvas, 30⅛ × 24⅛ in. (76.5 × 61.3 cm)
Acquired 1927

ROBERT SPENCER (1879–1931)
Across the Delaware, c. 1916
Oil on canvas, 14 × 14 in. (35.6 × 35.6 cm)
Acquired 1921

EVERETT SPRUCE (1908–2002)
Arkansas Landscape, 1938
Oil on hardboard, 21¼ × 25 in. (54 × 63.5 cm)
Acquired 1942

THEODOROS STAMOS (1922–1997)
The Sacrifice of Kronos, No. 2, 1948
Oil on hardboard, 48 × 36 in. (121.9 × 91.4 cm)
Acquired 1949

MAURICE STERNE (1878–1957)
Benares, 1912
Oil on canvas, 39¾ × 30½ in. (101 × 77.5 cm)
Acquired 1946

Temple Feast, Bali, 1913
Oil on paper mounted on cardboard, 21⅜ × 19⅝ in.
(54.3 × 49.8 cm)
Acquired 1927

CLYFFORD STILL (1904–1980)
1950-B, 1950
Oil on canvas, 84 × 67⅛ in. (213.4 × 170.5 cm)
Acquired 1969

AUGUSTUS VINCENT TACK (1870–1949)
Aspiration, 1931
Oil on canvas, 74¼ × 134½ in. (188.6 × 341.6 cm)
Acquired 1932

Night, Amargosa Desert, 1935
Oil on canvas mounted on plywood panel, 84 × 48 in.
(213.4 × 121.9 cm)
Acquired 1937

RUFINO TAMAYO (1899–1991)
Carnival, 1941
Oil on canvas, 44⅛ × 33¼ in. (112.1 × 84.5 cm)
Acquired 1942

Mandolins and Pineapples, 1930
Oil on canvas, 19¾ × 27½ in. (50.2 × 69.9 cm)
Acquired 1930

MARK TOBEY (1890–1976)
After the Imprint, 1961
Gouache on illustration board, 39¼ × 27⅛ in.
(99.7 × 69.5 cm)
Acquired 1962

BRADLEY WALKER TOMLIN (1899–1953)
No. 9, 1952
Oil on canvas, 84 × 79 in. (213.4 × 200.7 cm)
Acquired 1957

ALLEN TUCKER (1866–1939)
The Rise, undated
Oil on canvas, 30½ × 36 in. (77.5 × 91.4 cm)
Acquired 1927

JOHN HENRY TWACHTMAN (1853–1902)
The Emerald Pool, c. 1895
Oil on canvas, 25 × 25 in. (63.5 × 63.5 cm)
Acquired 1921

Summer, late 1890s
Oil on canvas, 30 × 53 in. (76.2 × 134.6 cm)
Acquired 1919

Winter, c. 1891
Oil on canvas, 21⅝ × 26⅛ in. (54.9 × 66.4 cm)
Acquired 1920

MAX WEBER (1881–1961)
High Noon, 1925
Oil on canvas, 20⅛ × 24⅛ in. (51.1 × 61.3 cm)
Acquired 1925

JULIAN ALDEN WEIR (1852–1919)
The High Pasture, 1899–1902
Oil on canvas, 24⅛ × 33½ in. (61.3 × 85.1 cm)
Acquired 1920

HAROLD WESTON (1894–1972)
Winds, Upper Ausable Lake, 1922
Oil on canvas, 16 × 22 in. (40.6 × 55.9 cm)
Gift of Mrs. Harold Weston, 1981

JAMES ABBOTT McNEILL WHISTLER (1834–1903)
Miss Lillian Woakes, 1890–91
Oil on canvas, 21⅛ × 14⅛ in. (53.7 × 35.9 cm)
Acquired 1920

WILLIAM ZORACH (1887–1966)
New York Harbor, 1923
Watercolor on paper, 15¼ × 21½ in. (38.7 × 54.6 cm)
Acquired 1925

PHOTOGRAPHIC CREDITS AND COPYRIGHTS

BIOGRAPHIES OF THE ARTISTS PHOTOGRAPHIC CREDITS

Milton Avery, c. 1935/photo by Alfredo Valente, Alfredo Valente papers, AAA; Gifford Beal, c. 1934/u.p., FW, AAA; George Bellows, c. 1900/photo by PAJS, AAA; Isabel Bishop, 1959/photo by Budd (New York, N.Y.), Isabel Bishop papers, AAA; Oscar Bluemner, July 13, 1932/photo by The Modern Studio, John Davis Hatch papers, AAA; Ilya Bolotowsky, May 24, 1938/photo by Cyril Mipaas, Federal Art Project, Photographic Division collection, AAA; Edward Bruce, c. 1930/u.p., Edward Bruce papers, AAA; Charles Burchfield, 1930/u.p., FW, AAA; Alexander Calder, 1968/photo by Benedict J. Fernandez © Benedict J. Fernandez, NPG; Arthur B. Carles, 1923/photo by Alfred Stieglitz © 2013 The Georgia O'Keeffe Foundation/ARS, courtesy Philadelphia Museum of Art; Jean Charlot, 1923/photo by Tina Modotti, Jean Charlot Collection, University of Hawaii at Manoa Library, Honolulu; William Merritt Chase in his studio, c. 1910/photo by Harriet Blackstone, Harriet Blackstone papers, AAA; Ralston Crawford, 1977/photo by Russell Lynes, Russell Lynes papers, AAA; Allan Rohan

Crite, photo by Martha Stewart © 2013 President and Fellows of Harvard College, Harvard University, Cambridge, Mass.; Arthur B. Davies, c. 1908/photo by PAJS, AAA; Stuart Davis, Jan. 1957/u.p., Downtown Gallery records, AAA; Willem de Kooning, c. 1955/u.p., Rudi Blesh papers, AAA; Charles Demuth, c. 1905/u.p., courtesy Demuth Museum, Lancaster, Pa.; Preston Dickinson, c. 1920/photo by Nickolas Muray, Miscellaneous photographs collection, AAA; Richard Diebenkorn, 1977/photo by Mimi Jacobs, AAA; Paul Dougherty, c. 1920/u.p., MG, AAA; Arthur G. Dove, c. 1938/u.p., Arthur and Helen Torr Dove papers, AAA; Thomas Eakins, c. 1898/u.p., Susan Eakins letter, AAA; Louis M. Eilshemius, 1913/photo by Jim Saah, Louis M. Eilshemius letters and photograph, AAA; Lyonel Feininger, 1926/u.p., Alfred Vance Churchill papers regarding Lyonel Feininger, AAA; Sam Francis, 1987/photo by André Emmerich, André Emmerich Gallery records and André Emmerich papers, AAA; Helen Frankenthaler, 1990/photo by André Emmerich, André Emmerich Gallery records and André Emmerich papers, AAA; Albert Eugene Gallatin, 1931/*Portrait* by Fernand Léger, ink on paper, NPG; Sam Gilliam, undated/photo courtesy Marsha Mateyka Gallery, Washington, D.C.; William Glackens, c. 1915/photo by PAJS, AAA; Adolph Gottlieb, c. 1950/photo by Alfredo Valente, Alfredo Valente papers, AAA; John D. Graham, 1940s?/u.p., John D. Graham papers, AAA; Morris Graves, 1938/photo by Robert Bruce Inverarity, Robert Bruce Inverarity papers, AAA; Philip Guston, 1978/photo by Larry Merrill © Larry Merrill; Marsden Hartley, c. 1940/photo by Alfredo Valente, Alfred Valente papers, AAA; Childe Hassam, 1913/u.p., MG, AAA; Robert Henri, c. 1908/photo by PAJS, AAA; Edward Hicks, c. 1850–52/*Portrait* by Thomas Hicks, oil on canvas, James A. Michener Art Museum, Doylestown, Pa., purchased and funded by Eleanor K. Denoon, Bella S. and Benjamin H. Garb Foundation Inc., Mr. and Mrs. Kenneth Gemmill, George S. Hobensack, Jr., Laurence D. Keller, William Mandel, Members of Newtown Friends Meeting, Olde Hope Antiques, Inc., Residents of Pennswood Village, Eleanor and Malcolm Polis, Ms. Leslie E. Skilton, Kingdon Swayne and Anonymous Donors; Stefan Hirsch, 1926–37/photo by Peter Juley, Stefan Hirsch and Elsa Rogo papers, AAA; Winslow Homer, c. 1907/u.p., MG, AAA;

Edward Hopper, c. 1928/photo by Soichi Sunami, Miscellaneous photographs collection, AAA; George Inness, c. 1860/u.p., NPG; John Kane, undated/u.p., courtesy Galerie St. Etienne, New York; Bernard Karfiol, 1930/u.p., FW, AAA; Rockwell Kent, c. 1940/photo by Arnold Genthe, FW, AAA; Karl Knaths, c. 1960/u.p., MG, AAA; Walt Kuhn, c. 1920/photo by Edward Weston, Walt Kuhn, Kuhn Family papers, and Armory Show records, AAA; Yasuo Kuniyoshi, c. 1940/photo by Konrad Cramer, Konrad and Florence Ballin Cramer papers, AAA; John La Farge, 1907/photo by Wilton Lockwood, MG, AAA; Jacob Lawrence, 1966/photo by Geoffrey Clements, American Federation of Arts records, AAA; Ernest Lawson, c. 1935/photo by PAJS, AAA; Doris Lee, c. 1940/photo by Yasuo Kuniyoshi, Yasuo Kuniyoshi papers, AAA; Seymour Lipton, c. 1970/u.p., Seymour Lipton papers, AAA; Morris Louis, 1950s?/u.p., Morris Louis and Morris Louis Estate papers, AAA; George Luks, c. 1920/u.p., FW, AAA; Peppino Mangravite, c. 1940/photo by M. (Marko) Vu Kovic, FW, AAA; Man Ray, 1948/photo by Robert Bruce Inverarity, Robert Bruce Inverarity papers, AAA; John Marin, 1950/photo by Jack Calderwood, Miscellaneous photographs collection, AAA; Alfred Maurer, c. 1931/u.p., Bertha Schaefer papers and gallery records, AAA; Kenneth Hayes Miller, c. 1924/photo by Margaret Wattsins, FW, AAA; Joan Mitchell, 1990/photo by Chris Felver/Getty Images; George L. K. Morris, 1942/photo by Soichi Sunami, George L. K. Morris papers, AAA; Grandma Moses at her Painting Table, undated/u.p., © Grandma Moses Properties Co., New York; Robert Motherwell, Peter A. Juley & Son Collection, SAAM J0005260; Jerome Myers, 1938/photo by PAJS, AAA; Jean Negulesco, c. 1955/photo by Hulton Archives/Getty Images; Kenneth Noland, 1960s?/photo by André Emmerich, André Emmerich Gallery records and André Emmerich papers, AAA; Kenzo Okada, 1981/photo by Arthur Mones © Estate of Arthur Mones, Brooklyn Museum of Art, gift of the artist; Georgia O'Keeffe, 1967/photo by Philippe Halsman/Magnum Photos, © Halsman Estate, NPG, gift of George R. Rinhart; Alfonso Ossorio, 1960s?/u.p., Robert Scull papers, AAA; Guy Pène du Bois, c. 1930/u.p., FW, AAA; John Frederick Peto, 1875/photo by George & William H. Rau, John Frederick Peto and Peto Family papers, AAA; Marjorie Phillips, 1940/photo by F. Vogel, The

Phillips Collection; Horace Pippin, 1940/photo by Carl Van Vechten, Downtown Gallery records, AAA; Jackson Pollock, c. 1945/u.p., Jackson Pollock and Lee Krasner papers, AAA; Maurice Prendergast, c. 1910/photo by Gertrude Kasebier, MG, AAA; Theodore Robinson, c. 1882/u.p., MG, AAA; Mark Rothko, 1954/photo by Henry Elkan, Rudi Blesh papers, AAA; Andrée Ruellan, Peter A. Juley & Son Collection, SAAM J0080283; Albert Pinkham Ryder, c. 1905/photo by Alice Boughton, MG, AAA; Ben Shahn, Dec. 12, 1938/photo by Farm Security Administration, Library of Congress Prints and Photographs Division, Washington, D.C.; Charles Sheeler, c. 1923/photo by Charles Sheeler, Downtown Gallery records, AAA; Everett Shinn painting a folding screen, 1920s?/u.p., Everett Shinn collection, AAA; John Sloan, c. 1930/photo by Alfredo Valente, Alfredo Valente papers, AAA; David Smith, c. 1942/u.p., David Smith miscellaneous papers, AAA; Joseph Solman, c. 1955–56/*Portrait* by Byron Browne, oil on canvas, HMSG, gift of Mrs. Rosalind Browne, New York, 1977; Niles Spencer, c. 1925/photo by Peter A. Juley & Son, Miscellaneous photographs collection, AAA; Robert Spencer, c. 1916/u.p., MG, AAA; Everett Spruce, courtesy of Jake and Nancy Hamon Arts Library/Jerry Bywaters Special Collection on Art of the Southwest, Southern Methodist University, Dallas; Theodoros Stamos, c. 1940/u.p., Theodoros Stamos papers, AAA; Maurice Sterne, 1931/u.p., Miscellaneous photographs collection, AAA; Clyfford Still, July 7, 1964/photo by Sandra Still © Sandra Still, courtesy the Clyfford Still Museum, Denver; Augustus Vincent Tack, 1940/*Self-Portrait*, oil on hardboard, The Phillips Collection, Washington, D.C.; Rufino Tamayo, Dec. 27, 1945/photo by Carl Van Vechten, Library of Congress Prints and Photograph Division, Washington, D.C., gift of Carl Van Vechten Estate, 1966; Mark Tobey, 1935/photo by Robert Bruce Inverarity, Robert Bruce Inverarity papers, AAA; Bradley Walker Tomlin, 1952/photo by Kay Bell Reynal, AAA; Allen Tucker, c. 1913/photo by PAJS, AAA; John Henry Twachtman,

c. 1900/photo by Gertrude Kasebier, MG, AAA; Max Weber, c. 1941/photo by Alfredo Valente, Alfredo Valente papers, AAA; Julian Alden Weir, c. 1880/photo by Frederick Hollyer, Olin Levi Warner papers, AAA; Harold Weston, June 1952/photo by John D. Schiff, Harold Weston papers, AAA; James Abbott McNeill Whistler, c. 1890/u.p., John White Alexander papers, AAA; William Zorach, c. 1930/photo by Alfred Stieglitz, FW, AAA

COPYRIGHT PERMISSIONS FOR REPRODUCTION OF ARTWORK